THE ART OF MAYA

HENRI STIERLIN

THE ART OF MAYA

EVERGREEN

FRONT COVER:
Front of the temple of the nuns in Chichen Itza

BACK COVER:
Flat relief of Tzompantli

This book was printed on 100 % chlorine free bleached
paper in accordance with the TCF standard.

EVERGREEN is a lable of Benedikt Taschen Verlag GmbH.

© 1981 Office du Livre Fribourg
© for this edition 1994 Benedikt Taschen Verlag GmbH,
Hohenzollernring 53, D-50672 Köln
Printed by Graficas Estella, Estella Navarra
Printed in Spain
ISBN 3-8228-9033-2

Table of contents

Introduction

The aim of this book is to explore, through words and pictures, the various forms of expression current in a specific area of pre-Columbian art, from sculpture and architecture to pottery and painting, in the light of the culture, religion, and technology that gave birth to them.

Although my purpose is to define a particular aesthetic outlook, it must be kept in mind that the notion of 'art' applies only retrospectively to this stage of civilization. When we refer to Olmec or Maya artefacts as art, we risk a misinterpretation in ethnographic and historical terms.

The original function of aesthetic creation was a quest for the sacred—an approach to the gods and to cosmic forces, attempting to tame them through beauty. Admittedly, not all manifestations of ancient peoples had a religious motive. But the works of the Olmecs and the Maya seem to have been governed by ceaseless piety, according to a strict hierarchy or sacred order, against the systematic background of divine powers.

Geographically, my concern is with the pre-Columbian inhabitants of an area extending from the Gulf of Mexico and Yucatán to Guatemala and Honduras, and from the Caribbean to the Pacific through the Petén and Chiapas. Within that zone of Mesoamerica, covering about 360,000 square kilometres, the Olmec and Maya territory resembles an equilateral triangle, surmounted by the Yucatán peninsula, and measures no less than 1000 kilometres on each side. Three periods or cultures distinguished this part of Central America:

a) the *Olmec* culture, which was the mother civilization of the pre-Columbian world in the northern hemisphere between 1500 BC and the beginning of the Christian era;

b) the *Maya* culture, which inherited several traits from its Olmec predecessor and brought the pre-Columbian arts and sciences to their peak. The historical development of these 'Greeks of the New World' spanned a millennium until about the year 1000;

c) the *Toltec-Maya* culture, in which the decadent Maya assimilated their Toltec invaders from the Mexican highlands. The Toltecs settled in Yucatán and caused a fresh civilization to flourish briefly. This Toltec-Maya renaissance lasted from the tenth to the thirteenth century, and in some places until the sixteenth when Spanish conquistadors, landing in the New World, witnessed the irreversible decline of the remaining Maya tribes.

Thus our study encompasses three millennia, from the genesis of Mesoamerican civilization till the death of its most illustrious branch once the continent was invaded by Europeans.

The limitations of archaeology

The area offers a wealth of archaeological sites. Although a few dozen of them have received scientific examination and careful restoration (especially in Mexico), hundreds of others lie abandoned in the virgin forests of the Petén and Quintana Roo, the swamps of Tabasco, the river valleys of Chiapas and the brush of Yucatán. Many sites have excited the interest, not yet of archaeologists, but of professional looters who sell stelae (carved slabs), bas-reliefs, sculptures, tombstones, and hieroglyphic inscriptions on the international antique market.

Despite investigations and rescue operations carried out by the governments and archaeological authorities of several countries in which ruins are located, as well as by leading American universities and European expeditions, there are still considerable gaps in our knowledge of pre-Columbian peoples. Most importantly, in the Olmec and Maya region, tragic damage has been wrought over the years by its humid tropical climate. Conditions were quite different in Egypt, where pieces of straw, wood, or cloth, and even dead bodies, have survived more or less intact, helping us to picture a world up to 5000 years old.

With the natives of the Gulf and the Petén, our evidence consists mainly of imperishable stone and pottery, besides occasional wood and wall paintings. Virtually nothing is left of textiles, feathers (which were quite important for the Maya), basketry, or body decorations. The image we have of Mesoamerican culture is correspondingly tentative, with room for reconstructions that must stray from the terrain of solid fact. This speculation should be modest and cautious. Who can guess the means of communication—apart from codices, nearly all destroyed by Diego de Landa—which are gone forever? Let us recall the fortuitous encounter in 1946 of a remarkable group of wall paintings at Bonampak, followed in less than thirty years by their disintegration due to the damp climate. These are the inherent dangers of attempting to understand the Olmecs and the Maya, and to explain the rise and fall of such civilizations from very scanty material.

Diversity in the human adventure

Our ability to outline the evolution of pre-Columbian societies is constantly broadened by new discoveries. In the last forty years, Mesoamerica has yielded a steady stream of data on the peoples who produced elaborate art dozens of centuries ago. What has survived of that art exerts a strong fascination over the specialist and amateur alike. For it was due to a unique genius which, judging from all the evidence now available, did not depend upon distant contacts as with Europe. The paradoxes of the Mesoamerican cultures show, indeed, how diverse are the ways in which a society can foster a brilliant civilization. Hence it is vital never to isolate the works from their creators, or the creators from their technological and cultural experience.

My treatment of Maya art will therefore not be devoted purely to the delights of 'art for art's sake'—a notion that would have been meaning-

1 Olmec colossal head (No. 1) from La Venta: this block of basalt, 2.41 m high and weighing 25,000 kg (25 tons), was sculpted between 1000 and 800 BC. The flat nose and down-turned mouth are characteristic of the classic Olmec style (La Venta Park-Museum, Villahermosa, Tabasco).

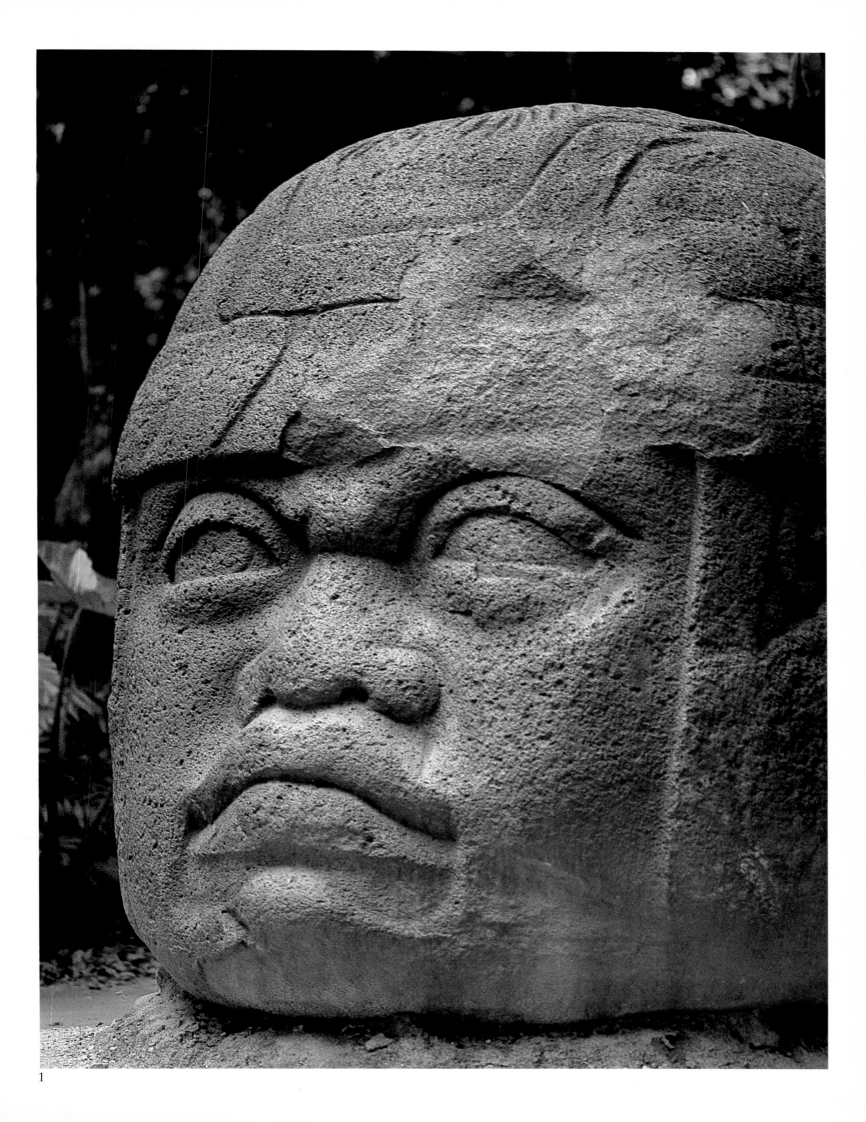

1

less to the population of that place and time. Nor is it intended as a manual for collectors. Rather we must seek the characteristics which gave a deep identity to such peoples, whose thought differed greatly but not totally from our own, and without whose heritage we should have an incomplete perspective of mankind. Only by familiarizing ourselves with the extraordinary range of paths which humanity has followed can we comprehend both the individuality of each culture, and its contribution to the rest of the race in attaining a coherent view of our material and spiritual universe.

From this standpoint, the achievements of the Olmecs and the Maya rank among the most surprising and moving of all. In the course of prehistory, these stone-age folk invented distinctive modes of expression. They generated styles that are astonishingly modern, grandiose and poignant. They devised intellectual systems and seminal techniques. They shaped beliefs, cults, and a pantheon whose gods pervaded the pre-Columbian world. Their religious conceptions, as well as adaptation to an environment that was hardly ideal, enriched the message of mankind. Mesoamericans elevated time to the level of a sacred continuum, marking it with dated stelae, as if to leave some permanent record of their existence. Although ignorant of the use of metals until the virtual end of their era, they fashioned mathematical ideas, urban architecture, and masterpieces that seem at first incompatible with the Neolithic Age to which they evidently belonged.

Much is worth learning today from the disconcerting yet intriguing type of civilization enjoyed by the pre-Columbians. Its rediscovery bore no fruit when the sophisticated, imperialist Christians arrived, massacring and next enslaving the 'Indians' whom they had refused to understand. But the Maya decline—unlike the Aztecs' vigour on the eve of conquest—revealed that this great culture was concluding its natural life cycle just as the earliest conquistadors dissolved it.

The cultural background of the pre-Columbians

Experience acquired by the Olmecs formed the foundation of a vast pool of knowledge common to the subsequent cultures of Mesoamerica. Although I shall not touch here upon the civilizations of Teotihuacán, Monte Albán, Mitla, Tula, the Totonacs, or the Aztecs whose empire eventually swallowed almost all of that region, the Olmec legacy was an essential factor in the later arts of ancient Mexico, to which a second volume will be devoted.

This division into two zones, of the Olmec and the Maya, and of the other old civilizations in Mexico, is logical and reflects a clear geographic demarcation. It exposes striking parallels, accentuates the chief human traits, and is confirmed by a pattern of convergences. But it separates cultural entities that lived in symbiosis, and had developed from a number of elements which I call their common background. The latter included use of certain basic food plants, analogous technological skills, a widespread mythology and pantheon, and key features of pre-Columbian thought and science. It is, then, somewhat arbitrary to segregate peoples whose forms of expression, while varied, comprise a single

family. To avoid serious errors of judgement, we must recognize that the folk of Mesoamerica shared one destiny. Even if they lived on a cultural 'island' in relation to the Old World, there was a constant and intricate process of interaction among them.

Nonetheless, the connections between the Olmecs and the Maya that will be stressed below were far closer than those between the Olmecs and the Teotihuacanos or the Zapotecs, for example. The subtitle of my book does not, of course, mean a conflation of the Olmecs and Maya, reducing the first to an initial phase in the history of the second. Differences between the two are indisputable, and I wish only to emphasize the immediate ancestry of the Maya. A knowledge of Olmec work is crucial in understanding how Maya forms arose, due to the many links in culture and environment. This true kinship permits a study of the arts in question only if we assume that they obeyed laws of inheritance, and regard them as a succession of allied phenomena.

The structure of the book

My arrangement of the material in chapters is essentially as follows: the Olmecs and their artistic legacy; the growth of Maya civilization, and of its large centres in the Petén and the Motagua valley; the great art of Palenque and Yaxchilán in Chiapas; a transitional phase including the earliest centres of Yucatán and the delicate figurines of Jaina; the blossoming of the so-called Puuc style in architecture; the circumstances and cities of the Toltec-Maya renaissance. In the Conclusion, I try to sum up the Olmec and Maya contribution to the arts, technology, and thought of the pre-Columbians.

Whenever possible, the author/photographer has correlated text with illustrations, avoiding scrutiny of monuments which will be found only in specialized publications. Thus our analysis may concentrate upon underlying features, the techniques involved, and interpretations of a functional, stylistic, or spatial kind. This balance of mind and eye will hopefully save the commentary from irrelevancies, and preserve the visual impact of the evidence. There are general maps on pages 14 and 44.

The enlightenment still emanating from such extinct civilizations is too often composed of mute signs. We must lend them words by deciphering the mentality and beliefs, or reconstituting the organization, behind a sparse series of artefacts. In the footsteps of an eminent tradition of archaeologists and art historians who have patiently endeavoured to revive these traces of pre-Columbian glory, I turn to a fresh view of the subject and an ultimate goal of encouraging attention to the lost peoples of the world.

2 Monolithic altar (No. 4) from La Venta: the crowned figure, emerging from a kind of cave surrounded by fertility symbols, is topped by the stylized image of a jaguar. He holds a rope attached to a captive carved on the left side of the altar (La Venta Park-Museum, Villahermosa).

3 Broken altar from La Venta, known today as the 'quintuplets altar': this basalt monolith, sculpted by the classic Olmecs in 1000-800 BC, portrays scenes that are difficult to interpret, and may allude to some lost mythology (La Venta Park-Museum, Villahermosa).

4 Olmec basalt statue: we do not know whether this figure, looking up at the sky and clasping both hands behind his neck, is a sun-worshipper, an astronomer, a monkey, or a tenon-stone which should lie horizontally (La Venta Park-Museum, Villahermosa).

5 Construction of natural basalt columns from La Venta: this 'cage' may have been used to keep a deified jaguar. During the final phase of Olmec culture, 500–400 BC, it was turned into a sumptuous tomb (La Venta Park-Museum, Villahermosa).

6 Serpentine mosaic representing a stylized jaguar-mask from La Venta: this work, dated 1000–800 BC, measuring 4 m by 5 m, was found in the ball court at La Venta (La Venta Park-Museum, Villahermosa).

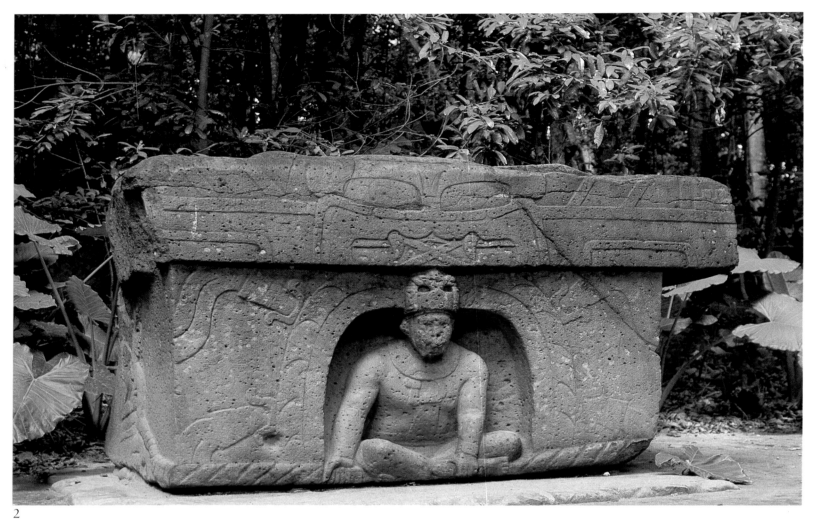

2

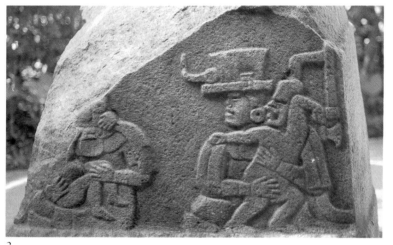

3

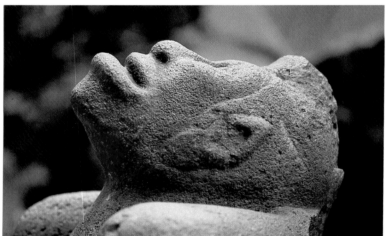

4

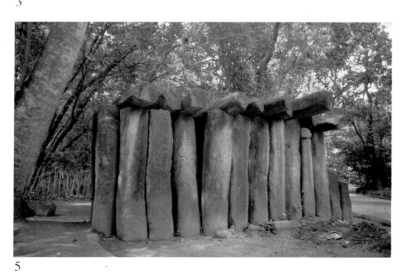

5

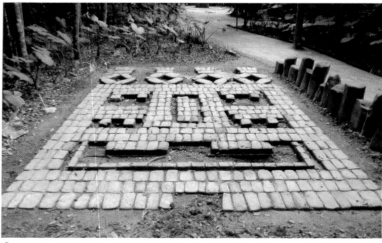

6

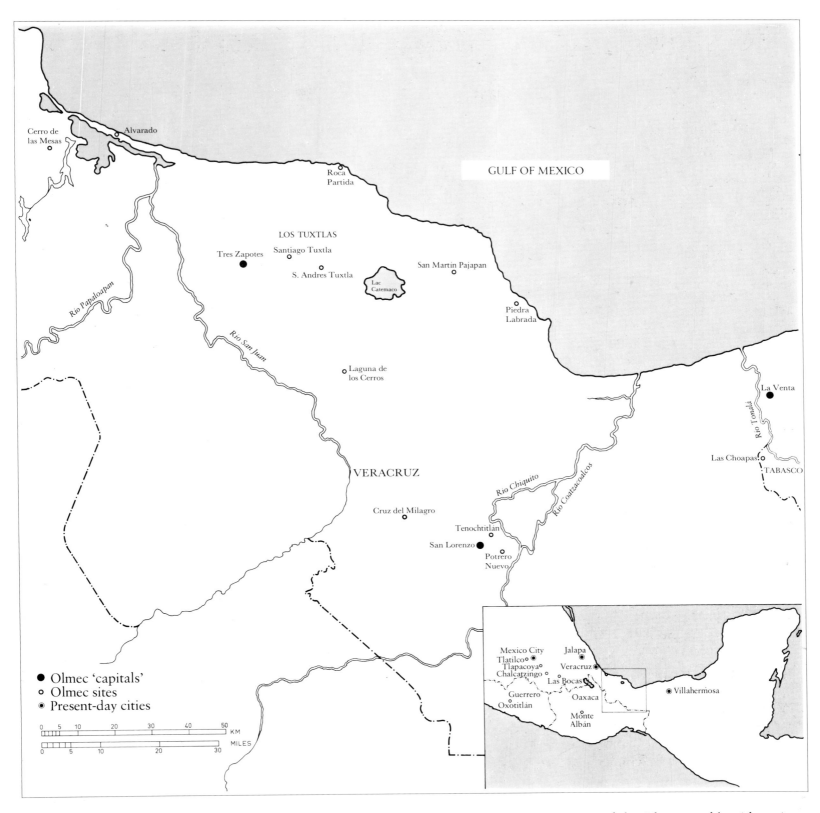

Cerro de
las Mesas

Alvarado

GULF OF MEXICO

Roca
Partida

LOS TUXTLAS

Tres Zapotes Santiago Tuxtla

S. Andres Tuxtla San Martin Pajapan

Lac
Catemaco

Rio Papaloapan

Piedra
Labrada

Rio San Juan

Laguna de
los Cerros

La Venta

Rio Tonalá

Las Choapas
TABASCO

VERACRUZ

Rio Chiquito

Rio Coatzacoalcos

Cruz del Milagro

Tenochtitlan

San Lorenzo

Potrero
Nuevo

● Olmec 'capitals'
○ Olmec sites
◉ Present-day cities

0 5 10 20 30 40 50 KM
0 5 10 20 30 MILES

Mexico City
Tlatilco
Tlapacoya
Chalcatzingo

Jalapa

Veracruz

Las Bocas

Guerrero
Oxotitlán

Oaxaca

Villahermosa

Monte
Albán

Map of the Olmec world, with an inset
showing sites influenced by Olmec civi-
lization

7 Basalt sculpture in the classic Olmec style from La Venta: a figure wearing a jaguar-mask is looking up at the sun in an attitude of entreaty. About 1.10 m high, this monolith was carved between 1000 and 800 BC (Tabasco Museum, Villahermosa).

8 Praying figure from La Venta: an Olmec basalt sculpture in the classic style of 1000–800 BC, about 1.20 m high, with a mouth that must once have shown a jaguar-mask deformation (Tabasco Museum, Villahermosa).

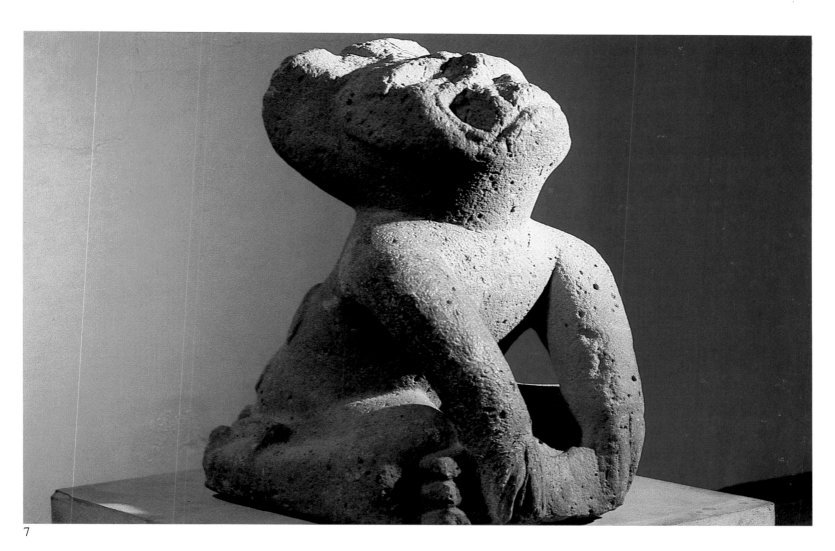

7

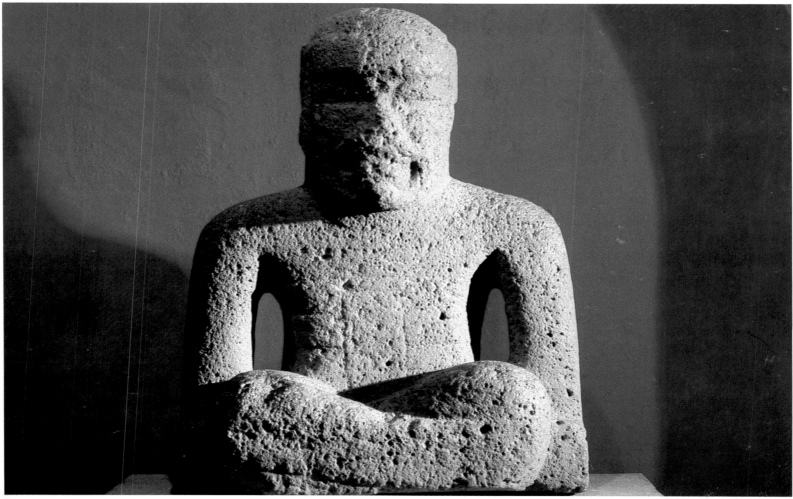

8

I. The Olmec dawn

Only during the last forty years have archaeological investigations brought the Olmec civilization to light. Its existence was suspected ever since a traveller by the name of José Melgar learned, in 1862, that a colossal basalt head had been found in the region of San Andrés Tuxtla, in the state of Veracruz. Much later, in 1925, the Danish antiquarian Frans Blom and the ethnologist Oliver La Farge alerted the world, with enquiries in the district of Los Tuxtlas and in the swamps of the state of Tabasco, where they discovered the site of La Venta on an island in a tributary of the Tonalá River.

The Olmecs are now emerging from their millennia of neglect. Alongside other major civilizations like the Sumerian or Hittite, and thanks to radiocarbon dating, they deserve a lofty place among the first peoples of America. The strange relics excavated from their tropical habitat bordering the Gulf of Mexico are recognized to be our earliest evidence of high pre-Columbian art. As far back as 1500–1200 BC, at their very inception, the Olmecs had developed the main forms of artistic expression—complex architectural centres, colossal monolithic sculpture, tiny hard-stone statuary, murals, and pottery.

The art of this awakening culture was initially preliterate, but simple inscriptions soon appeared on stelae, giving dates in hieroglyphic writing. A manner of calculation and a calendar existed, suggesting some familiarity with astronomy and mathematics. Hence the immediate fascination of archaeologists by Olmec civilization, which bloomed in a humid, stifling, infested virgin forest, one of the least hospitable places on earth.

Three main centres—La Venta, San Lorenzo, and Tres Zapotes—have been systematically excavated, while lucky discoveries on ten other sites have revealed Olmec settlements, particularly at Laguna de los Cerros, Piedra Labrada, Roca Partida, and Cerro de las Mesas. Results include not only the stone heads whose puzzling 'negroid' features and gigantic proportions (one of them weighs over 60,000 kilograms, or 60 tons) first caught the attention of archaeologists, but also large monolithic altars, stelae, sculptures in the round representing seated or crouching figures, admirably polished statuettes, and masks frequently based on a stylized figuration of the jaguar. This animal recurs everywhere in emblematic form, and must have been the Olmecs' principal god. Its characteristic features are slit eyes, flame-like brows, a mouth with down-turned corners and, often, powerful fangs. The image of a jaguar god is a leitmotif of Olmec art, and shows how important a role that formidable carnivore played in the minds of the earliest New World tribes, although it is sometimes overemphasized.

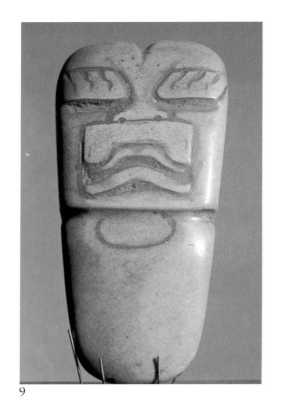

9

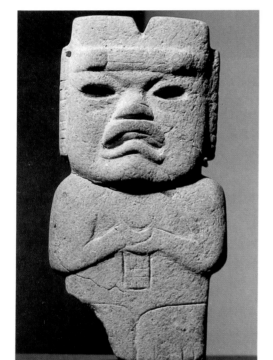

10

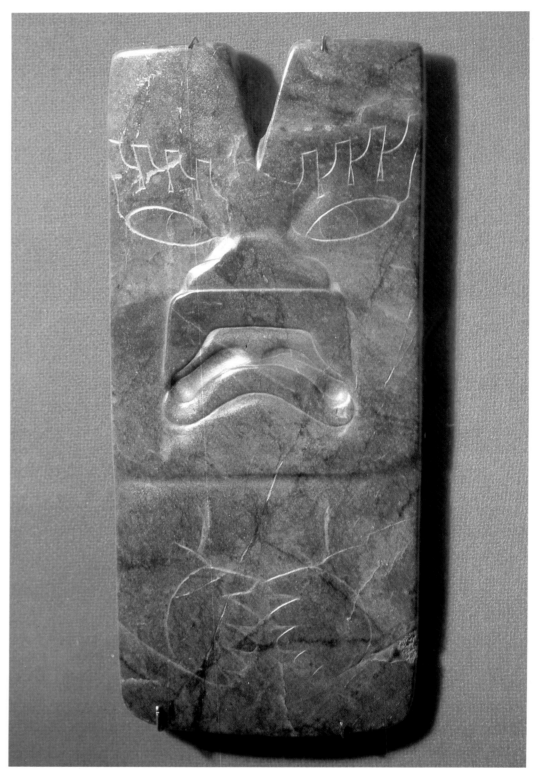

11

But before going any further, we must ask who the Olmecs were, where they lived, how long their civilization lasted, what they achieved, and which position they occupied in the family of pre-Columbian peoples.

Living conditions

Let us begin with subsistence among the people whose distant descendants, 2000 years later, were called 'Olmecs', or 'people of the land of rubber', by the Aztecs. Olmec country is extraordinary by any standards, but especially when one remembers that it harboured the first great Mesoamerican civilization. To modern eyes, nowhere could be more hostile than the low coastal region along the Gulf of Mexico, just below the Tropic of Cancer, with a hot damp climate providing ideal conditions for jungle vegetation.

From the air, the flat forests and swamps of Tabasco and Veracruz seem a vast maze of rivers and streams, dotted by lakes and lagoons. Spreading forth is a tracery of flooded soil, sluggish meanders, and stagnant marshes, where water and humus mix in a slime like the primeval 'soup' that preceded even the separation of the continents. What attracted man to an impenetrable labyrinth in which, each season, a varying expanse of land behind the lagoons along the coast is inundated from rivers and the sea? How did the earliest tribes succeed in populating a virgin forest, drenched by rains and shrouded in mist for much of the year? And why should an environment so fatal to us have favoured a civilization?

It was the Mexican archaeologist, Alfonso Caso, who in 1965 first pointed to the advantages of Olmec territory as compared with other areas of pre-Columbian culture. This region, extending for 250 kilometres along the bottom of the Gulf of Mexico and 70 kilometres wide, includes an array of deep tropical rivers which can rise spectacularly after rains, flooding their alluvial deltas. From east to west, they are the Río Tonalá and the Coatzacoalcos, then the San Juan, the Tesechoacan and the Papaloapan. These flank the Los Tuxtlas massif and its highest peak, the volcano of San Martín Pajapan (1200 metres), between Lake Catemaco and the sea.

The warm floodlands of this area did offer a number of benefits to early man. Navigable rivers facilitated access by raft and dug-out canoe, so that people could descend from the mountains in the west and penetrate the forest. Coastal travel allowed infiltration through the lagoons and deltas as well. Equally, pre-Columbian farmers were unfamiliar with the use of ploughs or fertilizers, and they prized terrain that was regularly enriched by annual floods. Elsewhere, once exhausting the soil in one place, they had to move on and create new fields by burning down sections of forest.

The loose, fertile humus of the watery deltas was suited to the digging stick (the sole farming implement known in pre-Columbian times), and to the planting of maize and black beans, which formed the staple diet of the peoples of the New World. The region's intense heat and heavy rainfall made it possible to grow two crops per year, while in the high-

9 Celt of hard stone from La Venta, carved to represent a jaguar-mask: this votive offering, 12 cm high, dates from the classic Olmec period, 1000–800 BC (National Museum of Anthropology, Mexico City).

10 Ceremonial Olmec celt: such pieces display a strange V-shaped indentation at the top of the skull, which was connected with the features of the sacred jaguar, or the maize deity (National Museum of Anthropology, Mexico City).

11 Large Olmec jade celt, from Mixtec territory, Oaxaca: this figure, dated 1000–800 BC, and 22 cm high, represents a stylized jaguar's face (National Museum of Anthropology, Mexico City).

lands, where drought was a constant threat, only one could be produced—and not every year. Lastly, these so-called *tierras calientes* (hot lands) provided a major source of protein in fish, crustaceans, shellfish, and turtles. It is noteworthy that the natives of the northern hemisphere had no domestic animals apart from dogs, turkeys, and bees. They therefore relied upon hunting and fishing to supply most meat.

The plucky communities that ventured into the coastal lowlands were, then, amply rewarded for their pains. Not only were they quick to thrive, but they soon built up enough surplus wealth to construct large places of worship, dedicated to the gods who had granted prosperity—the deities of the elements and of cosmic forces, such as the sun, water, and vegetation.

The process was similar to that which spawned the civilizations of the Old World in Egypt, Mesopotamia, the Indus Valley, and along the Yellow River. In each case, the inhabitants succeeded in harnessing the potentially destructive power of annual floods, and in turning the fertility of the alluvial plains to their own advantage. Sophisticated cultures resulted, no longer content to lead a precarious existence, but amassing wealth and abundant food. Certain social classes were thus released from preoccupation with survival, and could turn their minds to higher pursuits. These included artistic and scientific activities such as architecture, which culminated in the erection of ceremonial centres with sculpted idols—and on the other hand, a calendar based upon astronomy and arithmetic, enabling people to forecast the dry and rainy seasons, plan when to sow or harvest, and reserve special days in the year for a cycle of festivals.

Excavations at La Venta

When the Olmec civilization died out, even before the beginning of the Christian era, the lowlands along the Gulf coast, to whose north the Totonacs of Tajín and Cempoala were later to flourish, were abandoned. The tropical jungle took over again. For many centuries the only humans that ventured there were occasional hunters of jaguars and, later, collectors of chicle and latex. Thus all trace of civilization in the region vanished for 2000 years, until its subsoil was shown, just before World War II, to contain enormous quantities of oil. In the wake of oil prospecting by the national company Pemex, scientific excavations commenced. They were to reveal, to a world then in the throes of war, the extraordinary story of the Olmecs.

The American archaeologist Matthew W. Stirling was commissioned by the National Geographic Society in Washington, D.C., together with the National Institute of Anthropology and History in Mexico City, to undertake the first excavations at La Venta. He had already discovered, in 1939, an extremely important slab at Tres Zapotes (Stele C, with an inscription perhaps indicating, according to one interpretation, the date 31 BC), and had examined the site of Izapa in southern Mexico, representing the transition between the Olmecs and the Maya.

In 1941, Stirling and Philip Drucker made three series of excavations which revealed the importance of the La Venta site. Their team brought

12 Votive offering No. 4 from La Venta: the group of six polished celts, some engraved, and sixteen statuettes about 20 cm high, was discovered in the arrangement illustrated here, possibly symbolizing a rite. Fifteen figures made of jade and serpentine, showing skull deformations, surround a figure of rough red sandstone. The group dates from Phase III of Olmec civilization at La Venta, 800–500 BC (National Museum of Anthropology, Mexico City).

13 Olmec concave mirror from La Venta: this hematite object, 12 cm long, and found with a votive offering, was probably used to focus the rays of the sun and ignite ritual fires, or to form sacred images. It dates from the final phase at La Venta, 500–400 BC (National Museum of Anthropology, Mexico City).

14 Jadeite plaque from the Gulf Coast: this remarkable Olmec profile has a mouth with down-turned corners. Atop its forehead is a kind of mask with identical features, and three other small engravings on the plaque show similar profiles. The object, measuring 15.4 by 16.6 cm, may date from the final phase, 500–400 BC (National Museum of Anthropology, Mexico City).

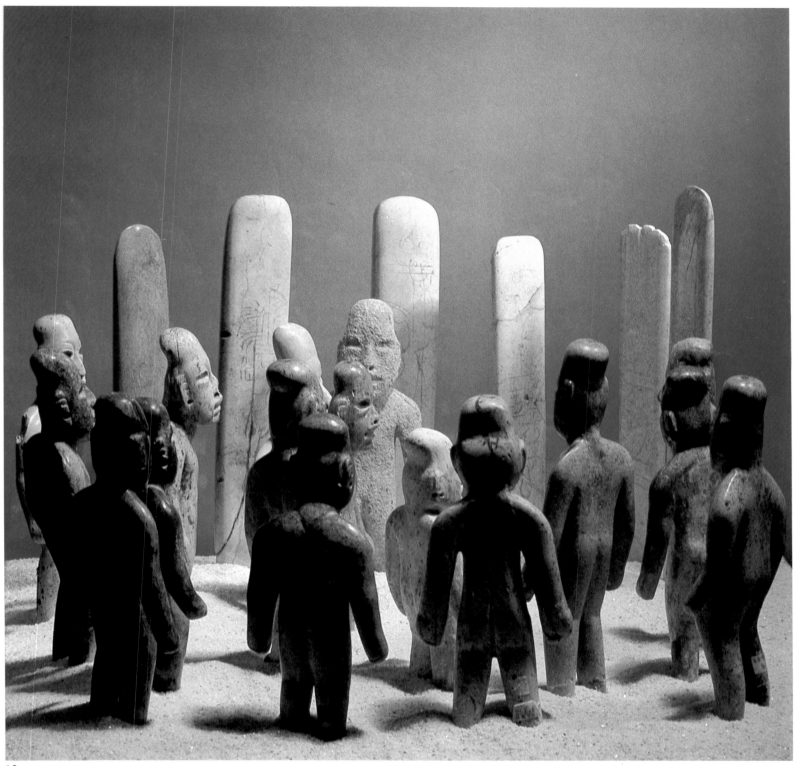

12

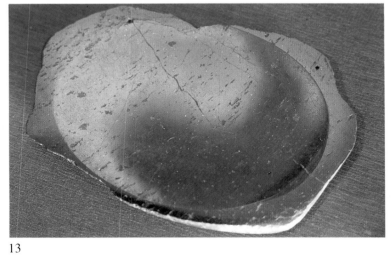

13

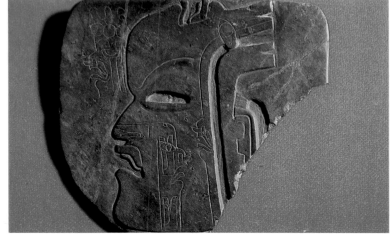

14

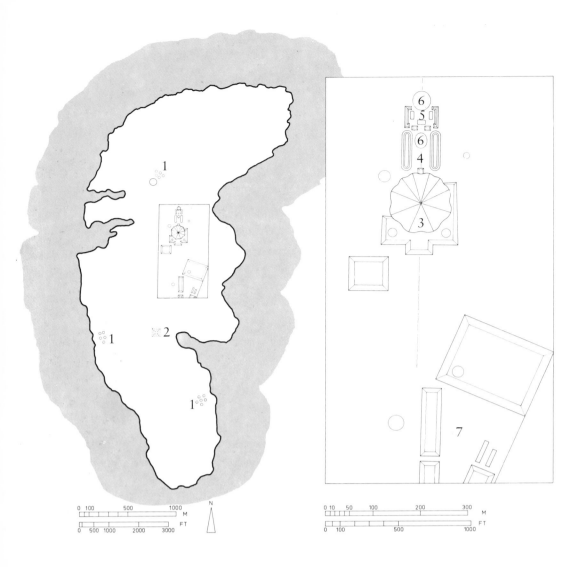

The island in a tributary of the Río Tonalá on which the site of La Venta is located. The inset shows the ceremonial centre of La Venta:
1. Burial mounds
2. Ruined pyramid
3. Principal pyramid
4. Ball court
5. Quadrangle
6. Late burial mounds
7. Stirling group

to light some monuments of considerable size: monolithic sculptures, including enormous altars, colossal heads, a kind of cage with basalt columns, and offerings of polished stone celts and jade statuettes; caches of several hundred tons of meticulously carved serpentine plaques, buried by the thousand between layers of coloured sand from distant quarries; huge enclosures with natural basalt columns, and burial mounds; large stone mosaics of over 20 square metres, depicting stylized jaguar-masks; and magnificent, highly polished concave mirrors made of hematite, magnetite, and ilmenite. These finds accompanied the discovery of a ceremonial complex, comprising a large clay pyramid, which confronted two long parallel mounds and a quadrangular court bordered by platforms. Its layout was very precise, with a north-south axis of symmetry. The pyramid has not yet been penetrated.

The rewards of the excavations were substantial, but there was still no means of dating them. Further investigation was undertaken in 1955 by Philip Drucker, assisted by Robert Heizer and Robert Squier, and under the auspices of the Smithsonian Institution in Washington, D.C., and in 1967 with the support of the National Geographic Society. Organic remains were sought in the form of charcoal, so that the radiocarbon dating technique could be used. This by-product of atomic science, devised by Willard Libby, relies on the natural radioactivity of carbon-14 to determine the age of objects. It led to a firm chronology for La Venta, with four phases: the first in about 1100 BC, the second between 1000 and 800 BC, the third and fourth extending from 800 to 400 BC, whereupon the site was abandoned.

The earth pyramid

During the first phase, building began on the great pyramid and the ceremonial centre. Surprises awaited the excavators when they freed the pyramid from its tropical vegetation in 1967. While Stirling and Drucker had originally believed its ground plan to be rectangular—and described it as such in their *Excavations at La Venta, Tabasco, 1955,* published in 1959—the pyramid turned out to be a conical construction built on a ten-sided polygonal base. The angles of the polygon were emphasized by thick ribs which gave the pyramid an uneven surface, in rather the same way that lava flows cause the irregularities on the side of a volcano.

Robert Heizer stated, in his *New Observations on La Venta,* in 1968, that the pyramid was 125 metres in diameter at its base and 31.5 metres high, and that 99,100 cubic metres of earth had been used to build it. The earliest pyramid of the pre-Columbian period was, then, a sizeable monument. One of the first questions that springs to mind is: where did the creators of this pyramid, weighing 200 million kilograms, procure their materials? The island on which La Venta lies is 4.5 kilometres long, with a maximum width of 1.8 kilometres, and is today surrounded by swamps. It is reasonable to suppose that the Olmecs chose the site because it could easily be reached by dug-out canoe or raft, and that floods subsequently choked its waterways with earth.

A similar phenomenon occurred in Egypt, where the canals and arms of the Nile required regular maintenance to prevent the floods from filling their beds with silt and shifting their course. Such maintenance had to be carefully planned: draining and dredging would be necessary in one section, while in another the dykes might have to be raised. It is clear that the Olmecs were similarly concerned with maintaining their waterways: at both La Venta and San Lorenzo, networks of U-shaped stone drains covered with flagging have been discovered.

Nor is it beyond the bounds of possibility that the Olmecs first developed the notion of a pyramid as a direct result of their efforts to dredge the river. On a site with limited space, disposing of dredged material is always a problem. The mounds of earth that disfigure the landscape of great rivers such as the Nile, Euphrates, or Indus are all too familiar. The same must have been true of La Venta, until someone decided to bring together the heaps of earth in an 'artificial mountain'. Indeed the pyramids of La Venta are located at points of the island nearest to its two banks, where it is indented and the river waters approach the centre of its unsubmerged surface. So the Olmecs intentionally chose those spots that were most accessible.

In this way, a use was found for the large quantities of mud available: it was offered to the gods as a temple-pyramid. Material taken from the river bed—the bounty of floods ordained by the gods—was thus returned to them, through a logic peculiar to primitive peoples. Possibly the vast collective task of land drainage, and its adaptation to the needs of agriculture, were the source of monumental architecture of the type that was to flourish in the pre-Columbian world. An implication would be that the platforms, pyramids, and terraces built for ceremonial purposes were the result of a cooperative human effort that was at once economic (to obtain food) and religious (to worship the gods), each function following naturally from the other in a harmonious cycle. This

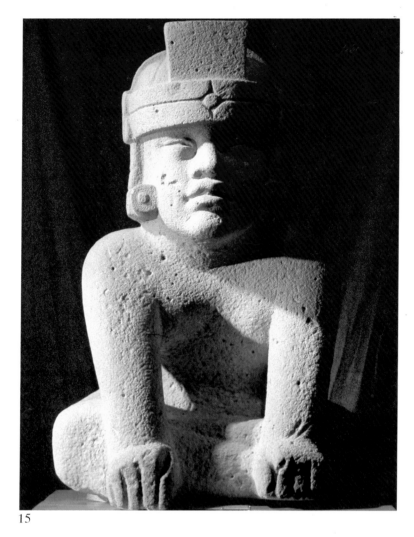

15

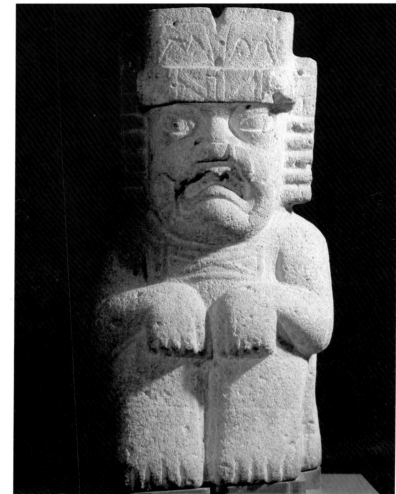

16

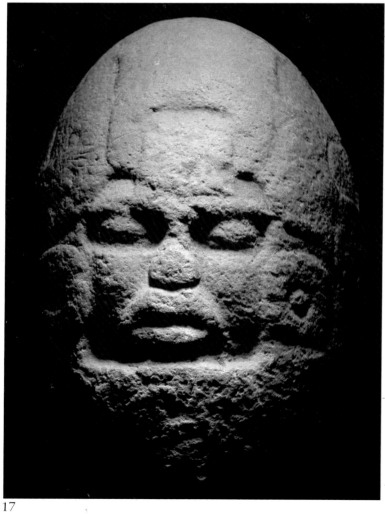

17

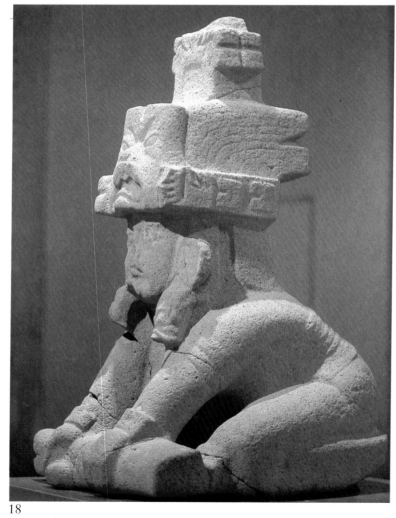

18

coherence was bound to prove satisfying for a society whose whole mentality was oriented towards the sacred.

The ball court

15 Statue from Cruz del Milagro, Sayula, in Veracruz: an extraordinary Olmec sculpture, known as the 'Prince', 1.22 m high and made of andesite, dating from the greatest period at San Lorenzo, 1200–900 BC (Jalapa Museum, Veracruz).

16 Monumental Olmec basalt sculpture from San Lorenzo: about 1 m high, dated 1200–900 BC, it represents a jaguar-man (National Museum of Anthropology, Mexico City).

17 Olmec sculpture from the island of Tasapi, on Lake Catemaco: the soberly treated, egg-shaped figure is carved from andesite and is 60 cm high. Probably dating between 1200 and 900 BC, it has a helmet and ear pendants, rather like the Olmec colossal heads (Jalapa Museum, Veracruz).

18 Olmec monolithic statue: this jaguar-man, carved from andesite and 1.43 m high, was discovered by Frans Blom in 1925 atop the volcano of San Martín Pajapan, in the Los Tuxtlas mountains of Veracruz. Note the jaguar-mask over the man's face (Jalapa Museum, Veracruz).

19 Olmec colossal head from San Lorenzo: this outstanding work of basalt, 2.85 m high and 2.11 m wide, weighs no less than 25,000 kg. It comes from the Cerro Cintepec, 70 km due north-west, but such blocks of stone must have been transported over 120 km by raft. The piece is dated 1200–900 BC (Jalapa Museum, Veracruz).

20 Detail of colossal head from San Lorenzo: such sculpted figures wear round helmets of the kind that may have been used by ball game players. This andesite monolith, 1.86 m high and 1.47 m wide, is dated 1200–900 BC (Jalapa Museum, Veracruz).

21 Olmec basalt column known as the 'Alvarado stele': almost 3 m high, it shows in profile a ball game player, wearing the wide belt on which the rubber ball had to bounce. Above his bearded face is a headdress similar to that on the San Martín Pajapan statue (Plate 18). This monumental sculpture may date from 900 BC (National Museum of Anthropology, Mexico City).

Between the conical pyramid of La Venta and the great ceremonial plaza surrounded by platforms and basalt columns, there are two elongated parallel mounds measuring about 85 by 16 metres, and 6 metres high. Between the mounds, both exactly north-south in alignment, lies an empty area 40 metres broad, which must have been a ball court of the type found on all the main Maya sites and in numerous Mesoamerican civilizations. These dimensions may seem curiously large for what is the earliest known example of such a ball court. But the Olmecs were not a people to be daunted by a major undertaking: their colossal heads, massive votive offerings, pyramids, and platforms were always conceived on a monumental scale. Moreover, this ball court was no bigger than that at Chichén Itzá, dating from the very end of the Toltec-Maya period.

It is no surprise that the Olmecs—the 'people of the land of rubber'—built the first instances of these ball courts. We know that this sacred sport was played with a solid rubber ball weighing up to 1.5 kilograms. The ball game naturally originated in a region where rubber trees grew, and where the collection of latex was no doubt practised at an early period. Much evidence supports this view, for, as we shall see, ball game players were the subject of sculptures and reliefs.

The reason why the space between the two parallel mounds had not previously been identified as a ball court (I suggested the possibility in 1967 in my study *Ancient Mexico*) is that its northern portion is occupied by a burial mound. But the mound was certainly a later addition and, as has been proved by votive offerings it contained, dates from no earlier than phase IV of La Venta. The prior construction of the court seems to be confirmed by three large stone mosaics, whose location shows that they formed an integral part of the monument in its original state. Two mosaics lie on either side of the entrance to the ball court as we come from the ceremonial plaza and look towards the pyramid, while the third is situated exactly in the middle of the court on the axis of symmetry of the whole complex. The mosaics date from phase II.

I would add that, in the pre-Columbian world, former sacred sites were frequently used as cemeteries by dignitaries of a later phase of civilization, who arranged to be buried there with pomp and circumstance. One need only point to the Mixtec tombs discovered in the great Zapotec ceremonial centre at Monte Albán. It therefore has to be supposed that during phase IV of La Venta, when a burial mound was built on the axis of the former ball court, the sacred sport was practised elsewhere—possibly in the second complex of La Venta, known as the Stirling Plaza, which has yet to be excavated completely.

There is a good deal of debate about what the mosaics represent. The first archaeologists to discover them (Stirling, Drucker, and Heizer) believed that the motif, made up of rectangular slabs of hard stone such as serpentine and diorite, formed a stylized jaguar-mask according to a strictly geometric and orthogonal pattern. This seemed to have eyes, topped by heavy flame-like brows, with a vertical nasal ridge descending to a broad rectangular mouth. But the theory was challenged by Michael

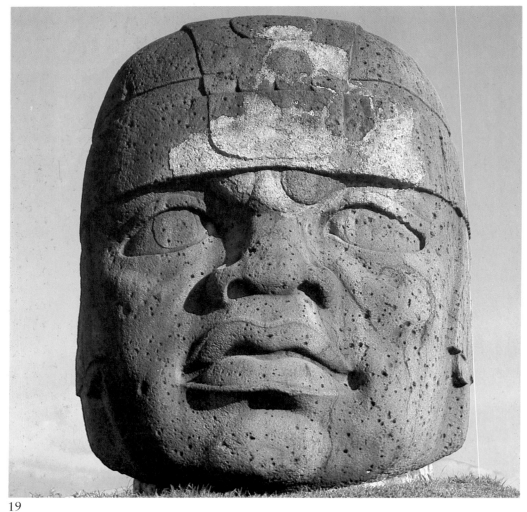

19

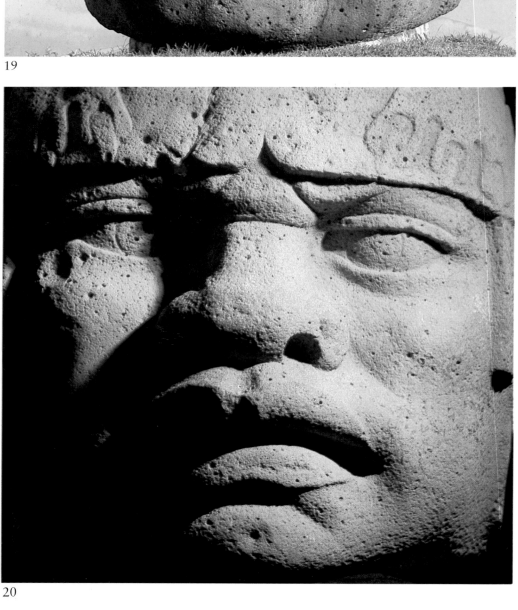

20

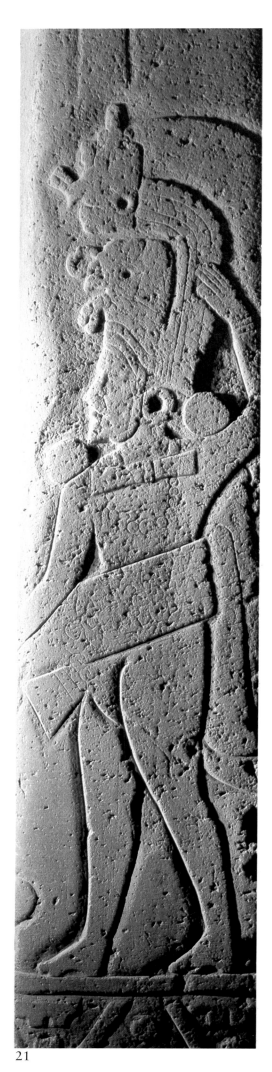

21

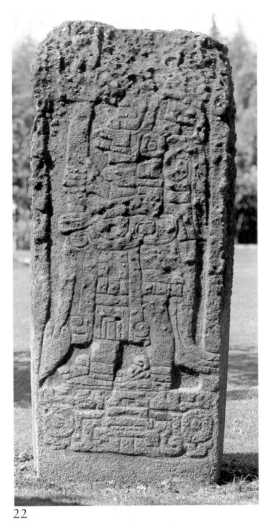

22

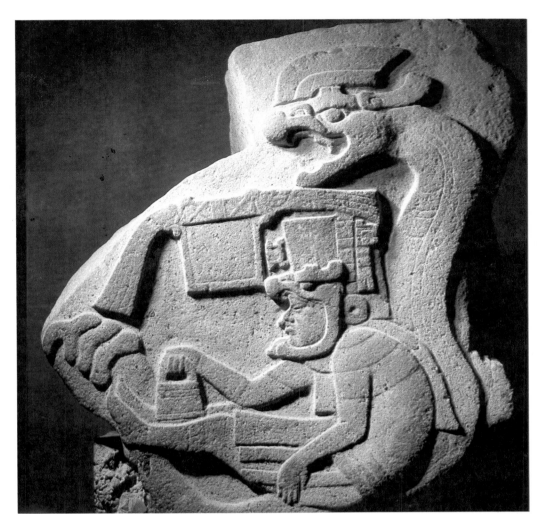

23

24

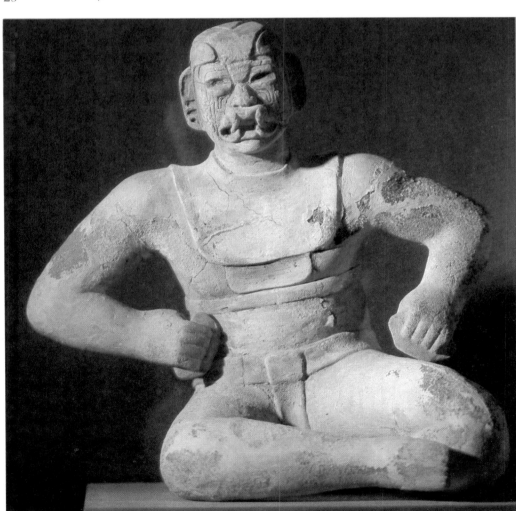

25

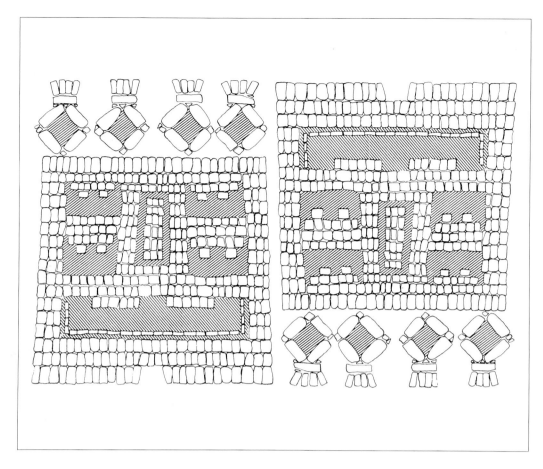

Two interpretations of the stone mosaic design at La Venta

D. Coe and Peter D. Joralemon, members of the new team from Yale University. They simply turned the motif upside down to reveal four dots and a bar—a numeral symbol of the bar and dot notation system, which I shall discuss later.

My opinion is that the two interpretations should not be regarded as having been mutually exclusive in the Olmec mind. On the contrary, the Olmecs may have seen some mysterious meaning in this ambivalence, just as the ancient Greeks, among others, detected a symbolic pattern in letters and numbers. A double interpretation of the jaguar-mask, which thus takes on a Janus-like quality, would accurately reflect the Olmec mentality. Many cases require such a view in pre-Columbian art, particularly on an engraved jadeite plaque, described as a pectoral, whose main profile is surrounded by a series of smaller secondary profiles, some facing upwards, and others to the right or left, almost in the manner of a picture-rebus.

The association between the jaguar and the ball game will be considered in our treatment of Olmec religion, which remains largely shrouded in mystery. But the topic of associated images should now recall an identical case of parallelism—a piece of sculpture with the jaguar-mask on one side and the glyph of the bar and four dots on the other. This remarkable Olmec figurine from Las Choapas (Arroyo Pesquero, Veracruz) is in the Dumbarton Oaks collection and was published by Elizabeth Benson in 1971. It is by no means insignificant that it should be these two complementary motifs which form the front and back of the 'crest' on top of the figure's head. Here, a front-back interpretation would be comparable to the head-tail character of the mosaics.

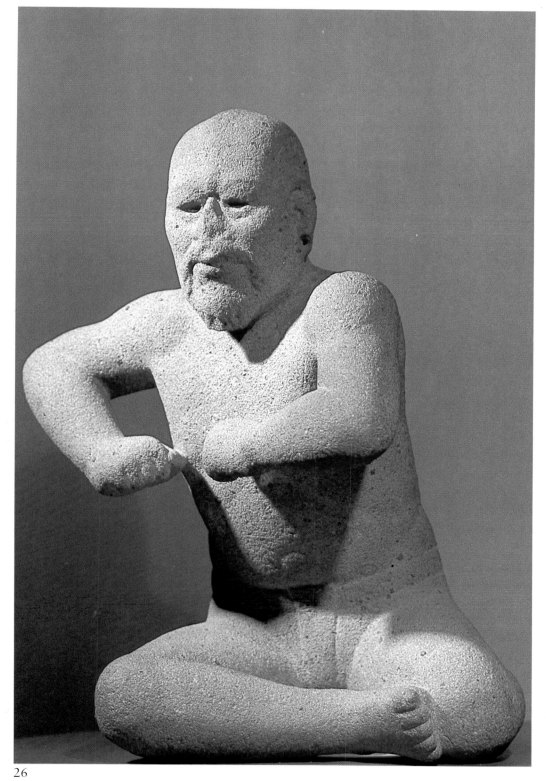

26

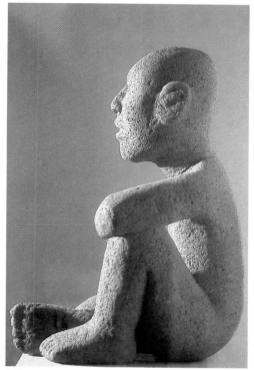

27

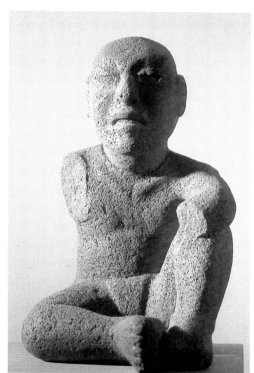

28

Front and back of the crest on an Olmec figurine in the Dumbarton Oaks collection: on one side is a jaguar-mask, on the other a bar and dot motif symbolizing the number 9

The ceremonial centre of San Lorenzo

Before proceeding to the various sculptures (colossal heads, altars, stelae, and votive offerings) discovered at La Venta, we may analyze the planning of Olmec ceremonial centres. A good opportunity is provided by the San Lorenzo site, near the Río Chiquito, a tributary of the Coatzacoalcos.

San Lorenzo belongs to a group of settlements including Tenochtitlán and Potrero Nuevo (2.5 and 2.7 kilometres away) that must have comprised one of the largest Olmec centres. According to radiocarbon dating, human occupation of San Lorenzo began in 1500 BC, while the first towns appeared between 1200 and 900 BC. The centre was then abandoned, to be reoccupied between 700 and 500 BC. Investigation by Matthew Stirling and Philip Drucker in 1945 and 1946 revealed many basalt sculptures, five being colossal heads. The excavations were resumed in 1966 by Michael D. Coe of Yale University, who detected dozens of buried monoliths.

A thorough survey of the ceremonial centre by George R. Krotser, published by Coe in 1968, reveals it as a gigantic platform 1200 metres long from north to south, and 770 metres wide, standing about 12 metres above the surrounding plain. This extraordinary volume of material (almost 9 million cubic metres) seems to be substantially artificial, consisting mainly of earth carried to the site by human labour. Even if the site was chosen because its natural features were appropriate, the fact remains that in order to build such a platform, over 3000 years ago, the Olmecs needed to transport some 10 billion kilograms of material.

It should be emphasized that the pre-Columbians had neither draught animals nor vehicles for them to pull. The wheel was used only on pottery toys, of a very late period. Hence enormous quantities of earth had to be shifted by men alone. At first sight, such methods of building both the pyramid at La Venta and the platform at San Lorenzo are puzzling. On the assumption that the urban community of San Lorenzo, for instance, could afford to relieve 1000 men from work in the fields and assign them to the task of earth-shifting, and that each worker could transport about 300 kilograms per day (roughly ten trips of 1.5 to 2 kilometres with a load of 30 kilograms), calculation shows that the platform must have taken 100 years to construct.

Simplified plan of the Olmec ceremonial centre of San Lorenzo (after the survey by George R. Krotser)

1. Diagram of the main orthogonal faults
2. Diagram of faults and mounds combined
3. Diagram showing original orthogonal structures
4. Schematic plan of the sacred centre of San Lorenzo showing the pattern of a jaguar-mask

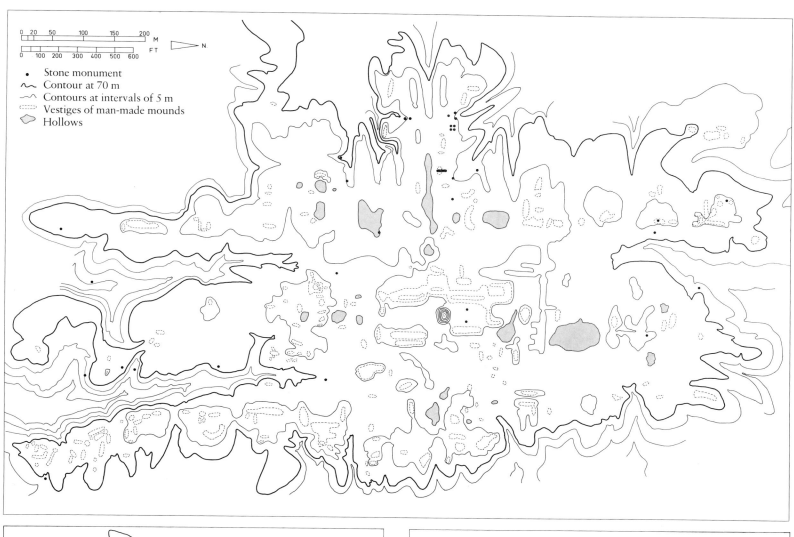

Stone monument
Contour at 70 m
Contours at intervals of 5 m
Vestiges of man-made mounds
Hollows

0 20 50 100 150 200 M
0 100 200 300 400 500 600 FT
N

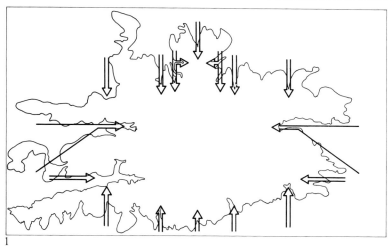

1

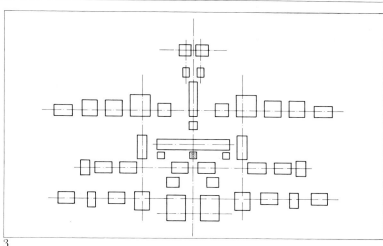

3

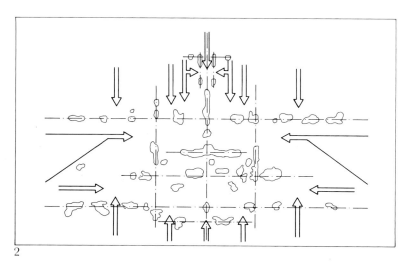

2

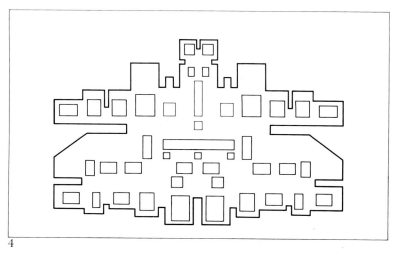

4

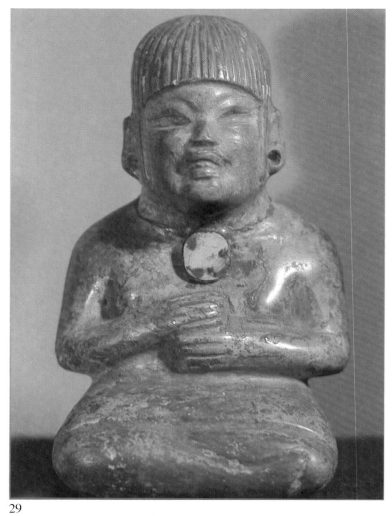

29

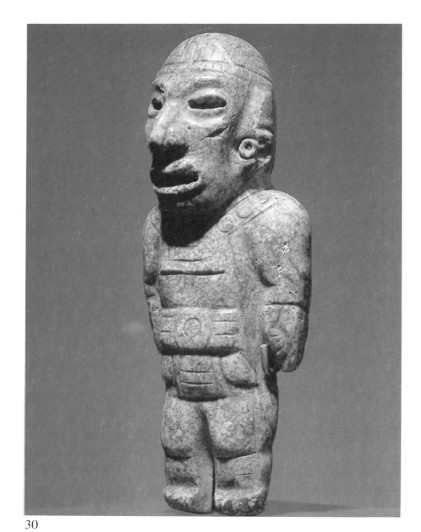

30

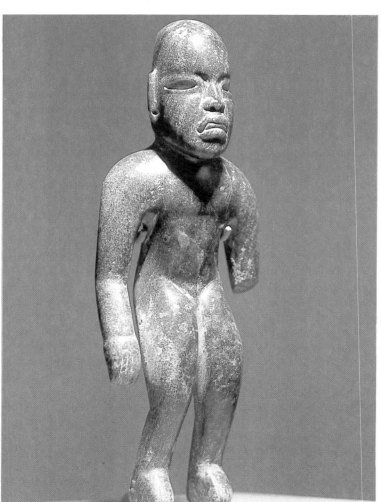

31

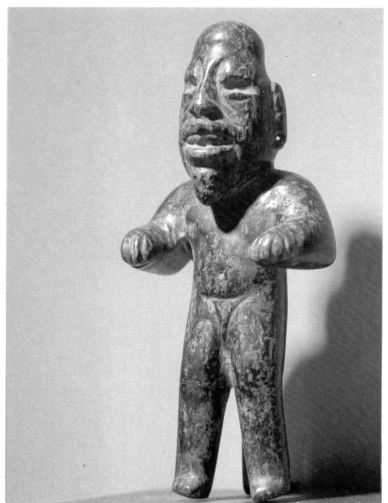

32

But the first occupation of San Lorenzo lasted three centuries. Further, it was customary for the pre-Columbians to build by successive stages of enlargement, as can be seen from many Maya pyramids. So the original ceremonial centre may have been much smaller than its final version, whose rain-eroded remains have survived. However, during its first period of occupation, San Lorenzo was probably in an almost permanent state of construction. This becomes plausible when we accept that the materials used for the artificial platform were supplied by maintenance work on the system of irrigation, drainage, and waterways that was essential to the proper functioning of the urban centre.

The general plan of San Lorenzo has not yet been exhaustively studied. Michael Coe pointed to a certain symmetry in its structures, insofar as they can be detected from the present dilapidated state of the site. This prompted me to seek an explanation for the overall layout of the complex. For it is scarcely conceivable that millions of tons of material were transported in the above manner without some precise plan. Aware that the Olmecs had their own specific preoccupations (they left caches of votive offerings, designed huge geometric mosaics, and created holy complexes with strict rules of axis and symmetry, often producing perfectly oriented vistas several hundred metres long), I felt that an attempt should be made to decipher the plan of San Lorenzo in the light of the various clues at the vast site—thanks to George Krotser's remarkable survey.

One odd feature, apart from the regular architectural layout on either side of the central pyramid, consisting of two groups of long mounds to the north and south, is a series of deep faults traversing the site. My first impression was that a process of erosion had simply produced haphazard furrows in the mass of earth. But closer inspection shows the furrows to be arranged symmetrically, from north to south and from east to west. An accurate plan of the faults enabled me to fit them into an orthogonal pattern, like that found in all Olmec art. The results were promising as testimony of a network or modular system governing the whole complex.

Data from these faults (hollow elements) and from the principal protruding masses (mounds in relief) can be combined to exhibit the site's 'lines of force'. An examination of the partly eroded earth platform shows that the masses deformed by mud flows, and the mounds washed into the plain, still reflect the main lines of the original composition.

It then becomes possible to recreate the general plan by fitting the volumes into rectangular units and by simplifying their outline.

As the hollows and the main mounds slip into place, there emerges an enormous stylized jaguar-mask similar, at least in its central section, to those on the ball-court mosaics at La Venta. But instead of a mere 25–30 square metres, its area is nearly 100 hectares, measuring 1200 by 770 metres. The face of this mythical beast, turned to the skies as though contemplating the sunrise on the eastern horizon, is perhaps the most extraordinary structure left to us by the Olmec civilization. Conceived 3000 years ago to glorify the jaguar god, this visionary design has survived the tropical climate and its torrential rains, despite being made only of hardened mud, and has resisted the onslaught of the jungle, to reveal to twentieth-century man the brilliant architectural planning of the New World's earliest known advanced culture.

29 Olmec statuette from La Venta: this praying figure, 7 cm high and covered with red cinnabar, wears a small hematite mirror as a pendant (National Museum of Anthropology, Mexico City).

30 Jadeite statuette in the Olmec style from Cerro de las Mesas: less than 20 cm high, the figure is dressed in finery (National Museum of Anthropology, Mexico City).

31 Olmec serpentine statuette, 18 cm high, dated 800–500 BC (National Museum of Anthropology, Mexico City).

32 Statuette of a figure with a deformed skull, similar to those found in a votive offering at La Venta (Plate 12), but only 15 cm high (National Museum of Anthropology, Mexico City).

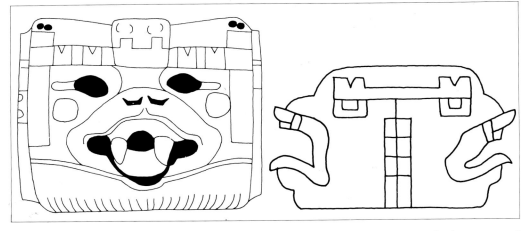

Jaguar-mask from Mixtec territory in Oaxaca, and double jaguar-mask engraved or a jade plaque (after a drawings by Covarrubias)

Although Michael Coe does not detect the presence of the sacred beast in the plan of San Lorenzo, he does sense 'that the ancients had visualized some kind of gigantic animal effigy—a huge quadruped as seen from above. But this is pure guesswork!' Coe also points to the existence of a group similar to a ball court, in an area between the two mounds to the south of the pyramid. And indeed its proportions correspond broadly with those of the ball court at La Venta which I have described: the two mounds are each about 75 metres long, while the open space between them is of the order of 40 metres wide.

San Lorenzo includes some 200 earth platforms that probably served as bases for dwellings or sanctuaries built of mud and thatch, as was customary during the initial phase of Maya architecture. These mounds are of rectangular shape and generally measure less than one metre in height. They are mostly arranged to form the sides of a square, with a courtyard in the middle. Even if there were dwellings on all the platforms at the same time, the number of Olmecs living in the sacred centre could never have exceeded 1000. We must infer that only people of high rank lived in the central complex, while the majority of Olmecs stayed in villages. Farmers inhabited huts near their fields, according to a system also found among the Maya, whose 'palaces' on the platforms of religious centres were occupied solely by 'nobles'.

Monumental statuary

These are the conclusions to be drawn from an examination of the Olmec ceremonial centres. We now come to the monumental sculpture that is found all over the sites of La Venta and San Lorenzo, not to speak of the many places where monumental works carved out of stone by the Olmecs have been discovered. The first creations of the Olmec civilization that caught the attention of archaeologists were undoubtedly the colossal heads, some fifteen of which have survived. Most of them occur at La Venta and San Lorenzo, but the site of Tres Zapotes contained two. The largest came to light at Cobata: it stands 3.4 metres high, has a diameter of 3 metres, and contains 25 cubic metres of rock weighing about 65,000 kilograms (65 tons).

The most striking thing about the heads is the physical type they represent. More than a century ago, José Melgar saw 'negroid' characteristics in them, which he described as Ethiopian. Their features in-

33 Olmec sculpture from Las Limas: this intact object of hard stone, 55 cm high, is among the most famous examples of Olmec art. It seems to represent a priest carrying a child with a jaguar-mask, but we do not know whether the child is being presented to a deity or intended as a sacrificial victim. The face, shoulders, and knees of the main figure are decorated with finely incised engravings, which may show six chief Olmec deities. The sculpture perhaps dates from 500–400 BC (Jalapa Museum, Veracruz).

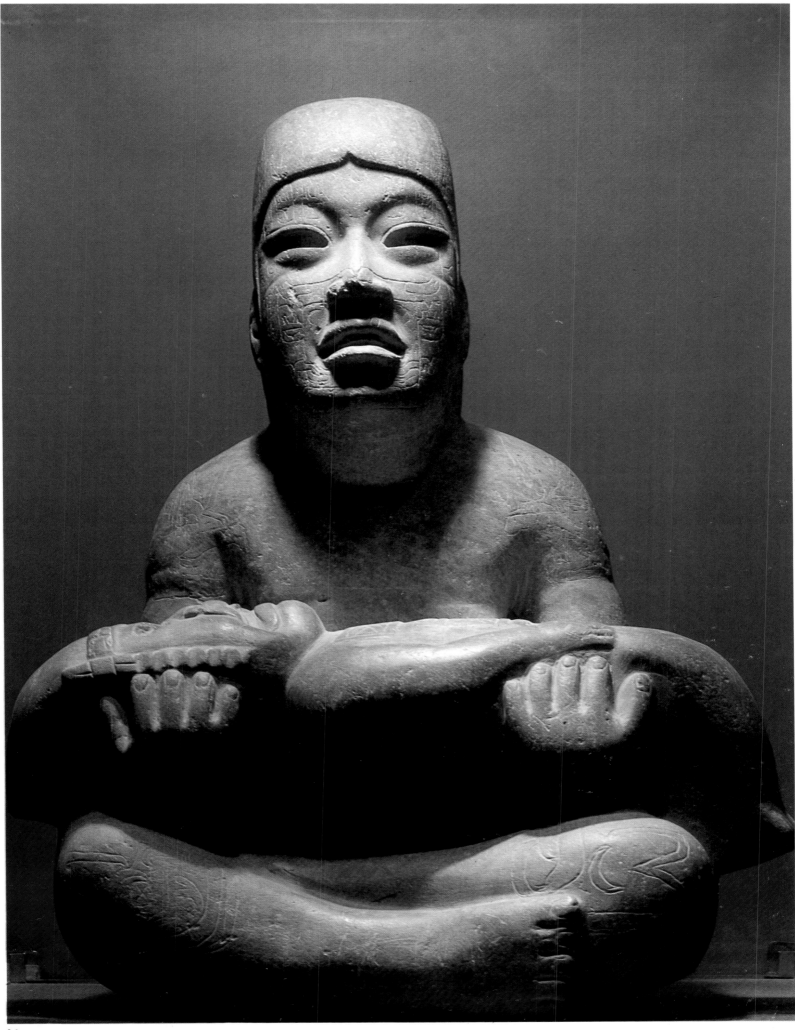

clude shallow eyes, a broad and rather flat nose, and thick lips turned down at the corners. The head seems to be covered by a kind of round helmet, with protective cheek-pieces or flaps descending in front of the ears, themselves decorated with depictions of jade jewellery. It is not impossible that the helmets shown on the heads were made of sea-turtle shells and used as protection by ball game players.

The entire visual treatment of the heads is guided by a desire for homogeneity. Their features (nose, arch of the eyebrows, and ears) protrude little, and the profile is understated, as though the artist decided to make only slight alterations to the block of stone, halfway between a sphere and a cube. The effect is undoubtedly brachycephalic. But I would suggest that this style is due to a mode of representation, rather than to depiction of a physical type. Some authors interpret the heads as portraits of individual people. Yet I prefer to see them as examples of a conventional plastic language designed to produce a special response. It is surely out of the question that the Olmecs raised monumental 'statues' of their rulers or priest-kings which were reduced to the mere head, or that any physical resemblance was intended. Such an intention seems to be chronologically inconsistent with so early a stage of civilization. Those who advocate it are simply transposing into the past a personality cult similar to that of ancient Rome or the Renaissance.

The most probable reason for the spheroidal shape and superhuman proportions of these heads is that they were believed to represent a god of the sun—which was itself symbolized by the ball used in games. What we have, then, is an effigy or 'holy face' of a sun-god, although this does not mean that personal touches have not been given to minor details or to certain individualized features. The fact that a Greek statue depicts Zeus, or that the 'Pantokrator' appears in a Christian mosaic, does not diminish the human content of those images.

The huge blocks of stone, from which the heads were carved, were brought by man to the sites concerned. The lowlands where the Olmecs lived had no quarries for stone. The monoliths at La Venta, Tres Zapotes, and Cobata are made of basalt, a volcanic stone obtained from the massif of Los Tuxtlas. The material used at San Lorenzo was andesite from the Cintepec mountain range. It is thought that the enormously heavy blocks were transported mainly by water, and subsequently on rollers: during the period of high water, rafts took them dozens of kilometres to the foot of the site's main platform. Then 1000 to 2000 workers toiled to shift them into position, and finally they were sculpted. Matthew Stirling says that the heads were covered with a white layer (a kind of stucco), and painted with red faces.

None of the colossal heads has survived in its original position. They were all moved, mutilated, or rolled into the ravines surrounding the centres. Some may even have been ritually buried, as were certain massive offerings. But the nature of the sculptures shows that they were intended to be viewed from the front, probably standing against buildings.

The other monumental sculptures worthy of mention are immense parallel-sided blocks of stone, regarded by archaeologists as altars. One of the most striking of these, discovered at La Venta, depicts a stylized jaguar's face with a cross-legged crowned figure sitting in a central opening. This could be interpreted either as the animal's gaping mouth or as an entrance to a cave, suggesting that the jaguar was seen as a

Profile of an Olmec deity engraved on the left shoulder of the Las Limas sculpture

chthonic power. Excavations at La Venta have revealed several such sculpted altar stones. Their reliefs show scenes which are often quite interesting, but usually inexplicable.

The Olmecs also produced statues in the round. Large sculptures, normally representing seated figures, have been found at the main Olmec sites. They display great plastic skill, and possess a considerable expressive power that derives from a sober treatment of masses, an often symmetric composition characterized by strict frontality, and, with few exceptions, a grandness of scale.

One of the exceptions is the admirable 'Athlete of Uxpanapa (or of Antonio Plaza)'. This slightly less than life-size statue shows a seated but very dynamic figure, treated in asymmetric fashion with an extraordinary elegance and sense of movement. The man has a moustache, beard, delicate face, shaven head, and relatively short legs. Although the muscles are not overemphasized, his torso ist strong. He wears a loincloth. Like other sculptures in the same style found in the state of Veracruz, this figure would seem to represent a ball game player in action.

Such works also exist in the form of large hollow terracotta statues. Their mobility contrasts with the more hieratic style of colossal statuary. They show what a varied range of expression the Olmec artists were able to draw upon. This art rendered with equal effect the solid masses of certain 'idols' and the muscular movements of athletes, who

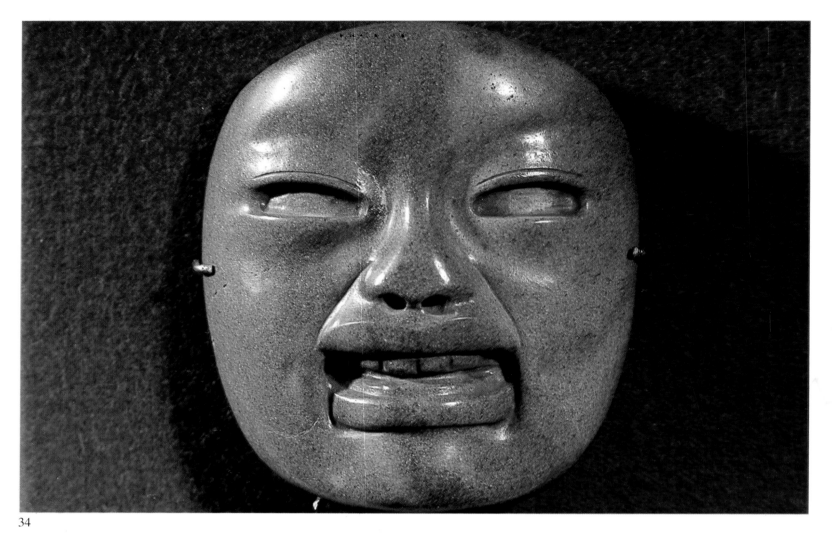

34

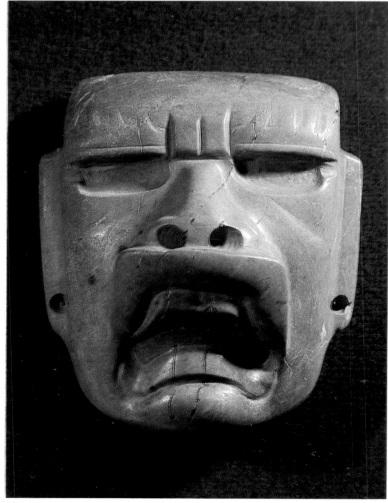

35

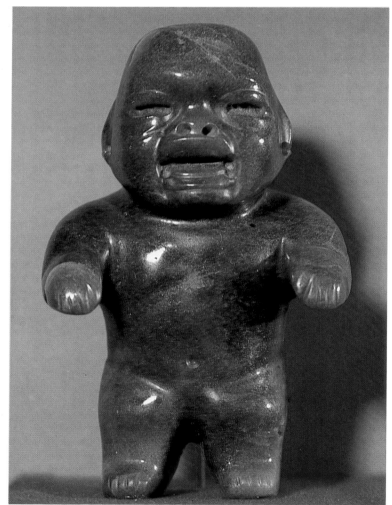

36

recall those created by artists of classical antiquity. One is then struck by the long duration of the Olmec civilization and the considerable aesthetic changes that can be observed in its artistic works over the centuries.

Lastly, mention should be made of a series of sculpted stelae decorated with relief carvings. Here again is a diversity of styles. At times the differences are so great that one wonders whether all the works described as Olmec could possibly belong to the same civilization. Perhaps some day, when our knowledge of early pre-Columbian art is more extensive, it will emerge that we have been a little too hasty in grouping certain works under a single heading. For there is no obvious connection between the 'Prince' from Cruz del Milagro, the 'Athlete of Uxpanapa (or of Antonio Plaza)', and the admirable 'Priest' from Las Limas who carries in his arms a child with a jaguar-maske face.

Small stone art

Olmec offertory caches have yielded a host of relatively small works, carved out of hard stone such as diorite, serpentine, or jade, and given a remarkably high polish. The pieces are often of great quality despite their size. Particularly interesting is the offering No. 4 from La Venta, which consists of six polished jade celts, fifteen jade and serpentine statuettes, and one statuette made of a reddish-coloured porous stone. The position of the statuettes (the one in a different stone was standing against a barrier of upright celts and surrounded by the others) suggests that some kind of scene was being described—perhaps a ruler presiding over a council of chiefs, or an accused man, standing in the centre and identified by the difference in stone, being sentenced by a court.

Characteristic traits of all the statuettes are a pronounced deformation of the skull and a mouth with down-turned corners. We know that it was customary among several pre-Columbian peoples for the skulls of new-born babies to be deformed by having bandages tied round them, and that the Maya continued this practice until quite a late date. In addition, there are carvings on four of the celt blades, but the motifs have been worn down so much that they are difficult to interpret.

Olmec statuettes of jade, jadeite, or serpentine often represent standing figures with slightly bent legs and a disproportionately large and usually deformed head. Some of them, including representations of babies, combine human and feline features, such as the mouth with down-turned corners which suggests a jaguar-mask. Similarly hybrid creatures are found on the decorations of large hard-stone celts, where it is possible to detect the stylized face of a jaguar with flame-like eyebrows and a strange V-shaped indentation in the top of the skull. This indentation is characteristic of Olmec representations, ranging from tiny objects to the great statues at San Lorenzo. But the meaning of such a physical trait, which bears little relation to human anatomy, has remained a mystery.

Among other artefacts created by the Olmec civilization are highly polished concave mirrors. Fashioned from chunks of ferric oxide such as magnetite, ilmenite, or hematite, they have excited the admiration of archaeologists, who find it hard to understand how the craftsmen of

34 Jade mask in the Olmec style from the region of Colima: the work, whose typically Olmec mouth derives from the jaguar-mask, is 10 cm high and may date from 800–500 BC (National Museum of Anthropology, Mexico City).

35 Mask in the Olmec style from Guerrero: this figure, half man and half jaguar, displays the same mouth and flame-like eyebrows as does a celt (Plate 11), and probably dates from 800–500 BC (National Museum of Anthropology, Mexico City).

36 Jade figurine from Cerro de las Mesas: it represents a baby with a typically Olmec mouth, and is 12 cm high (National Museum of Anthropology, Mexico City).

3000 years ago achieved not only an absolutely regular concavity, but a perfectly smooth finish. The mirrors, which measure up to 120 by 90 millimetres, and are no more than 6 to 8 millimetres thick, probably enabled the Olmecs to focus the rays of the sun and ignite fires. It is likely that the mirrors were designed to be used in sun rituals during spring solstice festivals, to set fire to offerings, or to burn vegetation on land to be cleared, and to produce sacred images by magnification.

Olmec expansion

As we have seen, the Olmecs, although living in a region of swamps and alluvial plains where no stone was available, had a predilection for that material in its noblest forms. The massive offerings discovered at La Venta, the various monoliths, jade statuettes, mirrors, and celts, all show how much they loved the high-quality stones that were not to be found in their own area. It was probably a desire to obtain further supplies of such rare materials that prompted the Olmecs to expand. They set up trading posts outside their territory, and settled in the Oaxaca mountains, in the highlands at Tlatilco and, after crossing the Tehuantepec isthmus, on the Pacific coast. Archaeological discoveries have revealed their presence over a very wide area, ranging from El Salvador and Guatemala up to the region of Mexico City. But it would be inappropriate to speak of an Olmec empire in the strict sense. Military conquest is not thought to have played a major role in Olmec expansion. Rather they settled alongside natives of less developed cultures, trading profitably and tapping the wealth of the highlands, passing it to their own lowland settlements.

The Olmecs exerted a civilizing influence on more primitive peoples, and provided these with knowledge and new beliefs. As I have said, they may be regarded as disseminators of a 'mother culture' in the pre-Columbian world of the northern hemisphere. It was due to the Olmecs that the principal Mesoamerican cultures became familiar with time reckoning, the use of a calendar, and astronomy, as well as with the recording of dates on inscriptions, which appeared during the final phase of Olmec history. I will return to the Olmecs' early scientific achievements when discussing the Maya, chief beneficiaries of Olmec knowledge: much more is known about them than about their predecessors, who all too often must be the subject of guesswork.

Suffice it to observe that the inscriptions on works like the statuette from Tuxtla, the Tres Zapotes stele, or the Piedra Labrada stele, display a notation system similar to the one we shall find among the Maya. But it remains uncertain whether the earliest date in the Olmec chronology is equivalent to that of the Maya era (which is generally calculated from the mythical date of 3113 BC). Such an interpretation of the Olmec inscriptions would seem to put this civilization at too late a time in the history of pre-Columbian America. The Tres Zapotes stele, for example, giving the date of 31 BC, would tend to show that the Olmecs were then still vigorous, whereas radiocarbon dating shows that La Venta and San Lorenzo had been abandoned by their founders as long ago as the fifth or sixth century BC.

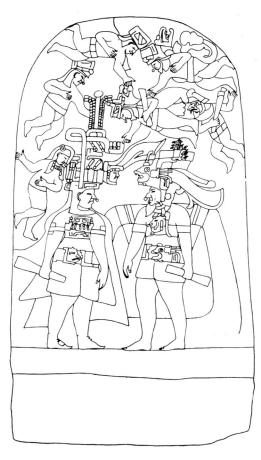

Reconstructed drawing of the figures decorating Stele 3 at La Venta, with the individual known locally as 'Uncle Sam' on the right (after Drucker)

37 OLmec mask from Las Choapas, Arroyo (or Río) Pesquero: this smiling, slit-eyed face, 13 cm high, is carved from a whitish stone with a brown patina, and seems to date from 500–400 BC (Jalapa Museum, Veracruz).

38 Olmec mask from Las Choapas: made of a hard dark stone with a brown patina, 20 cm high, it may have been placed upon the face of a dead man, and dates from the final Olmec period in 500–400 BC (Jalapa Museum, Veracruz).

39 Olmec mask from Las Choapas: this very fine piece, of light jadeite, shows a smiling face with fine features and beautifully formed slit eyes. Its delicate engraving is similar to that on the Las Limas statue (Plate 33). The mask is dated 500–400 BC (Jalapa Museum, Veracruz).

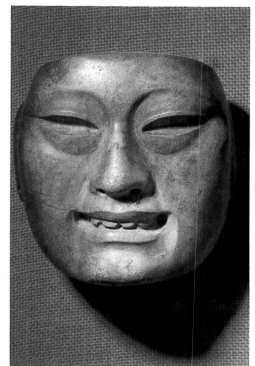

37

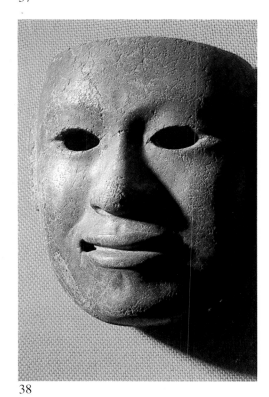

38

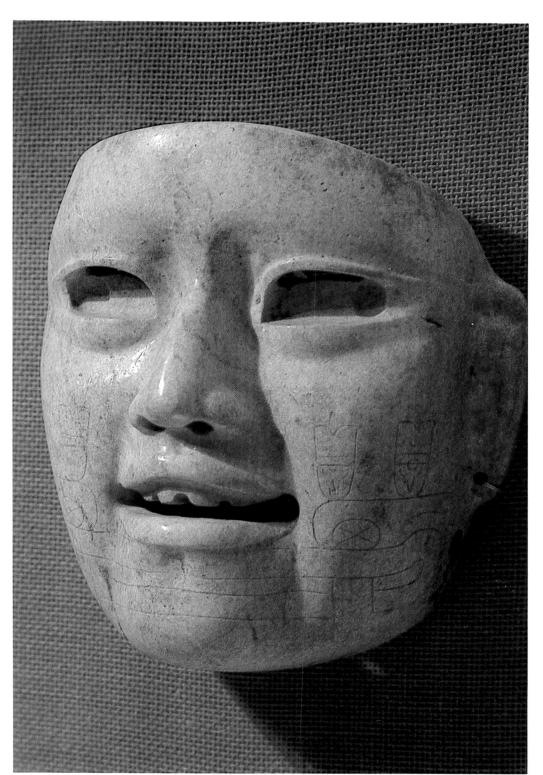

39

The religious system

Of Olmec man we do not know even his physical characteristics. No bones have survived, because of the dampness and acidity of the ground. Artistic records yield divergent evidence. Stele 3 at La Venta, for instance, depicts a bearded figure—beards were rare among the Mesoamericans—with an aquiline nose, a dolichocephalic skull, and emaciated features (Jacques Soustelle reports that the figure is known to the locals as Uncle Sam), while other portraits show small, brachycephalic, rather plump men who could well be eunuchs. The Alvarado stele represents a tall figure, again bearded, seemingly about to sacrifice a small pot-bellied creature with a deformed skull.

Main scene of the frescoes at Oxotitlán, Guerrero (after David Grove)

If, then, we cannot define the very physique of the Olmecs, it might appear presumptuous to ascertain the ideas of that lost people. Their religion is difficult to piece together, as almost no written testimony remains, apart from a few dates. The only way to estimate the Olmecs' beliefs is by interpreting the artistic remnants of their culture.

First of all, one should bear in mind the climatic conditions of Olmec life. On the highland plateaus, drought was common and the most important deity was Tlaloc, the god of rain. But the low virgin forest and swamps, in which the Olmec cities lay, were constantly drenched by tropical rains and flooded by rivers from the mountains. It was natural for the inhabitants of a misty, watery region, where the slightest ray of sunlight produced spectacular plant growth, to favour a sun-god. We have seen that the jaguar is a ubiquitous motif in the Olmec world. It occurs not only on the sculpted masks or mosaics in the ball court at La Venta, but in the plan of the San Lorenzo ceremonial centre. With certain qualifications, one can say that the jaguar symbolized the sun.

The most striking connection between the jaguar and the principle of heat or fire is to be found in a large sculpture from atop the volcano of San Martín Pajapan. This is the statue of a crouching man who carries on his head a mask, displaying the combined features of a jaguar and a human being. An almost identical statue, broken into pieces, was encountered by Drucker at La Venta. An association would therefore seem to have been perceived between the jaguar and the fire of the earth as manifested in volcanoes. Moreover, it was probably on the analogy of the cone of volcanoes that the pyramid at La Venta, with its curious contours reminiscent of lava flows, was constructed.

A relevant fact is that, according to the mythology of certain later tribes in western Mexico, the sun was born in a volcano. Hence the close link between fire, sun, volcano, cave or crater, and the feline's mouth. The sun travels underground during the night, and sometimes appears in the form of volcanic explosions. It was, too, in the caves of Oxotitlán in the state of Guerrero, investigated by David C. Grove, that the only surviving decipherable frescoes left by the Olmecs were found, apart from those in the caves of Juxtlahuaca studied by Carlo Gay. Their theme is, appropriately, an immense jaguar-mask. The paintings, which depict a masked figure sitting on a huge stylized jaguar's mouth, are analogous to altar No. 4 at La Venta, where a crowned figure is seen emerging from the beast's jaws.

It seems possible, then, to establish a direct affinity of the sun with volcanic fire. We should perhaps seek a god of some fiery element,

represented by the jaguar. And the sun, appearing as a disk in the sky, would also correspond in shape to the spherical faces of the colossal heads, or to the ball used in games: for a correlation is known between that sacred sport and the movement of the sun. A comparable link existed in ancient Egypt between Atum (the solar disk) and Ra (the element of light). This is enough to have associated the jaguar (a nocturnal animal) with the fire of the earth (whose lava manifested the sun during its nocturnal course). We observe the same message at the Maya Temple of the Sun at Palenque, where the main bas-relief shows in its centre 'the jaguar-mask symbolizing the sun in its night aspect', as Michael Coe says.

Some authors, in an attempt to explain the various works combining the traits of man and jaguar (among them, the priest from Las Limas with a jaguar-child), have advanced the theory of a hierogamy or 'sacred marriage', from which the Olmec race was descended. Scenes in bas-relief on rocks at Chalcatzingo, in the highland plateaus, are Olmec in style and could be thought to support that theory. The rock carvings also include a composition in which a crowned figure, seated on a throne, seems to be in a cave. Above the cave is a triple scheme of emblems, suggesting clouds with drops of rain falling from them. Chalcatzingo lies in a generally arid region, known as central Meseta to the Mexicans, and it is natural for a rain-god to have been worshipped there. On the other hand, symbols representing maize and vegetation at the corners of the cave motif (also found on another bas-relief at the same site and at the corners of altar No. 1 at La Venta) reflect the Olmecs' constant concern for agriculture. Joralemon, who has made a special study of these religious themes, distinguishes as many as ten different deities.

I am inclined to agree with Jacques Soustelle that it is premature to reconstruct an Olmec pantheon. The available information is scanty, from different periods and regions. More proof is needed of a coherent religious system that could apply to the Olmec world throughout its geographic extent and historical development.

The Olmec legacy

What consequences follow from this survey of Olmec civilization and its surviving works? An agricultural society of the Neolithic type, ignorant of metallurgy, produced architectural complexes centred on great sanctuaries. The social structure seems to have obeyed a rigid hierarchy, with clear divisions of class. A minority of rulers and nobles reigned over the craftsmen (quarriers, sculptors, engravers, and so on) and the farmers constituting the majority of the population. The élite who held high religious and political office, probably led by a priest-king, relied on the working classes for enormous manpower needed to build great ceremonial complexes (pyramids, platforms, ball courts) and to shift the stone transported there from distant regions (basalt, andesite, serpentine, diorite, jade, and various pyrites).

The scale of their religious buildings shows that the Olmecs acquired a degree of affluence. Their opulent offerings would be inconceivable,

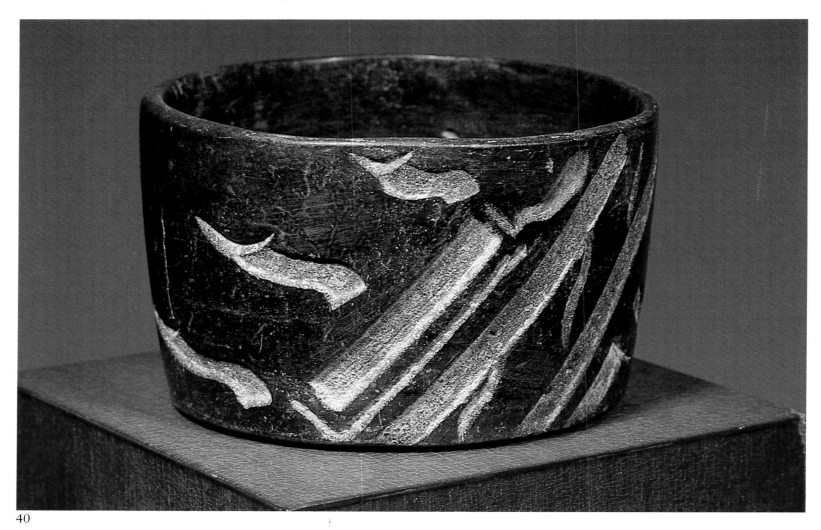

40

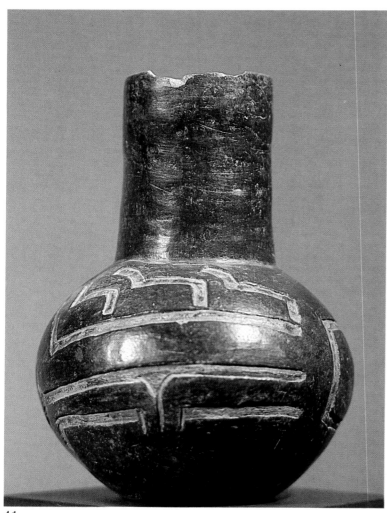

41

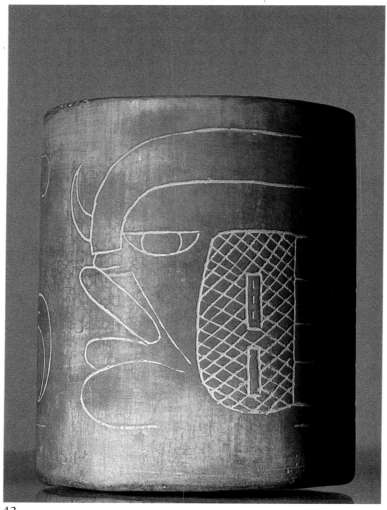

42

had agriculture not been sufficient for workers to leave the fields and cope with the vast sacred projects. Indeed, the religious system governed the rhythm of the community and pervaded daily life. It was doubtless responsible for maintaining beliefs fervent enough to impose collective discipline, demanded by the tasks of irrigation, drainage, land development, and creation of ceremonial centres and monumental sculpture.

Olmec art embraced a wide range of modes of expression, distinguishing itself by full and lively forms, which were given a powerful coherence by recurrent themes drawn from a mythology of cosmic forces. But in its final phase, the Olmec civilization seems also to have perfected its world with a chronological system, a kind of writing, a mathematical science, and an astronomy on which a calendar was based.

This was the legacy of the declining Olmecs to the young Maya. The two cultures have so much in common that Coe has gone so far as to assert that the Olmecs were actually Maya. To the tribes of the Petén, Yucatán, Chiapas, and Quintana Roo, they bequeathed the foundations of the great classic Maya civilization—pyramids, ball courts, plazas, stelae, monolithic altars, jade offerings, skull deformations, a jaguar god (as on the E-VII-sub pyramid at Uaxactún, which is decorated with large jaguar-masks), a chronology with calculations according to the so-called 'Long Count' method, hieroglyphic writing, and mathematics. Hence one can hardly study Maya civilization without first having probed its foundations. Maya thought was rooted deeply in the Olmec past, even if the two peoples need not be equated today.

Although the demise of the highly sophisticated world developed by the Olmecs is still enigmatic, we know that it came suddenly. A wave of destruction wrought by invaders (arguably from the north) who stormed the Olmec cities, pulled down the stelae, toppled the monolithic monuments, and rolled the colossal heads into ravines, speaks for itself.

Another question is why all traces of civilization vanished from the coastal regions just before the beginning of the Christian era. Probably at about that time, for reasons not yet explained by epidemiologists, an outbreak of malaria wiped out the last generation of Olmecs. Only malaria or yellow fever can account for the abandonment of such a fertile area, which had nurtured the first great pre-Columbian culture. Sylvanus Morley claims that malaria did not exist in America until the arrival of Europeans. But it is hazardous to insist that a disease was unknown in certain regions, if epidemic outbreaks can occur after long endemic periods. And this is particularly true when such regions have been abandoned by their inhabitants for centuries.

Morley adds that yellow fever appeared first in 1648, and was introduced to Yucatán by black slaves, imported from Africa by whites to replace native workers on the plantations. This is a different case altogether, since yellow fever is not as closely associated as malaria with a swampy environment and a carrier like the anopheles mosquito. Indeed most specialists in tropical diseases consider yellow fever to have originated in America, contradicting the claims of the great archaeologist. In view of our present state of knowledge regarding the history of malaria, it would be premature to rule out that disease as having caused the abandonment of Olmec territory.

40 Black pottery dish with Olmec decoration from Las Bocas, Puebla, dated 1000–800 BC (National Museum of Anthropology, Mexico City).

41 Black pottery vase in the Olmec style from Tlatilco (National Museum of Anthropology, Mexico City).

42 Olmec goblet from Veracruz: its sober style and finely incised jaguarmask in profile are characteristic of classic art between 1000 and 800 BC (Tabasco Museum, Villahermosa).

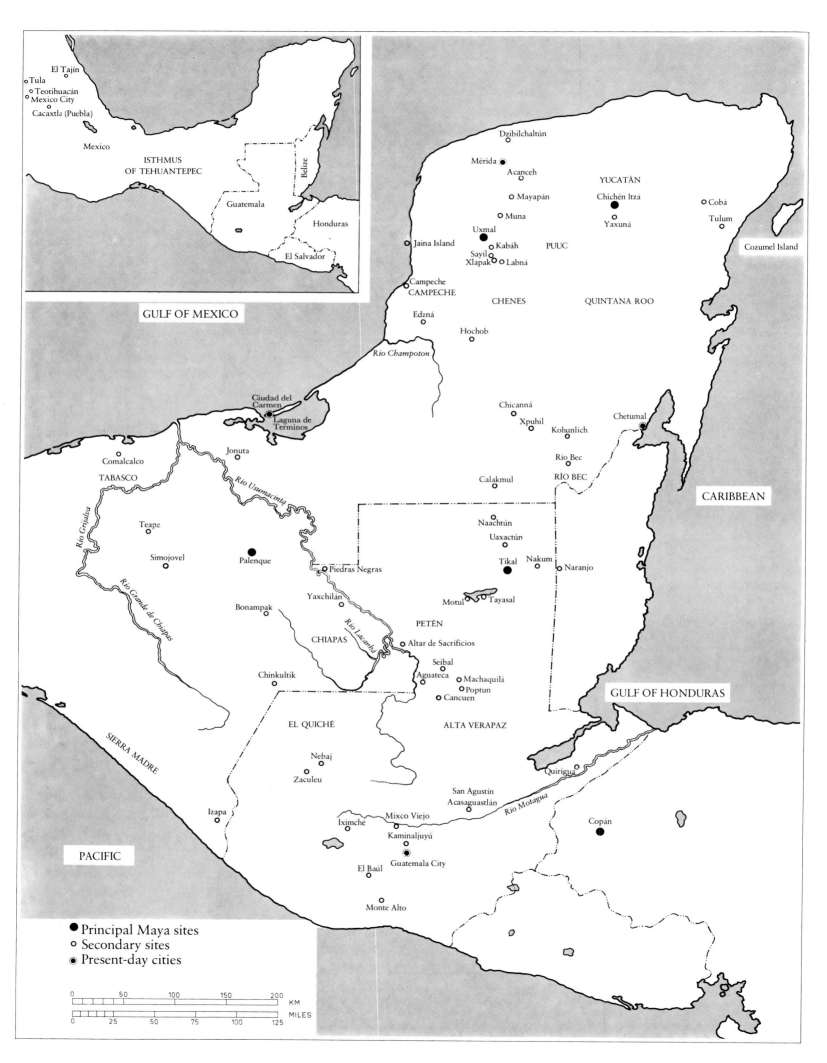

El Tajín
Tula
Teotihuacán
Mexico City
Cacaxtla (Puebla)

Mexico

ISTHMUS
OF TEHUANTEPEC

Belize

Guatemala

Honduras

El Salvador

GULF OF MEXICO

Dzibilchaltún

Mérida
Acanceh

YUCATÁN

Mayapán
Chichén Itzá
Cobá

Muna
Tulum

Uxmal
Yaxuná

Jaina Island
Kabáh
PUUC
Sayil
Xlapak Labná

Campeche
CAMPECHE
CHENES
QUINTANA ROO

Edzná

Hochob

Río Champoton

Cozumel Island

Ciudad del
Carmen

Laguna de
Terminos

Chicanná
Chetumal
Xpuhil
Kohunlich

Jonuta

Comalcalco
Río Bec
RÍO BEC

TABASCO
Río Usumacinta
Calakmul

CARIBBEAN

Río Grijalva

Teapa
Naachtún

Uaxactún

Simojovel
Palenque
Piedras Negras
Tikal Nakum
Naranjo

Río Grande de Chiapas

Motul Tayasal

Yaxchilán

Bonampak
PETÉN

Río Lacantá

CHIAPAS
Altar de Sacrificios

Seibal
GULF OF HONDURAS

Chinkultik
Aguateca Machaquilá
Poptun
Cancuen

EL QUICHÉ
ALTA VERAPAZ

SIERRA MADRE

Nebaj
Quiriguá

Zaculeu

San Agustín
Acasaguastlán
Río Motagua
Copán

Izapa

Iximché Mixco Viejo

PACIFIC
Kaminaljuyú

El Baúl Guatemala City

Monte Alto

● Principal Maya sites
○ Secondary sites
◉ Present-day cities

0 50 100 150 200
KM
MILES
0 25 50 75 100 125

II. The rise of the Maya

Of all the great pre-Columbian cultures, the Maya civilization has undoubtedly earned the greatest number of studies and publications. Ever since European explorers, venturing into the virgin forest at the end of the eighteenth century and during the nineteenth, stumbled upon the ruined cities of its central region, the Maya world has continued to fascinate those interested in the history of man.

It is true that immediately after the Spanish Conquest some Europeans, such as Bishop Landa, were intrigued by the remains visible then in the sixteenth century, particularly at Uxmal. But imaginations really began to glow when the sites of Tikal and Palenque were discovered beneath thick tropical vegetation, and when Frederick Catherwood's romantic engravings, illustrating John Stephens' *Incidents of Travel in Central America, Chiapas and Yucatán,* were published in 1841. There was speculation that the local people might have descended from the lost tribes of Israel. Ancient Egyptian and Babylonian influences were detected, and 'Chinese' characteristics in the art were adduced as evidence of an Oriental emigration to Mesoamerica. For it seemed at first impossible that the few 'Indian' tribes still living in the forest could have descended from the extraordinary folk who once constructed the jungle 'cities'.

The Maya world

The region in which the Maya flourished spans five modern countries: Mexico, Guatemala, the north-west corners of Honduras and El Salvador, and Belize (formerly British Honduras), whose political status is currently disputed between Guatemala and Mexico. Maya territory may be divided into four zones:

1) a central zone chiefly made up of the Petén, including Belize. Perhaps strangely, it was in this flat country, covered by tropical forests, that the earliest Maya cities such as Tikal and Uaxactún arose;

2) the river valley of Usumacinta to the west, scattered with sites like Bonampak, Yaxchilán, Piedras Negras, and Palenque, down to Jonuta and Comalcalco in the extreme west of the Maya world, by the Gulf coast, less than 100 kilometres from the Olmec site of La Venta;

3) a northern zone, which covers most of the Yucatán peninsula and contains Puuc-style towns like Uxmal, Kabáh, Labná, and Chichén Itzá

(later the centre of the Toltec-Maya renaissance), and the Río Bec-style cities of Xpuhil, Chicanná, and Kohunlich;

4) a southern zone, comprising the mountainous region in the south of Guatemala and its range of volcanoes along the Pacific coast. These highlands were always strongly affected by the various Mexican cultures; particularly evident is the influence of Teotihuacán at the site of Kaminaljuyú, near the present capital of Guatemala. On the borderline between this zone and the lowlands of the Petén, there is also the valley of the Río Motagua, with cities like Quiriguá and Copán, which I shall consider as part of the central zone.

For many years, it was customary to divide Maya history into two periods, as first postulated by the great specialist in Maya civilization, Sylvanus G. Morley (1883–1948): the Old Empire and the New Empire. The former included the sites of Tikal, Uaxactún, Copán, Quiriguá, Palenque, Yaxchilán, and Piedras Negras, while the latter concerned subsequent northern sites such as Uxmal and Chichén Itzá. But this division, analogous to the dating of Egyptian history, is no longer in use. It was realized that manifestations of culture reached their zenith almost simultaneously in both the northern and central regions of the Maya world, and that a classical age existed in both areas at the same time even if the forms it took were different.

These historical divisions have been replaced by generally accepted archaeological criteria. Maya chronology—a subject to which I shall return later—begins with a Formative period (about 1500 BC to 150 AD), itself subdivided into three phases, the Early, Middle, and Late. There are similar subdivisions in the Classic period (about 300 to 900 AD), followed by the Post-Classic period (from 900 to the Spanish Conquest in the sixteenth century).

The physical environment

As regards the natural ambience in which the Maya civilization emerged, the above division into zones is broadly valid. Low-lying tropical forests of the Petén extend, via Belize, across to the Caribbean coast in the east. Inland, there are few rivers and the terrain is relatively flat. The whole area is covered with a thick canopy of trees, some of which soar up to 40 metres high. A dense screen of vegetation is provided by mahogany, sapodilla, cedar, hevea, and palm, whose branches give dark shelter ideal for a profusion of creepers, palm leaf, ferns, and shrubs.

But analysis of fossil pollen suggests that the virgin forest was not as dense 4000 years ago as it is today. We may imagine it then as interspersed with grassy stretches of savannah and oak coppices—a more favourable environment for early human settlers, presenting no need to burn sections of forest in order to cultivate fields (*milpa*) and grow such crops as maize, calabash, black beans, manioc, and chili. In addition, the technique of burning forests, which was first applied to the tall savannah grasses, may have been partly responsible for the forest completely covering land that farmers abandoned. It would thus be incorrect to speak of virgin forest as normally defined by botanists, since the growth was helped by man. This hypothesis makes it easier to understand why

43 Pottery vase from Kaminaljuyú in Guatemala: 23 cm high, decorated in relief with a human face, it dates from the Pre-Classic period between 300 BC and 150 AD (National Museum of Anthropology and History, Guatemala City).

44 Stone ball game marker from Kaminaljuyú: this stele, decorated with highly stylized reliefs and perforated at two points, dates from the period locally called Miraflores in 300 BC–150 AD. It is worth comparing with the stone rings of the Toltec-Maya period at Chichén Itzá, and with the use of posts as at Teotihuacán (National Museum, Guatemala City).

45 Granite stele from Kaminaljuyú: 1.83 m high, decorated with a remarkable bas-relief, it depicts a dignitary in profile, wearing a mask of the long-nosed god and a complicated ceremonial headdress. Some resemblance may be noted to the helmet on an Olmec stele (*Plate 23*). This piece is dated 300 BC–150 AD (National Museum, Guatemala City).

46 Three-legged quern (*metate*) and polished pestle from Kaminaljuyú: typical stone utensils in a maize culture for grinding grain and preparing flour (National Museum, Guatemala City).

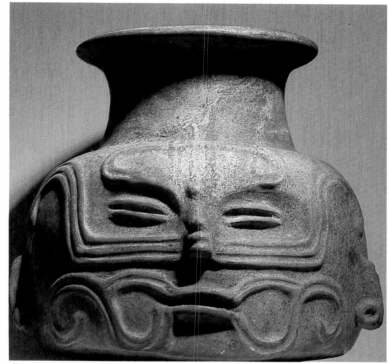

43

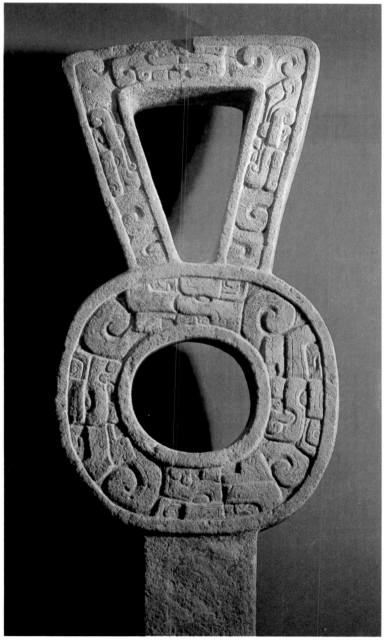

44

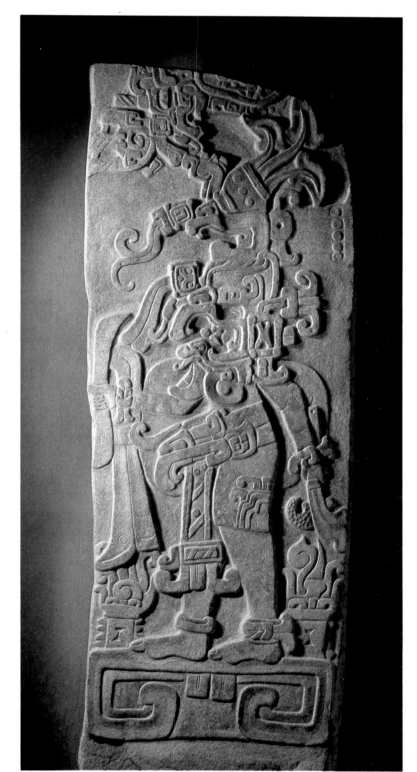

45

46

the earliest communities of Neolithic farmers settled in the Petén region.

The second zone to which I have referred is the Usumacinta river valley. The Usumacinta is a big river of the Amazonian type, which flows majestically down from the heart of Maya country to Olmec territory. It is lined by the dense tropical forest that covers the foothills of the mountain range connecting the isthmus of Tehuantepec and the Guatemalan highlands. The considerable ruins found on either side of the powerful Usumacinta show that the river must have been an important waterway between the cities in the Petén and Chiapas during the Classic period.

The northern zone on the Yucatán peninsula contains, like the Petén, few rivers and streams. The northern and western portions of the flat peninsula, whose average altitude is only 30 metres above sea level, are covered by dense low brush. Their poor vegetation becomes green during the wet season, then gradually shrivels up and loses its leaves after rain gives way to drought, forming an impenetrable, unprepossessing maquis.

Man can easily clear land for cultivation by burning the scrub. But as there is only a thin layer of humus on the soil, which is made up of limestone karst, farmers are forced to abandon plots of land after working them for two or three years, so that the soil can regenerate itself. The sole useful watering places are the *cenotes,* large natural wells that were created when the upper limestone crust collapsed, revealing the underground water-table. Their depth varies from 5 to 20 metres, depending on the area. The eastern coast of Yucatán, on the Caribbean, receives humid sea winds and, like the Petén, is covered by thick forests. Vegetation is particularly dense in the region of Quintana Roo next to Belize.

Lastly, the Guatemalan highlands, which culminate in the volcanoes of the Sierra Madre (about 4000 metres), run down in a south-westerly direction to the rich plains along the Pacific coast. The temperate surroundings of the present capital, Guatemala City (altitude 1500 metres), were inhabited from a very early date because of their great fertility and favourable climate. Valleys hemmed in by vast coniferous forests offer farmers ideal terrain, in a well-protected landscape dotted with lakes and overlooked by the characteristic cones of active volcanoes. This mountainous massif harbours the sources of the main rivers, such as the Motagua, which waters a huge tropical plain, then flows into the Gulf of Honduras at the border between Honduras and Guatemala.

Canals revealed by aerial radar

A recent discovery, published by NASA (the National Aeronautics and Space Administration in Washington, D.C.) in May, 1980, gives a fascinating answer to the problem posed by the development of a populous civilization in the heart of a region covered by virgin forest. There seemed to be no explanation for the fact that many Maya centres were self-sufficient in food in such a hostile environment as the Petén, Belize, and Quintana Roo. Intensive agriculture would have been necessary to nourish the two or three million Maya. But the practice of burning forests to create cultivable fields meant that farming was extensive, widely scattered, and dependent on the system of fallowing land. So how did the Maya grow enough crops to prosper?

47 Temple I at Tikal in Guatemala: also known as the Pyramid of the Great Jaguar, it is seen here from the upper platform of Temple II. A stairway runs up the pyramid's nine stages, to a temple with three vaulted rooms and a roof comb whose relief decoration is ruined. Radiocarbon tests on the sapodilla lintels have dated the pyramid, 47 m high, to about 684 AD, at the climax of the Classic Maya period.

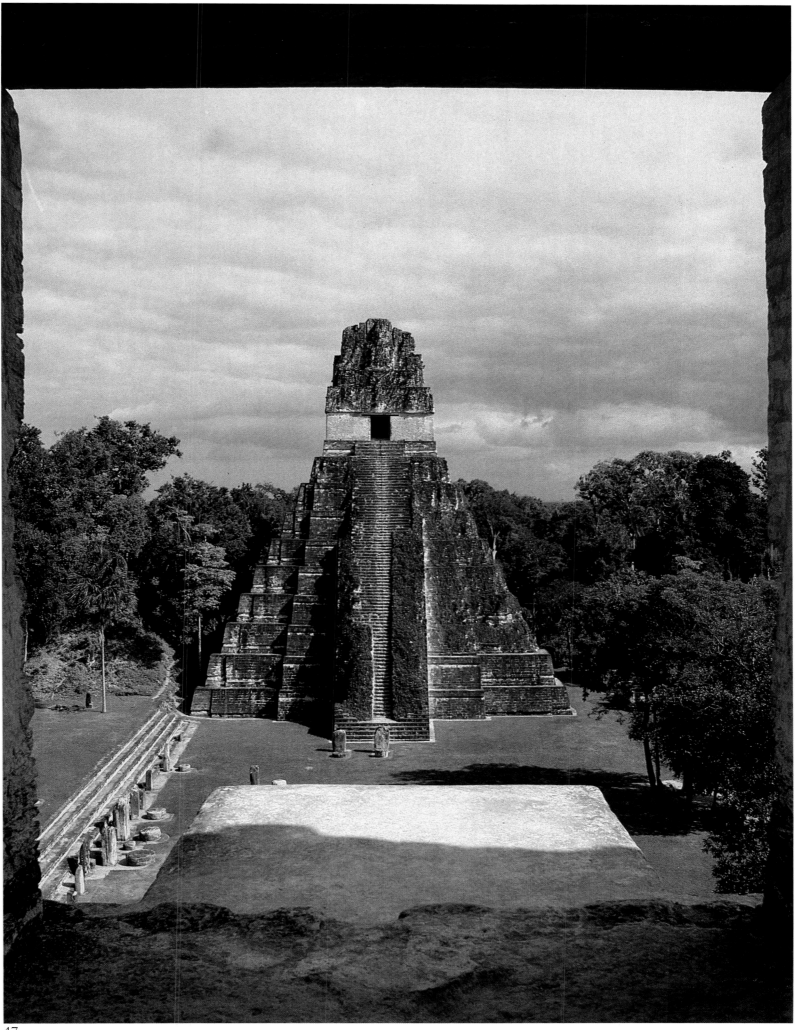

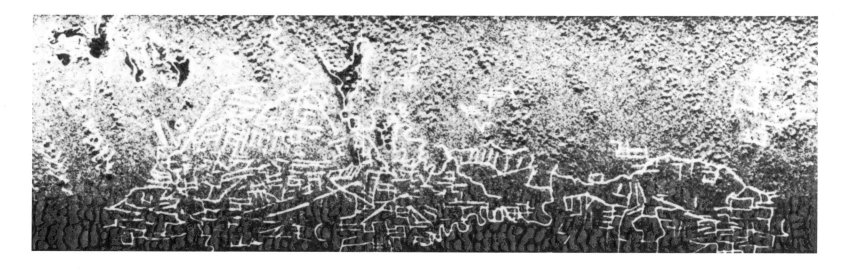

The aerial research program initiated in 1977 by NASA used a new type of radar, invented by the Jet Propulsion Laboratory in Pasadena, California. Known as SAR (Synthetic Aperture Radar), it can scan the ground from an altitude of 10,000 metres, through the cloud layer and even the thick forest. According to its readings, over an area of about 80,000 square kilometres of jungle in Guatemala and Belize, most of the lowlands bordering the river valleys of the Petén are laced with interconnecting canals, ducts, and ditches. This feat of Maya engineering was the subject of fieldwork by two archaeologists, Richard Adams from Cambridge University, and Patrick Culbert from the University of Arizona.

In February, 1980, they observed that an area estimated thus far at 14,000 square kilometres (about the size of Connecticut) held a fantastic labyrinth of channels, some 1.5 metres deep and 2 to 3 metres wide. In a region with abundant tropical rains and a humidity approaching 100%, the function of the channels was clearly not irrigation, but the removal of excess water from the saturated ground. The Maya had, then, constructed a vast drainage system. It was probably only by developing the normally flooded terrain of the Petén in this way that people were able to procure much land of the high-yielding type needed for intensive farming. The analysis of fossil pollen, already mentioned, indicates that the Maya lowlands, before the construction of the drainage system, were covered by grassy savannah, or more precisely by swamps that were flooded during the wet season by rivers and torrential rainfall. The forest was prevented from growing freely by this regime of floods.

There is clearly a parallel between the terrain of the Petén and the Gulf regions inhabited by the Olmecs who, as we have seen, needed to dredge their canals in order to survive. But similarities with other civilizations are also worth mentioning. The Nile delta, for example, before being made cultivable by the efforts of Neolithic Egyptian farmers over thousands of years, was a swampy waste with no real forest. The same was true of the Mesopotamian basin between the Tigris and Euphrates rivers. It would seem that all great early civilizations saw the light of day in such an environment. And only the collective development of the land was capable of achieving a surplus production of food, releasing labour to build cities.

This recent discovery reveals an even closer relationship between the Olmec and Maya cultures than was suspected. At least it proves that analogous techniques contributed to the emergence of civilizations in

Network of Maya drainage canals in the Petén jungle as revealed by the NASA aerial radar readings

Mesoamerica. Lastly, we can now be more certain that the lowlands degenerated at the end of the Maya era, through insufficient drainage, from agricultural soil to virgin forest. The implication is that man himself caused the jungle to flourish, in a region originally consisting of swampy grass surrounded by tall trees growing on land high enough to escape the seasonal floods.

Natural resources

Tropical Maya country contained a variety of natural resources. The forest fauna included jaguars, peccaries, deer, tapirs, monkeys, and a host of birds like toucans, parrots, and quetzals, whose green feathers were valued by the nobility of the Classic period. There was other quarry for hunters, such as lizards, caymans, fish, and crustaceans. As for flora: tobacco, cacao, avocado pear, and countless medicinal plants were picked in the wild, then cultivated alongside maize, beans, gourds, chili, and cotton.

As I have pointed out, the American natives of the northern hemisphere possessed no pack or draught animals, no herds of cattle or flocks of sheep. Since the only domestic animals were dogs, turkeys, and bees (for honey), hunting played an important role in the economy. The volcanic or limestone subsoil was generally poor. In particular, there were no metals, although modern prospecting has revealed oil. But the mountainous areas of Maya country held other mineral wealth such as hard stone, obsidian, and jade. A deposit of jade—the stone which the pre-Columbians prized above all others, and carved into jewellery and funerary ornaments—was recently discovered near the Motagua valley. The remarkable techniques used by the Olmecs to carve stone have already been described. The Olmecs probably provided the Maya with valuable lessons about how to hew and transport large blocks of stone, and about the polishing of hard stones.

Maya origins

Let us try to imagine what occurred when the Olmec culture of San Lorenzo, Tres Zapotes, and La Venta came to an end. If one accepts the view that the fall of the Olmec civilization was caused by an invasion (perhaps from north to south—the direction taken by all major migratory movements in Mesoamerica, just as throughout the history of ancient and medieval Europe the barbarians came from the north-east), two conclusions may be drawn. First, some Olmecs must have fled before the invaders, and would have moved eastwards, toward the Petén via the Usumacinta river valley. There, they would have found tropical living conditions not very different from those to which they were accustomed including the seasonal floods of the deltas that had sustained their wealth.

Secondly, it is possible that Olmec territory underwent, as I have suggested, a terrible outbreak of malaria which caused it to be abandoned by both previous and new inhabitants. It is believed that malaria can

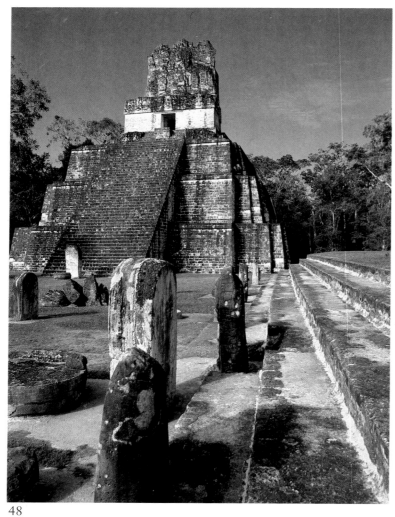

48

49

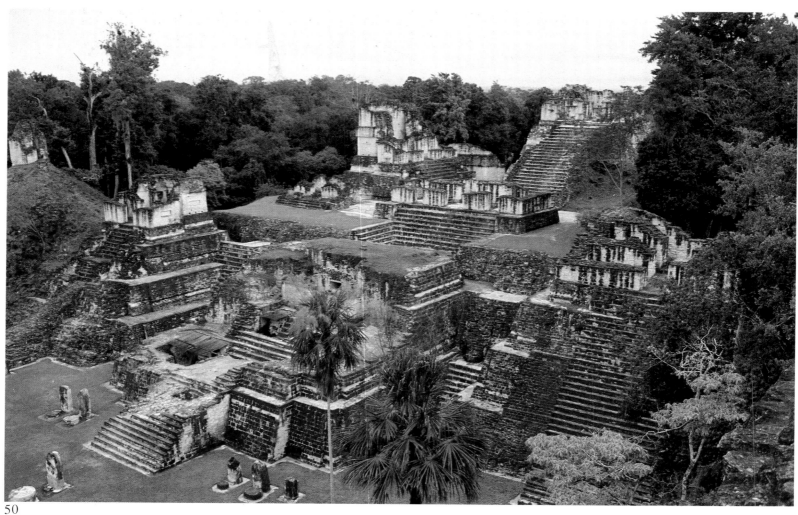

50

exist in an endemic state in swampy regions. The arrival of people from outside—a military task force, for example—can be enough to start an epidemic. This is the explanation proposed, by recent publications on medical parasitology, for the abrupt appearance of malaria in areas that have always known a humid, swampy climate. Thus it cannot be ruled out that the sudden invasion of tribes from the north not only compelled the Olmecs to abandon their lands and flee to the east, but engendered a new civilization in the Maya region—with the fleeing Olmecs acting as a catalyst for the less developed milieu into which they were moving.

Radiocarbon dates of archaeological deposits form an unbroken sequence from the finds at San Lorenzo and La Venta to the first cultural manifestations at Tikal. Michael Coe tabulated these facts in his book *San Lorenzo and the Olmec Civilization,* to prove a strict continuity until the earliest stirrings of Maya culture, which existed in the Petén as long ago as 300 BC. This picture, if correct, could make the Olmecs the originators of the Maya civilization, as well as explaining the numerous parallels between the two cultures, from the stelae, monolithic altars, pyramids, and ball courts to writing, the calendar, and time reckoning, not to speak of such religious leitmotifs as jaguar worship.

The Formative period does go back as far as 1500 BC in Maya territory. But settlements then were only of a Neolithic type shared by the rest of Mesoamerica. Specific Maya characteristics began to appear in the urban communities that sprang up as ceremonial centres around the third century BC. It was, in any case, before the Christian era that the Maya became acquainted with the technique of producing quicklime, by heating limestone to a high temperature, and of making a mortar that enabled them to build stone roofs with corbel-vaults. This discovery could have taken place only in an area possessing plenty of limestone, like the Petén and Yucatán.

First signs of the Maya

At several points on the Pacific side of the mountain ranges, the final centuries of the Formative period show a different face from that of the emerging Maya world. Both at Izapa in the extreme south of Chiapas in Mexico, at El Baúl and Monte Alto on the coastal plains of Guatemala and El Salvador, and up at Kaminaljuyú in the present-day suburbs of Guatemala City, interesting items from that period have been found. But they are very dissimilar, and display none of the consistent style that characterized the full Maya culture.

Izapa, for instance, contains some 22 stelae and 19 stone altars with carved decorations which, though probably influenced by the Olmec tradition, look forward to Maya artefacts. Their style is original and, while using Olmec themes, it gives them a voluted treatment that also heralds the art of the Totonacs, a people who later flourished at Tajín in Veracruz. There are no traces of writing or a calendar.

Much has been written about the monoliths discovered along the Pacific coast, and more particularly the colossal heads measuring between 1.5 and 2 metres in height. Some authors, despite the evidence, argue that they are pre-Olmec. Yet their traits are in no way comparable with the heads found at La Venta or San Lorenzo, and are clearly the

48 Temple II at Tikal, opposite Temple I on the Great Plaza, which is bordered with stelae. Erected in about 700 AD, the building has only three stages, and its roof comb shows traces of relief decoration.

49 Vaulting of a long chamber in the five-storey Palace at Tikal. The triangular concrete roof imitates the interior of a traditional Maya habitation. Its few doorways let in little light, but kept the chamber relatively cool. Sapodilla tie-beams reinforce the structure, which has resisted the dampness and roots of the Petén jungle. Here the American archaeologist Teobert Maler lived while excavating the central acropolis of Tikal at the beginning of our century.

50 North acropolis at Tikal, seen from the top of Temple I. The group is laid out with strict axial symmetry, and contains seven pyramids, whose upper temples have been partly destroyed. A succession of stelae stands in front of the acropolis, which dates from the Classic Maya period.

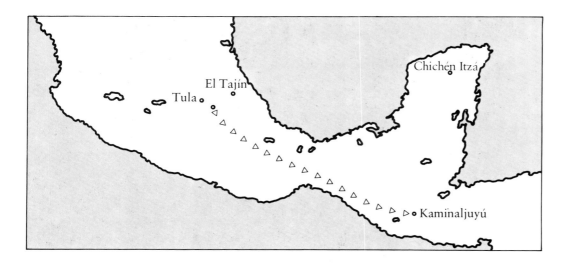

Map of the great migration of the peoples of Teotihuacán, who left their ruined capital around the end of the fifth century AD and reached the site of Kaminaljuyú some 1000 km to the south-east

Structure A–VII at Kaminaljuyú, with its panels in the style of Teotihuacán architecture and its thatch-covered temple sanctuary (after A. Kidder)

cruder manifestation of a less structured, plastically less consistent, art. They range from a fat-cheeked figure at Monte Alto, summarily hewn out of a block of stone, to a head at Canal San Francisco which has deeply scored features and a thin, aquiline nose jutting from a face that is broader than it is tall. Found along with these works were some sculpted stelae with bas-relief figures and numerical glyphs. Stele 1 at El Baúl displays what could be the equivalent of the date 36 AD. This would make it earlier than the oldest Maya dates, although later than the Olmec monuments (apart from the Tuxtla statuette, possibly dated 162 AD).

The stelae at Kaminaljuyú also bear writing, yet to be elucidated. Kaminaljuyú, a large complex which flourished before its counterparts in the Petén, is now swallowed up by the suburbs of Guatemala City. Its archaeological riches have, sadly, been plundered by generations of treasure-hunters, with only a few rescue operations by archaeologists. These reveal that the site's history can be divided into two main phases. One comes at the end of the Formative period (from the beginning of the Christian era), and includes some sumptuous tombs containing jade objects. The contemporary stelae heralded classic Maya works, both in their treatment of human figures and in the way they were arranged over the sculpted surface. But the finds at Kaminaljuyú are also illuminating because they give examples of still undeciphered writing that looks forward to Maya glyphs.

The second phase, several centuries later, shows that the 'city' had by then fallen into the hands of invaders from the north. They had fled from Teotihuacán (also known as City of the Gods), the great Mexican highland capital which was destroyed by barbarians after 450 AD. Survivors embarked on a journey of 1000 kilometres through mountain valleys, and decided to rebuild, at Kaminaljuyú, a miniature version of their lost capital. This resulted in a considerable renaissance at Kaminaljuyú, where many new buildings were put up in style similar to that of Teotihuacán, The process recurred, some 500 years afterwards, when Chichén Itzá was invaded by the Toltecs, as we shall see.

Evidently this southern region of the Maya world was subject to substantial population movements along the valleys of the Sierra Madre. It amounted to a crossroads, testing various sorts of culture without yielding a genuinely homogeneous one. The melting-pot contained too many incompatible ingredients. Only the Maya achieved what became a far more coherent civilization, regardless of any differences between 'cities'.

51 North acropolis at Tikal: approached by steps some 80 m wide, it borders the Great Plaza and is the heart of the ceremonial centre.

52 Stele 10 at Tikal: dating from the middle of the sixth century AD, it represents a Maya dignitary in profile, dressed in finery and holding a long 'effigy sceptre'.

53 Stele 16 at Tikal: it shows a Maya dignitary in frontal view, with only his face in profile, surmounted by a headdress of quetzal feathers. The sculpture, dated 771 AD, stands on the edge of the Great Plaza.

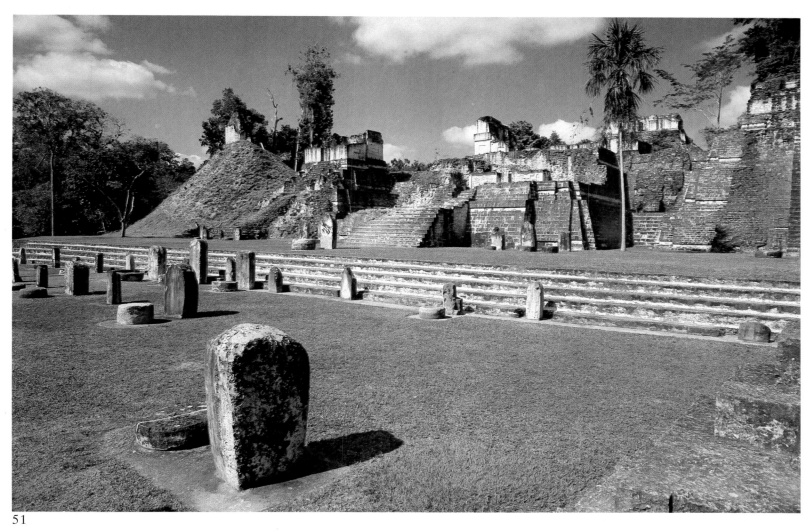

51

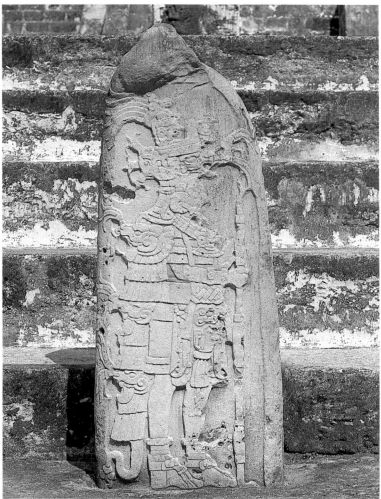

52

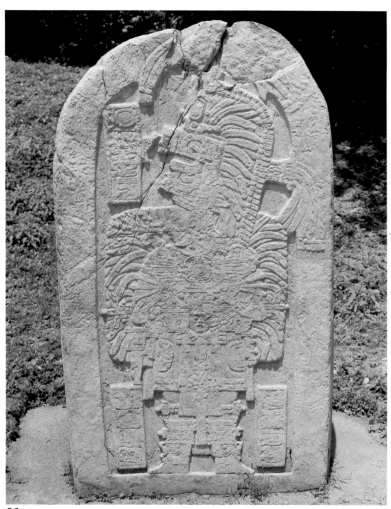

53

Architecture and the city

Elevation and schematic plan of a Yucatán Maya dwelling

Such was the geographic and historical context that produced true Maya classicism at the beginning of the fourth century AD. But the urban revolution which marked the maturity of Maya society, having existed in embryo for two or three centuries, is not comparable to similar phenomena in Europe and the Middle East. In the Old World, the city's function was usually to provide a fortified refuge for people and for the wealth they had accumulated (food, precious materials, decorative and religious objects). A city was packed into the smallest space possible and surrounded by walls, there were few entrance gates, and the houses were separated only by narrow streets—an ideal place to protect treasures that might excite the desires of outsiders. Maya urban areas, on the other hand, consisted solely of a ceremonial centre with pyramids for worship and palaces where the ruling class lived.

The rest of the Maya population (farm-workers and craftsmen) were housed in surrounding hamlets, which consisted of huts with mud walls and palm-branch roofs, identical to those still built in the inhabited parts of Maya country. The farmer's hut, perfectly adapted to the climate, had a two-pitched thatch roof with rounded, semi-conical ends. Its layout might be oval or rectangular, depending on the region. Normally a square door was in the middle of each long side. Every family tended to own two huts, not far apart. Their functions were often distinct, one being used for domestic tasks and sleeping, the second for cooking. The huts stood on a small plot of land, surrounded by a drystone wall, and shaded by a few palms or other trees.

Thus the villages were loosely grouped, and frequently spread some distance from the nobles' ceremonial centre. This arrangement of living areas, to include fields where food crops such as fruit and leguminous plants could be grown, solved the problems of transportation facing the Maya. Forced to carry all their food by hand, they found an advantage in living among the fields they tilled. Until a relatively late period (in the eleventh and twelfth centuries), when the first defences appeared, Maya towns were not protected by walls. Their inhabitants lived in a widely scattered community, parts of which were quite far from the centre itself. Almost the only surviving traces of their huts are the earth platforms on which these were built in rainy areas, to avoid being washed away by torrential tropical downpours.

So what remains is basically the skeleton of a 'city' consisting solely of those constructions that were built of stone. Moreover, it is an urban complex in its final phase—the ceremonial centre dating from the Late Classic period. Although some major buildings go back to the fourth or fifth century, they were frequently expanded and remodelled, looking now as they did in the seventh or even the eighth century. This is true of both the central region and Yucatán.

Ancient structures are, on the whole, deeply buried or hidden by later additions—a process of superimposition which is characteristic in pre-Columbian civilizations. The new, larger and taller pyramid would be built over the existing pyramid, completely encasing it. There might subsequently be a third or fourth 'layer', as in an onion or a nest of dolls. Not only are the latest constructions the most imposing and grandiose, but they conceal the successive phases of their architecture. Archaeologists

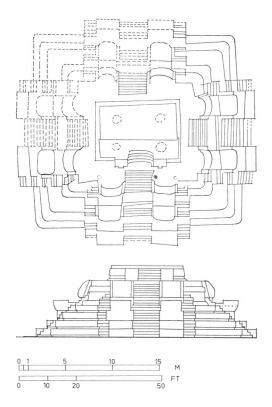

Plan and elevation of the E–VII-sub pyramid at Uaxactún (after Marquina)

are naturally aware of this feature, and must dig tunnels into the cores of buildings to ascertain traces of previous periods.

Such methods have revealed several very old edifices in an intact state, beneath a more recent addition whose stucco decoration and facing masonry have been badly affected by rains and the roots of trees. Under what resembled shapeless mounds, excavators have unearthed structures in exactly the same condition as when they were 'buried' by Maya builders. The most striking example is the discovery of the temple at the top of the inner Castillo pyramid at Chichén Itzá: archaeologists were fortunate enough to find a sanctuary complete with offerings and a throne in the form of a red jaguar, as on the day of their interment after a ceremony.

But let us return to the Petén and to one of the chief discoveries of this kind, the E-VII-sub pyramid at the site of Uaxactún, near Tikal. Discovered by Ricketson, this stucco pyramid having four radially symmetric staircases, decorated with parapets and large sculpted jaguar-masks, is thought to date between the second century BC and the second century AD, a formative phase in Maya architecture. As at Kaminaljuyú, the temple at the top of the pyramid was roofed with perishable materials. It must have looked rather like the ordinary Maya thatched huts, presumably to show that the house of the gods was no different from that of man. The pyramid rises from a platform 25 metres square, to a height of 9 metres. A similar design became the basis for more imposing later Maya pyramids. The largest of them, Temple IV at Tikal, built during the eighth century which marked the zenith of Maya genius, was almost 70 metres high, the tallest construction ever erected by the pre-Columbians.

The Classic age is typified by a constant use of the Maya vault—a 'false', or corbel, vault secured with lime mortar and given the shape of an inverted V. This made the interiors of stone buildings resemble the roofs of Maya huts, in which the two inclined planes of thatch met at a central ridge piece. Maya interiors always reproduced the forms of ordinary homes, even when extending their scale as in the Governor's Palace at Uxmal. This type of vault distinguished Maya architecture from all the other building techniques of the pre-Columbian world. It was used by the architects of the Petén, Usumacinta, and Yucatán, in temples and in the vast palaces of the ruling élite.

The Maya dignitaries were, at least in an early period, invested with both temporal and religious powers—they were military leaders as well as organizers of worship and sacrificial ceremonies. That they were quite literally deified can be seen from their magnificent tombs, often located in the heart of a pyramid. During their lifetime, these nobles occupied the countless rooms of the buildings reserved for them. A blend of the religious and secular—in the present case, between the temple and the palace—can also be seen in a subtle shift that sometimes occurs from one to the other. At Uaxactún, Structure A–V shows several stages of remodelling and overlaying, in which three small temple-pyramids standing in a row were linked together to form a single palace-like structure for habitation.

Although archaeologists are not always agreed on the purpose of such long buildings, frequently assembled around a quadrangular court or patio, it is difficult to see what other use could have been found for huge structures containing dozens, and sometimes hundreds, of chambers.

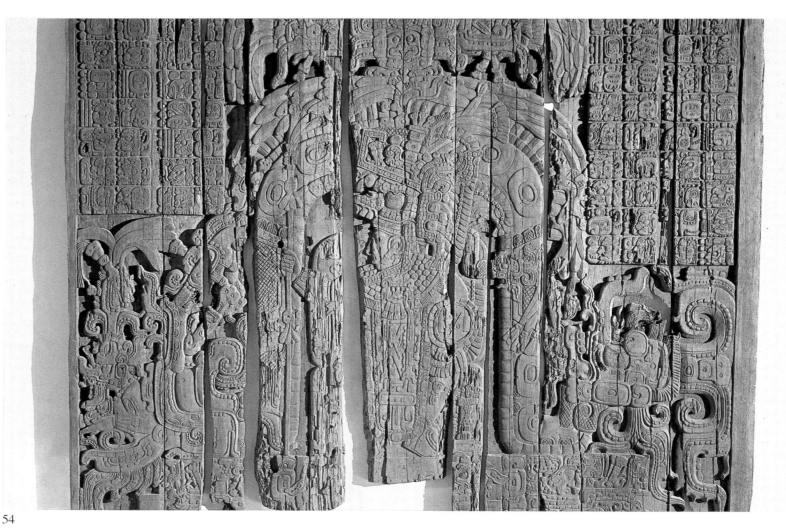

54

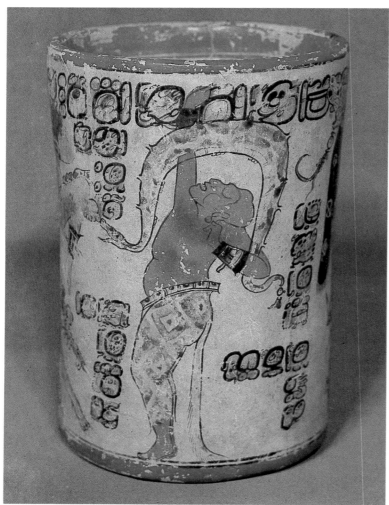

55

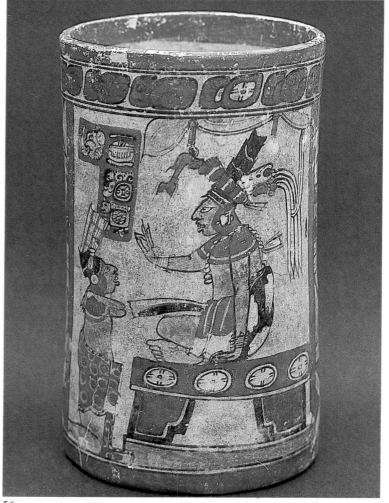

56

The rows of chambers were often arranged two-deep, recalling the huts of farmers: a front room, lit by daylight from a large square opening, was kept for daytime activities, meals, receptions, or council meetings, and behind it lay a dark windowless room for sleeping.

A point worth mentioning is that, although present-day Maya commonly use the hammock, this invention was peculiar to the Caribbean island peoples and was introduced into Maya regions only after the Spanish Conquest. So we may imagine that the Maya of the pre-Columbian age slept on bedding placed upon low trestles, of the kind depicted in some vase paintings (where they are usually described by historians as 'thrones'). The arrangement of the palace chambers, moreover, suggests the existence of furniture. Rooms may have been closed by wooden doors, or else by door-curtains, to keep out mosquitoes during the hot season.

These are some of the basic elements of Maya architecture, which I will examine in greater detail when discussing individual examples.

Tikal: a giant among Maya ceremonial centres

Discovered only in the eighteenth century, the site of Tikal was first described in a publication which appeared in Berlin in 1853. In 1877, the Swiss traveller Gustav Bernoulli sent the magnificent carved wooden lintels from the site which are now the prize pieces of the Museum of Ethnography in Basle. In 1881 and the following years, Tikal was investigated successively by Alfred P. Maudslay, Teobert Maler, Alfred M. Tozzer, and Sylvanus G. Morley. But it was in a long campaign by the University of Pennsylvania between 1956 and 1966 that its principal monuments were extricated from the tropical vegetation and, after fruitful excavation, meticulously restored.

Tikal has been made the core of a vast protected park in an attempt to prevent the uncontrolled looting that has affected all too many Maya sites. The total area of the park is more than 500 square kilometres, while its central area of 16 square kilometres comprises over 3000 monuments. The heart of this enormous ceremonial centre covers 1200 by 600 metres, and contains the principal buildings such as pyramids and palaces. The spot where the Maya chose to erect the sacred 'city' of Tikal—which, along with Teotihuacán in the Mexican highlands, is the largest pre-Columbian urban site—lies in the virgin forest to the north of Lake Petén Itzá. As well as the centre itself, numerous smaller complexes are scattered in the surrounding jungle within a radius of several kilometres.

It should be borne in mind that the scale of Tikal and the quantity of its architectural structures are the result of a long history, from the third to the ninth century AD (the Classic period). In the course of almost 700 years, the gigantic religious centre was continually expanded. Attempts have been made to determine Tikal's main phases. Apparently as early as the sixth century AD, Maya civilization in the Petén underwent considerable political upheavals, probably the final effects of the population movements from northern Mexico that affected the regions to the south.

54 Carved sapodilla-wood lintel from Temple IV at Tikal: sent back to Switzerland in 1877 by the explorer and botanist Gustav Bernoulli, one of the first visitors to the site, it probably dates from 741 AD (radiocarbon analysis suggests about 636, but the wood could have been used a century after the tree was felled). It portrays a Maya lord beneath an arch formed by a huge double-headed serpent (Museum of Ethnography, Basle).

55 Polychrome pottery vase from Altar de Sacrificios, in the southern Petén: this cylindrical piece, 25 cm high, dates from 754 AD according to the text along the rim and between the various figures. On the side shown here, an apparently ecstatic officiant, his eyes closed, dances with a huge snake (National Museum, Guatemala City).

56 Cylindrical vase from the tomb of Temple I at Tikal: the polychrome painting shows a Maya dignitary, seated on a throne beneath a canopy, giving orders to a kneeling vassal. The piece is 28.4 cm high and dates from the eighth century AD (Tikal Museum).

We have already examined the impact of invaders from Teotihuacán on the site of Kaminaljuyú in Guatemala. The same newcomers were to disrupt the heart of Maya country, halting the sculpture of dated stelae and the construction of temples.

Only in the seventh century did the builders of Tikal again become productive, creating from that time, and especially in the eighth century, some of the finest edifices on the site. These monuments, often the result of additions to earlier structures, have received most of the modern restoration work. Towards the end of the ninth century a further cataclysm, due to a second wave of invaders, caused the site to be abandoned. Tikal was not reoccupied until the eleventh, twelfth, and thirteenth centuries, and then sparsely, by people who looted its ruins before leaving them to be swallowed by the jungle.

Tikal's long history is one reason for the almost unfathomable complexity of its structures. In the great groups of palaces on its central acropolis, for example, we observe a host of interlocking edifices with different orientations and levels, separated by spaces made up of courts and broad staircases. The architects of Tikal over the centuries were constantly remodelling buildings or changing their function. This can be judged from the arrangement of the chambers, which sometimes lie in rows four-deep and which, lit only by doors on the façade, are usually plunged in total darkness; from their extremely long and narrow proportions, at times turning them into what must be termed galleries or corridors; and from the accumulation of architectural masses atop or behind each other in a bewildering conglomeration. The impression one gains is that whole sections of structures were put to new uses as the need arose, and that unexpected events inspired fresh plans. All types of civil buildings adjoined each other at Tikal, from the nobles' living quarters to the administrative edifices and meeting halls for chiefs or priests.

The layout of Tikal, with an unfortunate lack of overall design, is a far cry from the rigorous composition of palace-like complexes in Yucatán, as at Uxmal. It owes to mere enlargement, and no deliberate attempt at planning is discernible. Only a vague east-west pattern governs the site, chiefly visible in the arrangement of twin temple-pyramids dating from the Late Classic period. The sole clarity of purpose occurs in individual complexes, or groups of buildings around a plaza, but their connection with the whole remains ill-defined. Broad processional thoroughfares are seen, as are the points at which drinking water for each quarter was stored in reservoirs between artificial earthen levees. Yet it would be more accurate to speak of a straggling accretion than of a fixed scheme.

The device whereby buildings are duplicated along an axis of symmetry, as in the groups making up the twin pyramids and culminating in Temple I and Temple II, is also found in the great complex of the north acropolis. Consisting of pyramid-shaped edifices arranged on a north-south axis, this group chiefly contains two facing pyramids, to the east and west. A principal pyramid, to the north, is mirrored by another smaller pyramid to the south. This cross-shaped layout is again faced by three pyramidal platforms. The ceremonial centre thus recalls an axial plan used by the highland Aztecs seven or eight centuries later.

As we have noted, the main architectural interest of Tikal lies in its pyramids, whose majestic lines immediately impress the visitor. Both

57 Head from Copán: sculpted from green volcanic trachyte stone, dating from the eighth century AD, and 35 cm high, it once decorated a building on the site, and represents the young maize god (Copán Museum, Honduras).

58 Sculpture from Copán: this vigorous and expressive head probably dates from the eighth century AD and (as in *Plate 57*) decorated a building. It represents a young nobleman wearing a high turban-like headdress and heavy ear disks (Copán Museum, Honduras).

59 Detail of cylindrical polychrome vase from Copán: a framed figure sits above a row of glyphs. This piece of pottery dates from the Classic Maya period (Copán Museum, Honduras).

60 Detail of Maya vase from Copán: the clean lines and elegant style of this incised pot, monochrome and cylindrical, make it one of the masterpieces of Maya draughtsmanship. The form of its glyphs is like that on a panel at Palenque in 783 AD (*Plate 98*), so a similar date seems likely here (Copán Museum, Honduras).

57

58

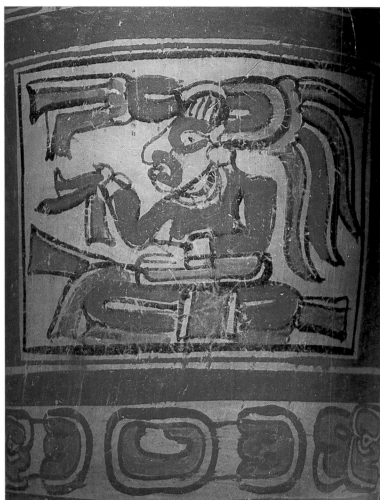

59

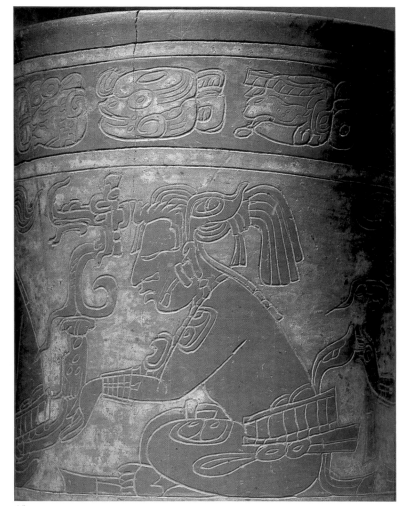

60

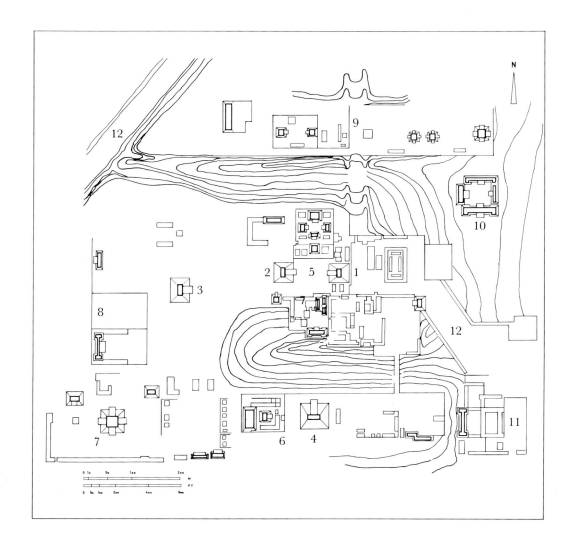

Simplified plan of the ceremonial centre at Tikal (the orthogonal nature of its layout is accentuated here):

1. Temple I
2. Temple II
3. Temple III
4. Temple IV
5. Group A, Great Plaza and North Acropolis
6. Group B and South Acropolis
7. Group C and Centre Acropolis
8. Group D
9. Group E
10. Group F
11. Group G
12. Causeways

their height (Temple IV rises nearly 70 metres) which sets them well above the tallest treetops of the forest (40 metres), and their steep slopes often attaining an angle of more than 70 degrees, amply justify calling them 'cathedrals of the jungle'. These pyramids, surely the most vertiginous ever erected by the pre-Columbians, exhibit various elements.

Each pyramid consists of a base and flights of steps ascending to a sanctuary for worship. The base is a series of receding tiers: Temple I has nine, and Temple II only three. The tiers, with edges blunted by graded re-entrant corners, display a slight batter effect. A great stairway runs in a single flight up the side of the pyramid to the top. There the sanctuary stands, on a foundation lower than the last tier of the pyramid. A few steps, narrower than the main stairway, lead to the square door of the sanctuary.

The place of worship was not intended to accommodate crowds of devotees. Only officiants such as lords or high priests had access to it. So the sanctuary was of modest proportions, with two or three rooms arranged breadthwise one behind the other—forming what we might call, on the analogy of the architecture of classical antiquity, the 'pronaos', 'naos', and 'holy of holies'. The rear chamber, necessarily dark, had lintels of finely carved sapodilla wood, was possibly decorated with tapestries, and contained the priests' ornaments and sacrificial instruments. Thus perched in the skies, some 50 metres above the religious centre, the Maya priests attempted to gain the good will of the gods. They also observed the paths of heavenly bodies, which helped them to draw up the sophisticated calendar that is admired for its accuracy by modern scientists.

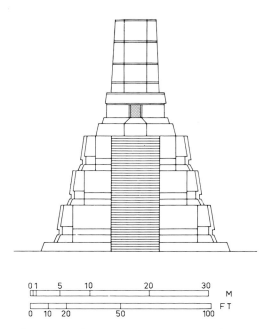

Elevation of Temple II at Tikal

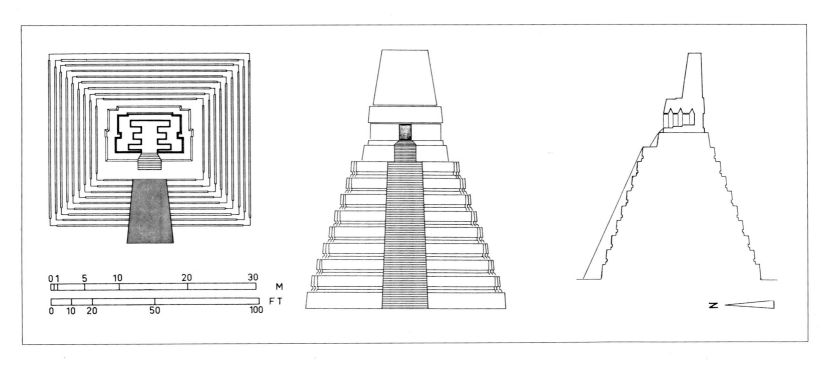

Plan, elevation, and section of Temple I
at Tikal

The sanctuaries at the top of the Tikal temples were tiny in comparison with the considerable volume of the pyramids themselves. In the case of Temple I, which is 47 metres high and covers about 35 by 30 metres at its base, the interior space of the upper temple rooms amounts to only 1/140 of the building's total volume of 16,000 cubic metres. But the sanctuaries have massive roof structures, and are surmounted by a tall stone crest. This feature, known to archaeologists as a 'roof comb', gives the buildings a certain elegance of outline. Sometimes the roof comb is taller, when its own supporting platform is taken into account, than the upper temple on which it rests. Maya architects often perforated the roof combs to make them lighter, and decorated them with ornamental motifs in stuccoed masonry.

Another characteristic feature of Tikal, which sets it apart from other major Maya sites, is the fact that it has only small ball courts. Seemingly all efforts were concentrated on building the pyramids which formed the most important part of this religious centre's architectural facilities. Also worth mentioning is the discovery, by excavators from the University of Pennsylvania, of a sumptuous tomb in Temple I, also known as the Pyramid of the Great Jaguar. According to radiocarbon dating, the tomb is contemporary with the erection of the edifice in about 700 AD. In the course of borings to determine the structure of the pyramid, investigators found the tomb in an intact state beneath the first platform. It contained the remains of a high priest, surrounded by hundreds of votive offerings—vases, shells, jade beads, and bone objects.

In order to imagine what life was like at Tikal during the seventh and eighth centuries AD (when the centre had just over 12,000 inhabitants, as estimated by American specialists), one must fill in the picture left today by the ruins. Their façades were stuccoed and painted in bright colours; there were grand ceremonies and processions led by dignitaries, dressed in gaudy costumes and covered with jade jewellery and the feathers of exotic birds; crowds of worshippers gathered at the foot of the buildings to attend the rites. These sometimes involved human sacrifices, as has been shown by the discovery of tombs containing not only people of high rank but, often, servants or wives to accompany them on their journey into the next world.

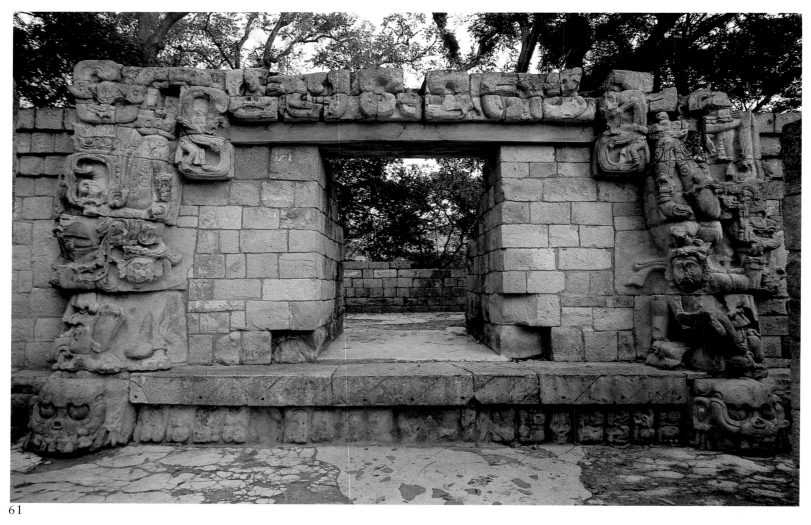

61

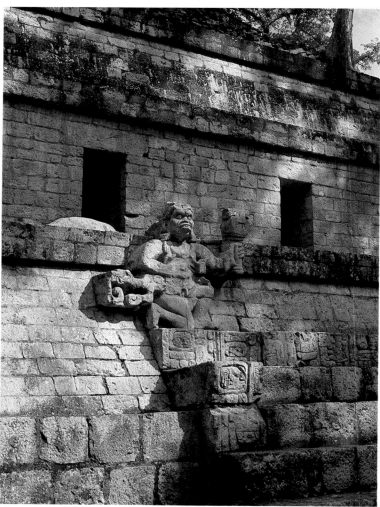

62

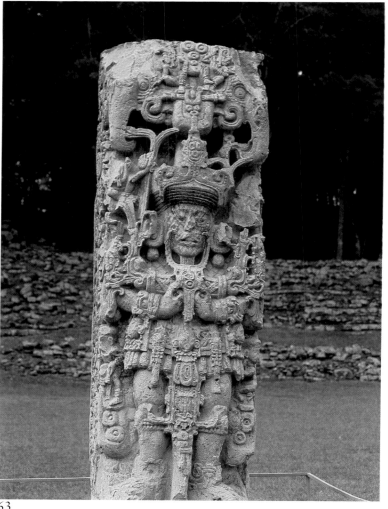

63

Maya civilization was 'theocratic' and needed little encouragement to organize grandiose ceremonies of every description—sowing and harvest festivals, offerings to tutelary gods, celebrations of astronomical phenomena (such as solstices and equinoxes) or of events like birth and death in the noble families, investitures of rulers, dedications of monuments, propitiatory rites before a campaign, and so on. These are usually the kinds of events commemorated by the stelae that were erected at key points of the ceremonial city. Such stelae, carved from a single block of stone, often represent an important figure in full regalia. Generally he asserts his authority by the mere fact of being in the centre of the composition, surrounded by hieroglyphic signs and dates. But sometimes he may be presiding over a commemorative rite, or even over a sacrifice, as we shall see at Yaxchilán.

Dozens of stelae, most of them dated, lie on the Great Plaza at Tikal, between Temple I and Temple II. The oldest example dates from 292 AD, while the most recent (after which it ceased to be customary to erect such monuments) bears the date 869 AD. So the practice may be assumed to have covered six centuries, when natural events and human deeds were arranged in a strictly chronological order. It is almost as if the Maya were fascinated, even obsessed, by the passage of time—and one may legitimately speak of a 'stele cult'.

The Maya's love of fixing precise dates, based on an era with mythical origins, is perhaps among the most 'modern' aspects of their civilization. No comparable features are to be found either in ancient Egypt or in the great cultures of antiquity, whose chronologies tended to start again at year one in the reign of each new king. Only with the relatively late introduction of Olympiads as units of time reckoning in Greece, and of years since the foundation of Rome, did the Greco-Roman world gradually adopt a linear time system, as opposed to the cyclical system governed by the rhythm of ever-recurring seasons which impressed primitive peoples. It should not be forgotten that this concern with time, first appearing at the end of the Olmec era, was bequeathed to the Maya by that civilization, along with a method of numeration which I shall soon review.

Copán and Quiriguá: the Río Motagua valley

Although the Petén contains dozens of Maya 'cities', some of which are only beginning to be located by archaeological missions in the vast expanses of virgin forest, it would be impossible to deal here with such sites as Nebaj, Machaquilá, Seibal, Cancuen, Tayasal, Nakum, or Motul. Let us turn to the valley of the Río Motagua, in the south-east part of Maya country, where other artistic and architectural 'styles', if one can so call them, are found.

The Motagua, one of Guatemala's biggest rivers, rises in the Sierra Madre to the west of Guatemala City, cuts its way through hilly country, and flows out to the Gulf of Honduras in the Caribbean. The valley watered by it provides a fertile environment, in contrast to the surrounding semi-desert, and was naturally chosen by the Maya as a place for one of their larger cities, Quiriguá. Quiriguá depended upon the great

61 Doorway to Temple 22, overlooking the eastern plaza at Copán: the baroque sculptural decoration consists of two 'Atlantean' *bacab* figures kneeling on death-heads, symbols of infernal deities, and supporting a great double-headed serpent which spans the lintel of the doorway.

62 'Torchbearer' at Copán: this figure, actually the storm-god, is on one side of the stairway with glyphs, leading up to the 'Grandstand' against the central acropolis on the north side of the west plaza. Architecture becomes sculpture in this work, dated 762 AD.

63 Stele B at Copán: like all the monuments at this site, it shows a wealth of baroque ornamentation that is characteristic of the eastern extremity of the Maya world. Its bearded dignitary wears a heavy crown and ceremonial costume. Inscriptions are on the sides and back of the stele. In the top right and left corners are motifs which may have been derived from macaw heads, but were often interpreted in the last century as elephants. It is of trachyte.

64 Stele H at Copán: this sculpture, dated 782 or 751 AD (depending on how the glyphs are interpreted), represents a Maya lord wearing a rich ceremonial headdress decorated with jade ornaments and feathers. Traces survive of the polychrome painting that once covered it. Underneath it was a votive cache containing gold jewellery from Central America, thus heralding the metal objects found in the Sacred Cenote at Chichén Itzá.

65 The northern part of the platform at Copán: in the centre is the ball court, built from 541 until the eighth century AD, when the vaulted galleries were added. On the right is the great hieroglyphic stairway, whose 63 steps are inscribed with 2500 glyphs, dating from 545 to 757.

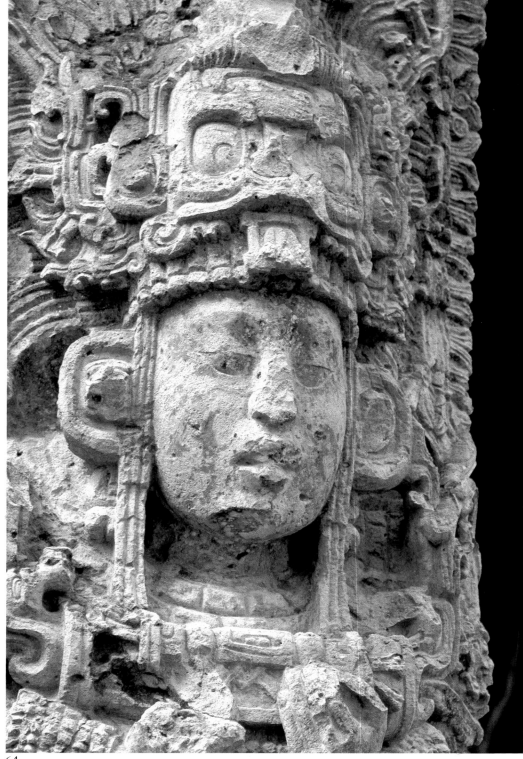

64

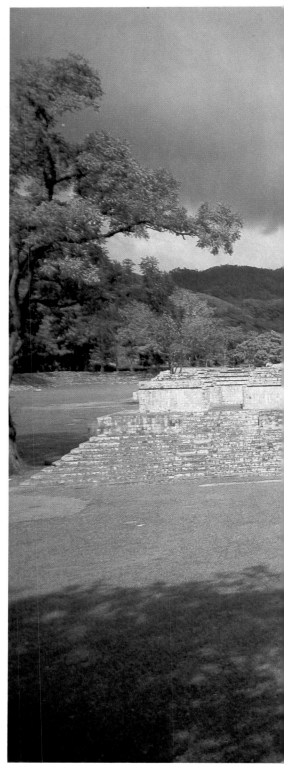

65

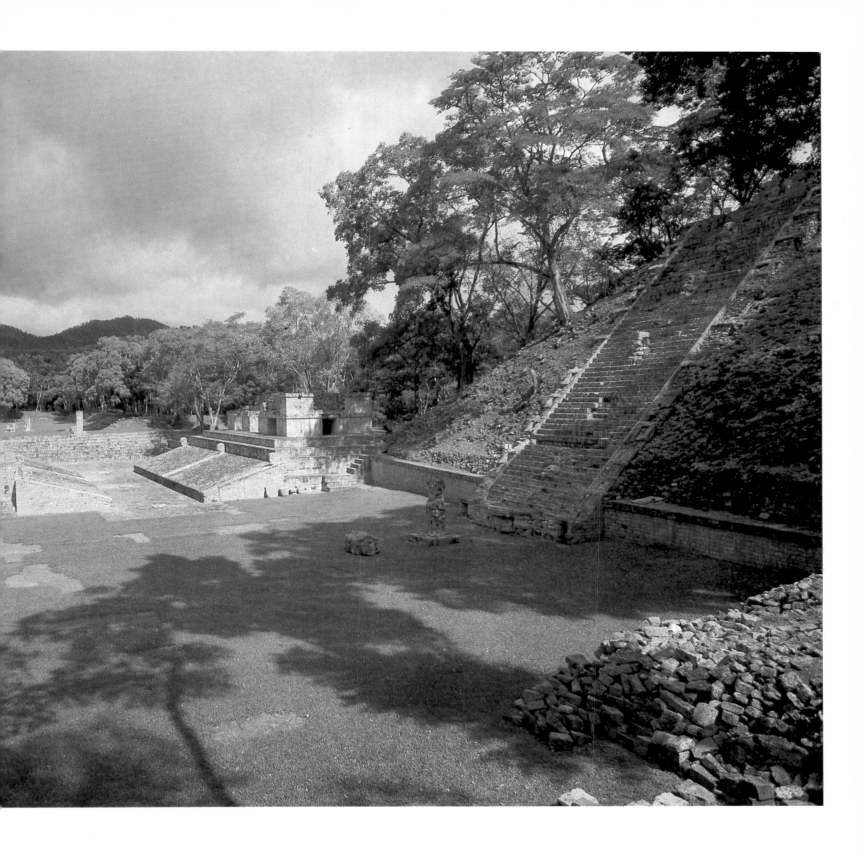

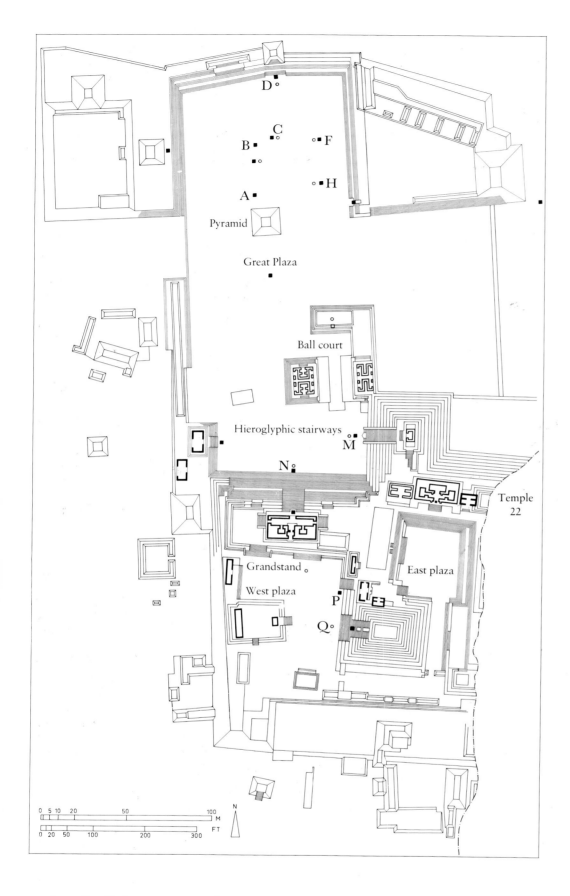

Plan of Copán (Honduras). Letters refer to stelae and altars, symbolized by squares and circles respectively

D

C
B F

A H

Pyramid

Great Plaza

Ball court

Hieroglyphic stairways
M

N

Temple 22

Grandstand
West plaza
East plaza

P

Q

0 5 10 20 50 100 M
0 20 50 100 200 300 FT

66 Stele C at Quiriguá: dating from 775 AD, it represents a bearded figure in frontal view, as on the monuments at Copán. Only the face is in high relief, while the rest of the body is given bas-relief treatment, as on the stelae in the Petén.

67 Stele K at Quiriguá: the centre shows a seated crowned figure in frontal view, similar to sculptures at Piedras Negras dated 608, 687, 731, and 761 AD. But this work is from 805 AD, and bears the penultimate recorded date on the site, where no inscriptions after 810 AD occur.

68 Zoomorph P at Quiriguá: this enormous monolithic altar, dated 795 AD, represents a turtle shell behind a seated figure wearing a curious ceremonial headdress. The sculpture, with its delicate workmanship and intricate motifs, which are arranged symmetrically across the stone block, marks the peak of baroque Maya ornamentation.

regional religious centre of Copán, in the mountains to the south, on the banks of the Río Copán, a tributary of the Motagua. The two sites have many features in common, such as their large number of enormous sculpted stelae, which are often given a high-relief treatment.

Copán, at the farthest western point of Honduras, is located at the heart of an easily defensible region. Its acropolis overlooks the river, which irrigates a fertile plain and, when in full spate, floods the area. As a result, through the centuries, much of the site's enormous artificial

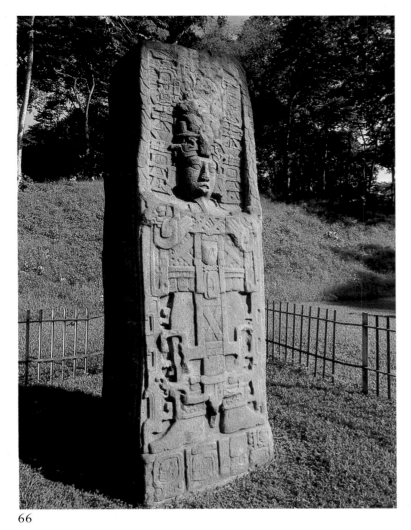

66

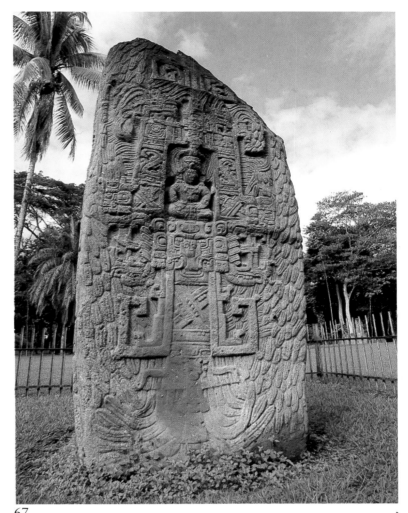

67

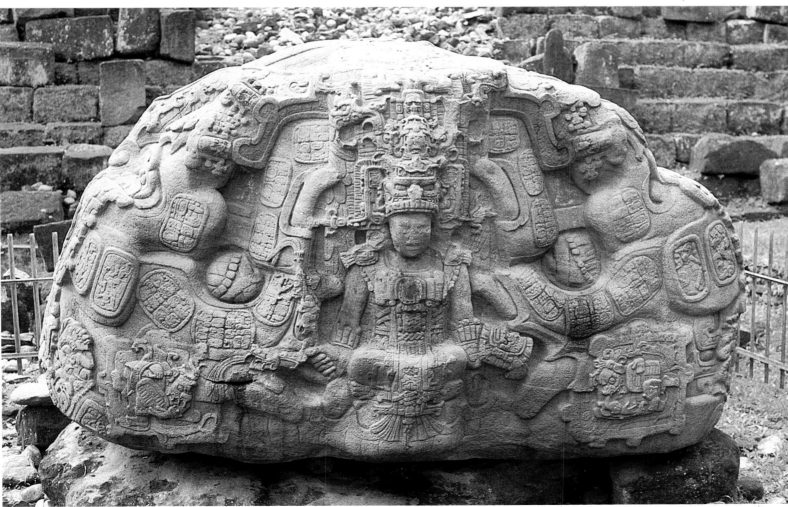

68

platform has washed away. Recently it became necessary to divert the Río Copán in order to protect the ceremonial centre. But the river's ravages have a positive aspect: they provide archaeologists with a vertical stratigraphic section of the acropolis where it has been eroded by water. This reveals that the extraordinary quantities of earth on which the centre's monumental stairways, temples, pyramids, and palaces are built were put there by man. To construct the platform, 30 metres high and 3.5 hectares in extent, the Maya had to accumulate almost a million cubic metres of earth and rubble. Its tallest pyramids rise to 38 metres above the river level.

Copán owes its reputation, as one of the finest Maya sites, less to the acropolis—with admirable plazas, platforms, staircases embellished by sculptures, and temples—than to the art of its stelae. The subtle and ornate qualities of their carving in the round have not only earned widespread admiration, but proved of irresistible interest to archaeologists. Bordering the representations of Copán's rulers, who were usually bearded and dressed in finery, are many hieroglyphic inscriptions.

These supply a series of dates from 485 to 801 AD, chronicling the city's history.

Most of the magnificent stelae were carved from a green volcanic rock known as trachyte. Its fine grain enabled sculptors to work in great detail and obtain a superb polish, originally highlighted by bright colours. They stand in the Great Plaza to the north of the acropolis. This immense quadrangle, surrounded by tiers and measuring about 300 by 100 metres, contains an excellent ball court in its southern section—nestling against the sharply rising mass of the acropolis to the south, with steep flights of steps and, in particular, the celebrated Hieroglyphic Stairway of Copán. The 63 steps of this stairway are bordered with sculpted parapets, and comprise some 2500 hieroglyphs, the longest Maya stone inscription that has yet come to light.

The expanse of this court, emphasized by a central pyramid of small dimensions, is literally dotted in its northern section with a series of stelae and altars. The groups of sculptures at Copán are usually arranged in sets of two—a stele combined with a low, rounded monolith depicting a turtle or some mythical monster. This arrangement, whose origins go far back into the Olmec world, must have resulted from the requirements of worship and of ritual offerings made before the stelae. Beneath the stelae, moreover, there is usually a tiny cross-shaped underground chamber, which must have been used as a kind of cache, and in which votive offerings of pottery and obsidian blades have been found by archaeologists from the Carnegie Institution, in the course of their restoration of the monuments of Copán.

The great quality of the Copán sculptures is matched only by those at Quiriguá. It lies in a strange blend of meticulous realism (the faces of the figures represented) and baroque ornamentation (the wealth of detail and profusion of decorative elements). There is a powerful tension between the serene, soberly treated features of the Maya dignitaries, who are depicted frontally with strict symmetry, and their florid costumes. The most startling thing about these tall monoliths is that one's gaze is drawn inexorably to—and almost hypnotized by—the smooth, calm surface of the face, which contrasts strongly with the riot of ritual ornaments worn by the figure.

69 Pottery censer from Altar de Sacrificios: the handle depicts a slit-eyed figure. Its fine dynamic execution recalls the best examples of Jaina art. This piece is dated 700–800 AD (National Museum, Guatemala City).

70 Two-piece censer from Tomb 22 at Uaxactún: this seated figure, 21 cm high, is made of black pottery with incised decoration, and dated 500–600 AD (National Museum, Guatemala City).

71 Detail of vase from San Andres Sajcavaja in Guatemala: this effigy of a monkey dates from the Classic Maya period (National Museum, Guatemala City).

72 Detail of pottery censer from the Petén: its relief shows the sun-god emerging from the jaws of the earth-monster. It is dated 250–600 AD (Popol-Vuh Museum, Francisco Marroquin University, Guatemala City).

69

70

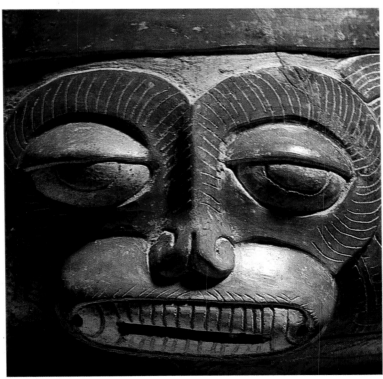

71

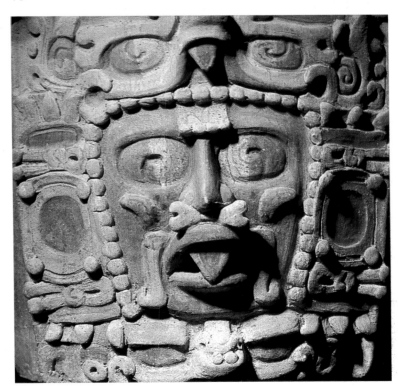

72

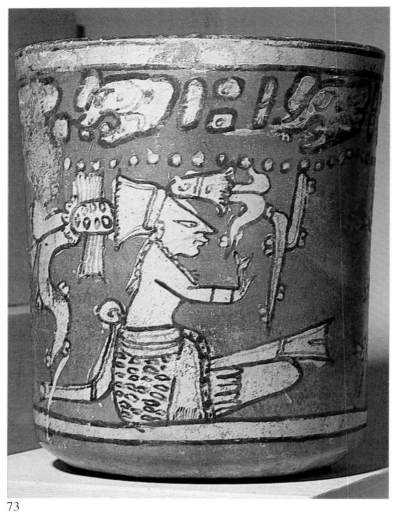

73

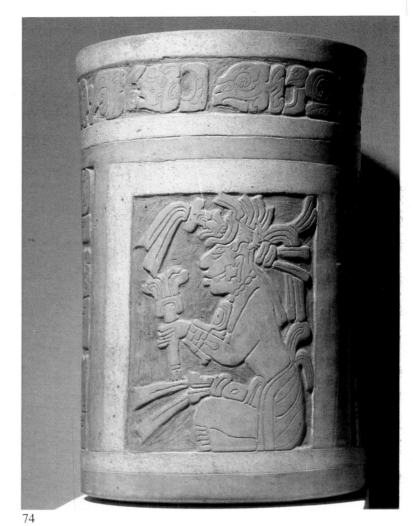

74

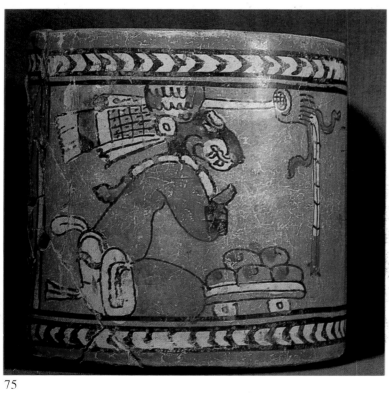

75

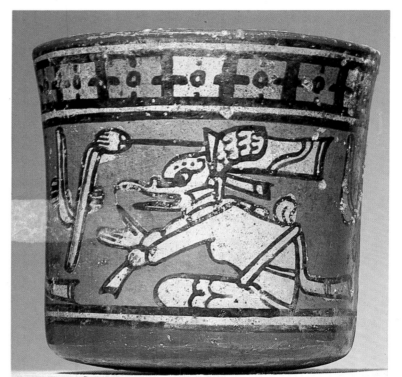

76

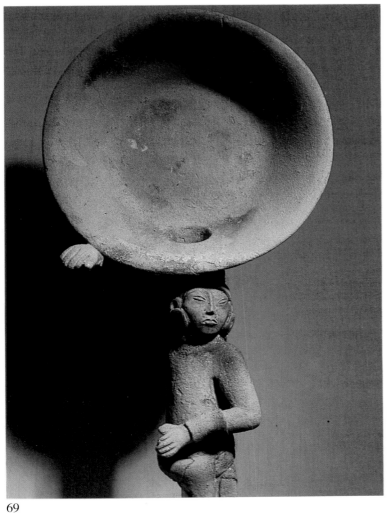

69

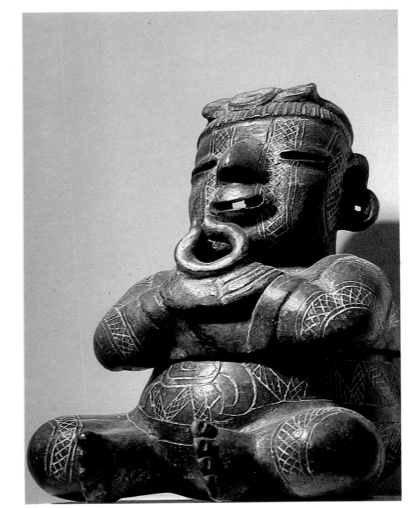

70

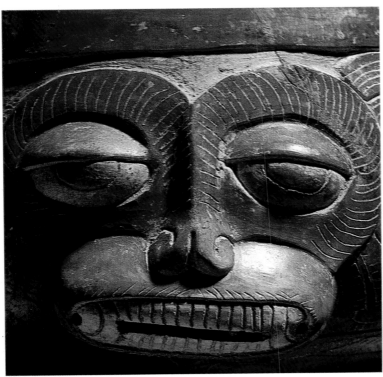

71

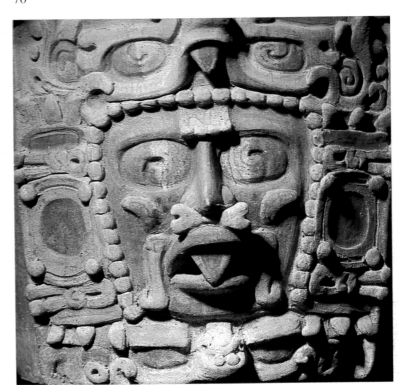

72

Although relatively small in size, the ball court at Copán, which occupies the very midst of the ceremonial complex, between the Great Plaza and the acropolis, ranks among the finest Maya achievements. Its gently sloping sides are lined on the right and left by rather low, vaulted structures with openings toward the playing area. The stepped terrace cuts off the vista to the north, and bears in its centre a tall stele marking the axis of the group. The sculpted ornamentation consists of six macaw heads, at each end and in the middle of the walls along the sloping sides, and of circular flagstones along the median axis that represent opposing players on either side of an enormous rubber ball. These features make the court, which dates from 514 AD but was subsequently remodelled three times, a gem of pre-Columbian architecture.

It is an architecture evolved slowly. Thus, while the ball court first existed at the beginning of the sixth century, the vaulted galleries on either side were probably not constructed until the eighth century. Similarly, the Hieroglyphic Stairway dates from 545, but the stele and altar which stand in front, to complete an organic whole, were erected only in 757, more than 200 years later. All these dates fall into the Classic period, and the site seems to have been abandoned in the ninth century.

Copán was an important centre of astronomical observation (some stelae commemorate what might be called the first congress of astronomers in the New World!), and it influenced several other Maya sites. One of the most interesting is Quiriguá, where the tallest Maya stele was discovered, 10.5 metres high, weighing 65,000 kilograms, and dating from 771 AD. This shows what kind of technological feat was within the grasp of the Maya, who were no doubt driven by intense religious feelings. As in the case of the Olmec monoliths, it would seem that their exploit was made possible by the proximity of a river on which the monolith could be transported by raft.

Like Copán, only 50 kilometres away, the ceremonial centre of Quiriguá, which is laid out along a north-south axis, has a main court dotted with stelae. Its not very imposing southern acropolis resembles Copán in that the principal architectural monuments are arranged around a plaza. An interesting characteristic of the dated stelae and altars of Quiriguá is that they succeed each other regularly every five years from 746 to 810 AD, when all activity in the centre apparently ceased.

The greatest quality of Quiriguá sculpture can be seen on the gigantic zoomorphic altars. The baroque traits we noted at Copán are multiplied in an explosion of amazingly complex and subtle forms which, however, follow a strictly symmetric pattern. Among the representations is a monster's gaping mouth, from whose awesome fangs a figure is emerging (Zoomorph P)—a striking parallel with what had existed more than 1500 years earlier at La Venta.

The Maya calendar

As illustrated already at Tikal, Copán, and Quiriguá, dated monuments played a dominant role in Maya creations of the Classic period. This calls for an outline of the Maya calendar and of the arithmetic it presupposes. These have been reconstructed brilliantly by a succession of

mainly British and American scholars, among whom Herbert J. Spinden, Sylvanus G. Morley, and J. E. S. Thompson were the pioneers. With very little evidence—the few surviving codices (essentially those in Dresden, Madrid, and Paris), data recorded by Bishop Diego de Landa in the middle of the sixteenth century, and epigraphic texts copied from sculpted monuments—they managed to make sense of Maya dates. As Champollion had done with Egyptian hieroglyphs, they paved the way for the decipherment, still far from complete today, of the writing devised by the most advanced of the pre-Columbian civilizations.

The Maya used two systems for calculating the days of the year. One involved a cycle of 260 days, the so-called sacred or divinatory calendar. This was shared by several pre-Columbian peoples and it named days through a combination of 13 numbers and 20 names. As 13 and 20 have no common denominator, the cycle could not start again until 260 days had passed. The other system comprised 365 days, or a solar year of 18 'months' of 20 days each, with 5 unlucky days added at the end of the year. When the two systems were intermeshed, a given day could not return to the same position in the 260-day count and in the 365-day count until 18,980 days had passed—a period of 52 years, which for the pre-Columbians was analogous to our 'century'. That period, the common denominator of the two systems, was equivalent to 73 sacred years.

It is now necessary to explain the Long Count (which the Maya inherited from the Olmecs). This was used to date events and to record time in the inscriptions engraved on monuments. Once again, multiples were intermeshed and added together. The Long Count cycles are as follows (a day is a 'kin'):

20 kins	equal	1 uinal (20 days)
18 uinals	equal	1 tun (360 days)
20 tuns	equal	1 katun (7200 days)
20 katuns	equal	1 baktun (144,000 days, or about 394.5 years).

With the help of these cycles, the Maya could determine any date expressed in five figures, which supplied a total number of days from a 'year zero' that marked the beginning of their era. Thus, a date written according to the convention of arranging its components in decreasing order (baktun, katun, tun, uinal, and kin), and consisting of the figures 9.13.16.5.8, would break down as follows:

9 baktuns of 144,000 days each	1,296,000 days
13 katuns of 7200 days each	93,600 days
16 tuns of 360 days each	5760 days
5 uinals of 20 days each	100 days
8 kins of 1 day each	8 days
giving a total of	1,395,468 days.

This is a considerable time—about 3823 years—counting from the beginning of the Maya era, whose comparison with our own system of chronology will be discussed later.

Apart from the five figures which form the 'initial series' within the Long Count system, the Maya were aware of the margin of error that existed between a year of 365 days and the astronomical year of 365.24

73 Cylindrical polychrome vase from San Agustín Acasaguastlan in Guatemala: a seated Maya dignitary is surmounted by a border of glyphs. The work dates from the end of the Classic period in 600–900 AD (National Museum, Guatemala City).

74 Cylindrical vase from the Motagua valley: with a chased bas-relief treatment, it depicts a Maya noble holding a sceptre. Around its top is a border of hieroglyphs (National Museum, Guatemala City).

75 Cylindrical polychrome vase from Alta Verapaz in Guatemala: 11 cm high, dated 600–900 AD, it shows a masked priest seated before a votive offering (Popol-Vuh Museum, Guatemala City).

76 Cylindrical polychrome vase from San Agustín Acasaguastlan: only 9.5 cm high, it is decorated with a figure wearing a bird-mask, and dated 800–900 AD (National Museum, Guatemala City).

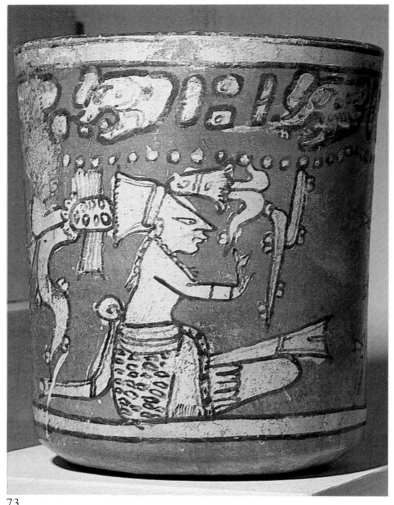

73

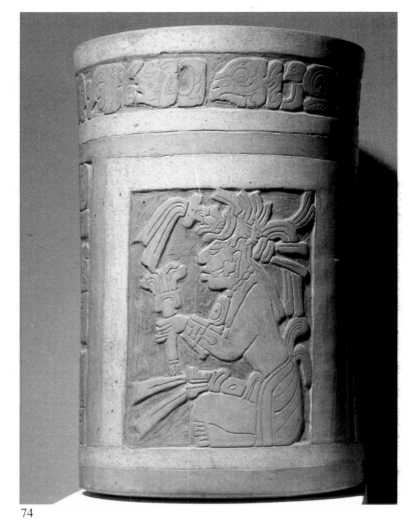

74

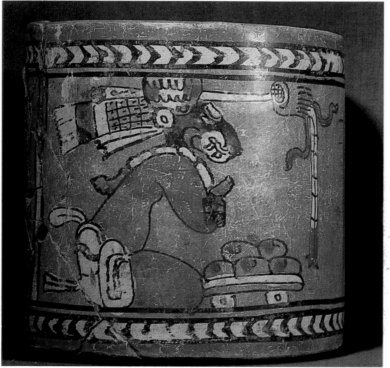

75

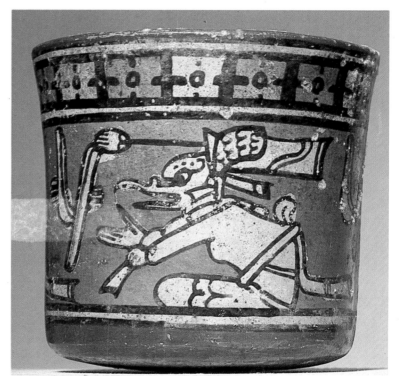

76

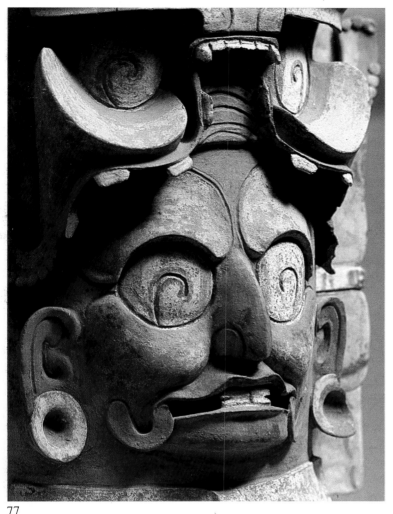

77

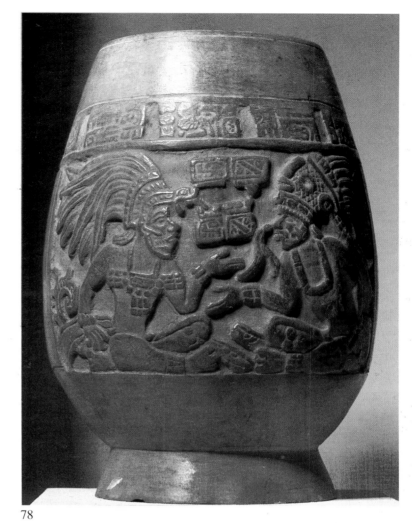

78

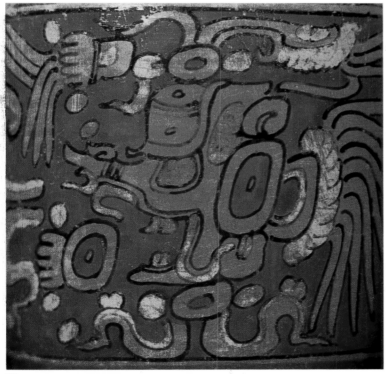

79

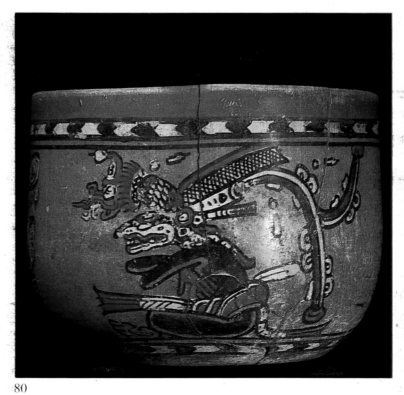

80

days. Hence they included a corrective device of additional days, expressed by two glyphs for uinals and kins.

The Maya subsequently attempted to simplify the expression of their dates, and to reduce the amount of information supplied by the Long Count, which required five glyphs. By the eighth century, the old system began to fall out of use and was replaced by the Short Count, requiring only three glyphs to be inscribed on monuments. Dates included the number of the katun, that of the day, and that of the 'month'. This was enough to determine any day within a 19,000-year cycle. Thus the Short Count indicated a day in the ritual calendar and its position in the month of the civil year. And as the Maya used a cycle of only 13 katuns, each associated with a deity, it would in theory return to the first katun after completing the thirteenth. But a complete rotation of the calendar would have to take place several times before the initial position could recur (the same day, month, and katun); and it is that series of rotations which amounts to 19,000 years. In the case of the Long Count, on the other hand, Morley calculated that the theoretical initial position would recur only after 374,440 years.

At the very end of Maya civilization, the system was further simplified by recourse to a single glyph. This made it possible to fix a given date within a cycle that recurred every 256 years. Paradoxically, then, it was at an early period in their history that the Maya used the most precise form of calendar. They gradually gave up manipulating enormous periods of time and restricted themselves to a more functional system. They replaced a fantastic mathematical machine, which they had so painstakingly set in motion, with simple concepts even if these resulted in a degree of ambiguity.

Yet the Maya were not deterred by complex calculations, as can be seen from their astronomical codices, all dating from the Post-Classic period. They sought to delimit time in ever greater cycles. Not content with the baktun, which totalled 400 intervals of 360 days, they multiplied these units of 144,000 days by factors of 20 to obtain periods of time much longer than our millennium. They were carried away by gigantic figures: thus, multiplying a baktun by four such factors, they obtained an 'alautun' of 23,040,000,000 days, slightly over 63,000,000 years. We have here nothing less than intoxication with the science of mathematics.

A striking characteristic of the various Maya systems is their ease in handling huge numbers. It should not be forgotten that the Maya civilization was one that had scarcely emerged from the Stone Age. Yet such familiarity with figures was never achieved by the Greeks or Romans of classical antiquity, who had nonetheless risen to a far higher level of technological skill—metallurgy, the potter's wheel, wheeled vehicles, lifting machines, draught animals, and agricultural machinery like the plough. The great handicap of all ancient cultures was an inadequate method of expressing figures in writing. Neither the use of letters of the alphabet by the Greeks to represent single units, tens, and hundreds, nor the clumsy device of Roman figures, was capable of dealing with large numbers. This leads one to ask: what was the notation method developed by the Maya which enabled them to juggle figures so confidently? We shall find that the Maya astronomical calculations, as opposed to mere chronology, required a writing system more sophisticated than those devised by Old World cultures at the same period.

77 Detail of funerary urn from Nebaj (El Quiché): the sun-god is shown in high relief. Such vases, sometimes as much as 1 m tall, date from a late period, between 900 and 1000 AD (Popol-Vuh Museum, Guatemala City).

78 Egg-shaped vase from Poptun in Guatemala: this chased piece, an example of 'fine orange' ware, is 22.5 cm high and shows two priests in animated discussion, separated by inscriptions and topped by a row of glyphs. It is dated 800–900 AD (National Museum, Guatemala City).

79 Detail of cylindrical polychrome vase from the Motagua valley: it represents a stylized serpent's head, and dates from the Classic period in 600–900 AD (Popol-Vuh Museum, Guatemala City).

80 Small round bowl from the region of Alta Verapaz: its polychrome decoration shows a seated figure wearing a cayman-mask. It dates from the Classic period (Popol-Vuh Museum, Guatemala City).

81 Circular stele from Cancuen: this bas-relief, 60 cm in diameter and dated 795 AD, was used as a ball game marker. It shows two players wearing the dress and accessories of the game, in particular the wide thick belts, and standing on either side of a large ball. They are separated by glyphs (National Museum, Guatemala City).

82 Detail of the decorated belly of a pottery flask from the Motagua valley: the flask is only 8 cm high and dated 600–800 AD (National Museum, Guatemala City).

83 Detail of an engraving on an obsidian chip, about 6 cm wide, showing a figure in profile (National Museum, Guatemala City).

84 Stele 4 from Machaquilá in Guatemala: it portrays a Maya dignitary in ceremonial costume, with a small sceptre symbolizing his power. The work dates from May 6, 820 AD (National Museum, Guatemala City).

81

82

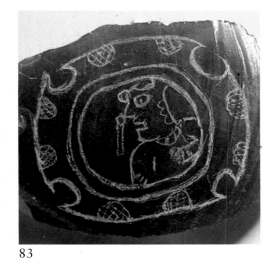

83

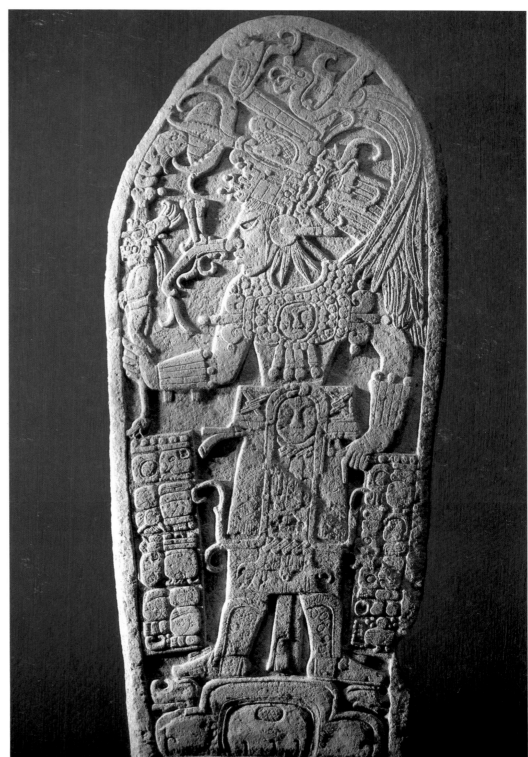

84

The Maya method of writing numbers is remarkably modern in being positional. But unlike our decimal system, it was vigesimal—based upon multiples of 20 instead of 10. While we move by one position each time in going from 10 to 100, 1000, 10,000 and so on, the Maya did this in going from 20 to 400, 8000, 160,000 and so on. Thus, their initial 19 figures went into the first position, 20 to 399 into the second, 400 to 7999 into the third, and 8000 to 159,999 into the fourth. It is easy to understand why such a method encouraged the use of very large numbers, like the alautun obtained from a baktun as we have seen. Even when using only six positions, the Maya got figures equalling up to 63,999,999, whereas in our system the results can go no higher than 999,999.

There was just one exception in this vigesimal system. When days are counted, as in chronological calculations, the third place has a value of 18 instead of 20, because the solar calendar comprises 18 months of 20 days (plus 5 extra days). That rule produces the progression of 20, 360, 7200, 144,000 and so on, which is used in calculating uinals, tuns, katuns, and baktuns.

This method involved the use of a sign that resembles our zero, in that it occupies a position which carries no figure. But the Maya zero, represented in hieroglyphic writing by a kind of shell symbol, multiplies the number preceding it by 20, not by our 10. The so-called 'bar and dot' system was used to write positional numbers. Three or four dots mean 3 or 4—but for 5 a bar is used and, for 15, three bars. The dots are juxtaposed and placed above the bars. Thus, the number 19 is written with a sign consisting of four dots on top of three horizontal parallel bars. The Maya also used a system of hieroglyphic signs for the numbers 1 to 19, replacing the bar and dot notation.

Certainly the Maya mathematical instrument, quite efficient although much more complex than our own, was an achievement never to be surpassed except by the decimal system. And since it is obvious that the precondition of any calendar is observation of the heavens, we may assume that the Maya obtained interesting results in astronomy. Some of their scientific successes will be touched upon in Chapter VI, concerning the observatory at Chichén Itzá.

It is difficult not to admire the ingenuity of the Maya who, hardly out of the Neolithic Age, embarked upon speculative mathematics and were probably, by the beginning of the Christian era, able to solve problems in arithmetic that would have daunted our greatest minds during both Roman and medieval times—until the numerals which we know as Arabic, apparently originating in India, were introduced to Europe by Moslem traders.

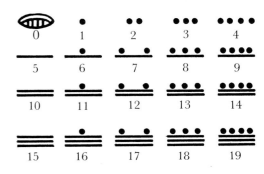

Maya numerals expressed by the bar and dot system

III. Palenque and western Maya art

I shall now turn from the Petén and the central area, including the Río Motagua valley, to the western region of Maya culture. This covers the middle and lower reaches of the Usumacinta, and the zone between that river and the Río Grande in Chiapas, which turns into the Río Grijalva by the time it enters the swamps along the coast of the Gulf of Mexico. The region comprises the states of Chiapas and Tabasco, forming a vital link between the ancient Olmec sites—La Venta is only about 100 kilometres from the Maya city of Comalcalco—and the great centres of the Petén. It is worth remembering the role that must once have been played in communications by the network of waterways. The Usumacinta has even been described by some American authors as the 'highway' of the Maya. And indeed the most important 'cities' in this area of Maya art, such as Yaxchilán, Bonampak, Piedras Negras, and Palenque, are all to be found on or near the Usumacinta.

These regional centres are surrounded by lesser towns, scattered over the whole territory. In 1975, the Mexican authorities organized a programme of archaeological prospecting, which brought to light some 70 Maya towns in the lowlands of Tabasco. This area, as yet little known, is bounded by Comalcalco and Teapa to the west, Palenque to the south, the Guatemalan frontier to the east, and Jonuta in the Usumacinta delta to the north. The archaeologists involved in its preliminary exploration believe that it probably contains a far higher number of towns. There are few major ceremonial centres, apart from those already known, but many secondary groups. In fact, only such a profusion of 'townships', under the power of occasional 'capitals', can explain the opulence of the latter, whose ruling élite enjoyed tremendous pomp and worshipped the gods in sumptuous temples.

Human settlements in the extreme west of the Maya world go back to the Formative period, when the Olmecs were a fundamental civilizing force. The coastal lagoons seem to have been occupied earlier than the hinterland. However that may be, further excavations will clarify the relationship between the last Olmecs and the first stirrings of Maya civilization at this regional junction.

Investigations should also elucidate various problems connected with the natural environment. For example, can the vast expanses of grazing land between jungle and swamp, so characteristic of these lowlands, be attributed to the excessive exploitation of their soil by farming at the time of the Maya, or to the introduction of herds of cattle after the Spanish Conquest? Or may these tropical savannahs be regarded, like those in the Petén according to certain scholars, as vestiges of Maya

country when it was first populated? For the time being, such questions must remain unanswered.

Yet it is certain that the maze of navigable waterways available in this region helped Maya culture to blossom, just as similar conditions had done in Olmec territory. Only a century ago—before railroads and highways had been built—one could easily travel by dug-out canoe through the labyrinth of river deltas to the area of Villahermosa and Laguna de Terminos, where the city of Ciudad del Carmen is located. Lakes, rivers, streams, and swamps form an immense network that was familiar to the local population and facilitated trade and pilgrimages. And it was from those waterways that people could reach the broad sweep of the almost Amazon-like Usumacinta and proceed into the south of the Petén, to sites like Altar de Sacrificios, Aguateca, and Seibal.

The discovery of Palenque

Although not comparable in scale to Tikal, Palenque is one of the principal Maya regional centres. It lies in the heart of the western region, less than 25 kilometres from the Usumacinta, on a small tributary called the Otolum. Its ceremonial buildings stand on high ground at the foot of hills that rise into the Sierra Madre. The view from its temple-pyramids extends over vast coastal plains toward the Gulf of Mexico, some 100 kilometres to the north. Palenque derived much natural protection from the steep hills behind it, and was easily accessible via the waterways crossing the plains. Taking full advantage of its strategic position and good communications, it prospered for hundreds of years, with an apogee lasting from the sixth to the eighth century.

The site of Palenque was discovered as far back as the end of the eighteenth century. But the Spanish explorers did not investigate it thoroughly. As at Tikal, the buildings were strangled by the tropical forest; roots of towering trees had grown into the monuments and pulled away the facing of pyramids; liana had filled the galleries of the Palace, run riot over roofs, and hidden many structures. The whole place, alive with the cries of macaws and monkeys and with the roar of jaguars (which the natives call tigers), was crumbling away in the steamy jungle.

Palenque was described on many occasions by travellers in the nineteenth century. These included John Lloyd Stephens, Alexander von Humboldt, Jean Frédéric Waldeck, Désiré Charnay, and Alfred P. Maudslay. Many of the first visitors, however, behaved irresponsibly, burning down the forest to find treasures. Such vandalism only served to speed up the process of decay, by cracking stuccoed decorations and rebaking mortar in walls and vaults. It was in the twentieth century that scientific investigation began, under Miguel Angel Fernandez from 1934 to 1945, and under Alberto Ruz Lhuillier from 1949 to 1958. During his ten campaigns, Ruz made several discoveries, the most extraordinary of which, in 1952, was the crypt in the Temple of the Inscriptions.

The layout of Palenque is organically associated with the hilly relief of the site on which the Maya decided to construct their ceremonial centre. There is no strict orientation (apart from a certain north-south

85 Aerial view of Palenque: the ruins stand against the jungle-covered hills rising to the south. In the foreground is the great Palace dominated by its tower; on the left, the partly ruined Temple XIV and, behind it, the Temple of the Sun; on the right, the Temple of the Inscriptions. All the buildings date from the seventh and eighth centuries AD.

86 Vaulted gallery on the west side of the main court of the Palace at Palenque: large square openings establish a close relationship between the interior and exterior spaces of this structure, dated 672 AD.

87 Detail of pillar on the side of the great stairway to the west of the Palace at Palenque: the stucco decoration on its outer side, shown here, is characteristic of this former Maya 'capital' in Chiapas, and once covered the whole building. Richly dressed and almost life-size figures are shown in very free attitudes. The stucco was originally painted in bright polychrome.

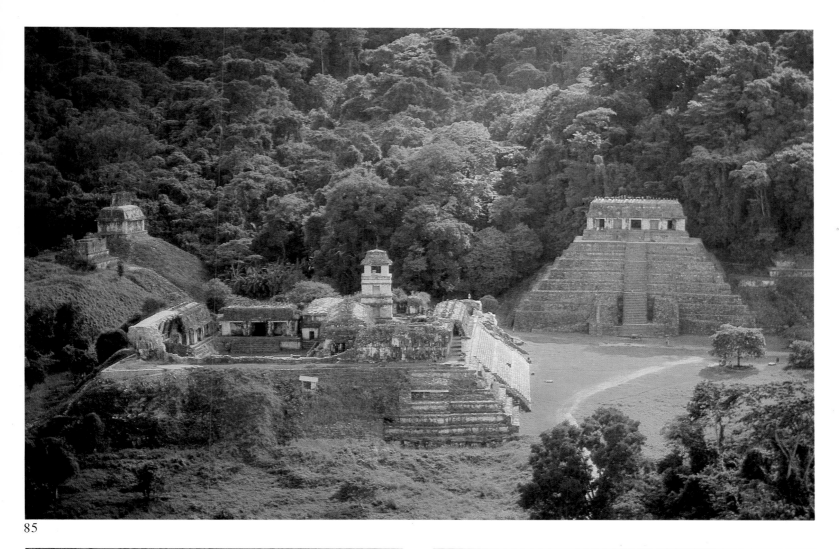

85

86

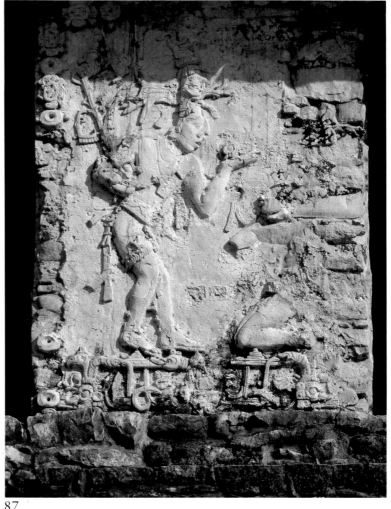

87

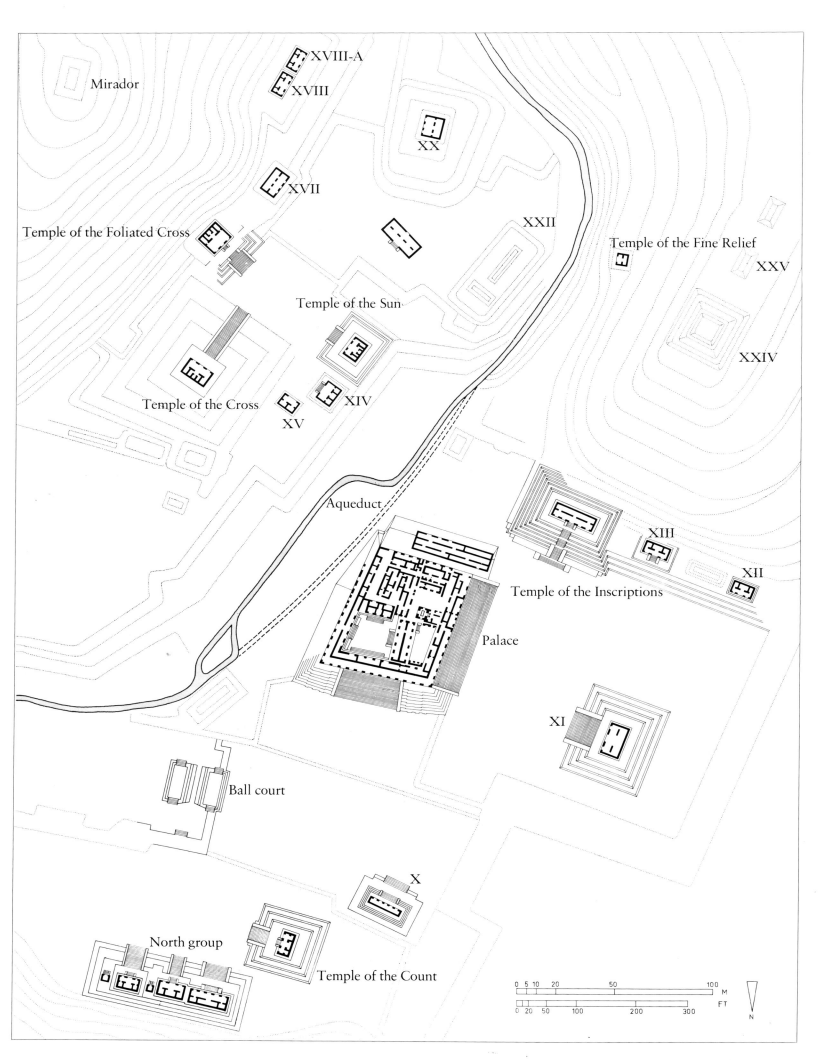

Mirador

XVIII-A

XVIII

XX

XVII

XXII

Temple of the Foliated Cross

Temple of the Fine Relief

XXV

Temple of the Sun

XXIV

Temple of the Cross

XIV

XV

Aqueduct

XIII

Temple of the Inscriptions

XII

Palace

XI

Ball court

X

North group

Temple of the Count

0 5 10 20 50 100
M

0 20 50 100 200 300
FT

N

arrangement) or rigorous plan. The area now freed of tropical vegetation comprises only the heart of the site and its principal buildings. Immediately beyond that, the jungle reigns supreme, spreading an impenetrable canopy over several other structures, some already localized.

Thus, atop a hillock to the south of the Temple of the Inscriptions stands a group of structures (XXIV, XXV, and XXVI) which must have dominated the site. On the opposite side of the valley is the Mirador, a point of vantage over the plain, surmounted by a structure which, if not completely man-made, has non-natural origins. At the western end of the site, Group 4, in an advanced state of ruin, shows that the 'city' was larger than the ceremonial centre which has been exposed. The northern groups (Groups 1–3), at the foot of the hilly zone, demonstrate that occupation of the site began at the level of the plain. The surrounding forest harbours further remains, such as tombs and buildings of various kinds, which stretch over a considerable area (up to eight kilometres in the west, according to Alberto Ruz).

The portion of Palenque excavated and restored in modern times, covering only 600 by 400 metres, gives little idea of the Maya regional centre's true scale. The core of Palenque is still very impressive, however, because of the striking contrast between its sophisticated, delicately decorated buildings and the luxuriance of the surrounding forest. When one approaches Palenque in the early morning, as the first rays of sunshine strike its walls through banks of mist, which then disperse to shroud the tops of trees and temple-pyramids, the ruins take on a bewitching ghostly quality. Equally dramatic is the tropical rain, turning the patches of moss and lichen on masonry into dark streaks.

The monuments that greet the eye are the tall pyramid on which the Temple of the Inscriptions rests and the huge complex of the Palace on an earthen mound. Between these two majestic constructions, smaller temples perched on artificial or natural hillocks can be seen to the west, against a background of virgin forest. Apparently the site was attractive to the Maya because its tortuous terrain offered, after minimal earthwork, ideal foundations for their temple-pyramids. While the Temple of the Sun is built on four successive platforms, each smaller than the other to produce a stepped effect, the Temple of the Cross seems to stand on a natural hillock whose sides have been reshaped. The same is true of the Temple of the Foliated Cross, against the steep hill rising to the Mirador.

Architecturally, the last three edifices have similar characteristics. At the front is a portico of three doors, leading into a broad room with a typically Maya corbel-vault roof. Behind this outer room or 'pronaos' is a comparable space, divided into three parts. The most important of these, at the back of the 'naos', contains a small structure like a miniature temple, with its own vaulted roof. This must have constituted the 'holy of holies' of the temple.

From the outside, each temple can be seen to stand on a special platform at the top of a pyramid reached by a stairway. It has a mansard roof with an extremely elegant, hollow and latticed comb resting on the centre above a partition wall dividing the two rooms within. In order to lighten the considerable weight amid the roof below the comb, Maya architects used the device of vaulted cavities; over the years these grew larger, reflecting the increasing skills of their builders. Still relatively small in the Temple of the Sun, these cavities, which resemble horseshoe

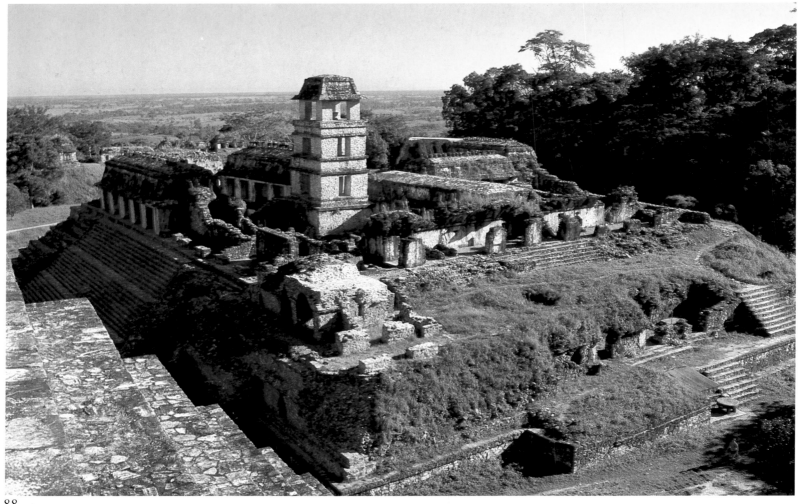

88

89

90

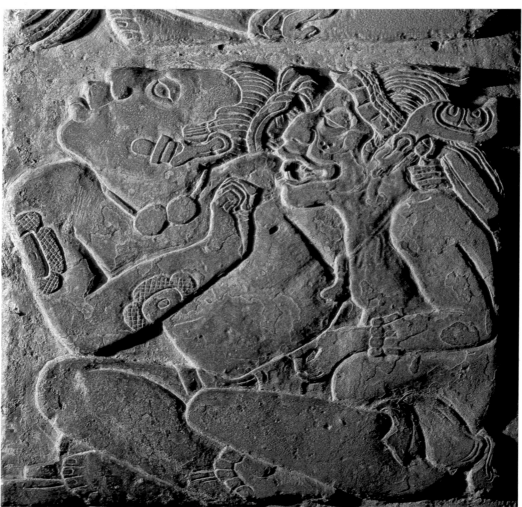

91

Plan of the Palace at Palenque:

1. Tower
2. West patio
3. Great patio, or main courtyard

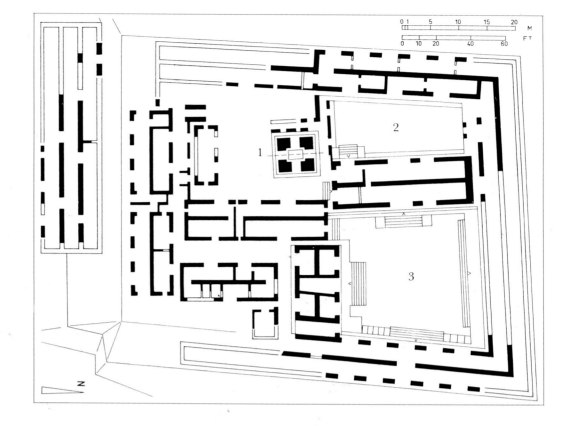

88 The great Palace at Palenque seen from the top of the Temple of the Inscriptions: the three ramps of the main stairway, recently restored, are visible in the shady area at the left. Overlooking the complex is a three-storey tower, possibly once used as an astronomical observatory. The plains bordering the gulf of Campeche on the north, behind the Palace, stretch to the horizon.

89–91 Three details of glyphs on the great stone panel from the Palace at Palenque: dated 720 AD, they show the remarkable skill and delicacy with which the site's sculptors executed bas-reliefs (Palenque Museum).

arches in shape, become bigger in the Temple of the Cross and in the Temple of the Foliated Cross, all three seemingly dating from 692 AD. The same architectural principle is found in the Palace (seventh and eighth centuries), while in the Temple of the Inscriptions this device comprises vaults of the Maya inverted-V type, set at right angles to the two vaulted rooms above openings in the central partition wall.

The Palace stands on a vast platform measuring about 80 by 100 metres, and covers earlier structures which are now underground chambers. The galleries along its platform are reached by broad flights of stairs that rise 11 metres from an area separating the Palace from the Temple of the Inscriptions. Most of the porched galleries around patios are based on a unit structure, consisting of a full central wall on either side of which are covered spaces bounded on the outside by pillars. The overall effect of this architecture is one of organization—as though it were intended for ceremonies rather than habitation. We can easily imagine Maya dignitaries using its galleries for processions, its interior courtyards for assemblies. There are relatively few chambers. The heart of the Palace complex is a large court in the north-east, surrounded by four broad stairways.

Another large court, in the south-west of the Palace, is dominated by an almost square, three-storey tower some 20 metres in height, with a central core that accommodates a very steep staircase leading to the vaulted third storey. This tower is traditionally believed to have been used as an astronomical observatory by the priests of Palenque. As at Tikal, the organization of the Palace complex was the result of successive additions, overlays, and modifications. Examination of its layout shows a labyrinth of juxtaposed corridors and chambers whose function is not always obvious.

Before going on to describe the Temple of the Inscriptions, where one of the most remarkable discoveries in Maya archaeology was made, let

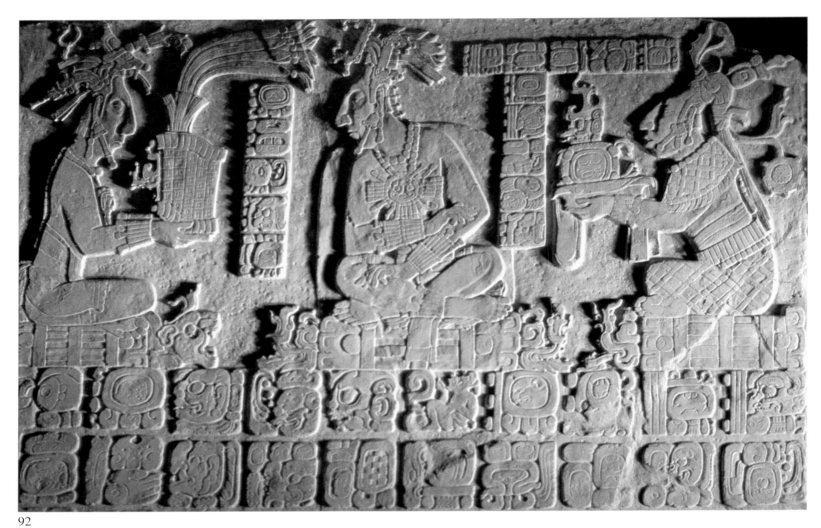

92

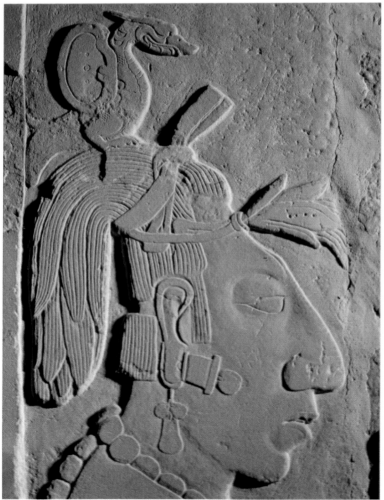

93

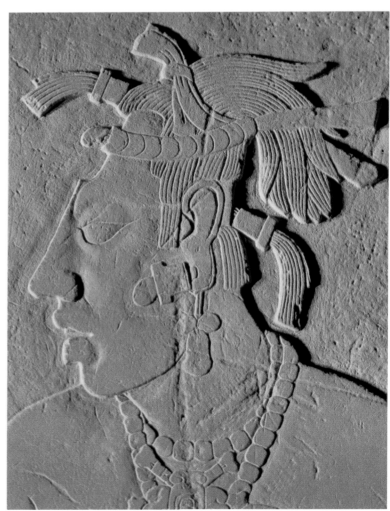

94

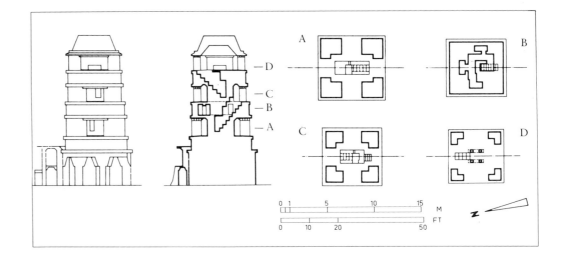

Elevation, section, and plans of the four floors of the observatory-tower at Palenque

me mention a rare feature of Palenque. As already stated, a small stream, the Otolum, runs through the site. The Maya canalized it along 100 metres of its course, and even diverted it through a tunnel that runs along the east side of the Palace. This aqueduct, 2 metres wide and over 3.5 metres deep, is covered with a corbel-vault that is strengthened by stone tie-rods. Its purpose was to prevent the river waters, when in full spate during the rainy season, from undermining the artificial mound on which the Palace stood.

The undisturbed crypt

92 Central scene of bas-relief from the Palace at Palenque: on the thin limestone panel, which was dicovered in the north edifice and is known as the 'Palace Tablet', the ruler Kan-Xul accepts the crown of Palenque from his father, the Lord Pacal. At right sits his mother, Lady Ahpo-Hel, holding a bundle of dynastic heirlooms (Palenque Museum).

93–94 Two details of figures situated, respectively, on the left and middle of the celebrated Panel of the Slaves in Group 4 at Palenque: this fine sculpture, carved from fine-grained limestone, dates from the beginning of the eighth century AD (Palenque Museum).

95–97 Massive inclined stone slabs bordering the stairway in the main court of the Palace at Palenque: these monumental figures, sculpted in a free basrelief style, and often larger than life, constitute a highly original form of decoration, contrasting with the meticulous detail on the panels found inside the buildings. They may have been brought from an earlier location elsewhere.

The Temple of the Inscriptions is a much larger building than the temples noted above. It rests on a pyramid of nine platforms, the lowest measuring 65 metres across. A single stairway on the north side rises in four flights, each with a decreasing number of steps. Following restoration, the monument now appears as it did after the first phase of its construction. During a second phase, several platforms were joined together by panels, which were placed over the tiers but left their original corners visible. A third phase resulted in broadening the lower section of the stairway and bordering it with parapets, as can be seen from vestiges today.

The temple itself stands on top of the pyramid. Unlike the other temples at Palenque, all of which are more or less square in shape, it forms a long rectangle. Five openings along its façade lead to a kind of gallery or portico which forms the 'pronaos'. Three vaulted doors then lead to three chambers, the middle one (also the largest) having on its rear wall a stone panel covered with hieroglyphs. This is framed by two panels on either side of the door in the partition wall. These three series of hieroglyphs, to which the edifice owes its name, make up one of the longest Maya inscriptions. There are, in all, 620 glyphs—140 in the middle, and 240 on each of the lateral panels. The text was destined to play an important role in the decipherment of Maya writing, with which I shall deal later.

When Alberto Ruz Lhuillier died on August 25, 1979, Mexican archaeology lost one of its great pioneers and an authority on Maya culture. Before becoming director of the National Museum of Anthro-

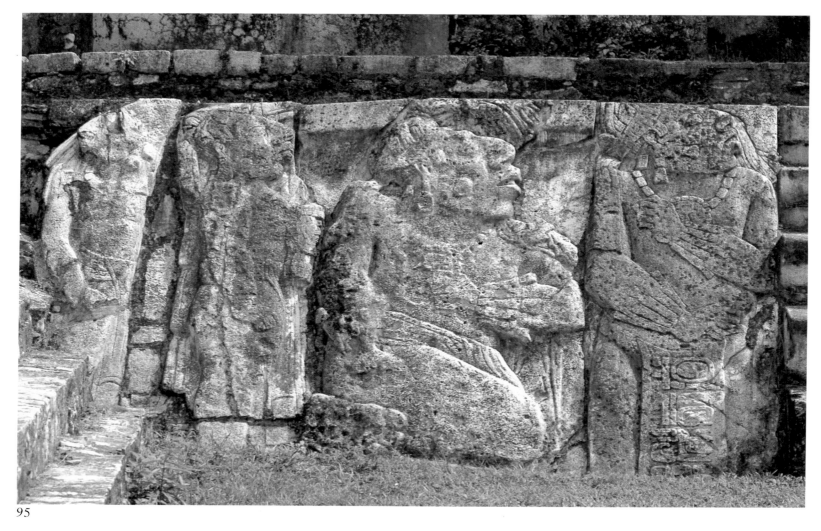

95

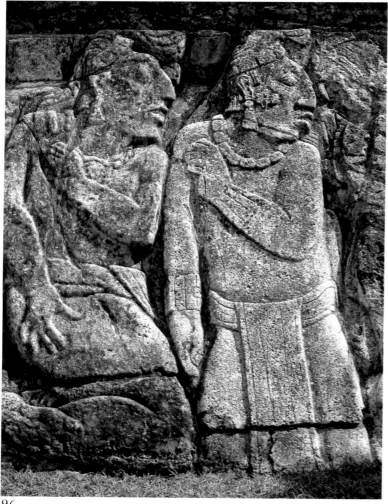

96

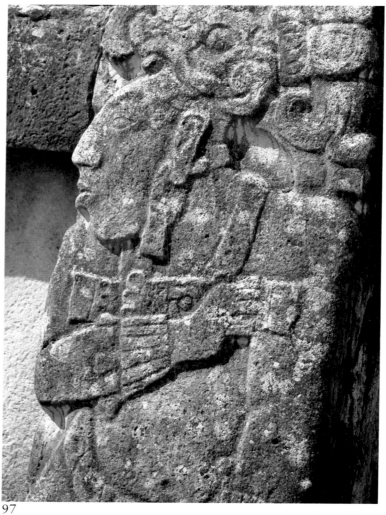

97

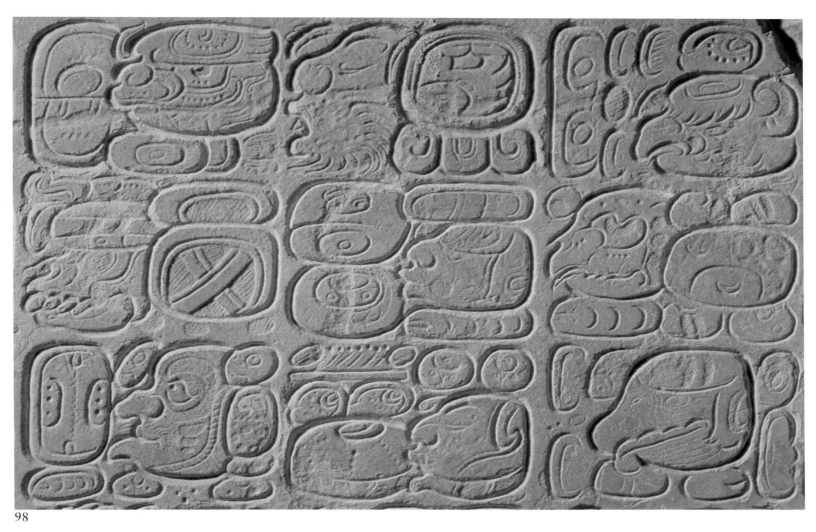

98

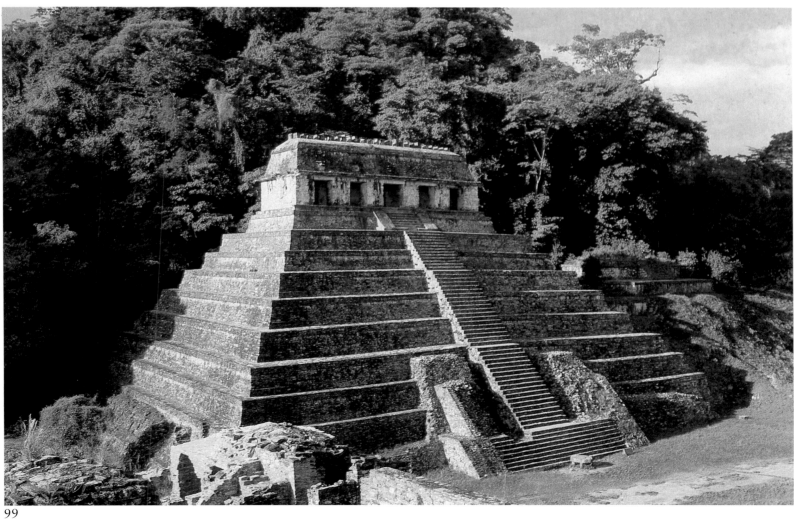

99

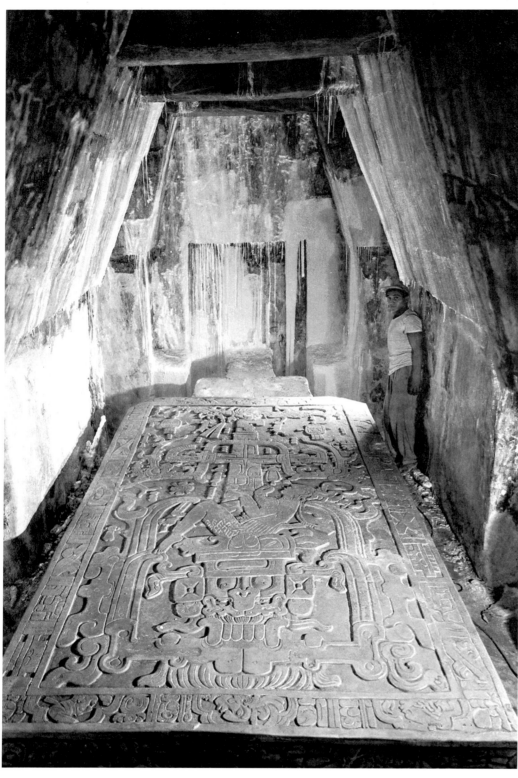

A historic document: the crypt beneath the Temple of the Inscriptions at Palenque when it was discovered on June 13, 1952. The enormous sculpted funerary slab covering the sarcophagus is still in its original position

98 Detail of the Panel of 96 Glyphs at Palenque: this work, dated 783 AD, was discovered at the foot of the tower in the Palace. The shallow relief and flowing style of the hieroglyphs show complete graphic mastery (Palenque Museum).

99 Dawn rising on the Temple of the Inscriptions at Palenque, seen from the tower of the Palace: after campaigns over some thirty years, the building has now been restored to its original state. It was built between the last third of the seventh century and the first third of the eighth century AD. The pyramid consists of nine platforms. The temple at the top, with five openings along its façade leading to a long gallery, is reached by a stairway of several flights. All that remain of the roof comb are toothing stones.

100 The vaulted internal stairway of the Temple of the Inscriptions: consisting of several stepped arches slotted into each other, this stairway leads down from the upper temple into the heart of the pyramid, where, in 1952, Alberto Ruz discovered the funerary crypt of a ruler of Palenque.

101 Huge triangular stone slab at the entrance to the funerary crypt: it can pivot on itself, and was cut to hide the opening completely.

102 Funerary crypt of the Temple of the Inscriptions at Palenque: strong stone tie-rods prevented the triangular vault from collapsing under the tremendous bulk of the building. Below is the huge sculpted stone slab, weighing 5500 kg, which covered the sarcophagus. It has now been raised by 1 m above its original position, so that visitors can see into the sarcophagus that once held the Maya sovereign who died in 683 AD.

pology in Mexico City, he proved himself a first-class excavator. The crowning achievement of his career was the discovery of the crypt hidden in the pyramid beneath the Temple of the Inscriptions.

Ruz was born in Paris in 1906 of a Cuban father and a French mother. After studying in Havana, next in Mexico City where he obtained the first post-graduate degree in archaeology ever issued by the National School of Anthropology and History, he went on a scholarship to the Musée de l'Homme in Paris, also taking a course at the École des Langues Orientales. On his return to Mexico, which had become his country of adoption, Ruz carried out excavations at Monte Albán and Tula. He then specialized in Maya culture, investigating such sites as Edzná, Kabáh, Uxmal, and Palenque.

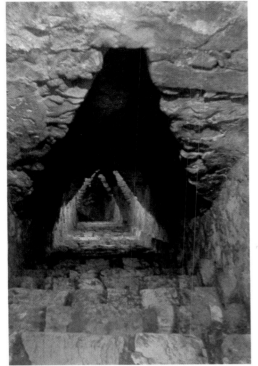

100

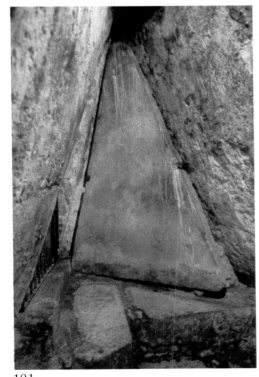

101

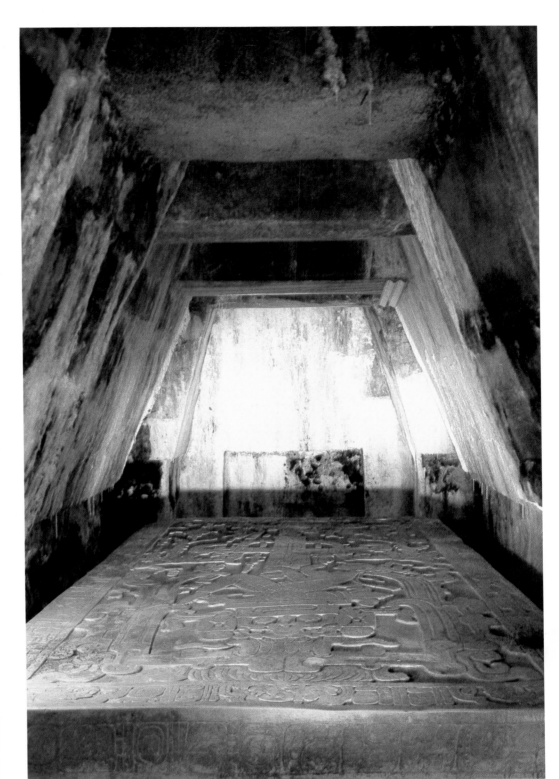

102

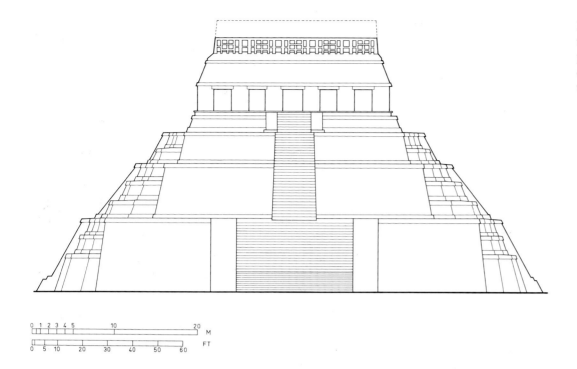

0 1 2 3 4 5 10 20 M

0 5 10 20 30 40 50 60 FT

When Ruz tackled the task of restoring the Temple of the Inscriptions, he was aware that pre-Columbian edifices characteristically contained older structures. Accordingly he looked for evidence of overlaid constructions. He was particularly curious about a large stone slab, in the flagging of the upper temple, which had a series of conical holes filled by stone stoppers. The slab had attracted the attention of Frans Blom in 1926, who did not know what to make of the holes. During his very first season on the site in 1949, Ruz removed the rubble covering the slab, and noticed that an excavation shaft had already been started alongside it. This led to the observation that the walls of the upper temple did not stop at the level of the flagging, but continued down into the pyramid.

So while restoration of the external façades of the temple proceeded, Ruz addressed himself to the meaning of the strange features he had detected in the upper floor. To that end, he asked his workmen to remove the rubble and mortar from the apparent hole in the structure. He soon realized that he had hit upon an underground stairway beneath the slab, descending into the core of the masonry. But the vaulted stairway had been blocked by the Maya with earth and stones. This fill was removed and, after four seasons in the hot humid climate, excavators finally reached the bottom of the shaft, which consisted of two ramps of steps. The total volume of rubble that had to be carried laboriously up the steps was 125 cubic metres, weighing about 300,000 kilograms.

On June 13, 1952, Alberto Ruz made his sensational discovery when a workman's pickaxe revealed a cavity, behind a slab blocking the passage at the bottom of the internal stairway. The archaeologist thrust a lamp through the opening and, to his amazement, saw a huge vaulted chamber. This crypt, some 26 metres below the floor of the upper temple, was almost entirely filled by a gigantic sarcophagus covered with a sculpted stone slab measuring 3.8 by 2.2 metres. When the funerary stone was eventually raised with infinite care (it weighed no less than 5500 kilograms), the monolithic sarcophagus (weighing 15,000 kilograms) was shown to contain the remains of a Maya dignitary, a priest-

103 Jade mask constructed of neatly interlocking pieces: 12 cm high, it adorned the belt of the dead man, and was found among his remains in the Palenque crypt (National Museum of Anthropology, Mexico City).

104 Jade statuette of the sun-god: 8 cm high, it was found in the sarcophagus of the Palenque crypt (National Museum of Anthropology, Mexico City).

105 Jade mosaic funerary mask from the Palenque crypt: with eyes of mother-of-pearl, irises of obsidian, and painted pupils, it covered the face (stripped of flesh) of the Maya lord. Made after his death in 683 AD, and restored by Mexican archaeologists under the leadership of Alberto Ruz, it is 24 cm high and contains no less than 200 pieces. Its mouth holds the T-shaped symbol which was associated with the rain-god and served as an amulet of survival (National Museum of Anthropology, Mexico City).

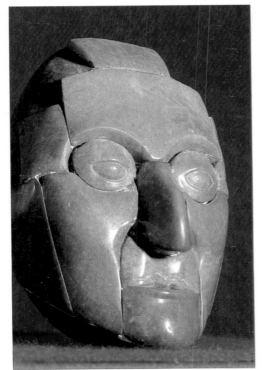

103

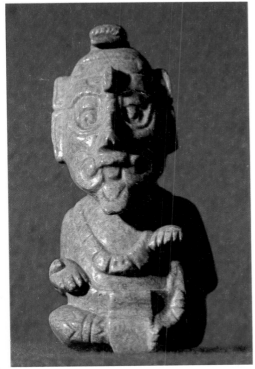

104

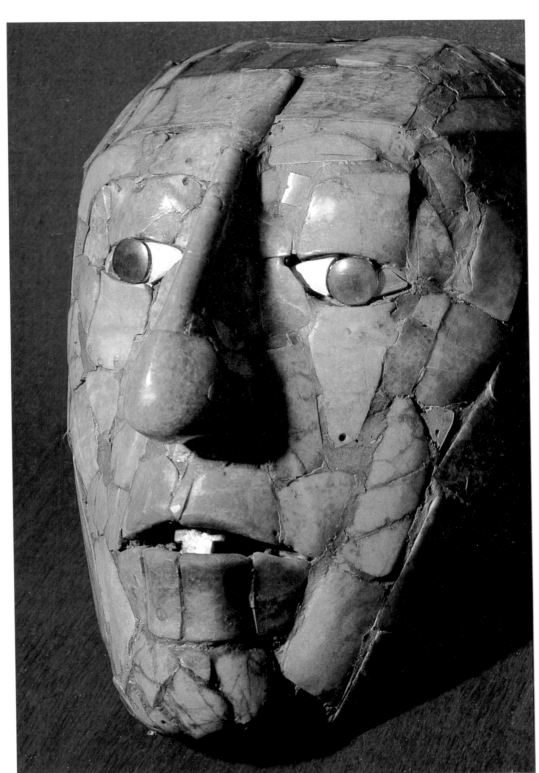

105

king in whose honour the Temple of the Inscriptions had been erected 1300 years earlier.

A treasure of jade—in particular an extraordinary mosaic mask made of that precious stone—accompanied the corpse, along with some stucco sculptures, bas-reliefs decorating the walls of the crypt, and ornaments such as necklaces, rings, ear spools, and a peculiar kind of 'frame' made of mother-of-pearl and iron pyrite, which was placed over the mouths of certain nobles. The most dramatic find was a votive offering on the floor before the huge triangular slab blocking the entrance to the Funerary Crypt. There, on the threshold, lay the remains of five individuals of both sexes. These adolescents and children were ritually sacrificed as company for the dead man on his journey to the next world. Lastly, the sarcophagus bore sculpted hieroglyphic inscriptions, which were to prove important for the interpretation of Maya texts.

The Temple of the Inscriptions at Palenque: left, plan and elevation, with section of the internal stairways; top right, plan and sections of the crypt; bottom right, transversal section of the pyramid, showing the stairways and the crypt

Architectural innovations

As well as developing the various innovations to lighten the roofs on temples, Palenque is notable for having made technological progress compared with Petén Maya architecture as a whole. Unlike those at Tikal, the pyramids themselves are of modest proportions. But a number of interesting improvements occur in the upper temples. Their chambers, for example, are no longer hollowed out from the mass of masonry, like tiny grottoes surrounded by massive walls. The architects of

Palenque succeeded in reducing considerably the thickness of the outer walls, and in refining the roof combs so that they were not merely hollow but latticed. Whereas previous building techniques had been cumbersome, Palenque introduced a more buoyant and articulated style.

But it is perhaps the Temple of the Inscriptions that displays the most revolutionary features of all. The internal stairway leading down to its crypt, for instance, is made of superimposed stepped arches, almost slotted into each other, which comprise seven levels of vaults in the upper ramp and three in the lower. This is a solution of great originality to the problem of dealing with a space that lies at an angle of 45 degrees.

An interesting method is also found in the vaulting of the crypt. The building materials in the pyramid and the upper temple create conditions of exceptional stress: there are more than 20,000 cubic metres of masonry, and the base of the edifice, containing the hollow crypt in its centre, has to support a weight of some 50 million kilograms. Evidently the hollow space had to be designed in such a way that there was no risk of its caving in. The Maya architects wisely chose a solution involving crossed vaults. The 'nave' of the crypt has two transept-like recesses or niches on either side which are also vaulted. Those structural set-backs in both plan and elevation help to increase the rigidity of the walls. Moreover, the two internal faces of the main vault are consolidated halfway up by enormous stone tie-rods, spanning the vault and visible from below. All these devices seem to have fulfilled their purpose perfectly, as not a single crack has appeared in the crypt in the thirteen centuries since it was built.

The latticed roof comb displays similar ingenuity. It consists of two parallel walls in which a series of quadrangular openings have been made. Separated by an empty space, the walls are joined together at the top and halfway up by stones. The result is a light frame, offering little resistance to wind and capable of supporting stucco decoration. Its role is comparable to that of the pediment in Greek architecture.

Decorative sculpture

This brings us to the decorative sculpture that was the strong point of the Palenque artists. Unlike Tikal or Copán, the city does not boast stelae—but it does possess some fine sculpture in a wide range of expressive modes. There are stone bas-reliefs, stucco high reliefs, statues in the round, pottery, and carved jade.

One may go so far as to state that the Maya world reached an apogee in the plastic art of Palenque, which stands on a level with the finest creations of ancient Egypt or classical Greece. This is a reason to analyze further the art that marked the peak of the New World's aesthetic achievements. It is at its best when exalting Maya lords, who were regarded not only as rulers but as priests, capable of interceding with the gods on behalf of the people. Hence a constant association occurs between these almost deified personages and the buildings used for worship.

At Palenque, Maya art was most individualistic, in that the finest sculptures are certainly 'portraits' of rulers. But there is also an urge to set such works in a holy context, if only as a kind of magical gesture

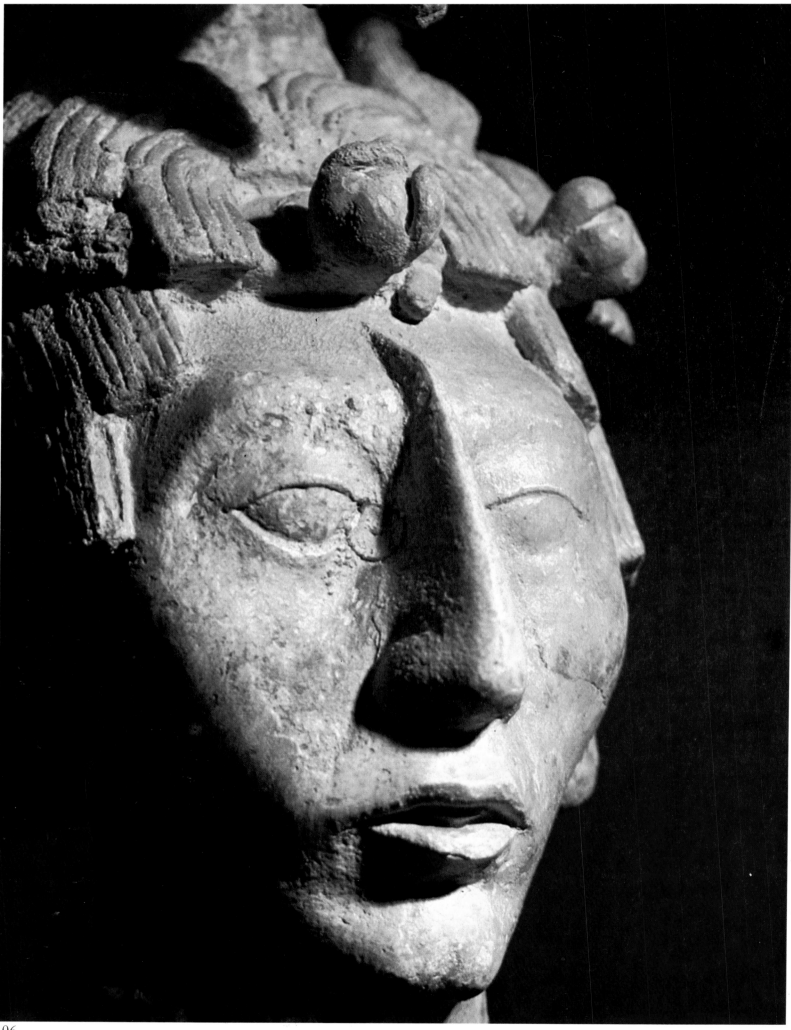

aimed at securing the salvation and survival of rulers in the next world. Indeed the first artefacts at Palenque that commanded the admiration of visitors were undoubtedly the large panels of thin limestone covered with hieroglyphs, as we have seen in the Temple of the Inscriptions, and with ritual scenes. Such scenes are found in the sanctuaries of the Temples of the Sun, Cross, and Foliated Cross. Priests or deities appear in profile, wearing ceremonial costumes or holy insignia such as jaguar-skins, and performing the rites of worship.

Similar in its aesthetic treatment is the curious scene carved on the upper face of the funerary slab resting on the sarcophagus in the crypt of the Temple of the Inscriptions. It depicts the great lord Pacal as an eternally young man descending into the jaws of a monster symbolizing the underworld—reminiscent of the Olmec jaguar-masks, with figures emerging from them, carved on the fronts of altar stones at La Venta. From the body of the young man, which is decked with jade jewellery, a diadem and a belt, there rises a complex structure analogous to the vegetable trunk that occupies the central part of the panels in the Temples of the Cross and Foliated Cross.

This vertically rising stem, decorated with signs related to the symbolism of water, is said by Alberto Ruz to represent the maize plant, which played an essential role in Maya thought. In agricultural Maya society, the maize god, who was associated with fertility and personified by a young man, was a symbol of life and resurrection. He shows some parallels with the cult of bread and wheat in the Christian mystery of communion.

But not all the scenes carved on the bas-reliefs at Palenque have such a clearly religious meaning. Both the Palace and Group 4 contain elegant reliefs depicting what is probably the investiture of a ruler. In each case, a figure on the left is presenting to a king, seated in the centre on a kind of 'throne', or possibly even on the backs of crouching slaves, a high crown topped with quetzal feathers, while another figure, on the right, prepares to hand him an emblem of power, which may serve as a sceptre. The figures are treated in bas-relief—from the main personages in the centre or upper part of the panels, to the tiny scenes decorating the hieroglyphs—with considerable virtuosity. The carving has been executed in a compact, homogeneous, and very fine-grained material that highlights the perfection of artistic skills. While the faces are always in profile, the bodies are shown from the side as well as from the front.

Everything in these reliefs, from the pure quality of draughtsmanship and the elegance of gesture to the beautifully detailed hands and the perfect proportions (despite the often rather large heads), ranks them among the finest of an aristocratic genre which requires the artist to come to terms with the constraints of symmetric and hierarchic composition. They have been compared with the decorations on ancient Egyptian tombs. The authority and sheer mastery of these reliefs are such that it is legitimate to speak of true classicism, notwithstanding their wealth of meticulous and subtle detail. We have here an art whose terms of reference are hermetic, whose symbolic system can be sensed only in the interplay of harmonious and well-balanced forms, belonging to an accomplished and mature plastic universe.

In contrast with the delicate restraint of these flattish bas-reliefs in beautiful light-coloured limestone, the stucco decorations on the ex-

106 Stucco head from the Palenque crypt: this admirable sculpture was discovered by Alberto Ruz underneath the sarcophagus. Probably it represents the lord buried with much pomp in the Temple of the Inscriptions, was inspired by his enthronement, and originally stood on the roof comb of the building. Including the top of the headdress, not visible here, the head is 43 cm high, and dates from the end of the seventh century AD (National Museum of Anthropology, Mexico City).

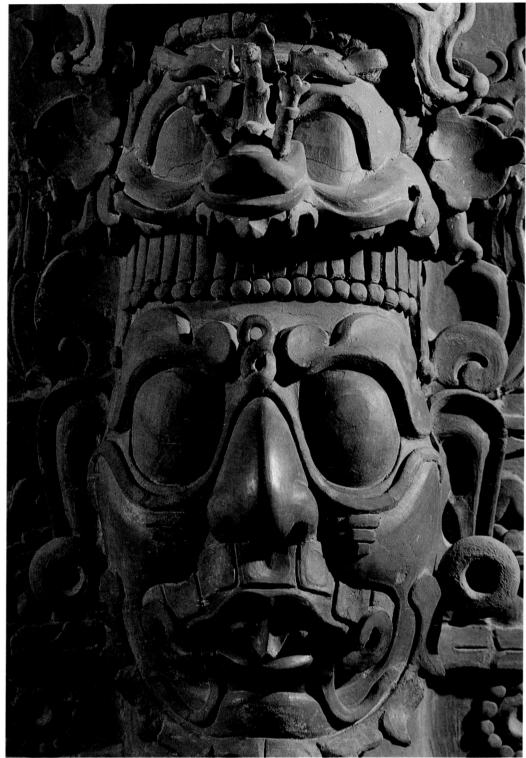

107

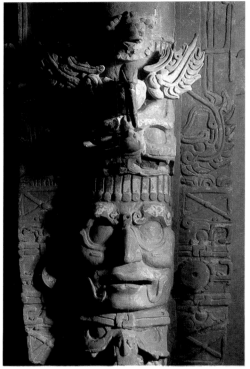

108

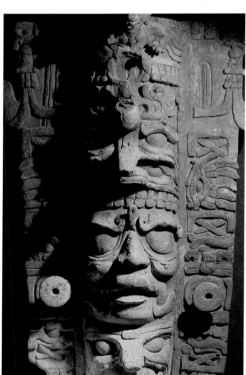

109

teriors of buildings at Palenque have a flamboyancy that is accentuated by the volume of their motifs, which are almost in high relief. The soft, malleable nature of the material used to embellish the pillars and the friezes running along the base of the mansard roofs helped to encourage the loud hyperbole of this exuberant form of ornamentation.

Both the Temple of the Sun and the Palace show traces of the vast expanses of stucco work that once covered almost all the outer walls of buildings and even decorated some rooms in the Palace, according to Maudslay, who saw a few remaining examples at the end of the nineteenth century. On the evidence of vestiges of pigment, it is clear that stucco artists painted their work in bright polychrome colours. This is a feature common to all ancient civilizations—Egypt, Babylon, Crete, Greece, and Rome—not to mention the Middle Ages. While the verve of stucco work, with its riot of foliage, garlands, floral arabesques, and lively hues, is reminiscent of European baroque art, the details of the drawing, such as the profile faces of the human figures, are totally in keeping with the great stone panels already described. It would be a mistake to overlook this essential aspect of polychrome stucco work when envisioning Maya monuments in their original state, for it is the only element that truly reflects the refinement achieved by Maya architecture.

Before leaving the bas-reliefs at Palenque, we should note the huge stone slabs, set at an angle of 45 degrees, which run along the inside of the main court in the Palace, and are also found on each side of the last flight of stairs leading to the sanctuary on the pyramid of the Temple of the Inscriptions. These slanting stele-like reliefs, hewn out of gigantic monoliths, depict figures larger than life. They form a kind of procession of kneeling or standing individuals on either side of the Palace patio steps, covering the slanted base of the surrounding galleries. Their sculpture, although partly eroded by rain falling on the inclined surface, displays a powerful line and a monumental sense of composition, suggestive of Expressionism. A curious feature of the slabs is that juxtaposed figures are not always treated on the same scale. The engraving, which is not very deep in comparison with the large size of the slabs, emphasizes certain details of clothing and ornamentation. It sometimes includes glyphs, for example on the two stelae forming a border to the last stairway on the pyramid of the Temple of the Inscriptions. The most remarkable traits of these lively inclined reliefs are their elegance of gesture and their free draughtsmanship. This architectural sculpture, while very different from the other Palenque bas-reliefs, has an authoritative style that accords well with its open-air setting.

The Maya not only excelled in the art of the bas-relief, but exhibited a keen sense of aesthetic values in their sculpture in the round. This skill has already been seen in some of the pieces from Copán, such as those representing a young maize god. But Maya sculpture reached its peak, perhaps, with the stucco heads that have been discovered at Palenque, and at sites in the western region influenced by that important centre. The finest are probably two 'portraits' found by Alberto Ruz in the crypt of the Temple of the Inscriptions. These works are totally lacking in exoticism. Their only odd elements are the headdress and the curious nasal ornament, running from the bridge of the nose up to the middle of the forehead, which Maya nobles liked to wear.

It should be remembered that the Maya profile, so characteristic of the bas-reliefs, and recurring in three-dimensional sculpture, is merely

107 Detail of pottery cylinder from the Temple of the Cross at Palenque: this polychrome effigy of the sun-god dates from 692 AD (National Museum of Anthropology, Mexico City).

108 Pottery cylinder from the Temple of the Foliated Cross at Palenque: this piece, almost 1 m high, has a relief decoration which combines birds with an effigy of the sun-god emerging from the jaws of the earth-monster (Palenque Museum).

109 Pottery cylinder from Palenque: such pieces, recalling the totem-poles of British Columbia, associated the sun-god with the mask of the earth. They were probably bases of burners for copal, the incense of the Maya (Tabasco Museum, Villahermosa).

the result of 'coquettishness'. The projecting ridge at the base of the nose could under no circumstances have been caused by cranial deformation. It was a kind of prosthesis worn on ceremonial occasions; its material is uncertain, but may have been latex. The diversity of shapes taken by this ornamental accessory can be seen in the profiles of the figures depicted on the so-called Bas-relief of the Slaves. One of them is wearing a nose-piece that fits neatly and imperceptibly against the forehead, while that worn by the other figure ends abruptly and jaggedly just above the eyebrows. Possibly this facial ornament, whose size and shape vary from one individual to another, had some hierarchic significance. It is, for instance, the most important figure (in the centre of the composition) who wears the nose-piece with the projecting top end. The ornament could also have been the distinctive sign of a family or tribe.

But let us return to the subject of Maya stucco statuary. The two portrait-heads discovered in the Funerary Crypt at Palenque probably represent a single person—the man who was buried in the sarcophagus wearing a jade mosaic mask. The shape of the nose ornament on that mask is the same as on the heads. One of the stucco heads, illustrated here, marks without any doubt a summit of Maya art: it is literally inhabited. The work is the fruit of a proud, noble, and intense art that always displays an admirable ability to transmit life and idealism. Those qualities lie in the delicate regularity of the features, the subtle modelling, and the restrained sobriety of form.

This art is immediately accessible to the spectator, and speaks directly to our sensibility: the quivering delicacy of the mouth, the faintly receding perspective of the cheeks, the emphasis of the cheekbones, the august bearing of the head, and the open expression, are neither harsh nor condescending, almost as if lost in a dream. Everything about the sculpture touches us so strongly that the millennium separating us from the Maya seems to have been wiped away.

In sum, the spirit of the dead man is conveyed. This notion of survival was probably the prime function of such works—to perpetuate in the next world images of men 'as they really were'. The heads are reminiscent of other stucco portraits, found in certain ancient Egyptian tombs, and called 'replacement heads' by archaeologists. They, too, probably played some kind of magical role in the afterlife.

The fact that the two Palenque heads were lying between the two southernmost supports of the monolithic sarcophagus in the Funerary Crypt should confirm that they represent, if not the dead man himself, then someone very close to him. Both show clear signs of having been broken off rather crudely at the neck. This led Alberto Ruz to the conclusion that the heads must originally have formed part of the decoration of a building, such as a roof comb or a frieze, and that they were torn away from the masonry after the sovereign's death to be placed in his tomb.

Why, then, are there two different sculpted heads? They are presumably portraits of the man at different periods in his life. Reproduced here is the second portrait, which, despite its delicate features, displays calm maturity. When the heads were found, by the way, they were covered in a thick limestone deposit resulting from centuries of water seepage. This calcite shell revealed, on removal, some traces of polychrome painting, which naturally suggests a parallel with the polychrome friezes on edifices.

110 Stucco portrait of a bearded man in the Palenque style, dating from the seventh or eighth century AD (Tabasco Museum, Villahermosa).

111 Stucco portrait of a moustachioed priest from Palenque: this head, about 12 cm high, was discovered among the rubble of a roof comb to the south of the Temple of the Inscriptions, and dates from the end of the seventh century AD (Palenque Museum).

112 Stucco portrait of an old person in the Palenque style: like the previous head (Plate 111) and that in the Palenque crypt (Plate 106), this portrait, 28 cm high, clearly shows the decorative nose-piece that the Maya wore to change their profile (National Museum of Anthropology, Mexico City).

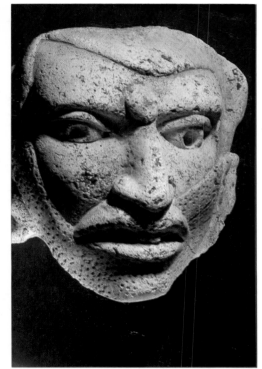

110

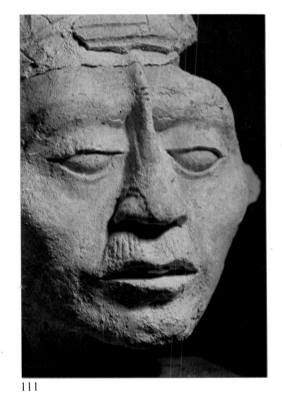

111

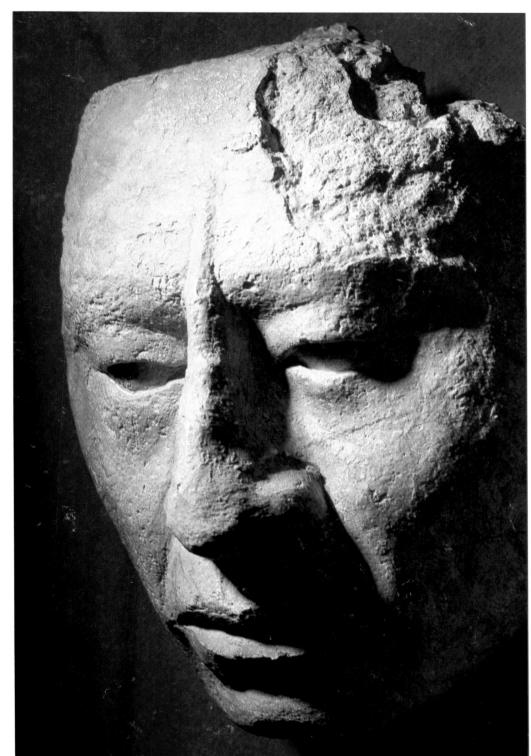

112

If one supposes that the pyramid of the Temple of the Inscriptions was built by and for the royal dignitary buried in it, and that the sarcophagus was placed at its base even before the crypt was constructed (its weight, and measurements of 3 by 2.10 by 1.10 metres, preclude its subsequent transportation down the stairway), then it is quite possible that the monument's own frieze or roof comb bore images of the king, as both founder and donor of the temple that was to be his grave. He would thus have appeared as a devotee of the god represented in the centre of the composition. One scene might have depicted the young noble when he came of age, for example, while another showed the king in the hour of his enthronement. Upon his death, it probably ceased— for reasons unknown to us—to be acceptable for an image of the dead man to remain in the full light of day. So the portraits had to join their model in the crypt and accompany him on his journey to the next world.

These are some of the hypotheses prompted by the admirable stucco heads of Palenque. Their function has yet to be totally elucidated, as has that of the ancient Egyptian 'replacement heads'. Whatever the truth may be, these portraits, stripped of the pomp that usually surrounds any representation of royalty (as we saw on the Copán stelae, where the central face stands out as a small area of tranquillity amidst a riot of ornamentation), are more moving, I think, than anything else created by the Maya imagination. With them, pre-Columbian art achieves universality.

Funerary customs

In connection with the discovery of the inviolate crypt at Palenque, some mention should be made of the funerary customs of the Maya, and particularly of the lords of Palenque. One of the most widespread practices of the pre-Columbian world, also found here, was to place a jade bead in the mouth of a dead person. This custom has survived for two thousand years and is still common among the native peoples of the New World. Jade had a magico-religious significance and was associated with the idea of eternal food: the aim was to ensure that the dead were properly fed in the next world.

Similarly, the jade mosaic mask that covered the face of the corpse was intended to give it eternal life. Many instances of this habit occur in Mesoamerica, from Olmec times down to the Aztec period. The mosaic masks differ from those consisting of a single piece of sculpted stone, in that they were made with the dead person's head (stripped of flesh) being used as a mould. Thus, perishable facial features are replaced, according to methods described by Bishop Landa in the sixteenth century, by an 'eternal face', examples of which have survived both at Monte Albán and in the Aztec region. The jade pieces of the Palenque mask were assembled on a stucco base that reproduced the volumes of the face. It was a remarkable feat of Mexican archaeologists to piece together the disparate elements of the mask as found.

Another widespread funerary custom was to cover both the votive offerings and the tomb with red paint. The corpse and the funerary slab

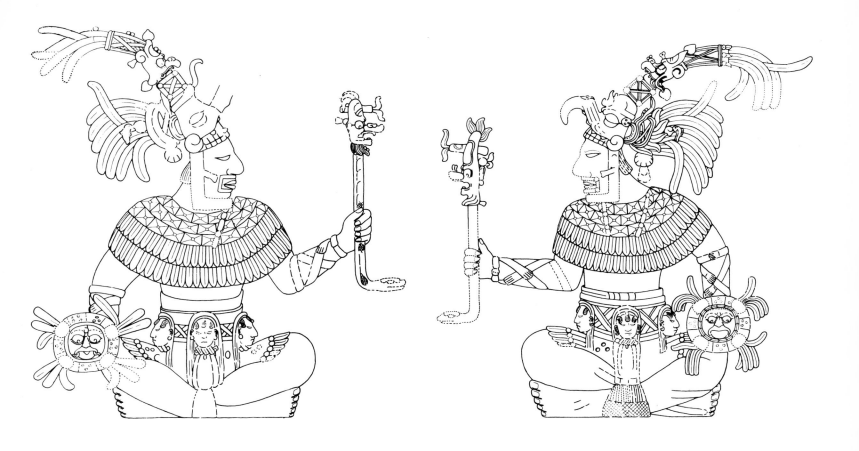

The infernal deities protecting the crypt in the Temple of the Inscriptions at Palenque. These two stucco bas-reliefs, on either side of the entrance to the chamber, show the gods in the guise of high priests wearing ceremonial costume and holding sceptres (after Alberto Ruz)

were given a coating of cinnabar. The colour red, put to such use by many peoples since Palaeolithic times, clearly suggests blood, seen as a symbol of life. But red was also associated by the Maya with the east—the point where the sun is reborn—and therefore it carried connotations of resurrection and eternal life.

As already observed, the customs that can be deduced from the Palenque tomb involved human sacrifice. The dead person was escorted to the next world by several slaves, who were put to death during the funeral ceremony. This practice continued until the Spanish Conquest, and it was common to bury the deceased along with those who had served them. Children and young people of both sexes, chosen for the purpose, were expected to continue serving the same masters forever.

An interesting architectural feature, related to funerary customs, is the hollow duct that runs up the side of the two ramps of steps in the inner stairway, connecting the tomb with the floor of the temple—the subterranean or infernal with the divine. Alberto Ruz called it a 'psychoduct', whose magical purpose was to enable the dead person's soul to communicate, not with the outside world (although this is possible as the duct emerges from the floor of the upper temple), but simply with the place of worship where priests invoked divine powers.

Lastly, the interior of the crypt contains on its side walls, in the recesses similar to transepts, and at the apse-like end of the chamber, stucco bas-reliefs depicting nine figures which Ruz saw as the nine Maya gods of the underworld, in the guise of sceptre-carrying high priests in full ceremonial costume. Furthermore, the exterior surfaces of the sarcophagus contain bas-relief images of ten individuals—six men and four women. These figures, perhaps ancestors of the dead man, seem to be emerging from the earth, thereby symbolizing birth, germination, and the cycle of life and resurrection. Here again is the image of the young

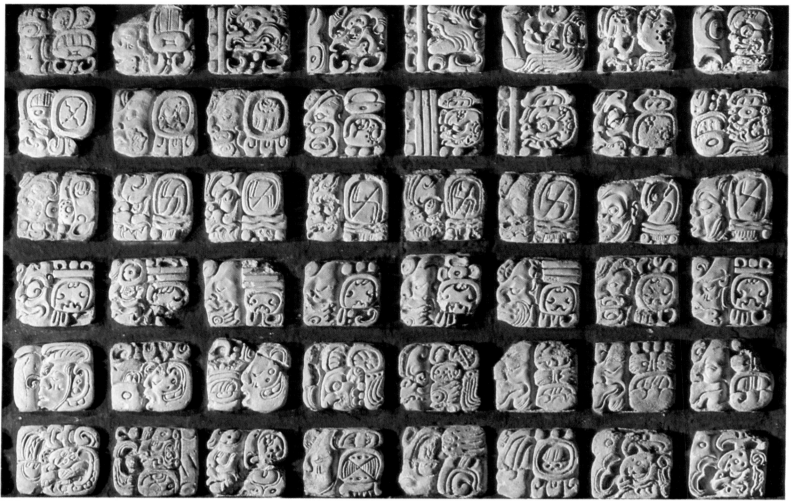

113

114

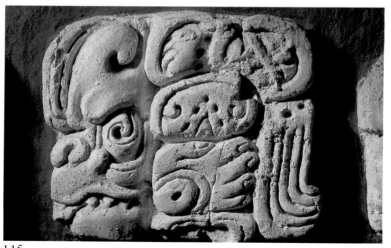

115

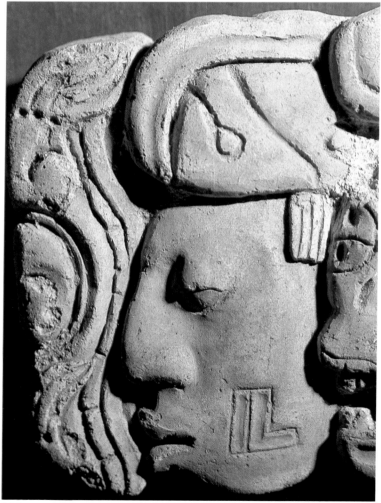

116

maize god who recurs in various forms in every agricultural society, which relies for its survival on the germination of seed.

Such were the ceremonial rites involved in the burial of a great Maya dignitary. Anthropologists tell us that the priest-king of Palenque, in whose honour the remarkable pyramid of the Temple of the Inscriptions was erected, was a tall man (1.73 metres). His skull shows an 'oblique tabular' deformation, and his hands were very slender, almost feminine.

The numerous inscriptions, both on the monument's great hieroglyphic panels and around the funerary slab covering the sarcophagus, provide us with more extensive information due to progress in the decipherment of Maya hieroglyphs. This is a convenient point at which to examine Maya writing and the attempts that have been made to understand it.

Maya hieroglyphic writing

Before dealing with the decipherment of Maya writing, it will be necessary to summarize the main methods of expressing the ideas or words of a system of communication, in the language of a specific population. This highly complex question, involving such topics as linguistics, semantics, and phonetics, cannot easily be outlined without distortion.

There exist several types of writing. The most primitive, restricted to a few simple notions, is pictographic writing: each sign forms a picture which corresponds to an idea. Thus a drawing of a tree, a man, or a house conveys the meaning of a tree, man, or house. Such a system is obviously limited, since objects are innumerable, and many notions are too abstract to be visualized. So ideographic writing was introduced to express, for example, the notion of walking by a pair of legs in a walking position; power by a hand holding a sceptre; the idea of thought by a head, the idea of love or life by a heart, and so on. This system uses a degree of symbolism. But it soon appears superficial: how can it express notions of time, will, desire, and other abstract concepts of a language, however primitive?

These early forms of writing were independent of the language whose ideas they expressed, just as Arabic numerals are now written in the same way by—and have the same meaning for—peoples of every continent. But soon certain ideographic signs began to be used for the sound value of the notion they expressed in a given language. Thus, the picture of an eye, which combines the idea of an eye and the pronunciation 'i', could be joined to other signs to form a new word. When, as in rebus writing, it is combined with a sickle (eye + sickle), the two lose their original meanings and express the word 'icicle'. Each sign may then represent only the sound of a syllable, yielding a phonetic system, or syllabary.

Yet the number of sounds that make up the syllables in a given language is very great, requiring a complex set of signs. And in order to avoid ambiguity or vagueness, semantic determinants are needed which, although not pronounced, specify the meaning of a word. These phonetic and semantic systems can be brought together in a combination of

113 Some of the 149 stucco glyphs from Temple XVIII at Palenque: most of these delicate bas-reliefs were found among the rubble in the ruined temple, so it is impossible to reconstruct the inscription they formed. Each piece measures 10 cm across (Palenque Museum).

114–116 Details of stucco hieroglyphs from Temple XVIII at Palenque, dated in the seventh century AD (Palenque Museum).

sound and meaning. This was the system used by the ancient Egyptians, whose hieroglyphic writing had between 400 and 600 signs in the classic period, and as many as 2500 in Ptolemaic times. Chinese, however, requires the memorization of some 7000 ideographic characters.

Syllables are complicated sounds, and a much simpler system can be obtained with phonemes, the smallest units of speech. This is the alphabetical system, using only a few dozen characters (26 in the case of our Latin alphabet). It considerably reduces the variety of signs, although raising the number of characters required to express an idea or word. While the Maya, for instance, needed only one glyph to convey a notion, we need several letters to write out the corresponding word. A similar mathematical process has recently taken place with the transition from decimal to binary notation, minimizing the types of signs but increasing their repetition. Where traditional arithmetic uses ten different signs, a binary electronic calculator employs only two (0 and 1) at a much higher rate.

The most elaborate of these systems, such as the Egyptian or Chinese, can be formulated in diverse ways, according to their balance between semantics and phonetics. These alternatives would make them relatively difficult to decipher. If Maya writing belonged to such a system, it would first be necessary to know the language spoken by the ancient Maya, or by modern native descendants, and to distinguish between the idioms used in different centuries.

Maya languages are divided into two groups, of which the principal ones are: Quichean (Eastern), Mamean (Eastern), Yucatecan (Western) and Cholan (Western). Cholan is accepted by most epigraphers and linguists as the Classic language, but there is evidence of limited influence from Yucatec and other bordering languages.

Apart from the epigraphic data on ancient monuments in the Maya provinces, and a text from Chiapas known as the Grolier Codex (now in Mexico), the only surviving texts are the three codices already mentioned (in Madrid, Paris, and Dresden). They date from the Post-Classic period (eleventh century), and come from the northern Yucatec area. All other Maya books, which were made of paper manufactured from beaten bark of ficus fibres covered with a layer of polished chalk, were destroyed in a gigantic bonfire organized by Bishop Landa, who regarded them as documents likely to encourage idolatry.

Ironically, we owe some understanding of Maya writing to none other than Diego de Landa. The Bishop spent much of his life recording the last characteristics of a civilization to which he was himself destined, because of his religious convictions, to deliver the final blow. His great work, dating from 1566 and entitled *Relación de las Cosas de Yucatán* (*Account of the Things of Yucatán*), was recovered in the middle of the nineteenth century by Abbé Brasseur de Bourbourg.

What does Landa tell us? This Bishop of Mérida met the last of the Maya priests, heirs to the fund of knowledge passed on by that glorious civilization, which was already in full decline by the thirteenth century, before the Spanish Conquest. The priests, still jealously guarding the remnants of their moribund culture, could read and count according to systems perfected more than 1000 years earlier.

Landa thus claimed to have found the key to a Maya 'alphabet', and listed 29 signs with their phonetic transcription. Yet all attempts to decipher Maya texts by his method have failed. It is now known that

117 Pottery statue from Simojovel in Chiapas, 100 km west of Palenque: this fine piece, about 50 cm high and dating from the Classic period, portrays a Maya dignitary wearing a robe, turban, scarf and, on his left wrist, a kind of muff (National Museum of Anthropology, Mexico City).

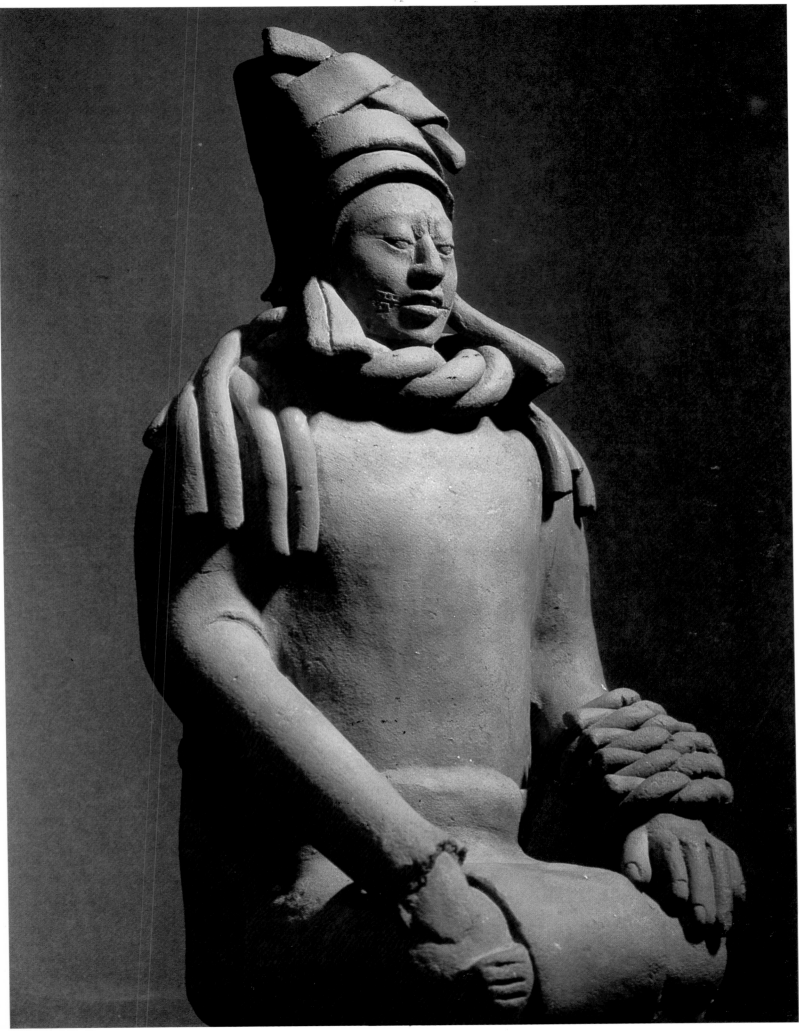

Maya hieroglyphs representing the eighteen 20-day 'months' and five unlucky days making up the year of 365 days:

1. Pop 2. Uo 3. Zip 4. Zotz 5. Tzec
6. Xul 7. Yaxkin 8. Mol 9. Chen
10. Yax 11. Zac 12. Ceh 13. Mac
14. Kankin 15. Muan 16. Pax 17. Kayab
18. Cumku 19. Uayeb (after Michael Coe)

Maya writing was not alphabetical, although Landa did not completely miss the mark. In his list, there are sometimes several signs for almost similar sounds. This suggests that the incomplete transcriptions provided by him are in fact an embryonic syllabary. If so, Maya writing would resemble the great cuneiform or hieroglyphic syllabaries of the ancient world, which were of a phonetic nature relying on semantic determinants. The large number of Maya signs recognized today (over 285) agrees with this hypothesis.

After a century of research, we cannot still 'read' Maya script fully, although it was certainly written from left to right and from top to bottom, and over eighty per cent of many texts has recently become legible. But even if a text has resisted decipherment, preventing us from pronouncing or recognizing its sounds, it need not be utterly meaningless. The combination of Landa's data about the glyphs representing days, months, and Maya datings with the work of modern researchers can yield a whole series of scientific facts.

We now know many terms, especially chronological notions. As for the reading of dates, no more great discoveries can be expected. But in astronomy, analysis of the codices has produced considerable results, to

Maya hieroglyphs for heavenly bodies:
1. The sky 2. The sun 3. The moon
4. Venus 5. The earth (after Michael Coe)

1 2 3 4 5

which I shall return later. The most serious gaps occur in learning about Maya history, religion, and society. Through cross-reference and deduction, with the techniques of philology and linguistics, scholars are advancing in their attempts to throw fresh light on the glyphs. Our grap of Maya texts is growing continually, yet gradually—and it would be wrong to hope for some miraculous find, like the Rosetta Stone in Egypt, that would instantly elucidate Maya writing.

The latest progress in decipherment

First of all I would like to express my gratitude to Linda Schele, Professor of Art at the University of Texas, for all the information she has given me on the latest progress in the decipherment of Maya glyphs.

Until the 1930s, study of the Maya glyphs improved swiftly. Reliable results had been obtained concerning dates, numbers, days, and months, as well as the names of certain stars, gods, colours, and directions. The mathematical and astronomical content of the three codices had been largely deciphered, revealing much scientific knowledge and an ability to predict eclipses and to record conjunctions of stars. Then investigations slowed, and no further success seemed possible.

A breakthrough came only in the late 1950s and early 1960s, with the publication of work by a new generation of investigators. In 1958, Heinrich Berlin suggested that the names of Maya sites were indicated by 'emblem-glyphs'. Tatiana Proskouriakoff next put forward important theories about the historical aspects of inscriptions at Piedras Negras (in 1960) and at Yaxchilán (in 1964). And in 1962 interpretations of the Quiriguá dynasty were published by David Kelley. Working on this basis, Alberto Ruz made his own contribution, in 1973, with an explanation of the epigraphic material from the Temple of the Inscriptions at Palenque. These discoveries have revived attention to Maya writing, and deserve further comment.

After examining more than 1000 monumental inscriptions, Berlin inferred that there was probably a special kind of glyph for each city, although he could not be certain whether the glyph stood for the city itself, its tutelary god, or its dynasty. He identified glyphs for Tikal, Naranjo, Yaxchilán, Piedras Negras, Palenque, Copán, Quiriguá, and Seibal. Next he studied the sarcophagus in the Palenque crypt, and concluded that each of the individuals represented on its sides was accompanied by a particular glyph which must have been his name. They were, then, figures who had played a historical role. Berlin also distinguished the glyph that indicated female figures.

Working along the same lines, Tatiana Proskouriakoff proposed that some glyphs associated with dates on the Piedras Negras monuments she was studying might signify a 'birth', an 'accession to power', or something similar. Since the span of time covered by the dates on the stelae was more or less the same as a human lifetime, the inscriptions

118 Structure 33 at Yaxchilán: this building, which is also known as the 'palace', is in fact a temple. Its northeast façade overlooks the low-lying parts of the centre on the banks of the Usumacinta river, 65 m below. The edifice, surmounted by a fine latticed roof comb that must once have been decorated with stucco statuary, contains a broken stone sculpture dating from 757 AD.

119 The south-west façade of Structure 33 at Yaxchilán, emerging from the forest that has overrun the site.

120 Lintel 53 from Yaxchilán: the site is famous for such sculpted stone lintels spanning the doorways of its main buildings, instead of the sapodilla-wood lintels that were the rule at Tikal. This example, 1.60 m long, and dated 766 AD, depicts a personage, 'Shield-Jaguar', holding a sceptre in front of his wife, who is giving him an object of dynastic importance (National Museum of Anthropology, Mexico City).

121 Detail of Lintel 26 from Structure 23 at Yaxchilán: this lintel, dated 726 AD, shows, with a marked cut-out effect, the same 'Shield-Jaguar' as in the caption above receiving a jaguar-mask from his richly dressed wife (National Museum of Anthropology, Mexico City).

122 Detail of wall painting from Bonampak: this mural, dated about 800 AD, is from the central room of Structure 1, and depicts captives being tortured after battle. Each figure is about 1.2 m high (copy of the original by Rina Lazo presented to the National Museum of Anthropology, Mexico City).

113

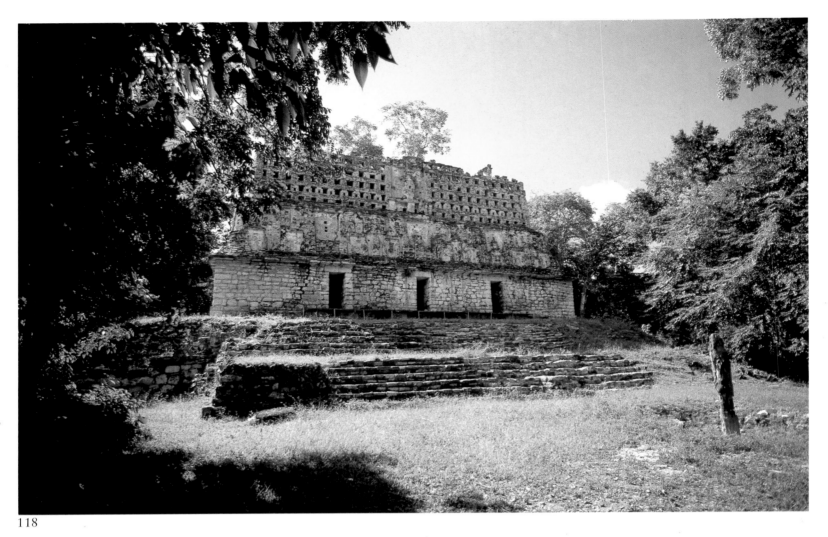

118

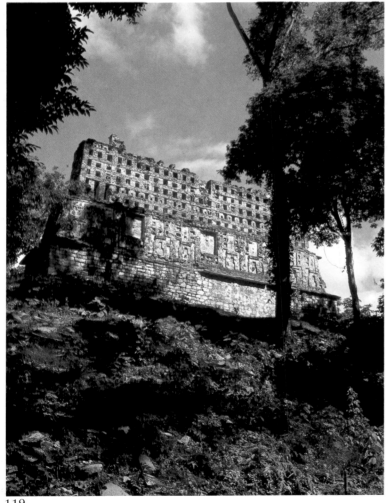

119

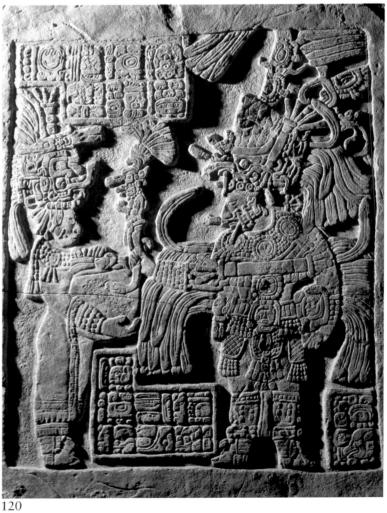

120

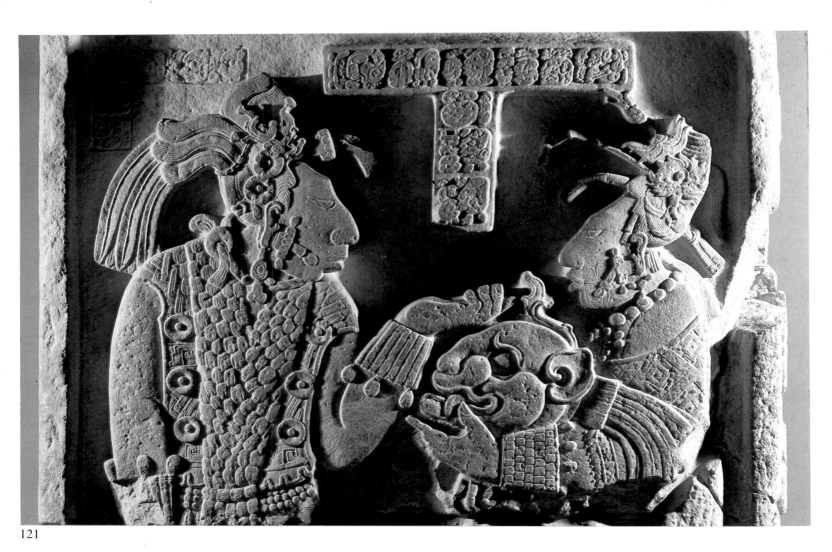

121

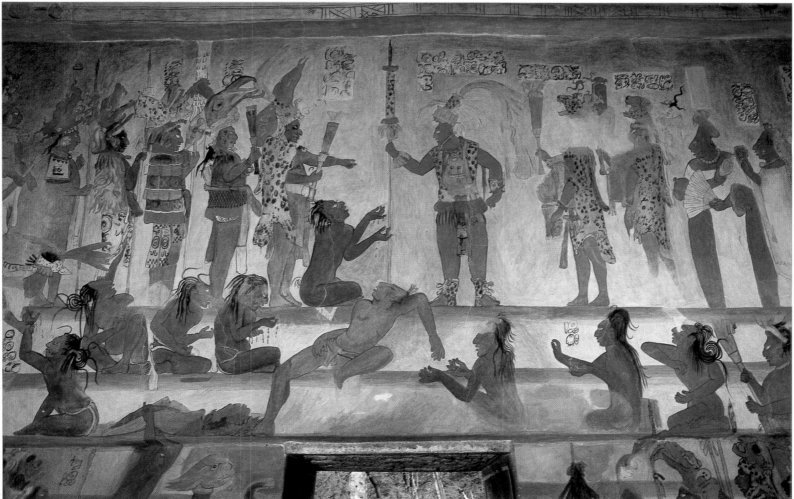

122

Maya hieroglyphs used as emblems for the names of cities:
1. Tikal 2. Naranjo 3. Yaxchilán
4. Piedras Negras 5. Palenque 6. Seibal
7. Copán 8. Quiriguá (after Michael Coe)

must have had a historical content. Applying these methods to the stelae and stone lintels of Yaxchilán, Proskouriakoff concluded that they recorded the chief events in the reign of each lord, such as birth, enthronement, military exploits, important prisoners captured in battle, major sacrifices, and the death of leading dignitaries. She eventually succeeded in discovering the names of the lords, of their ancestors and successors, of their possible usurpers, of their wives and marriage dates, and of the sites that were dependent on Yaxchilán, at that time a 'capital'. In this way, Proskouriakoff assembled all the historical data usually provided by documents that have come down to us from the other civilizations of antiquity, thus proving what Morley had always doubted— that the content of Maya texts was historical and not, as was long believed, centred on an abstract cult of time.

With similar aims in mind, David Kelley strove to piece together the history of the Quiriguá dynasty and to define that city's relationship with the regional centre of Copán. He distinguished the names of five successive rulers who reigned for 55 years, determined the names of their wives, and established the degree of kinship between them all.

When he discovered the Funerary Crypt at Palenque, Alberto Ruz immediately assumed that the slab resting on the sarcophagus should, logically, bear the name, date of birth, and date of death of the person in the tomb, as well as recording key events in his life. He noted no less than 13 different dates on the border and on the central section of the tomb-stone. Ruz reviewed his theory in 1973 in the light of findings by Berlin, Proskouriakoff, and Kelley. Now he suggested that the inscription began at the southern end (nearest the entrance to the crypt), continued round in an anticlockwise direction to the eastern and northern sides, and ended on the western side.

The southern side, according to Ruz, supplies the date of birth of the man in the tomb (in 655 AD), the date of his accession to the throne at the age of 28, his name, and that of the sovereign he succeeded. On the eastern side are the name of his principal wife and the date of their marriage (in 680), as well as various dates indicating the years when he was 14, 19, 22, 32, and 21. The northern end shows only one date, when he was 9. On the western side is a similar date, minus 155 days, followed by the date when the personage was 20, then by his date of birth, the

123 Stucco head from Comalcalco in Tabasco: this superb portrait of a bearded and moustachioed Maya lord, 44 cm high, was found set into a wall. The style of the work, which is dated 700–800 AD, resembles that of the stucco heads of Palenque, and shows the power of artistic inspiration in the extreme west of the Maya world (National Museum of Anthropology, Mexico City).

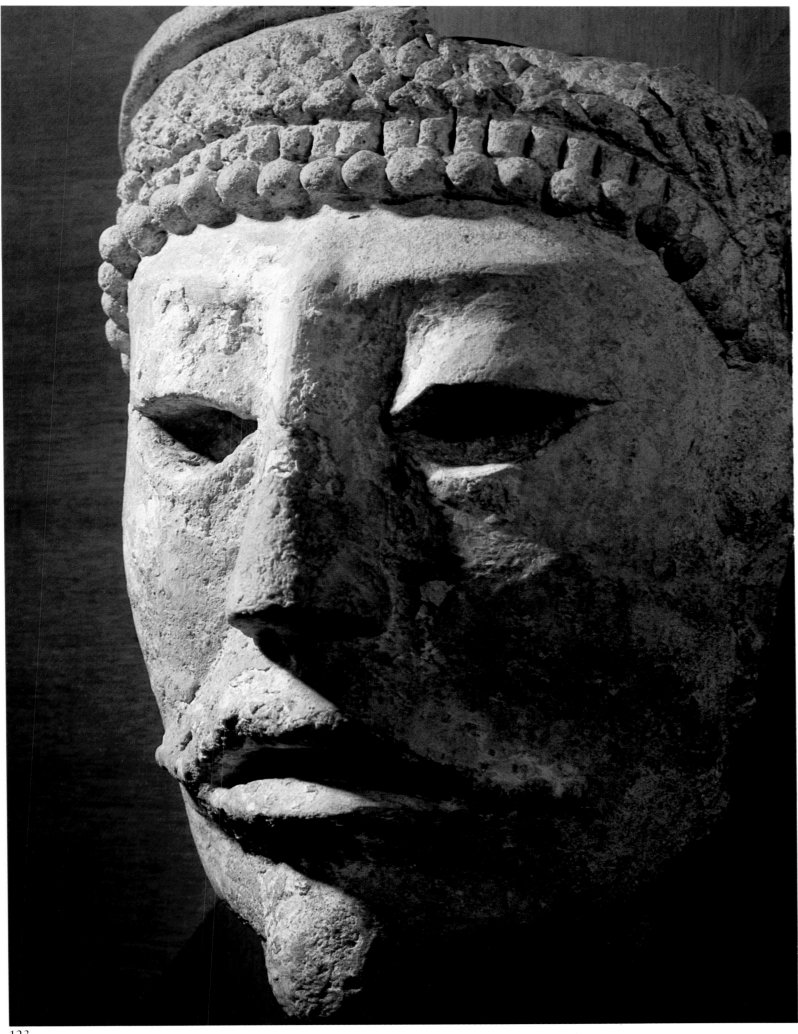

1 2 3 4 5

and semi-private spaces of Maya sites primarily to proclaim the cosmological and historical legitimacy of Maya rulers and to record their deeds as rulers and warriors.

So the Maya, long thought unique in their metaphysical obsession with time, have turned out, like all civilized people, to be thoroughly integrated with their historical context. Their fascination with time and astronomy was the result of their need to provide a temporal and cosmological framework for historical events, and not the result of abstract, metaphysical concerns.

The historical nature of Maya inscriptions was further demonstrated by the interpretation of the text of the sarcophagus at Palenque. Berlin has originally identified name glyphs which occur with the portraits on the sides of the sarcophagus, and Lounsbury, Mathews and Schele have confirmed his proposal by identifying the same persons in the texts of the Tablet of the Cross where their births and accessions are recorded, on the tablets in the Temple of Inscriptions corridors where their accessions are recorded, and on the edge of the sarcophagus lid where their deaths are recorded. The buried ruler began the text on his death monument with the date of his birth and death, and continued with the deaths of all his historical predecessors, concluding with those of his mother and father. He surrounded his coffin with portraits of these ancestors, but edited to show only those ancestors who were in his genealogical descent line—in other words, his mother and father, his grandfather, his great-grandmother, and three additional generations. He marked his burial place with both the full dynastic history and with those progenitors through whom he received his personal legitimacy as ruler.

Yaxchilán and Bonampak

There are two ways of reaching the site of Yaxchilán: in a dug-out canoe, which requires a journey of several days up the Usumacinta (and against the current), or in a light aircraft which succeeds, one knows not quite how, in landing on the tiny strip of grass that has recently been cleared in the forest. The site has been overrun with vegetation, and all that can be seen as one arrives by air is the roof comb of Structure 33 peeping above the towering trees.

This ancient site lies on the left bank of the great river in the Mexican state of Chiapas, some 110 kilometres to the south-east of Palenque, in the middle of a region inhabited by the Lacandón Indians, the last survivors of the original jungle peoples. Located halfway between Tikal, in the central province of the Petén, and Palenque in western Maya territory, Yaxchilán is a vast centre along the bank of the Usumacinta, which

is 175 metres wide at that point. Indeed, some edifices were built too close to the river, and have since been partly washed away by it during the rainy season. The principal buildings date from the sixth century to the beginning of the ninth.

The largest constructions at Yaxchilán are spread out over an area of 1000 by 600 metres, both along the river bank with a large central plaza, and on the rising ground behind. Temple-pyramids are perched on natural hills some 100 metres higher than the level of the river. Great flights of stairs run up the gradients, broken here and there by man-made terraces. Surveys carried out by Teobert Maler, and later by John Bolles, show that the landscape was remodelled to accommodate the centre.

Like Palenque, Yaxchilán was not designed according to any regular plan, although the buildings along the waterside tend to be arranged parallel to the river. The palaces and temples on the surrounding knolls, on the other hand, have varying orientations depending on the relief of the terrain. No less than 86 structures and buildings have survived in fair condition, making Yaxchilán one of the great Maya 'cities', and the largest in the western region except for the vast site of Piedras Negras. Piedras Negras, farther down the Usumacinta, but on the right bank in Guatemalan territory, comprises, like Tikal, hundreds of structures which are divided up into three main groups.

The architecture of Yaxchilán reflects its location between the Petén and Palenque. It presents features characteristic of both zones: on the one hand, a series of carved stelae like those at Tikal, Uaxactún, Seibal, and Machaquilá (thus differing from Palenque, which has none), and, on the other, temples perched on hills, with tall latticed roof combs that were once decorated by large polychrome stucco sculptures.

Most of the religious buildings at Yaxchilán have sloping upper façades that were also ornamented with stucco sculpture, some vestiges of which have survived, in particular on Structure 33. The central chamber of this temple contained the statue of a seated, cross-legged, Buddha-like deity. Maler thought that it represented Quetzalcoatl, but a connection is improbable between that highland deity, who appeared only during the Post-Classic period, and this magnificent statue hewn from white limestone—now sadly lying in fragments on the ground—which is decorated with a pectoral of sun-god masks and a headdress of quetzal feathers, and dates from the Late Classic period.

Yaxchilán includes a peculiarly original feature: stone lintels over doorways decorated with bas-reliefs. The quality of the sculpture has resulted in their being much sought after, and fine examples of such lintels are to be found in the British Museum in London as well as in the National Museum of Anthropology in Mexico City. The dates appearing on them range from 509 to 771 AD. A characteristic of the lintels and stelae is their often very high relief. Some figures on them are given almost full-round treatment and seem to stand out from the background. This lively expressive style has nothing in common with that found on stelae at Tikal, Copán, or Quiriguá.

Not very far south of Yaxchilán, on a tributary of the Usumacinta, the Río Lacanhá, stands the small Maya site of Bonampak. This secondary centre suddenly became famous in 1946, when Giles Healey happened upon some admirable murals, missed by two explorers visiting the site four months earlier. Structure 1 consists of a succession of three rooms

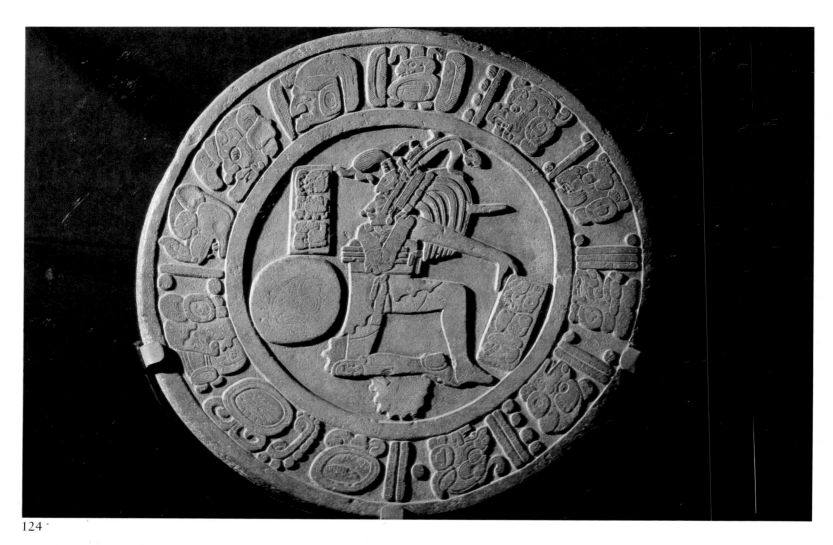

124

125

126

whose walls are covered with beautifully coloured scenes of eminent artistic quality. Paradoxically, it was in the heart of the humid forest that the finest surviving examples of pictorial Maya art have been preserved. These Classic works date from about 800 AD.

Since their discovery, the Bonampak paintings have already lost something of their freshness, and are now best seen in the remarkable copy by Rina Lazo, which stands in a replica of their original building in the last-mentioned museum. It would seem that this vast mural composition, which forms a narrative whole, should be read from left to right, like Maya writing. The visitor approaching the building should therefore start with the room on the left. Each of the vaulted rooms measures only 4.5 by 2.5 metres, and is 2.3 metres high; these make up a building whose total length is 16.5 metres. Running round the inside walls of each room is a bench on which the chief and his councillors must have sat. Although often referred to as the 'Temple of the Paintings', Structure 1 at Bonampak is not really a temple, but a palace in which the exploits of a Maya lord were glorified.

In the first room a solemn ceremony is depicted, involving the presentation of a child who is probably of royal blood. Accompanied by musicians and dancers, nobles in full regalia with a retinue of servants carrying parasols attend the festivities, which may also mark preparations for war. The second room, in the middle of the edifice, has the greatest concentration of pictorial effect. It contains a battle scene of extraordinary animation and violence, followed by the capture and torture of prisoners by the victors. This scene occupies a whole wall, and shows in its centre a wounded captive sprawled on the steps of a platform, surrounded by fellow prisoners with blood pouring from their fingers as though their nails have been torn out. All the figures in the composition are looking at the victorious lord, in the top centre, who appears frontally with his head in profile. He holds a spear and is clad in a poncho-like garment and shoes, both made of jaguar-skin. One of his enemies pleads for mercy at his feet. Lastly, in the third room on the right, there are scenes of triumphal festivities: the victors dance to the sound of trumpets before a stepped pyramid, in the presence of their prince on his litter, while the vanquished chief is ceremonially sacrificed.

These 'frescoes' show a verve and skill that only increase our regret at the rarity of surviving examples of Classic Maya pictorial art. Both their draughtsmanship—in particular, the sprawling abandon of the dying warrior, who is foreshortened in a manner worthy of a Renaissance artist—and their kaleidoscopic colours put the Bonampak paintings among the masterpieces of pre-Columbian art. Bright oranges, yellows, browns, luminous emerald greens, reds, and deep blues are used with a uniform, flat-tint technique that makes the paintings strikingly 'modern'. A sure aesthetic sense is displayed in their generous dimensions (each figure is about 1.2 metres high) and full composition.

The warlike and non-religious themes of these paintings implicitly confirm the most recent interpretation of Maya writings and their historical content. Although the lack of fortifications around Classic Maya cities—such walls arose only in the Post-Classic period—strongly suggested to earlier scholars a culture with a peaceful and unaggressive ethos, the spirited Bonampak murals have ended doubts on the matter. Like all the native peoples and, more generally, all powerful civilizations, the Maya were sturdy warriors, not utopian pacifists.

124 Stone disk from Chinkultik in Chiapas, near the Guatemalan border: this fine circular bas-relief, which may have been a ball game marker, is 55 cm in diameter, and dates from 590 AD. It portrays a player wearing the traditional belt and other equipment necessary for that sacred sport, such as a protector on the right forearm and a knee guard on the right leg. The player is sending back the huge rubber ball visible on the left (National Museum of Anthropology, Mexico City).

125 Stucco head from Piedras Negras, on the Usumacinta river: it will be noted that this sculpture, in a style similar to that of Palenque, shows two distinct layers, as though a second decoration overlaid the first in the manner of Maya architectural superimposition (National Museum, Guatemala City).

126 Large pottery brazier-urn from Teapa in Tabasco: this 'baroque' work, which dates from the seventh century AD, shows a seated sun-figure emerging from the jaws of the earth-monster, and recalls the style of the Palenque cylinders (Tabasco Museum, Villahermosa).

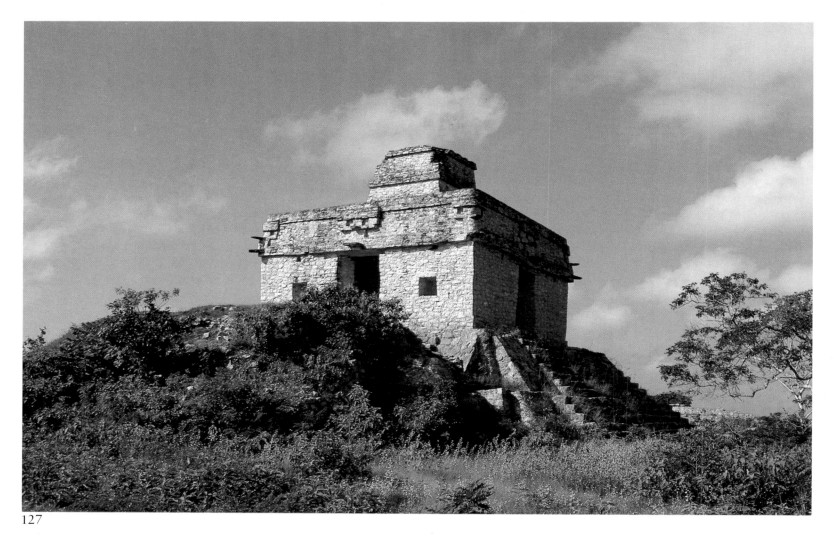

127

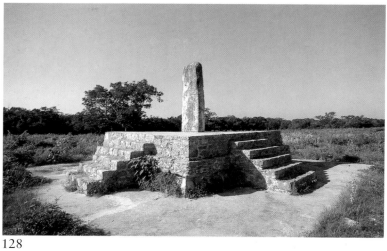

128

129

130

IV. On the periphery of Yucatán

Moving from the Maya provinces of the central and western regions up to Yucatán in the north, we reach a peninsula washed on the east by the Caribbean Sea, and on the west by the Gulf of Campeche. Along its periphery, this important province of Maya art contains a series of very different sites, which flourished at varying times over several centuries from the Pre-Classic to the end of the Late Classic period, and even until the Spanish Conquest.

Among the earliest traces of human settlements showing characteristics of Maya civilization in the province, the huge complex of Dzibilchaltún lies in the far north of the peninsula, only fifteen kilometres from the coast. To the east, we shall examine the city of Cobá with its seventh-century pyramids. To the south, a group of sites which have still not been properly investigated or restored, and which exhibit the so-called Río Bec style of architecture, include Xpuhil, Becán, and Chicanná. Farther to the north-west is the great centre of Edzná, with a five-storey palace: although in Chenes territory, it shows the influence of the Puuc style—the apogee of Classic architecture—which occurs at sites in central Yucatán, the subject of the next chapter. Lastly, continuing clockwise round the peninsula, the celebrated island of Jaina, off the Yucatán coast a little to the north of Campeche, holds a necropolis in which many admirable polychrome figurines portraying Maya nobles have been found.

This large province contains the highest concentration of surviving Maya, some 1.5 million of them living in villages that have not changed much in aspect since pre-Columbian times. It varies as much in climate as in its artefacts. As mentioned already, the whole of the north is covered with dry brush and dense copses, lacking large trees. In the east, on the other hand, there is virgin forest similar to that in Quintana Roo and the Petén. In the region of the Chenes and Río Bec styles, vegetation becomes progressively thicker as one proceeds south towards the Petén.

Dzibilchaltún and the earliest Yucatec architecture

It was long believed that the civilization of the north flourished at a later date than that of the central region. Excavations have proved this to be untrue. Investigation by Miguel Angel Fernandez at Acanceh revealed an apparently fourth-century pyramid, with a decoration of stucco

127 The Temple of the Seven Dolls at Dzibilchaltún in northern Yucatán: dating from about 450 AD, this is one of the earliest buildings known in the northern Maya region. Its central sanctuary is reached by four radially symmetric stairways and topped by a curious roof comb.

128 The square 'worship platform' at Dzibilchaltún, dominated by a very primitive stele, and approached by four stairways.

129 Vaulted corridor running round the temple at Dzibilchaltún: it has square openings of a type that is rare in Maya architecture.

130 Mask of the long-nosed god Chac, symbol of rain: such masks adorn the corners of the temple at Dzibilchaltún. The stonework, quite crude, shows traces of carved stucco.

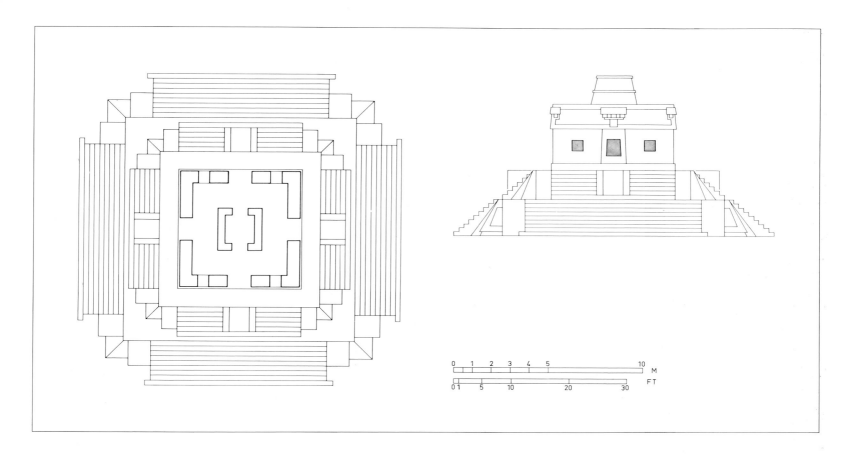

Plan and elevation of the Temple of the Seven Dolls at Dzibilchaltún

masks and four radially symmetric staircases, as at Uaxactún. Exploration of the site of Dzibilchaltún, by Wyllis Andrews of Tulane University, shows that major buildings and ceremonial centres were being erected in Yucatán as far back as the Proto-Classic and Early Classic periods.

Dzibilchaltún is one of the very largest Maya sites. Buildings are scattered for almost 50 square kilometres around a centre, whose numerous structures are grouped with no sign of a coherent plan. The largest construction is now called the Temple of the Seven Dolls, because seven figurines of deformed creatures were found there in a cache of votive offerings. The temple, dating from about 450 AD, was subsequently buried by a pyramid built over it, which preserved it well. So the American archaeologist had the good fortune to disinter a virtually intact temple.

The building is square in layout, with four radially symmetric staircases leading up to a central sanctuary. This contains a corridor running round a square room, and is surmounted by a tall structure rather like a roof comb. But instead of being rectangular, it has the appearance of a square 'chimney' and gives all four sides of the edifice an identical profile. Another feature, unparalleled in the rest of the Maya world, is the presence of curious square windows on either side of the doorways in the middle of the north and south fronts. The gallery around the inner sanctum, which must have held the 'idol', is roofed with broad vaulting, typically Maya although rudimentary in technique.

At the four corners and in the middle of each side of the building's mansard roof, which heralds the sloping roof designs of Palenque, there are crude masks of a long-nosed god. This motif was later developed in Puuc decorations consisting of large masks of the rain-god Chac, who was particularly revered in this region, where no rain falls during the entire dry season.

131 Palace at Xpuhil, in Quintana Roo: this building, about 40 m wide, and seen here from the back, has three towers topped by model temples that are reached by illusory stairways. The living quarters on the lower platform have fallen in.

132 Door of the temple of Chicanná, representing the mouth of the rain-god: decoration typical of the Río Bec region covers all the walls and the frieze of this eighth-century building.

133 Façade at Chicanná: half-strangled by tropical vegetation, it shows the luxuriant ornamentation typical of the Río Bec region, and also found in the Chenes style.

134 Stucco mask from a primitive structure at Kohunlich in the Río Bec region, in the south of the Yucatán peninsula: this style of decoration has parallels with that of Uaxactún and Acanceh.

124

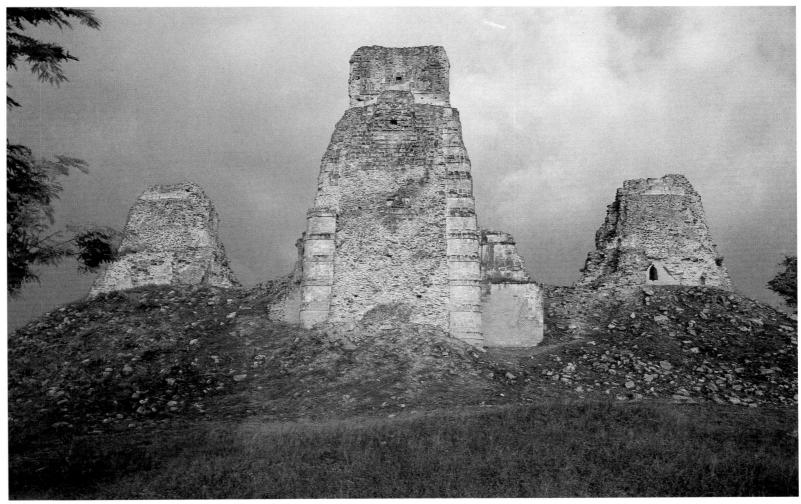

131

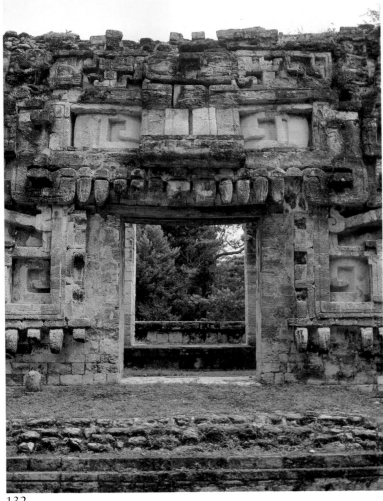

132

133

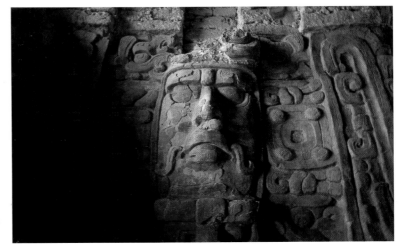

134

Cobá and the Maya causeways

The site of Cobá, in eastern Yucatán, is one of the ancient Maya settlements of the peninsula. It is in fact a vast group of centres, built among five lakes which, because of their rarity in the region, attracted human inhabitants at an early period. Several centres with pyramids are spread over an area of nine by five kilometres.

The Castillo at Cobá comprises numerous superimposed masses ascended by a staircase, and has rounded corners reminiscent of the great Tikal temples. The edifice, which is in a sorry state, rises to a height of 24 metres. It stands between two lakes and dominates structures, including a ball court and some palace buildings, which are just discernible in the tropical forest that overruns the site. Another centre, called Nohoch-Mul, two kilometres to the north-east, has a pyramid of the same height with an intact upper temple. But a distinction of the buildings in the Cobá area is the occurrence of stelae, unusual in the Yucatec region. They range in date from 613 to 732 AD, putting Cobá mainly in the Late Classic period.

Most startling, however, is a causeway of perfectly straight sections between Cobá and Yaxuná, a Maya site some 100 kilometres to the west near Chichén Itzá. This is the longest of Maya causeways, known as *sacbeob* (plural of the word *sacbe*). They are raised roads with retaining walls on either side, traversing all natural obstacles horizontally and unswervingly. The causeways are generally 4 metres wide, raised by about 60 centimetres above the surrounding terrain, although they may be as high as 3 metres when crossing a dip (Yucatán is, of course, normally quite flat). From the air, these causeways are detectable even today, as vegetation grows less densely on their surface of limestone rocks.

This network of ancient causeways—at least sixteen have been found—is particularly puzzling because the Maya had neither vehicles nor horses. It is also difficult to see why such wide and straight thoroughfares were necessary for the transportation of people on litters, or of loads on workers' backs. The causeways must have replaced navigable waterways in Yucatec territory, which has no substantial rivers.

Southern Yucatán and the Río Bec style

In the extreme south of Yucatán, near the Guatemalan border, the ruins at Balakbal, Naachtún, and Calakmul yield stelae dating from between 400 and 600 AD. But the region slightly to the north, located on a line between Ciudad del Carmen and Chetumal, contains later buildings designed in the Río Bec style (named after the first site in the area to be explored). There the Mexican authorities are now extensively restoring sites such as Ypuhil, Becán, Chicanná, and Kohunlich.

The architectural style developed in this part of the Maya world is very different from those described above—and somewhat disconcerting to Western eyes. It is heavily ornamental: façades are sometimes treated like gigantic effigies of the rain-god, with his snarling mouth forming the temple doorways, and highly stylized eyes and ears. This type of

Elevation and plan of the Palace at Xpuhil

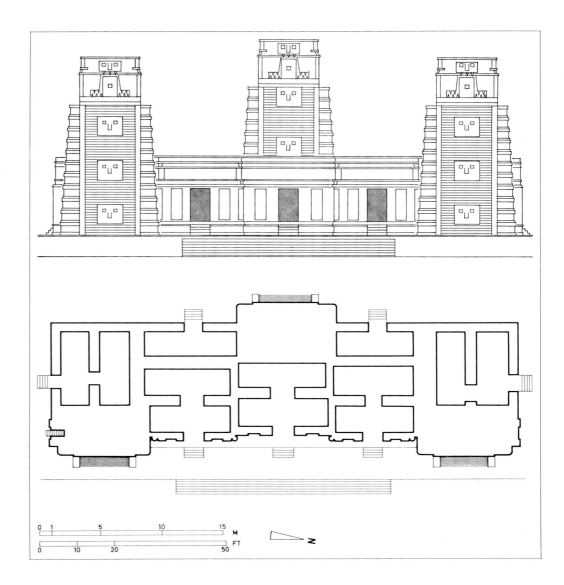

embellishment is analogous to the curious *t'aot'ieh* mask decorations of the Shang dynasty in China.

Most of the buildings subordinate architectural considerations to flamboyant effect, and have lost any trace of functionalism. The towers of the Palace at Xpuhil, for example, are solid and inaccessible. The steps leading up these pyramids are illusory, and the temples atop them are useless with no interior. The architects of the Palace, with its three symmetrically arranged towers, one of which is set back from the other two, clearly intended to give the greatest emphasis to the façades. Everything about the pyramids—the fake steps, solid temples, and imitation doors like the rain-god Chac's mouth—is symbolic.

In the living quarters on the lower platform, however, are twelve vaulted chambers. The distribution of inner space has a logic and clarity that is absent from similar constructions in the palaces of Tikal and Palenque already discussed. Indeed, much of our interest in the principal examples of architecture in the Río Bec, Chenes, and Puuc styles derives precisely from this rigour of design. One feels a determined attempt at organization, both in the overall volumetry of the buildings and in their 'structuralist', almost abstract ornamentation. Despite the purely decorative and ceremonial nature of the towers, which are over 20 metres high, it is impossible not to admire the audacity and compositional sense of their architects, who always achieved remarkable elegance.

Río Bec architecture yields few dates, and the use of stelae was almost unknown. It is generally thought that the buildings were erected be-

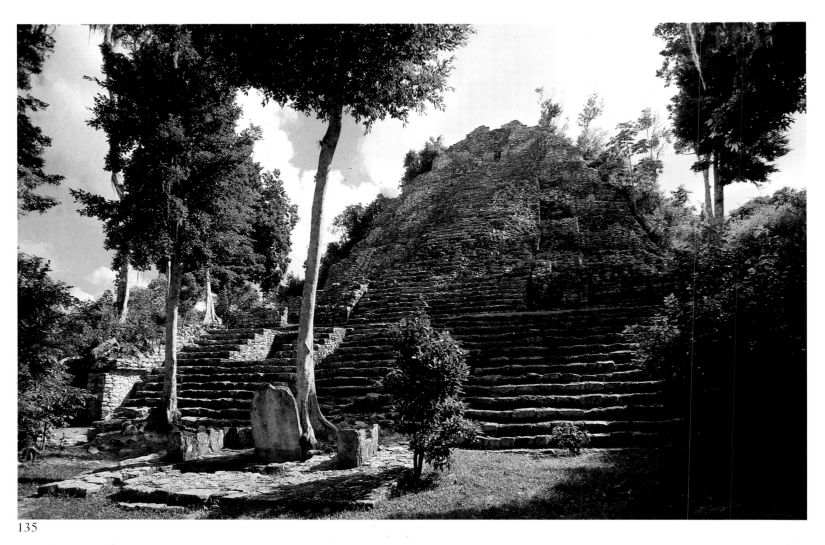

135

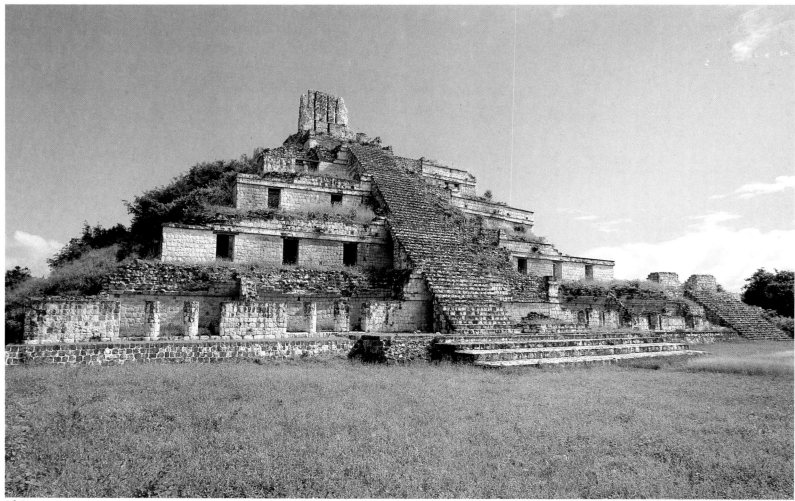

136

tween the sixth and eighth centuries. Further light will probably be thrown on the subject by the current programme of excavation and restoration. Moreover, the visible edifices are often found to overlay earlier structures, whose large stucco masks, as at Kohunlich, could be related to similar practices recorded at Uaxactún and, in northern Yucatán, at Acanceh.

A point worth mentioning is that special technique was required to construct the edifices at Chicanná, Hormiguero, Becán, and Hochob, with their florid, complicated decoration and stylized geometry. The builders grouted the rubble fill with mortar, to produce something like concrete. The sculpted stone visible on the façade then acted in the same way as the 'form' used to mould concrete in modern buildings.

It should be observed that the various distinctions in architectural style made by specialists in Maya art are neither completely clear nor geographically precise. Thus, the intricate façades at Hochob, while not very different in style from those at Chicanná or Becán, belong to the so-called Chenes style, which we shall also find on the east wing of the Nunnery at Chichén Itzá, and on the upper temple at the west side of the Pyramid of the Magician at Uxmal. So it would be a mistake to attach too much importance to such classifications.

Edzná and its five-stage edifice

My last remark is borne out particularly by Edzná. One might expect this site, from its position, to be related to Chenes. Yet it displays certain Río Bec features and obvious Puuc influences. Edzná, to the south-east of Campeche, is known chiefly for its extraordinary five-stage temple-palace, which is almost square in layout (58 by 60 metres) and has five set-back levels rising to a roof comb at the top (31 metres high). The roof comb, on an upper temple reached by a monumental stairway, shows traces of polychrome stucco decoration. Alberto Ruz, who studied the site, noted that this huge edifice lies over an older structure of the Petén type with re-entrant corners.

The five-storey edifice presents a series of vaulted chambers on its façade. The chambers on the lower level have masonry columns of the kind found in Río Bec buildings, while the fourth storey contains several monolithic columns like those used in Puuc work. The gigantic pyramidal structure overlooks a vast central plaza on an artificial acropolis, whose base measures 160 by 148 metres and is 6 metres high. Access to this is by a stairway 45 metres wide, made from very large blocks of stone, and flanked by pyramid-like structures once topped by temples. The whole ceremonial centre shows an inspiration, grandeur of design, and sense of composition that lend it considerable artistic importance.

But the site is also interesting because of its original hydraulic system. Edzná was connected to the Río Champoton, 40 kilometres away, by a huge canal with a width of 50 metres and an incline of only 50 centimetres per kilometre. Edzná is unusual, too, for a Yucatec site, in that a number of stelae have been found, covering a period from 672 to 810 AD. Furthermore, the great stairway leading up to the five-storey pyramid bears hieroglyphs on its risers, which could indicate a date as

135 Castillo at Cobá, in eastern Quintana Roo: this great pyramid, which probably dates from the seventh century AD, has a single stairway and rounded corners—features shared with the monuments of the Petén—and a ruined upper temple.

136 Five-stage edifice at Edzná, in Campeche: this great temple-palace, square in layout and ascended by a huge axial stairway, closely combines the Río Bec and Puuc styles. Its upper temple is surmounted by a tall roof comb that must once have been decorated with sculptures. The edifice seems to date from the seventh century AD, although certain superstructures may have been added during the next century.

137 Polychrome clay figurine from the island of Jaina, in the Gulf of Campeche: 22 cm high, it represents a Maya dignitary seated on a circular throne. With a beard on his chin and scarifications on his face, he wears a headdress of feathers and a very rich costume (National Museum of Anthropology, Mexico City).

138 Small clay figurine from Jaina: this piece, which dates from the Classic period between 650 and about 1000 AD, depicts a Maya lord in a long robe, holding a shield in his left hand. The right hand probably held a spear, but has been broken off (National Museum of Anthropology, Mexico City).

139 Jaina figurine, only 16 cm high, cleverly representing a pensive young man in a graceful attitude (Tabasco Museum, Villahermosa).

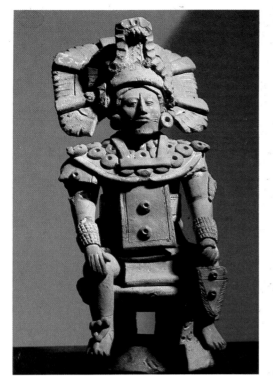

137

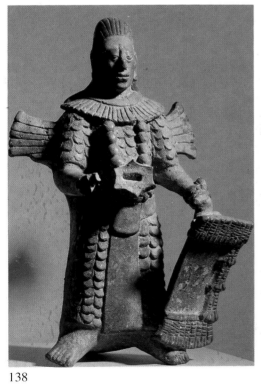

138

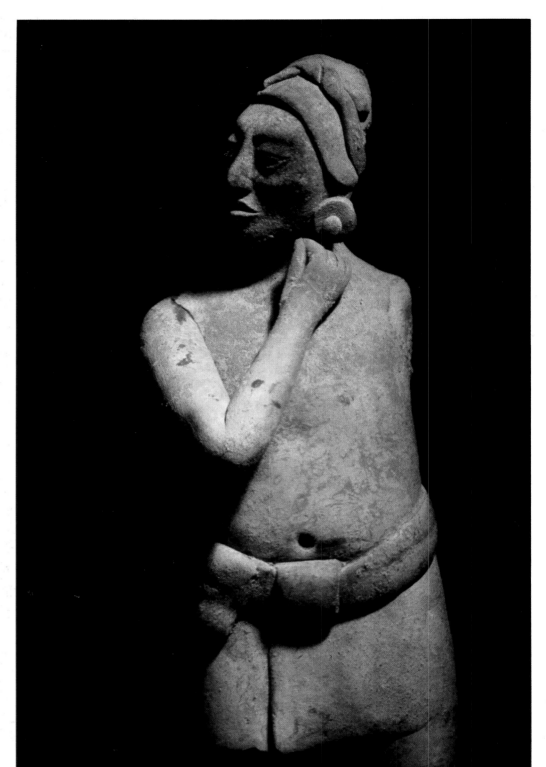

139

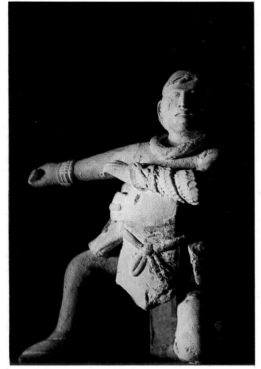

140

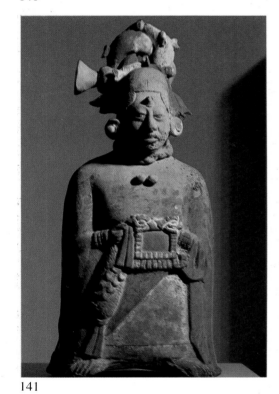

141

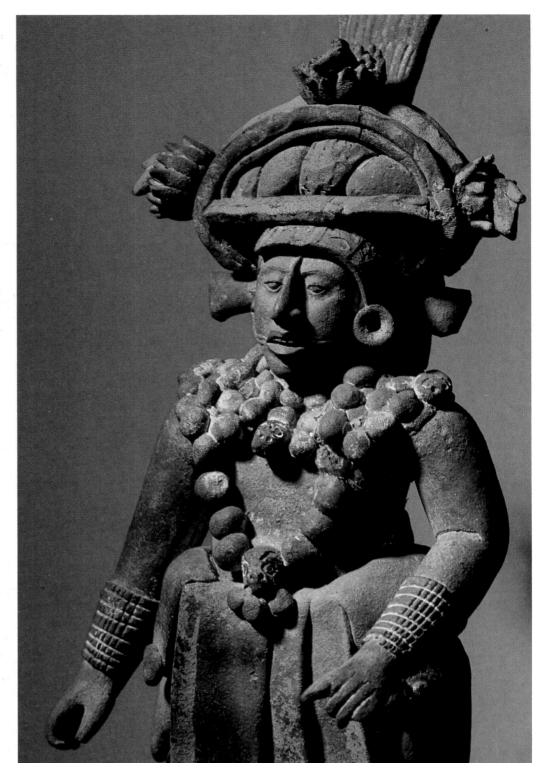

142

far back as 652. In any case, it can be stated that the centre flourished from about 550 to 900.

The necropolis on Jaina Island

The island of Jaina, lying a few dozen metres off the western coast of Yucatán, 80 kilometres to the north of Campeche, is only 1000 metres long and 750 wide. There have been numerous scientific investigations, particularly in 1964, on the site of this huge necropolis, which has always attracted unauthorized excavators and is now protected by the military.

The island comprises a ceremonial centre, dating from the end of the Classic period, whose severely eroded structures are of no great interest. But its cemetery, where over 1000 tombs have been excavated, has proved a source of attraction for more than a century, due to large numbers of polychrome pottery figurines, originally placed as votive offerings in the hands of the dead. These discoveries make Jaina, along with Jonuta, one of the main centres of Maya pottery. The Jaina figurines are smaller than those found in Chiapas (as at Simojovel), yet tell much about the daily lives, clothes, weapons, and ornaments of Maya nobles of both sexes. The sensitive art displayed in them reflects the Maya craftsman's enormous skill.

Hollow or solid, and rarely more than 25 to 30 centimetres high, the pieces are extremely expressive. Both the faces—even with tattoos and scarifications—and the gestures and attitudes of their subjects are brought vividly to life. These small figurines, like the admirable Bonampak paintings, help us to gain some idea of how Maya dignitaries and their wives looked in ceremonial attire, with headdresses and jade jewellery.

Although the finest of the figurines are entirely hand-made, many of them are moulded. Mass production with moulds would imply a large market for such funerary pottery. The figurines were not placed in the tombs merely as mementoes of daily life. They were probably regarded as indispensable aids for the survival of the dead person in the next world. There is one last puzzling point: the hollow figurines are often made in such a way that they can be used as a whistle, or as a musical instrument like the ocarina. One wonders whether they were played during funeral ceremonies. This pottery dates from between 650 and 1000 AD, after which the island seems to have been abandoned for a time.

Classic pottery

In another branch of ceramic art are the vases with polychrome or relief decoration, particularly common in the Petén. While the Jaina pieces may be compared to the Tanagra figurines of ancient Greece, the Maya vases with figures against a red background suggest some parallel to Athenian painted ceramics.

140 Jaina figurine portraying a Maya ball game player, 15 cm high: he has one knee on the ground, and his right arm outstretched to keep balance. His body is protected by the heavy belt against which, one imagines, the large rubber ball has just bounced (National Museum of Anthropology, Mexico City).

141 Polychrome Jaina figurine of a Maya noblewoman in her finest attire: she wears an imposing turban, and her face is decorated with scarifications or tattoos (National Museum of Anthropology, Mexico City).

142 Jaina figurine of a Maya lord: this work, 27 cm high and dating from the Classic period, shows traces of lively polychrome colours. His face, topped by a tall headdress, is decorated with a nose-piece, ear disks, and scarifications at the corners of his mouth. His chest and shoulders bear a heavy necklace with several rows of beads (National Museum of Anthropology, Mexico City).

143 Jaina figurine of a seated Maya lord: the elongated torso and the reduced proportions of the legs lend this bearded and moustachioed personage an air of profound dignity. The classical simplicity of the work is emphasized by his clothing—a mere loincloth (National Museum of Anthropology, Mexico City).

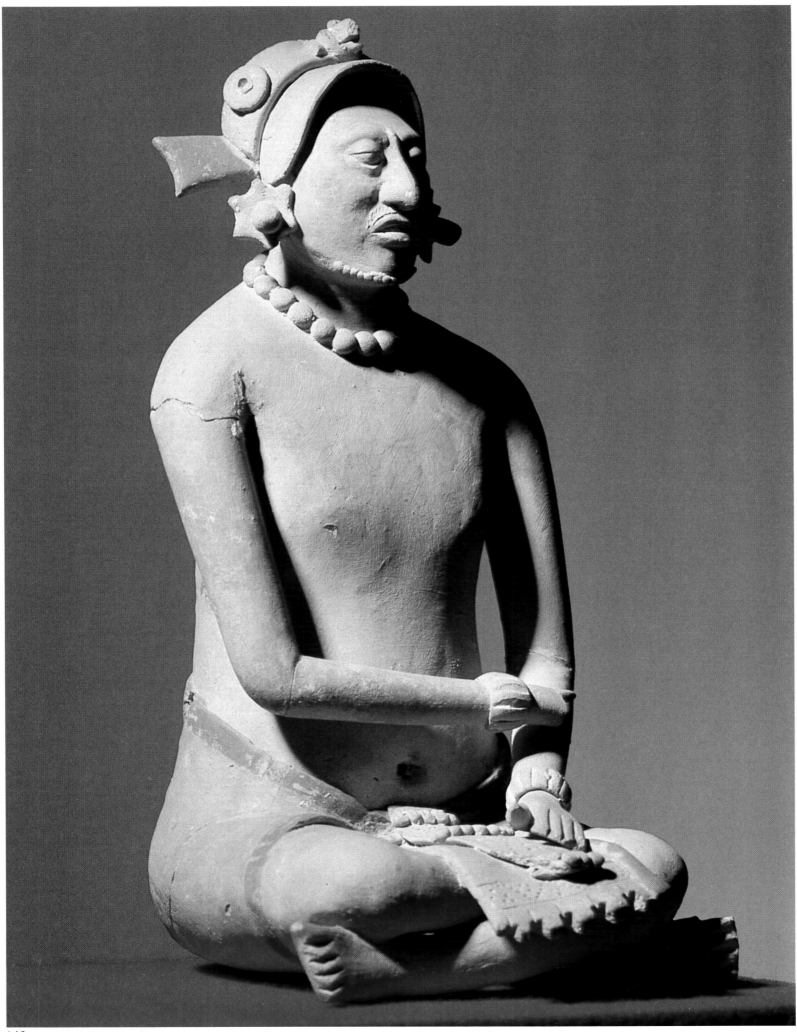

143

The vase decorations fill in our patchy knowledge of Maya painting techniques. Although almost all painted walls—except those at Bonampak, a few fragments at Tikal, Uaxactún, and Mulchic, and the recently discovered 'frescoes' at Cacaxtla (Tlaxcala) which are distinctly Maya in style—have perished, there does remain a host of scenes reproduced on the exteriors of vases and goblets. The same style and aesthetic conventions can be detected on them as on the larger paintings.

We should remember that the Maya manufactured their vases, dishes, and goblets without a proper potter's wheel. The delicacy and regularity of their finest work would, of course, have been impossible unless they had some means of revolving the objects while shaping the clay by hand.

But it does not seem that they were familiar with the use of a heavy turntable on an axis driven by a foot-pedal. They must have relied on the old technique of coiled pottery, used by all civilizations, including the pre-Columbian ones, before the adoption of the wheel.

This drawback, however, had no adverse effect on the pottery, which is light, graceful, and elegantly shaped. The Maya, more than any other Mesoamerican people, raised the manufacture of vases to an art. True, the simplest of them, intended for everyday use, are commonplace enough. But the vases destined for religious purposes display a quite admirable refinement of form, ornamentation, and colour. Abbé Brasseur de Bourbourg, writing in the nineteenth century, was even of the opinion that 'the fine vases from Guatemala and Peru [are] greater examples of ceramic art than those of Egypt and Etruria'.

In America, as in the rest of the ancient world, pottery plays a cardinal role in the dating of stratigraphic levels. The existence of so-called 'diagnostic potsherds' has made it possible not only to establish parallels between cultures, but to date objects or monuments found in the same deposit as a given type of pottery. The importance of ceramics is therefore greater than the aesthetic qualities of its finest pieces, such as those found at Copán or in the Motagua valley and Petén.

Among the most attractive pieces are cylindrical vases and goblets with figures painted against a red or white background. A whole world of people, activities, costumes, and attitudes—a high priest carrying out a sacrifice, a ball game player in action, dancers, magicians, warriors, and nobles—is vividly revealed to us. Some of the figures wear ritual masks, others ceremonial attire with complicated tall headdresses, as on stele reliefs.

The drawing is extremely confident, usually outlining figures and objects in black. The often bright colours, applied with the flat-tint technique, cover a range that is common to the pottery of many cultures—predominantly ochre, terracotta, white, and yellow. The pieces' ease of line, sense of layout, delicacy of detail, and naturalness of movement put them on the same level as the finest examples of Maya sculpture. In some cases, scenes are even accompanied by an explanation in hieroglyphic writing with dates. There are also occasionally texts above figures, rather like the 'bubbles' in modern strip cartoons.

But the wealth of expressive modes made possible by pottery is so great that almost every region has its own particular forms and uses. Thus, in the Quiché area of the south-west Petén, the Maya produced enormous funerary urns which are marvellously decorated with powerful, stylized reliefs depicting the face of the sun-god, the jaguar-mask,

the eagle's beak, and other subjects intended to accompany the deceased to the next world.

At Palenque, on the other hand, in the Temples of the Sun, Cross, and Foliated Cross, tall pottery cylinders have been found which bear vigorous carved representations of the face of the sun-god accompanied by other creatures, including long-beaked birds. The function of these tubular pieces, some of them more than a metre in height, is not clear. They were probably used as censers for burning copal, a common practice throughout the Maya world. With a strange combination of infinite delicacy and overabundant ornamentation they recall the totem-poles of British Columbia.

As we have seen, Maya artists used a wide variety of techniques in ornamental ceramics. They also made incised pieces, with the same elegance as the engravings on Etruscan mirrors. These depict figures or glyphs in a fine outline normally to be expected of the etcher's needle. This art, perhaps more than any other, shows the prodigious talent of Classic Maya artists and craftsmen.

Although I have chosen to discuss Maya ceramics in connection with the superb Jaina figurines, the pottery of Yucatán as a whole is not particularly exceptional. It is rather in the central region that the varied range of polychrome vases is to be found. But the Yucatec peninsula does boast an artistic achievement of great merit: Puuc architecture.

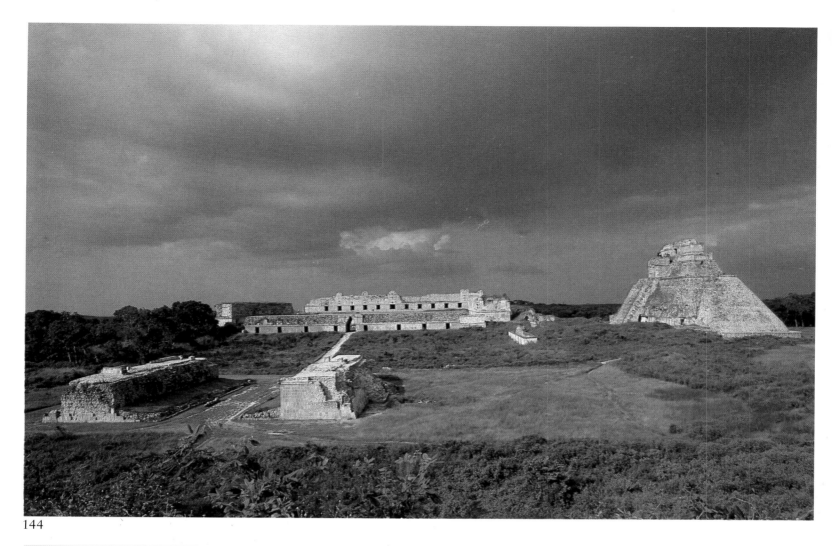

144

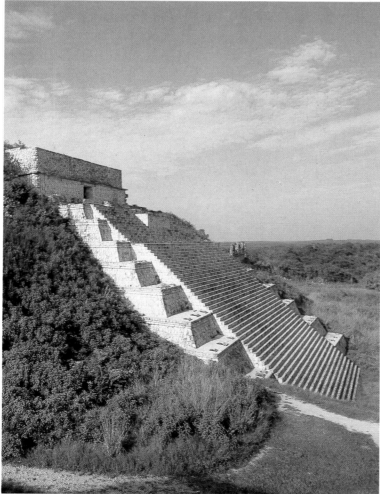

145

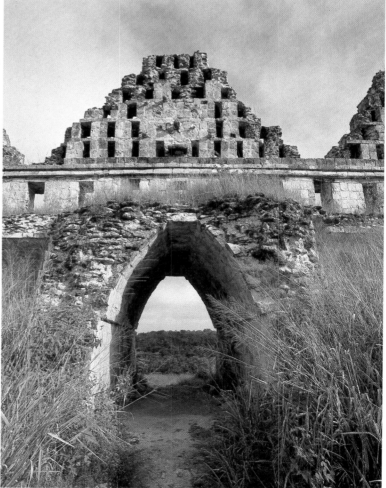

146

V. The masterpieces of the Puuc style

We now come to the buildings that mark the apogee of Maya architecture: the Puuc structures of Yucatán. They occur in the north-west part of the peninsula, chiefly at the sites of Uxmal, Kabáh, Labná, Sayil, and Xlapak. But the Puuc style spread from this core to Chichén Itzá in the east (at least the buildings of its first period) and, as noted in the previous chapter, even influenced Edzná in the south-west.

The area covered by the Puuc style is barely 200 kilometres long. But it comprises a series of overwhelming architectural masterpieces, especially at its centre, Uxmal. Before describing the site, however, we should recall that the theories about 'Old' and 'New' Maya Empires, which were held by the pioneers of Maya archaeology, and by Sylvanus Morley in particular, have now been abandoned. Already in 1958, Alberto Ruz, in collaboration with Eric Thompson, established the foundations for a firm dating of Uxmal, and drew conclusions from it that affect the whole of Maya chronology. Yet old habits die hard, as is clear from a recent work, *Pre-Columbian Art* by José Alcina Franch, professor at the Universities of Madrid, Seville, and Valencia. His book, published in 1978, repeats those outmoded categories while revising them—an 'Old Empire' is said to include the Puuc style, which Morley put in the 'New Empire' and saw as beginning right at the end of the tenth century.

Puuc buildings were indeed coeval with the main architectural achievements of the Petén, the Motagua, and the Usumacinta (sixth to eighth centuries). It is true that the sites of Tikal and Uaxactún arose well before the great Puuc centres. But they only blossomed after the eclipse which I have mentioned in connection with Tikal, and which also affected the central and southern provinces of the Maya world. The eclipse was characterized by the influence of Teotihuacán, introduced by Mexican invaders, and by the lack of any new sculpted stelae or buildings between the middle of the fifth century and the beginning of the sixth century AD.

After this passing upheaval, architects all over Maya country began to work again with renewed energy and unquenchable creativity. Everywhere, from the Petén to Yucatán, they built bigger and better cities than ever before. One of the reasons for the greater homogeneity of Puuc buildings may be the fact that these were constructed afresh, while those at Tikal, for example, were built over existing edifices.

I shall return to such chronological questions in the light of the latest research, when discussing the problem of the correlation of the Maya and Christian calendars. This thorny question has long preoccupied spe-

144 General view of the north sector of Uxmal in Yucatán, from the terrace of the Governor's Palace: in the left foreground is the ball court; in the centre the Nunnery; and on the right, the Pyramid of the Magician. These Puuc-style buildings stand against a flat landscape whose sole relief is provided by man-made terraces.

145 North side of the Great Pyramid at Uxmal: a broad stairway, bordered by tiers on either side, runs up to a sanctuary with a single doorway. The building, which underwent many alterations and dates from the seventh and eighth centuries AD, was recently restored.

146 Archway to the Pigeon Quadrangle at Uxmal: the palace on the north side of the court is topped with triangular latticed roof combs of a type unique in Yucatán.

cialists in pre-Columbian civilizations, even leading some to doubt the validity of the results obtained by radiocarbon dating.

Uxmal: an architectural apotheosis

The city of Uxmal, in northern Yucatán, was not discovered by archaeologists, as it had been well known since the Conquest. From the sixteenth century onwards, it was visited and admired by the Spanish, then by successive travellers like Stephens and Catherwood, who were enthusiastic about its architecture. Excavation and restoration began in 1943, and Alberto Ruz worked on the site in 1951 and 1952.

Uxmal was never forgotten because, unlike sites in the Petén and Usumacinta regions, it had not been abandoned before the arrival of the Spanish, and is not located in an area prone to devastation by the tropical jungle. After being adapted by Toltec invaders in the tenth century, and belonging to the Mayapán League, Uxmal survived the collapse of Mexican domination in the thirteenth century, and endured until the first conquistadors landed in the sixteenth. The Spanish organized fruitless campaigns against the Xius of Uxmal in 1527 and 1531; but after two insurrections, in 1546 and 1547, the latter finally succumbed to their invaders. At the time of the Conquest, the Xius tribe was one of the most powerful in the Maya world, then torn by dissension and civil wars.

Whatever finds may yet emerge from the Yucatec jungle, Uxmal will remain the crowning achievement of Maya builders. The breadth of its vistas, its aura of monumentality, the extraordinary planning of its ceremonial centre, and the great quality of its edifices, which combined sobriety with profuse geometric decoration—everything about Uxmal exerts a special appeal. And the experience of being faced with its grandiose palaces and temples for the first time is indescribable.

No other Maya urban centre, perhaps, can produce the same effect on the visitor. This is partly because the surrounding vegetation of dense brush has caused less damage and been more easily controlled than the virgin forest. Thus extensive areas have been cleared and it is possible to take in, at a glance, monuments that are sometimes very far apart. One is free to contemplate the juxtapositions of white limestone complexes that seem to have been poised on the green carpet of meadows.

But a further reason is the startling modernity of the buildings, with long horizontal slab shapes built on platforms reached by broad flights of monumental stairs, vistas enhanced by series of pyramids, and a symbiosis of architecture and landscape that serves to exalt the vastness of the surrounding plains. The palace buildings, moreover, are surprisingly restrained, with straightforward square doorways at rhythmic intervals along the lower façades. Above, projecting friezes bordered by mouldings and overhanging cornices emphasize the general horizontality of line. Lastly, mansard roofs are here replaced by strict rectangularity: there is no longer any trace of an incline on the upper parts of buildings (which reduced their weight) or of roof combs. They are replaced by pure, clean-cut volumes.

147 Stairway on the west side of the Pyramid of the Magician at Uxmal: its breathtakingly steep steps are bordered by a series of masks of the rain-god Chac. At the top is a Chenes-style façade entirely covered with mosaic motifs glorifying Chac. In the background stands the Pyramid of the Old Woman, still entangled by vegetation.

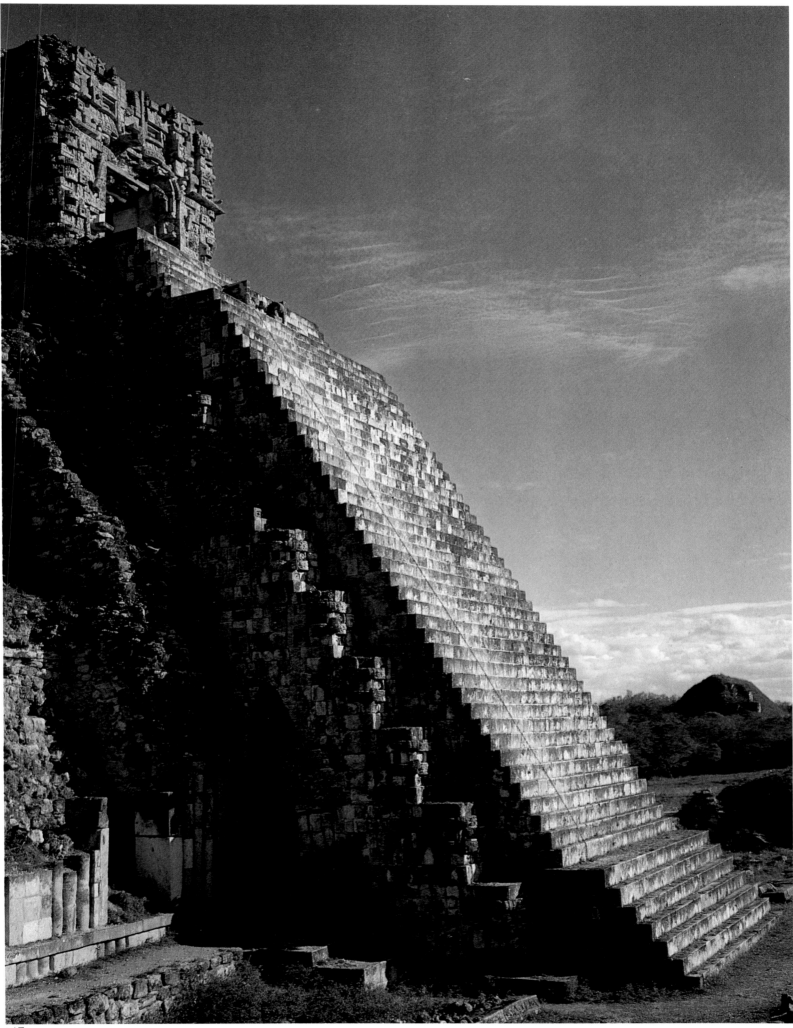

Similarly, the decoration no longer represents ritual or festive scenes with individuals wearing hierarchic insignia, as on the stelae at Copán and Yaxchilán or in the stucco work at Palenque, but restricts itself to geometric ornamentation. All that can be discerned is a schematic mask of Chac, the rain-god, repeated interminably along ornamental friezes imitating the wooden openwork of ordinary huts. As we shall see, this allusion to traditional huts became a leitmotif on the friezes of certain palaces, demonstrating that their permanence, as buildings, was viewed as a petrification of forms that were originally created from perishable materials, such as pole-and-thatch.

Planning the centre

The architects of Uxmal took full advantage of the flat spaces at their disposal. Unlike the buildings of the Usumacinta region, grouped around temples perched on hillocks, Puuc structures such as those at Uxmal are erected on huge, entirely man-made platforms, which raise the level of the complexes and form distinct groups.

Thus, Uxmal is a centre made up of a series of groups, each with its own organic unity. The buildings are generally arranged in huge quadrangles consisting of four palaces. But the palaces are free-standing and the quadrangles open-cornered, so the space they surround is not enclosed. The lack of alignment at the ends of the buildings creates a discontinuous layout, which enables each palace to preserve its entity and also provides access to the courtyards. The quadrangles, then, are truly the conjunction of four different edifices, and not the sum of various masses to form a surrounding gallery of the kind we saw at Palenque. The palaces, too, are composed of cells based on the design of popular huts, and not porticoes intended for ritual processions or displays of pomp by the ruling oligarchy.

The groups usually combine a series of palaces with a pyramid. The vertical inflexions of the temple were contrasted to the long, flat, horizontal buildings which housed the dignitaries. It is even possible to observe an opposition between the 'empty' space of the courtyard or patio and the 'full' volume of the pyramid. This dialectic of expressive modes is fully developed at Uxmal.

If we examine how the groups are related to each other, it emerges that virtually all Uxmal buildings are oriented in a way that does not correspond with the cardinal points. The great majority of the groups of pyramids and palaces are arranged along a north-north-east to south-south-west axis. This orientation varies slightly from building to building, particularly in the case of the largest palace on the site, the Governor's Palace, oriented most strongly towards the south-west. There can be little doubt that such an orientation, which governs a ceremonial complex measuring 1000 by 600 metres, and which is especially marked in the pyramids (with almost no exceptions), must be due to a deliberate design.

The architectural historian Horst Hartung has suggested that Uxmal may have followed a plan based on lines of sight going from one building, doorway, or stele to another. His hypothesis, which is at times convincing, shows connections and intersections between buildings which are often widely separated. But it exposes neither the mechanism of

Plan of the ceremonial centre at Uxmal
(Yucatán)

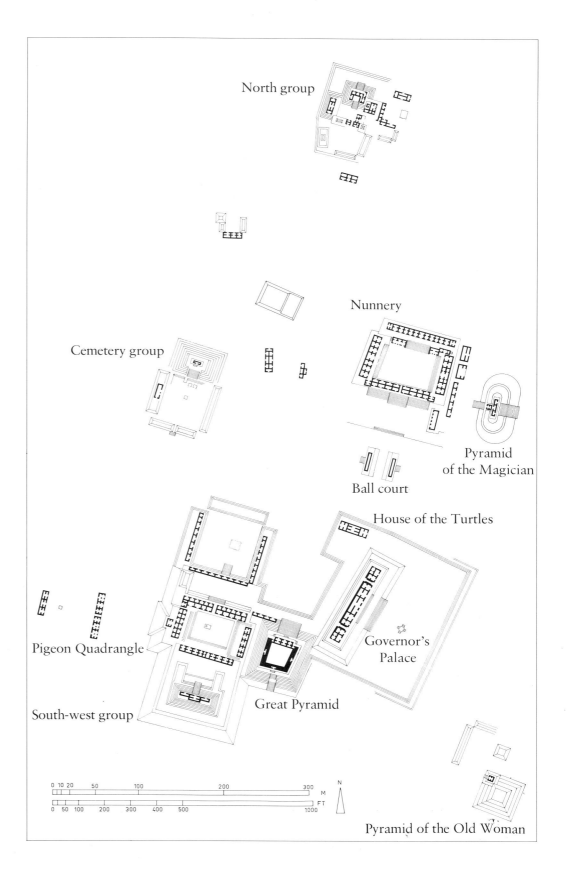

North group

Nunnery

Cemetery group

Pyramid
of the Magician

Ball court

House of the Turtles

Pigeon Quadrangle

Governor's
Palace

South-west group

Great Pyramid

0 10 20 50 100 200 300 M
0 50 100 200 300 400 500 1000 FT

N

Pyramid of the Old Woman

these relationships nor their purpose in the minds of the planners. Hartung restricts himself to observations that were perhaps founded on celestial lines of sight. He offers interesting examples but they do not in themselves explain why such a plan was adopted.

It is easy to see, for instance, that one side of the quadrangle in the Nunnery at Uxmal (the inner façade of the south building) provides a line of sight that runs straight from that building eastwards along the south wall of the east palace, and up the stairs of the Pyramid of the Magician to the Chenes doorway of the temple at the top. But can this

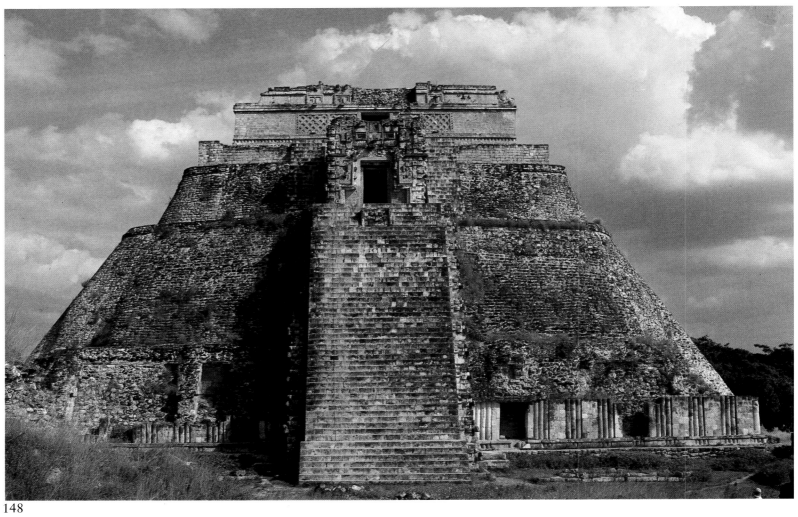

148

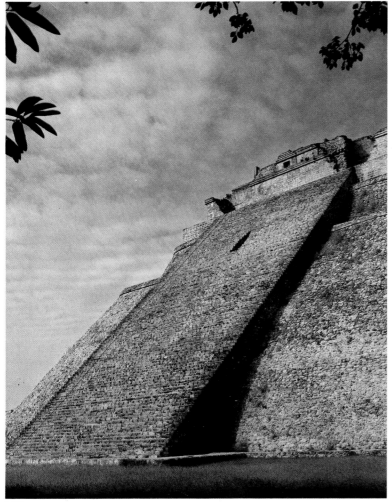

149

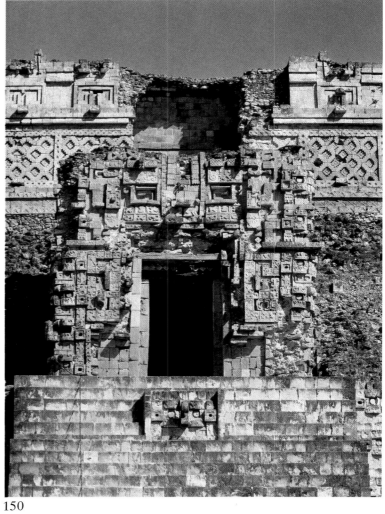

150

fact be used to deduce some motive or plan for the relationship between the Nunnery and the Pyramid of the Magician? The alignment may well owe to more than chance—but to what?

Likewise, a straight line can be drawn from the middle of the ball court, through the archway entrance of the Nunnery's south building on its axis, across the quadrangle and up the stairway of the north palace to one of its doorways. But the line does not lead to the doorway of the building's central chamber, or even pass through the axis of the stele standing in the middle of the stairway. In sum, there are striking coincidences, but it is difficult to guess how they could have formed the basis of a plan for the Maya builders of Uxmal.

All this shows how little we still know about Maya architectural planning and the laws that governed it. Even in the case of Uxmal, a centre that apparently has a greater homogeneity of design, and was built less gradually, than Tikal for instance, the answer escapes us. Similarly, it has so far proved impossible to detect the 'governing plan' behind the composition of the façades. Thus, the symmetric spacing of the openings in the three sections of the Governor's Palace, or in the east palace of the Nunnery, is based on an alternation of solid and hollow parts, whose rhythm remains a mystery. 'Normal' rules are not obeyed; the interplay of proportions is different from what we would expect. Yet, miraculously perhaps, there is harmony.

The main groups at Uxmal

Analysis of some of the architectural groups that are characteristic of Uxmal art may throw light on the subtlety of expression to be found in its buildings. I shall examine the group with the Nunnery and the Pyramid of the Magician, the esplanade containing the Governor's Palace and the House of the Turtles, and the ball court between the two groups. I shall then describe the Great Pyramid bordering the Pigeon Quadrangle, next to the unrestored south-west Temple. This leaves aside the North Group, the Cemetery Group, and the South Group dominated by the Pyramid of the Old Woman: all are insufficiently restored to reveal the aims of their architects except from the ground-plan. It should be noted that the odd names of buildings have nothing to do with their original purpose, but were invented by Spanish friars.

The most complete group at Uxmal is the well-preserved and remarkably restored Nunnery, overlooked by the Pyramid of the Magician. The latter, immediately visible to anyone approaching the site, has the shape of a truncated cone and is almost oval in plan, with smooth steep sides that must have been stuccoed or painted. A great stairway runs, in a single flight, up the east side of the structure to the back wall of Temple IV at the top, some 30 metres above the ground.

The pyramid consists of a series of overlaid structures. The east stairway was built over earlier steps which led to an older sanctuary, Temple II. This construction contained one room to the east and two to the west, topped by a roof comb that has since been engulfed by the overlaying process. The Chenes façade forming a kind of vestibule, or Temple III, now reached by the very steep west stairway, was originally built in front of the west entrance of Temple II, which used to be reached by steps now overlaid by the present stairway.

148 Front view of the west side of the Pyramid of the Magician: the stairway rises to the Chenes-style entrance which leads into Temple II. Above it is the Puuc-style upper temple, with a doorway to Temple III.

149 Stairway on the east side of the Pyramid of the Magician at Uxmal: three-quarters of the distance up this great stair, archaeologists dug into the pyramid and found the rear chamber of Temple II, which had been obscured during the final superimposition.

150 Detail of the Pyramid of the Magician: this Chenes-style façade consists of an immense Chac mask, its mouth represented by the doorway leading into the vestibule of Temple II, and its eyes by recesses above. A small Chac mask on the last few steps of the west stairway forms a kind of sacrificial altar in front of the entrance.

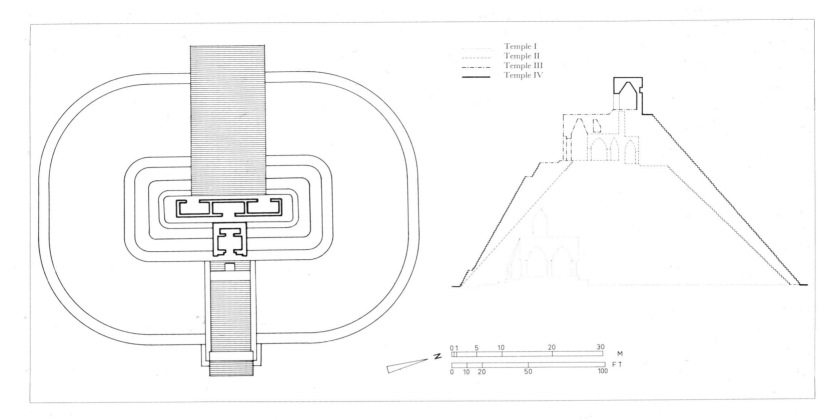

Temple I
Temple II
Temple III
Temple IV

0 1 5 10 20 30
 M
 F T
0 10 20 50 100

Plan and section of the Pyramid of the Magician at Uxmal

This complex and rather unorganized creative process took place over a period of time. It was clearly of interest to archaeologists to establish exactly when the process started. Luckily they found, buried in masonry at the foot of the pyramid, an even earlier sanctuary, Temple I, which contained an intact sapodilla-wood lintel. The wood was subjected to radiocarbon analysis in the laboratories of Yale University. The results suggested that Temple I dated from about 569 AD. So, thanks to nuclear physics, we know that the Maya buildings at Uxmal (and Puuc structures in general) are almost certainly much older than the date previously ascribed to them (ninth or tenth century). This estimate is confirmed independently by datings obtained by Ruz and Thompson for the ball court on the basis of hieroglyphic inscriptions.

Overlooked by the massive pyramid is the Nunnery, an extremely sophisticated construction. The group consists not only of four palaces around a courtyard, but of a series of subtly graded progressions, or tiers, on several levels. When one approaches the group from the direction of the ball court to the south, one is faced with a broad stairway (not yet restored) running the whole length of the south building. This monumental stairway rises 6 metres to a corbelled Maya archway in the centre of the palace.

This triumphal arch in the façade, which is 70 metres wide and is also broken by eight cell doorways (four on either side of the arch), leads into a huge trapezoidal courtyard measuring about 60 by 48 metres (the average length of its opposite sides). Stairways, 2 metres high, on the right and left sides of the courtyard, ascend to two palaces, respectively 53 and 48 metres in length. These have different numbers of entrances (five and seven), yet give an impression of symmetry. Neither the style nor the ornamental motifs of their friezes, however, resemble each other in the slightest. These two palaces stand on each side of the north building, which rises 6 metres above the courtyard. A third stairway, flanked on the right and left by porticoes of different sizes, and in whose middle stands a badly eroded stele, leads up to it. The north palace not only

151 Sculpture from the upper temple of the Pyramid of the Magician: this fine work, 80 cm high, and carved out of Yucatán limestone, represents a priest with a tattooed face emerging from the stylized jaws of a great serpent. It probably dates from the ninth century AD, and marks the introduction into Maya country of the highland god, Quetzalcoatl, who became the much-venerated Kukulcan of Chichén Itzá after the Toltec invasion of Yucatán (National Museum of Anthropology, Mexico City).

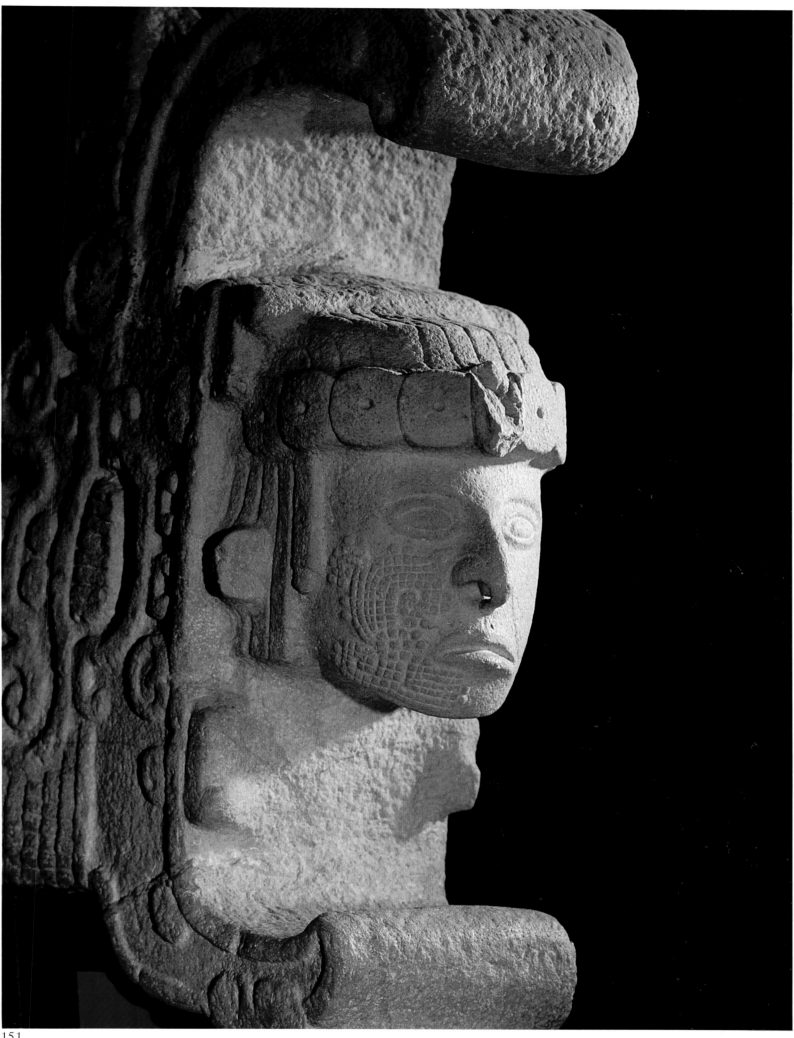

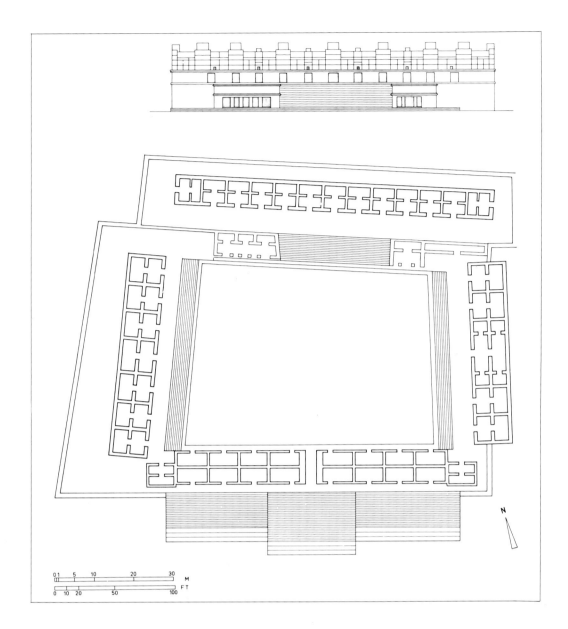

dominates the whole group, but is bigger than the other buildings—81 metres long, with eleven doorways in its façade.

The lack of right angles in the arrangement of the group, and the disparity between the buildings on the sides of the quadrangle, result in an asymmetric layout. Yet because the pattern is well balanced, there is an illusion of symmetry. Each façade has an uneven number of openings and a doorway in its centre. There is also a clear hierarchy between the four buildings: the south palace is the lowest (with a cornice 6 metres high) and built on the same level as the courtyard, whereas the structures to the east and west are built on platforms 2 metres high and rise a further 8.5 metres from that level. Lastly, the north palace, whose base stands 6 metres above the courtyard, is 8 metres high along most of its length, while the upward-projecting elements on its façade (vestigial roof combs) rise to a height of 11 metres, or 17 metres above the courtyard.

It will be seen that this tiered progression upwards, obeying no systematic plan, produces a dynamic space in the open-cornered courtyard with subtle side vistas, non-alignments, and irregularities. Whether these are due to skilful calculations, or to chance juxtapositions of buildings in the course of successive construction programmes, is hard to tell. Whatever the case, the architects of the Nunnery took advantage of the

146

Transversal section of the east palace of the Nunnery at Uxmal

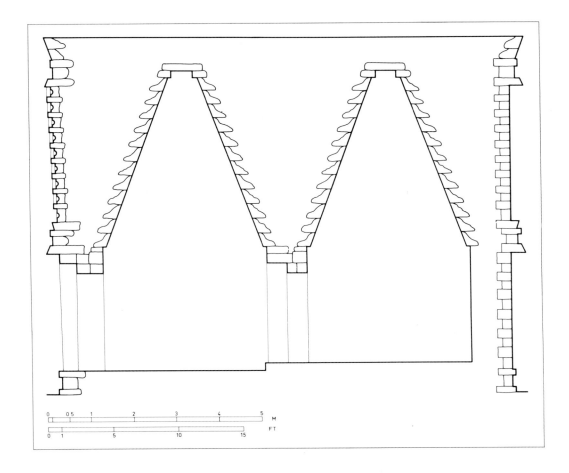

most favourable orientation for the play of light on the friezes, and showed themselves masters in the use of variables to produce spatial harmony without rigidity or monotony.

The ball court at Uxmal resembles those at Copán and Piedras Negras in its proportions, vaulted lateral chambers, and faintly inclined playing surfaces. The court is oriented exactly at right angles to the south palace of the Nunnery and, as already pointed out, its axis runs straight through the monumental archway leading to the quadrangle. Excavations by Alberto Ruz, and in particular the hieroglyphic inscriptions found on the stone rings of the markers, have made it possible to determine the age of the structure. In collaboration with Thompson, Ruz ascertained a date that corresponds to 649 AD. The axial relationship between the ball court and the Nunnery means, according to Ruz, that the two buildings were coeval. This would imply that, at least in the early stages of its construction, the Nunnery goes back to the seventh century—two centuries older than previously estimated.

Embracing the whole structure of the ball court is a decoration which represents a huge feathered serpent. It is achieved by means of a sculpted torus, laid out along the interior walls of the playing area. This serpent is a late addition, dating from the time of the Toltec domination in Yucatán, at the end of the tenth century or in the eleventh. A similar addition is to be found on the west palace of the Nunnery, where the frieze, originally decorated with Puuc-style geometric motifs, has undergone alterations. A strip of stone relief overlaid between the existing motifs has produced a huge feathered serpent that covers the façade. A human head can be seen in its gaping mouth. Sculptures in the round, representing standing figures, complete this series of Toltec additions, which were undoubtedly responsible for the late date originally ascribed to the Nunnery.

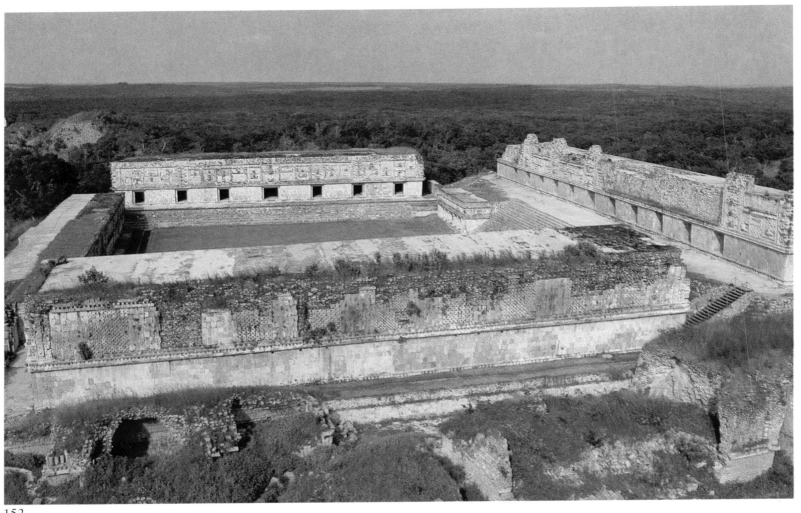

152

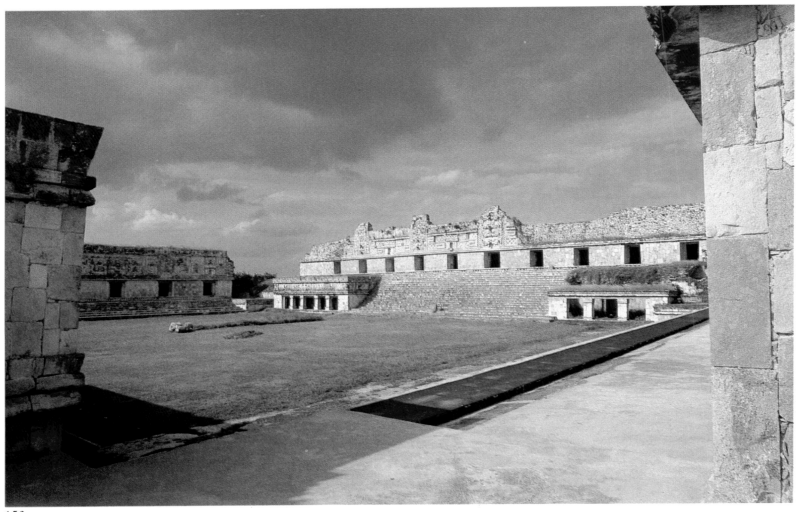

153

We now move south to the great esplanade, overlooking the ball court, with the House of the Turtles and the Governor's Palace. This gigantic platform, measuring 180 by 154 metres, about 12 metres high on its north side and as much as 17 on the east, is a man-made structure. But Alberto Ruz records that, during excavations underneath the two-headed jaguar seat in the centre of the esplanade, he found natural rock only 1 metre below the ritual platform. Evidently, its siting was chosen because of a stretch of higher ground overlooking the plain. Still, most of the materials making up the esplanade were transported there, amounting to several hundred thousand cubic metres, and weighing perhaps a billion kilograms.

Built on top of this colossal foundation is a further platform, measuring 122 by 27 metres and 7 metres high. Atop it is a third and smaller platform bearing the vast Governor's Palace. This admirable building is reached by a monumental staircase consisting of three flights, the first of which presents the subtlety of having deeper steps and, therefore, a less steep slope. About 100 metres long, 12 metres deep, and 8.60 metres high at the top of a cornice, the building is made up of three parts: a middle section 55 metres long, flanked by two symmetric wings, to which it is connected by two large transversal archways (these were subsequently blocked and fronted by columned porticos). The front façade has 11 square doorways (two in each wing and seven in the central section); each of the side façades also has an entrance. These 13 doors lead to 20 rooms arranged in two-deep rows, as is the case in most Maya buildings.

In the centre of the Governor's Palace is a very large room, which alone has three façade entrances. It measures 20 metres long and 4 metres deep, while its powerful triangular roof vault rises to 8 metres. Its rear door leads into a room of the same dimensions but, with no further entry, quite dark. These dimensions are considerable when compared to other major Maya buildings. The front room must therefore have been used as a courtroom or council chamber by the dignitaries of Uxmal and their 'vassals'.

The unadorned walls of the façades, in which the doorways are set, rest on a vigorously modelled plinth of two stone string-courses, between which is a rhythmic alternation of smooth recesses and motifs made up of close-set colonnettes. Halfway up the façade, running round the building, is an *atadura* (binder) moulding that imitates the fibre ropes tying trusses of thatch on traditional huts. Between this moulding and the cornice at the top, an immense frieze unfolds, broken only by the two great archways connecting the sections of the building. The geometric motifs of this limestone mosaic frieze include step-and-fret, alternating with Chac masks against a latticed background. The Chac masks undulate diagonally across the façades, and are superimposed on the corners of the building.

Although the Governor's Palace is in relatively good condition, accurate calculation is difficult because some parts of it have been restored and others are missing. But apparently there were 260 masks and 104 key frets. If so—and assuming that the pre-Columbian step-and-fret design is bound up with solar symbolism—then the frieze on the building represented the alternation between rain and sun. The intricate, almost interlaced metaphorical motifs on the frieze symbolize the inexorable cyclical rhythms of time at a cosmic level. For they combine a

152 Nunnery at Uxmal seen from the top of the Pyramid of the Magician: the group of white palaces making up the Nunnery is perhaps the most original architectural creation of the Puuc style. Their long horizontal lines blend perfectly with the flat natural landscape.

153 North palace of the Nunnery, seen from the south-west corner of the group. A large stairway, flanked by porticos, leads up to the palace, part of whose mosaic decoration has collapsed.

154 East palace of the Nunnery: the undecorated part of the façade, with five doorways, is bordered at top and bottom by mouldings of close-set colonnettes. The frieze, of crosspieces imitating wicker trellis-work, is enlivened by superimposed double-headed serpents.

155 Detail of the frieze on the north palace of the Nunnery: a thatched Maya house is represented between key frets and double-headed serpent motifs.

156 Present-day Maya hut: even now, the Maya of Yucatán live in houses identical to those of their ancestors 1000 or more years ago. There is only one opening in the façade, while the walls, rounded at the ends of the hut, consist of branches covered with mud and surmounted by a thatched roof.

157 Interior of a typical Maya house at Muna, near Uxmal: the inner space of traditional habitations inspired the form of Maya vault found in palaces. The order and cleanliness of Maya villages show that not all their customs have been lost. Here a young woman is making a hammock.

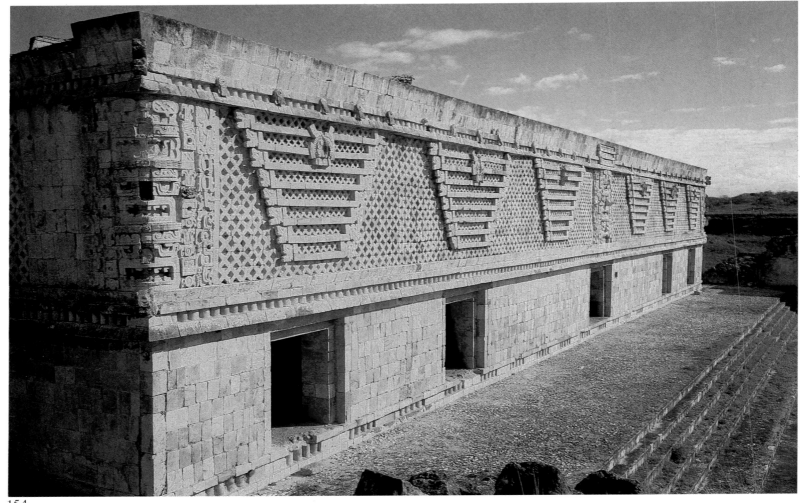

154

155

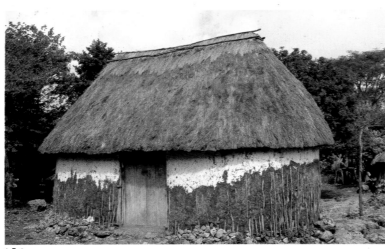

156

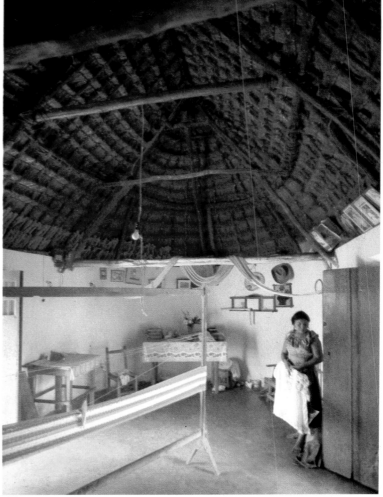

157

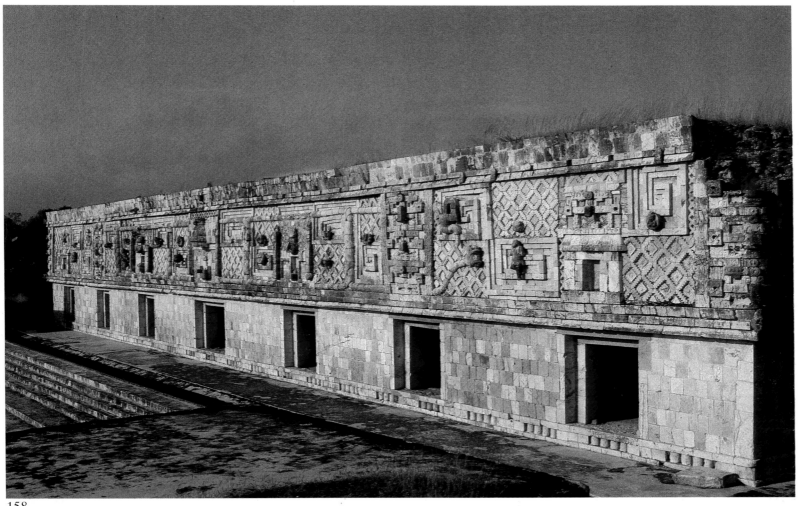

158

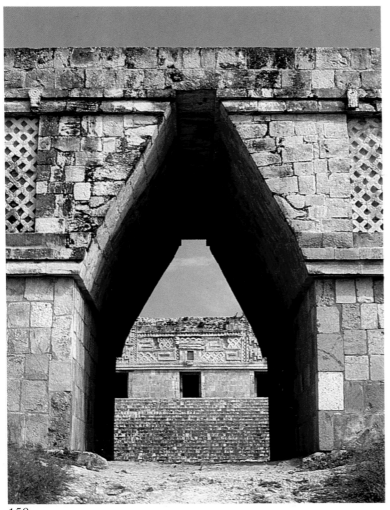

159

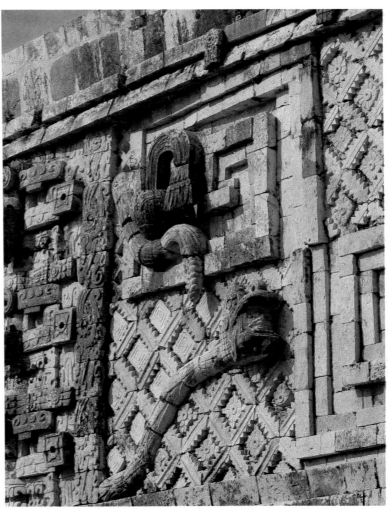

160

reference to the sacred year of 260 days with a direct multiple of the 52-year period that made up the 'century' of the pre-Columbians.

Careful examination of the edifice shows that both the foundations and the cornice are very slightly curved, with the result that its centre is higher than its extremities. If this were due to a subsidence of the platform under the great weight of masonry, the mass of concrete in the vaults would show cracks—which is not the case. It would seem rather that the architects of the Governor's Palace deliberately chose to employ the same optical laws that led the ancient Greeks to curve the platforms of their temples—in other words, to provide a visual correction to the appearance of central sagging that would otherwise have marred such a long building.

In strong contrast with this grandiose, glaring white façade (it probably once had polychrome decoration), the dark interior rooms are well shielded from the sun and, consequently, cool. Similarly, perched as they are on platforms above the surrounding plain, the Maya palaces of dignitaries must have felt the benefit of the gentlest breeze.

As already mentioned, the spacing of the doorways in the façade of the Governor's Palace does not follow a simple pattern. It obeys a symmetric, alternating design of great subtlety. The lengths of the full panels between the door recesses, for example, seem to be determined by proportions based on the numbers 4, 5, 7, 8, and 9. The same holds true for the façade's vertical proportions, between the plinth, the undecorated surface, the frieze, and the total height. These relationships are difficult to define, but the balance of the monument is such that there can be no question of its not being based on a highly sophisticated aesthetic system.

The rectangular House of the Turtles, set slightly back from the Governor's Palace, at an angle of almost 90 degrees to the north, does not stand on a platform. Its longer façade runs along the edge of the vast terrace, so only its shorter end façade—an admirably balanced and harmonious piece of architecture—is visible to anyone standing on the terrace. It therefore resembles a Greek temple more than a Maya palace, in that its end façade is the chief feature. The façade has three doorways of different sizes; much as in the Governor's Palace, a large central entrance is flanked by two smaller ones. Its decorative frieze is sober: an *atadura* moulding juts out from the wall, dividing the façade into two halves, a smooth base and an upper part with a rhythmic series of close-set colonnettes.

This plastic idea is reminiscent of a Khmer device in south-east Asia, of placing a grating of balustrades in front of gallery windows. (There are other parallels between these two jungle architectures, such as corbel-vaults, and temples atop pyramids.) Over the close-set colonnettes of the frieze, and on the side of the powerful cornice which repeats the smaller forms of the *atadura* moulding, is a succession of high-relief turtle motifs. Here again the interplay of proportions is perfect. The modest base, bare façade, moulding halfway up, frieze of columns, and cornice together produce a grace that never lapses into prettiness. Clearly, then, Maya architecture at Uxmal ranks with the greatest in the world, whether on a limited scale as in the House of the Turtles, or of considerable size as in the Nunnery and the Governor's Palace.

The Great Pyramid makes up a unit with the Governor's Palace, but is older since its base goes below the esplanade level, and its stairway orig-

158 Façade of the west palace of the Nunnery at Uxmal: its seven doorways are topped by a rich frieze, in which house motifs and key frets alternate with Chac masks. The great serpent whose meanders run along the frieze is an addition made in Toltec times, when the cult of Kukulcan emerged.

159 Triumphal arch in the middle of the south palace of the Nunnery: in the background is the north palace with its broad stairway.

160 Detail of the frieze on the west palace of the Nunnery: it is easy to detect the late additions of the great Feathered Serpent—the rattlesnake's tail with horny rings can be seen here, and below it a human face emerging from its open jaws. This is the Classic Maya theme of a god issuing from the earth, now given fresh life with the god Kukulcan, who derived from Quetzalcoatl of the Mexican highlands.

161 One of the porticos with square piers flanking the stairway of the north palace of the Nunnery: the structure supporting the vaults has been considerably lightened.

162 Interior of the portico with square piers: three doorways lead off the back of the gallery into dark, cool rooms.

163 Chac masks on the south corner of the east palace of the Nunnery: Chac, the long-nosed god and symbol of rain for the Yucatec Maya, is shown with a curiously hooked nose whose origin and meaning have not been elucidated.

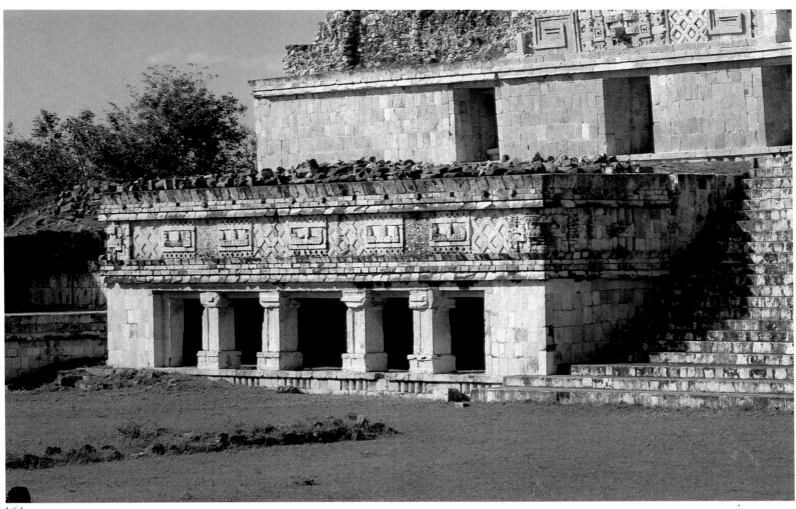

161

162

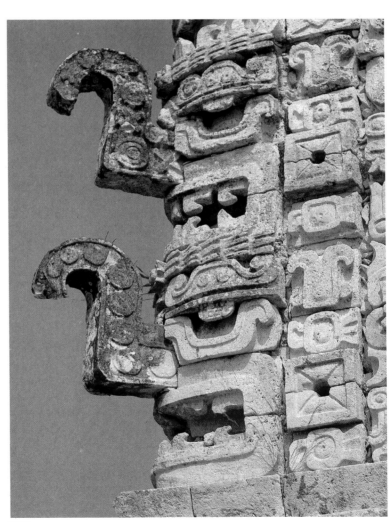

163

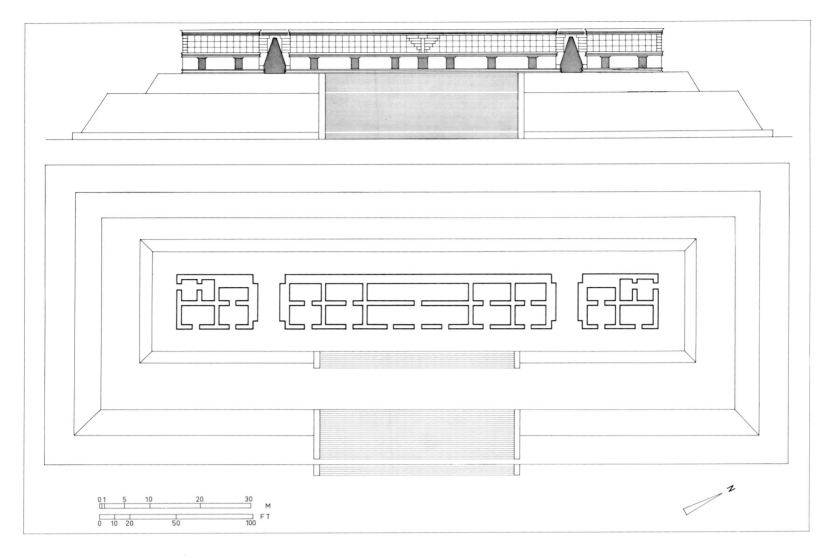

inally went down to actual ground level. Excavations to the west of the first terrace of the Governor's Palace revealed a small, badly damaged Chenes-style building that must once have been allied to the Great Pyramid and was subsequently encased. The stairs leading to the upper temple of the pyramid have tiered parapets, recently restored along with the façade of the temple itself. In the latter case, hasty work has produced some regrettable results—decoration blocks with bird motifs were even reassembled upside down—owing to the demands of tourism rather than to archaeology.

West of the Great Pyramid, whose layout is no more orthogonal than that of the Nunnery, stand the ruins of a vast complex built on a platform of tiered terraces. Its northernmost part must have contained a quadrangle. A building on the north side of that quadrangle was either not preserved, or never erected. The sides of the quadrangle and its south building, which is badly ruined, held only a single row of masonry chambers.

The most imposing section of this complex is the Pigeon Quadrangle. Like the Nunnery, it is entered by a large archway in the centre of a palace, originally reached by a wide stairway (not restored). The court was flanked by two raised palaces and closed, to the south, by a fourth palace now totally in ruins. Continuing in the same direction, we come to the south Temple, a broad pyramid surrounded by further palaces.

The entire complex, whose three successive courts are bordered by buildings used partly as noble living quarters and partly for worship, is almost 300 metres long. Its architects must, like the designers of the

Nunnery, have made full use of its different levels, tiers, vaulted passages, and sweeping vistas. The Pigeon Quadrangle is named for the curious latticed structures, in the form of triangular roof combs like dovecotes, which served in a unique decorative manner to lighten the bulky outline of the palaces.

Maya building techniques

We have seen that some of the artificial platforms built by the Maya as foundations for their architectural groups contained as much as a billion kilograms of material. As in the case of similar achievements by the Olmecs, particularly at San Lorenzo, it will be remembered that, in the absence of wheeled vehicles and draught or pack animals, these gigantic amounts of earth had to be transported by man. The sheer volume of the structures built in this way must have required a labour force running into thousands of unskilled workers. During the dry season when farming was impossible, peasants were transferred to the building sites. The magnitude of the task would have necessitated decades of effort by seasonal labourers, while skilled workers toiled permanently on the sites. Maya cities seem to have been in a continuous state of flux, as buildings were overlaid or expanded, and new groups of structures proliferated outwards from the centre.

I have pointed out that Maya vaults were achieved by mixing rubble with mortar to obtain a kind of concrete. It is this feature of what is otherwise monolithic architecture that has been responsible for the survival of Yucatán buildings in relatively good condition. In such a vast limestone region there was no difficulty in finding the raw materials. Lime mortar was manufactured as follows: chunks of broken limestone were placed on a huge circular pile of firewood, 4 to 5 metres wide and over 1 metre high, then burnt to produce quicklime. Although the method was primitive, the resulting mortar was very tough.

The technique of mounting stone slabs, vaults, and walls generally involved formwork. Thin plates of stone, to be left as facing on the façade, were carefully cut into shape, next matched and fitted together to form an even surface. But these plates had a rough-hewn, irregular protuberance at the back which served as a tenon. Successive courses of facing stone were mounted, then grouted with concrete. Once the concrete had set, only its formwork of stone remained visible, as a smooth veneer fixed to the core of the building.

The same method, when applied to Maya corbel-vaults, needed considerable masonry, as at least two thirds of the total volume of buildings consisted of full masses with no hollow space. This particular characteristic lends Maya architecture its solidity. The thickness of the roofs also provided a genuinely cool atmosphere in the rooms, despite the torrid climate of the region, as well as offering reliable protection against the downpours of the rainy season. But there can be no doubt that such building methods were extravagant, involving the transportation of heavy material and the burning of firewood to obtain lime.

Yet it was a technique admirably suited to the kind of ornamentation found at Uxmal—an elaborate geometry of lattice-work, step-and-fret,

164 Façade of the Governor's Palace at Uxmal: the central section of the building has seven doorways, and is flanked by two wings with two doorways, to which it is connected by two large triangular arches set in recesses along the façade. In the foreground is the building's monumental stairway, before which stands a huge monolithic phallus that must have served as a stele. This undisputed masterpiece of Maya architecture is 98 m long, and probably dates from the eighth century AD.

165 Arch connecting the central section of the Governor's Palace with its south wing: the entrance was seemingly walled off and fronted by two columns, supporting a tall structure designed to hide the recess in the frieze.

166 Room in the centre of the Governor's Palace: this vast chamber, 20 m long, has three doorways, and is roofed by a triangular vault 8 m high. It is the largest interior vaulted space ever built by the Maya, before the renaissance that followed the Toltec invasion of Chichén Itzá.

167 Façade of the Governor's Palace at dawn: the end of the building, 12 m wide, has a single doorway. This noble edifice is decorated with a mosaic frieze consisting of more than 20,000 stone blocks, a remarkable example not only of geometric art but of prefabrication on an industrial scale. From the top of its vast artificial esplanade, the building dominates the rest of the centre of Uxmal.

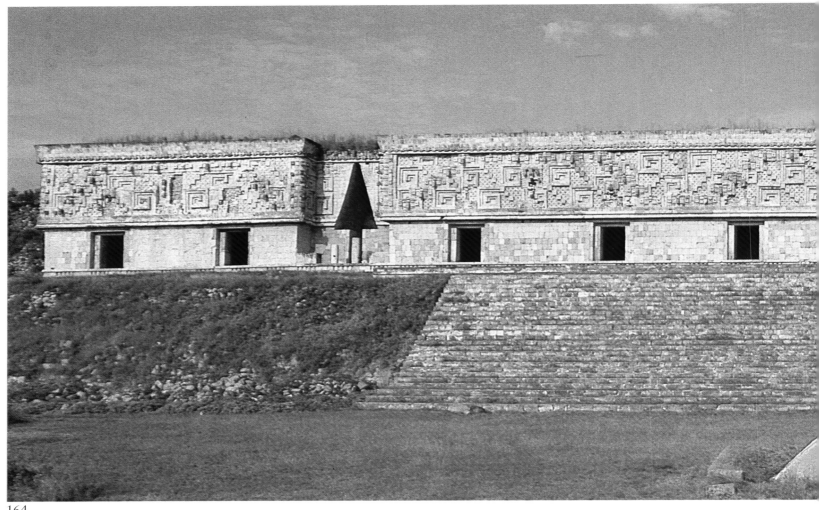

164

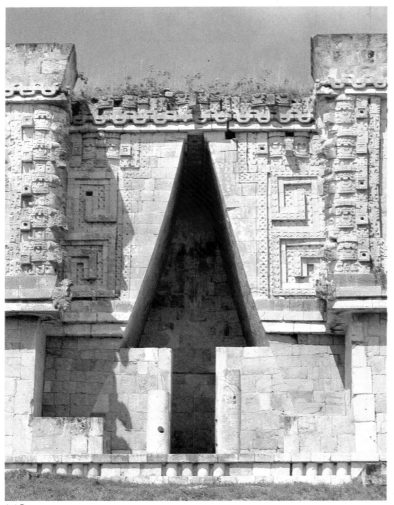

165

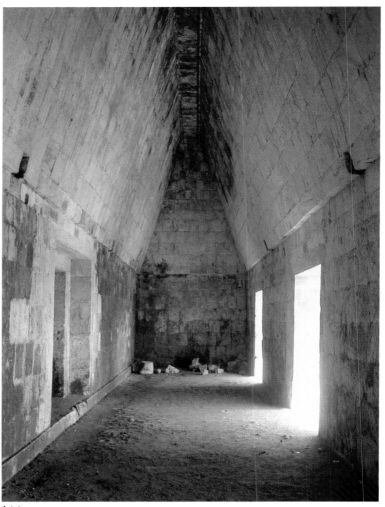

166

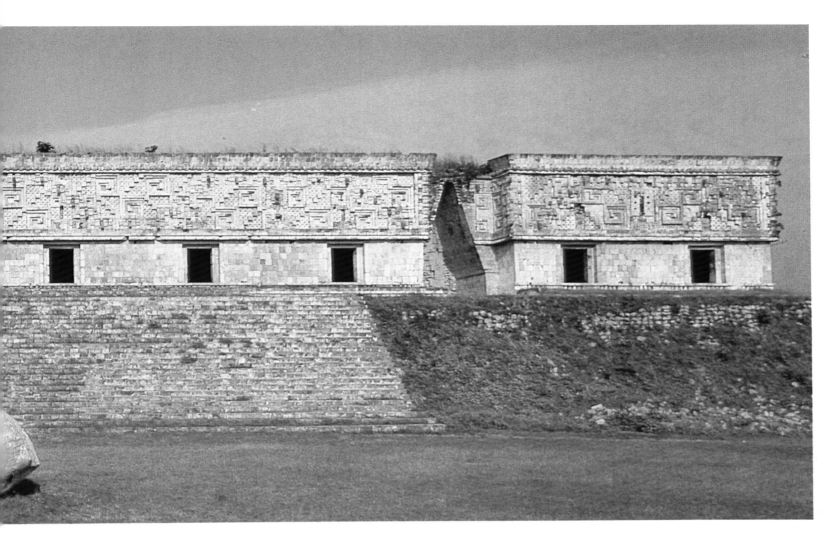

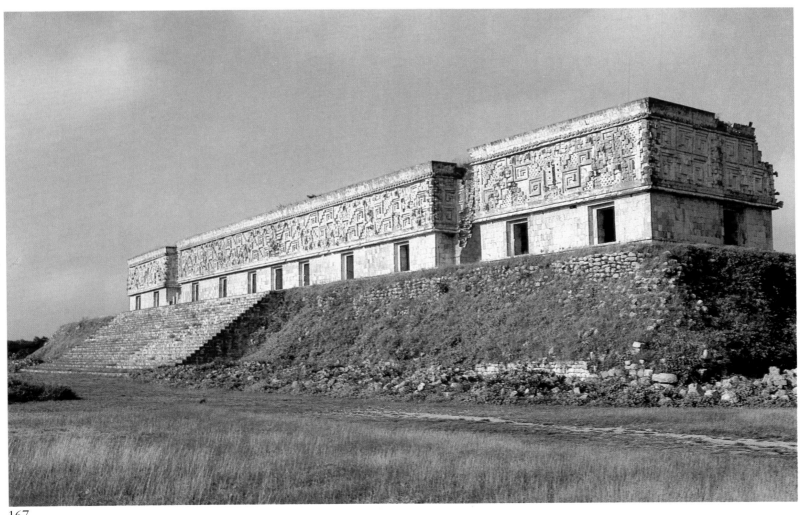

and meanders, combined with never-ending mask motifs, all executed in stone mosaic. By carving the hundreds of stone blocks, already hewn to the required dimensions, before casting the concrete, Maya artists were able to assemble the luxuriant frieze mosaics so characteristic of the Puuc style. Thus, even before the erection of a monument, not only its facing but its decorations were ready for use as formwork.

In order to understand just how original this method was—it involves unexpected technical, artistic, and sociological repercussions—we should examine an example. No building is more relevant than the Governor's Palace at Uxmal, which, as I have said, held no less than 260 Chac masks and 104 key frets on its decorated frieze. The frieze, which runs round the three sections of the building, is more than 220 metres long and 3.4 metres high, covering some 750 square metres. In an earlier book (*Maya*, 1964), I discussed the implications of the techniques used in Puuc decoration, as illustrated by this very frieze. Further field observations have led me to improve the conclusions drawn. Although my original estimates for the number of decorative motifs repeated on the frieze were not great enough, my argument thus seems all the more convincing, and will be repeated here with the necessary corrections.

The background, against which the frieze's motifs of key frets and masks stand out, consists of rhythmic crosspieces imitating latticed wickerwork. It covers slightly more than a third of the frieze's total area, or about 300 square metres. The crosspieces are stone blocks, each with a relief carving of a Saint Andrew's Cross, the motif being repeated by juxtaposition. As the blocks measure roughly 20 by 20 centimetres, their total number on the façade is between 7500 and 8000. Turning to some 260 Chac masks on the frieze, close examination shows that each of them, measuring about 1.2 by 0.6 metres, consists of 20 blocks arranged in strictly symmetric fashion. These mosaic units include: three different units for the nose (which is trunk-like), two identical units for the eyes, two for the eyebrows, two for the lower eyelids, two for the motif above the ears, two for the motif below the ears, four for the ears (each of which consists of two symmetric pieces surrounding the opening of the earhole), and three units for the mouth and its fangs. Hence the sculptors had to carve a total of 5200 pieces with 11 different designs.

The same principle holds for the execution of the frieze's 104 great key frets, string-courses, mouldings, and cornices. Thus, the number of carved stone pieces making up the mosaic covering the frieze of the Governor's Palace is around 20,000—all of which had to be completed before the edifice was even built. The technological implications of a system involving thousands of identical units are staggering. So is the degree of accuracy required for such an enterprise: the slightest error in the dimensions of a block, if only a few millimetres, would result, when repeated hundreds of times, in the frieze being distorted and impossible to assemble.

What we have here is a case of rationalized mass production. One can well imagine a system based on the division of labour, whereby a crew would rough-hew the stone and pass it to more skilled craftsmen, who cut it into final shape. Last in the chain would be the sculptors proper, decorating each unit. Even for these, we may suppose some degree of specialization, with a team carving the eyes or the brows, another the mouths, and so on, according to the skill required in every operation. (The same division can be inferred from the Persepolis bas-reliefs of

168 End façade of the House of the Turtles at Uxmal: the frieze of close-set colonnettes, between an *atadura* moulding and the powerful cornice at top, shows a classic restraint. The only rhythmic element in the bare wall below is provided by its three doors of different sizes. The building probably dates from the eighth century AD.

169 Detail of the House of the Turtles: one of the turtle motifs along the cornice, which give the building its name.

170 Long façade of the House of the Turtles: there is the same rhythm of different-sized doors as on the end façade. In the background stands the Nunnery.

171 Room with three openings at the end of the House of the Turtles: on the right, a room leads into a second chamber in the traditional manner of Classic Maya habitations.

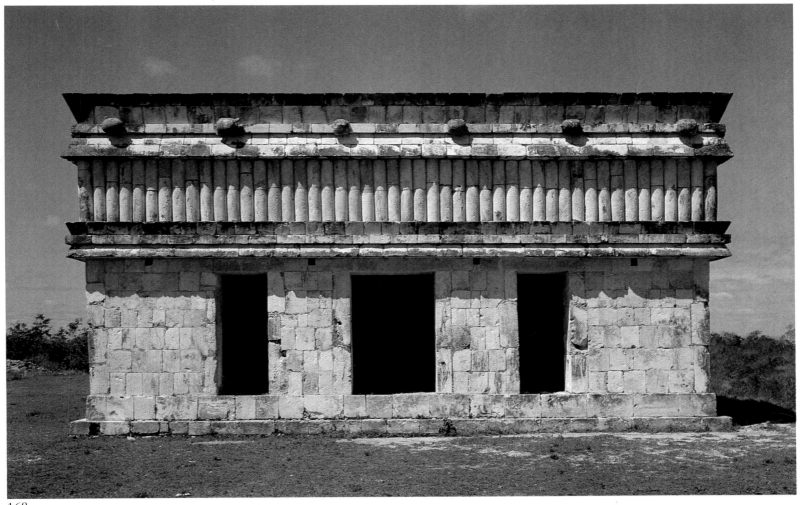

168

169

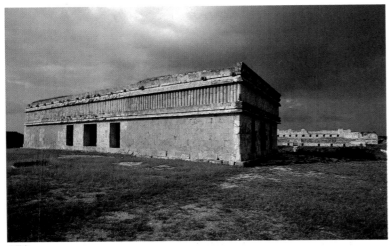

170

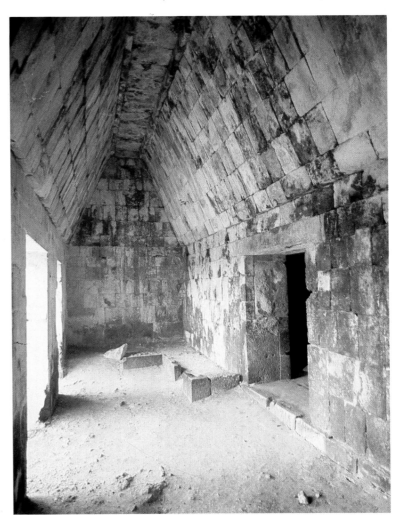

171

ancient Persia, with specialists for headdresses, hair, eyes, or hands.) Thus the Maya must have organized something approaching an assembly line.

What is the significance, in a civilization only emerging from the Neolithic Age, of this process of mass specialization and prefabrication? Should we conclude that the Maya were the inventors of a pattern that has been adopted by modern industrial societies? At least the audacity of their system, the reasoning behind it, and the organization needed to mobilize such technology, tell us much about both the mentality and the social structure of the Maya. They presuppose extraordinary discipline and strict hierarchy.

This evidence helps to illuminate the aesthetic conceptions of the Maya, and the practical consequences of their mathematical speculation and love of huge numbers based on a positional and vigesimal system. But it also reflects upon their 'social pyramid'. At the bottom was a very great quantity of farmers, given unskilled jobs during the dry season. Then came many workers such as quarriers and stone-cutters, who also made lime on open-air kilns, cut down trees, and hewed wooden beams. Above these were the true craftsmen, in ranks depending on length of service and skill, from the stonemason to the sculptor. Next came the traders who, as is known, conducted business between the various Maya provinces, and even voyaged to Central America. Over these stood the warrior caste, commanded by the élite of dignitaries including priests, councillors, astronomers, mathematicians, and architects.

The sovereign and his family occupied the summit of society. He was a kind of 'king' with absolute powers, half man and half god, identified with the destiny of his people. Yet as can be seen from this summary, the Maya hierarchy is fairly typical of the way in which agricultural civilizations are organized.

Further Puuc sites

The whole area around Uxmal is dotted with centres built in the Puuc style. Most spectacular among them are Kabáh, Labná, and Sayil. Kabáh is one of the biggest complexes of monuments in Yucatán, with pyramids, palaces, a triumphal arch and a *sacbe* causeway. It is famous for its Palace of the Masks, also known as Codz Poop, which is one of the strangest creations of Maya civilization. The building, 45 metres long, is constructed on a square terrace about 80 metres long on each side, reached by a flight of stairs. A second, smaller platform supports the palace, whose ten rooms are arranged in two rows and communicate with each other. The building is surmounted by a latticed roof comb of step-and-fret design which stands out against the sky.

The main characteristic of Codz Poop is a large number of Chac masks covering the façade and sides of the building. Not only is the frieze above the binder-moulding decorated with three horizontal rows of 34 masks depicting the long-nosed god, but the lower part of the façade (normally bare in Puuc architecture) exhibits the same relief motifs, punctuated in this case by five doorways. The edifice stands on a

172 Codz Poop at Kabáh: this building, also known as the Palace of the Masks, was covered with 260 stylized effigies of the god Chac. This Puuc monument is, visually, one of the most fascinating in all Maya architecture. It is thought to date from the eighth century AD.

173 The celebrated 'King of Kabáh': this somewhat crude and probably Post-Classic statue is one of the few known examples of sculpture in the round from the Yucatec area (National Museum of Anthropology, Mexico City).

174 Interior of Codz Poop at Kabáh: its two rooms, surprisingly, are not on the same level. The stairway leading to the second chamber is designed as a Chac mask with the long nose rolled up.

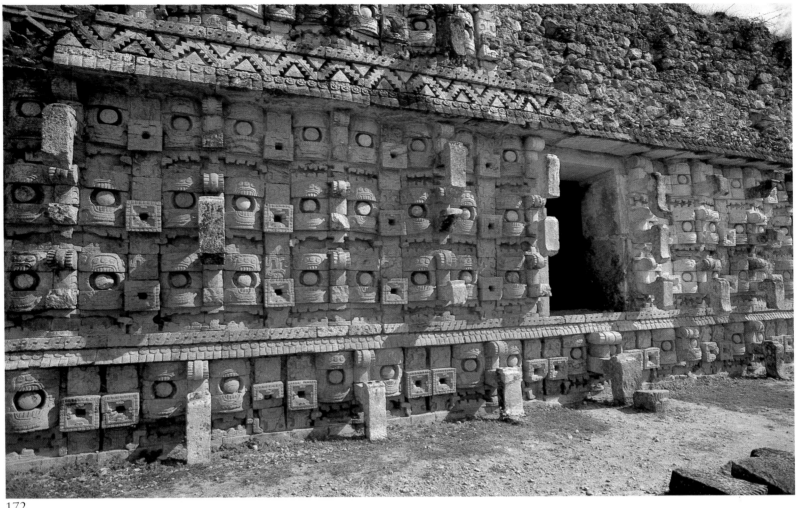

172

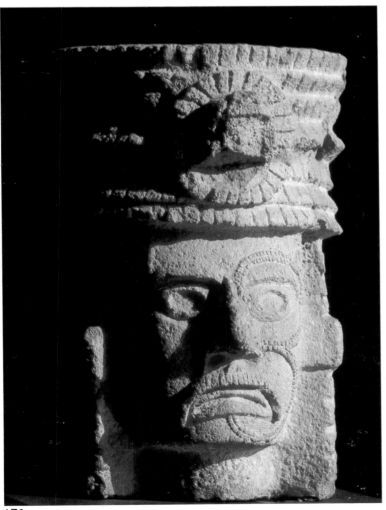

173

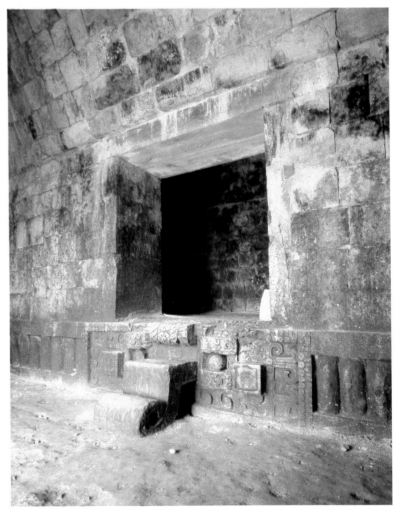

174

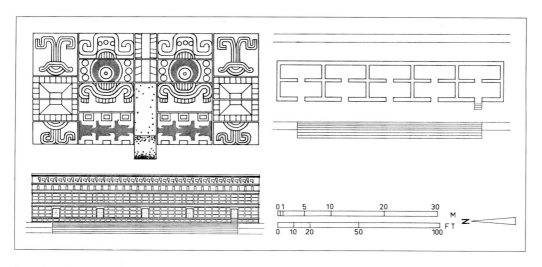

Detail of a Chac mask, and elevation and plan of Codz Poop, or Palace of the Masks, at Kabáh

kind of plinth, also with juxtaposed masks. The corners are adorned by identical motifs, one on top of another as at Uxmal.

Although calculations are difficult, because the upper part of the palace is badly damaged and not yet restored (the pieces of the puzzle lie at its feet), we may estimate that this proliferation of eyes, upturned hook noses, ears, and eyebrows originally added up to some 260 masks—the same number as on the Governor's Palace at Uxmal, and as the number of days in the sacred year. Thus, the association of the rain-god Chac with symbols of the sun—the step-and-fret design running up the roof comb—suggests an interplay of cosmic forces similar to that on the Uxmal frieze.

However that may be, the riot of juxtaposed decorative motifs at Codz Poop, with its serried ranks of masks, has a more startling effect on the visitor than do any of the other Yucatec centres, which are usually distinguished by greater expressive restraint. The site combines the stylized vocabulary of Puuc buildings with the extravagant Chenes style, which can turn a whole façade into the effigy of a god. The result is a fascinating, almost hypnotic effect, like some litany without beginning or end. At Kabáh, the Yucatec Maya symbolized the omnipresence of their tutelary god and created what was in effect an eternal prayer for rain—the rain without which the soil would not bear fruit, and the life-giving maize would fail to grow.

The site of Sayil, less than five kilometres south-east of Kabáh, boasts a remarkable three-storey palace similar, in its set-back levels, to the great pyramid at Edzná described in the previous chapter. Here, as at Edzná, the building is divided in two by a large axial stairway which rises to the top in three flights. The Sayil palace is huge, covering an area of 85 by 40 metres. The ground floor probably fulfilled a minor function—the rooms are very small, and there is no decoration on the frieze of colonnettes along the right side (the only side to have been restored at this level).

The second storey is rather like an Italian *piano nobile:* it consists of two interconnecting rows of large vaulted rooms which, in the front row, have broad openings with the lintel and frieze supported by two columns. This means that the living quarters on the façade were well lit. The storey must originally have had four bays with columns on either side of the central stairway. The panels between the bays, consisting of close-set colonnettes (with three bands, at the bottom, middle, and top), imitate pole-and-thatch structures with an ornamental rhythm that strongly recalls the Asian temples of Angkor. The frieze itself combines

Elevation, plan, and detail of the façade of the Palace at Sayil

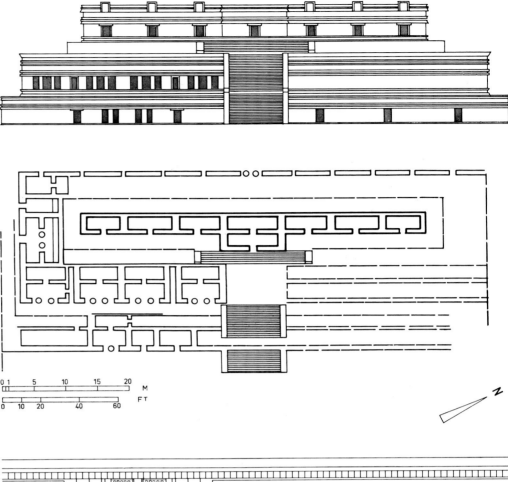

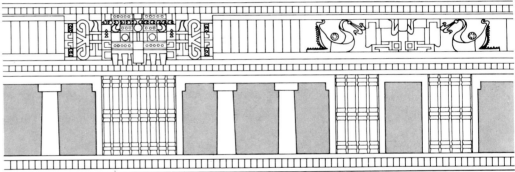

Chac masks and wide-mouthed serpents with the theme of a 'descending god' that is characteristic of many late constructions, such as those at Tulum in the Post-Classic period: it shows an individual in an upside-down position like a diver, facing the wall, with his legs drawn up. The symbolism is of the sun descending towards the horizon at dusk.

About ten kilometres farther in the same south-easterly direction lies the site of Labná, whose considerable group of ruins has been only partly extricated from the brush. There is a two-storey palace of irregular plan, which has bays with columns like those at Sayil. The lower level contains a *chultún*, one of the large underground storage cisterns used by the Maya on many Puuc sites to make up for the lack of rivers and even of *cenotes* (the natural sink holes formed by collapse of the limestone crust due to erosion by rain, and filled with ground water). Labná also has a stepped pyramid, known as the Mirador, in a poor state of preservation. On it rests a temple, part of whose vaulted sanctuary still stands, topped by a latticed roof comb. Along the roof comb was once a row of sculpted figures larger than life—which have since, alas, disappeared.

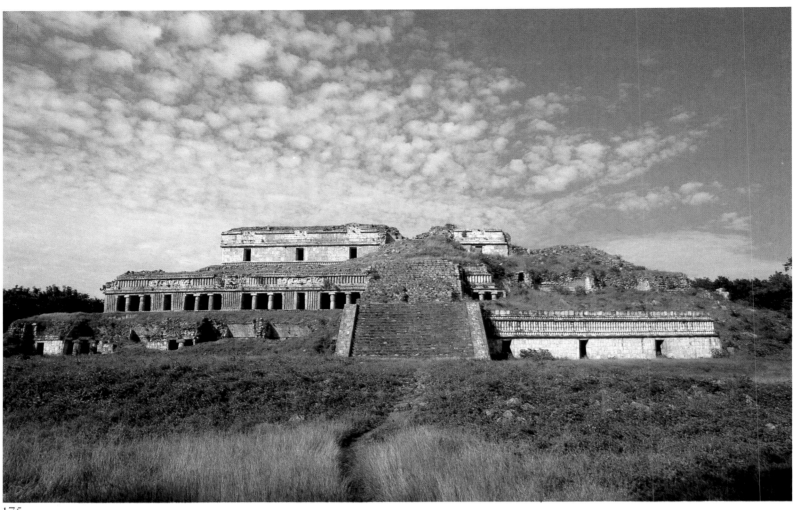

175

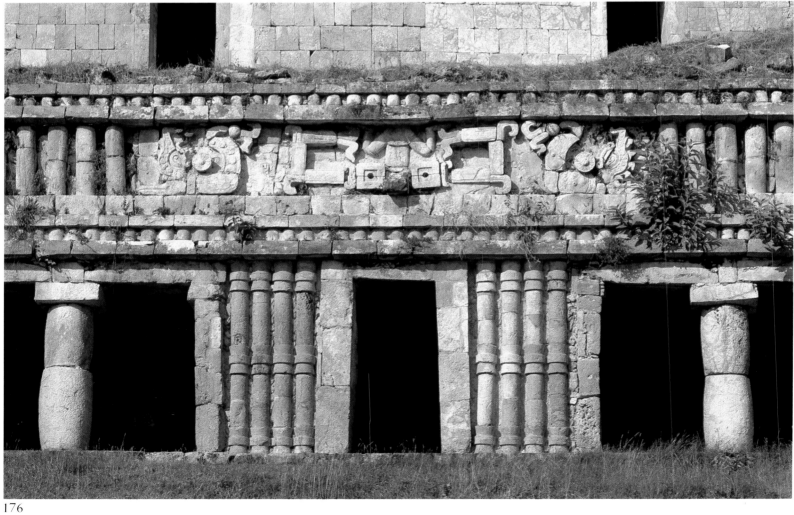

176

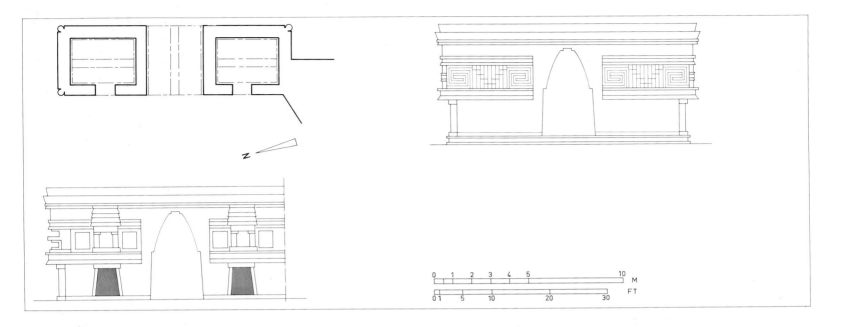

Plan, south-east façade and, below, north-west façade of the Arch at Labná

175 Three-storey palace at Sayil: this monumental Puuc buildings is ascended by a three-ramp stairway, analogous to that of the temple-palace at Edzná. The lowest level, simply decorated with colonnettes, is surmounted by a more ornate second storey with an elaborate frieze above the columned bays, while the top storey is as elementary as the lowest. The edifice may date from the eighth or ninth century AD.

176 Detail of the second storey of the palace at Sayil: rows of close-set colonnettes alternate with round columns that consist of two drums and a very sober abacus. The frieze above shows, in the centre between two large serpents, an image of the 'descending god', a theme recurring at Tulum near the end of Maya civilization in the twelfth and thirteenth centuries.

But the most interesting building at Labná is the great triumphal arch that separated two courtyards at the foot of the Mirador. Designed as a distinct monument, although connected to the wings of ruined palaces, the arch is a highly original structure. The transversal archway, surmounted by a vestigial latticed roof comb, is flanked on either side by vaulted chambers at right angles to the central opening, which provide an effective buttress. The frieze of the north-west façade is decorated with representations of typical Maya huts, their miniature doorways leading to niches that once contained sculptures. On the south-east side of the building, the ornamentation consists of two facing pairs of large key frets whose effect is at once vigorous and abstract.

There is undoubtedly a tendency towards geometric abstraction in the powerfully structured, almost standardized patterns of Puuc art. Forms become starker and begin to conform to a symbolic, orthogonal grid. The baroque elegance of the stucco bas-reliefs at Palenque, with their free-flowing flourishes, have here given way to a specifically architectural kind of decoration, which harmonizes plastically with the volumes of the building and, basically, stems from an 'industrialization' of forms.

The few surviving examples of sculpture remain difficult to date. As we saw, the additions to the frieze on the west palace of the Nunnery at Uxmal, consisting of statues in the round and a plumed serpent (a theme also found in the ball court), were probably made late, at the time of the Toltec invasion. Both the celebrated 'Priest' with scarifications, who emerges from the jaws of a serpent on the Pyramid of the Magician at Uxmal, and the sculpture known as the 'King of Kabáh' are probably Post-Classic, the first because it refers to the cult of the Feathered Serpent, or Kukulcan, which was of Mexican origin, and the second because of a retrogressive technique that is scarcely compatible with the Puuc style at its peak. And even though the fine sculpture at Uxmal, belonging to architectural decoration, displays remarkable sensitivity, it has to be remembered that the greatest artistic heritage of the Puuc era was left not so much by sculptors as by architects.

Civilization in Yucatán did not stop in 909 AD, the date of the latest chronological inscription found there, but persisted through the period of Mexican domination. Then, after the fall of the invaders from the highlands, the power of the Xius of Uxmal lasted for several centuries

until the Spanish Conquest. When the conquistadors landed, the Maya world, torn by civil strife and power struggles, was in decline—but it had not forgotten all its traditions.

The correlation of the Maya and Christian calendars

The problems involved in dating Yucatec monuments, which only rarely bear inscriptions, have led to a thorough reassessment of the dates originally ascribed to these works. It can be a distressing experience for archaeologists and historians when the assumptions on which they have always worked suddenly change. But in the case of Maya buildings in Yucatán the process of re-dating has, fortunately, been gradual. As research has shown that certain structures are older than was thought by the archaeologists who first dated them, so they have been shifted back in time. Some buildings which once seemed exceptional—like the ball court at Uxmal—have come to be used as guidelines for the re-dating of a whole style or period.

Slowly but surely, everyone has had to accept the new chronology of the Yucatec Maya world: it was coeval with the great architectural blossoming of the Petén and of the Motagua and Usumacinta river valleys, extending broadly from the end of the sixth century to the eighth, or very beginning of the ninth, century. Only in northern Yucatán did the culture continue to flourish until 909 AD (the last recorded date), just a few decades before the Toltec invasion, which is the subject of the next chapter.

This brings us to the question of the relationship between Maya dates and the Christian calendar. How was it possible to establish a correlation between the two methods of time-reckoning? As we saw earlier, the Maya recorded dates on inscriptions according to the Long Count, giving a total number of days. But from what 'year zero' should the number of days be calculated? Many civilizations calculate their dates from a particular point in time. For the ancient Greeks, it was the first Olympic Games; for the Romans, the foundation of Rome; for the Christians, the birth of Christ; for Moslems, the Hegira, or the flight of Mohammed to Medina.

The only reliable source that can help us to establish a correlation between the Maya and Christian calendars is, once again, Bishop Landa. He records that the foundation of Mérida by the Spanish in 1542 fell shortly after the close of a Maya cycle, and moreover that the date of July 26, 1553 in our chronology coincided with a certain date in the Maya 52-year calendar. At that late period, the Maya no longer expressed dates by means of the Long Count system, but used its abbreviated version, the Short Count which, as we noted, has the disadvantage of being equivocal. So the correlation produced two possibilities separated from each other by 256 years. This ambiguity led to a dispute between archaeologists who supported one or the other.

The first person to decipher inscriptions dated according to the Long Count was the American J. T. Goodman. In 1905, he adopted a correlation which was later accepted by the great scholar Eric Thompson, after

177 Arch at Labná: this structure, connecting two groups of palaces, is on the scale of a veritable triumphal arch. Its eastern side is seen here, with a powerful step-and-fret decoration.

178 Arch at Labná: this western façade is decorated with representations of thatched Maya houses, which once contained sculptures.

179 Two-storey palace at Labná: as at Sayil, the upper level of this building has triple bays with columns.

180 Castillo at Labná: this stepped pyramid, in a poor state of preservation, has a tall latticed roof comb that was once adorned by sculptures in the round, whose supports alone survive.

166

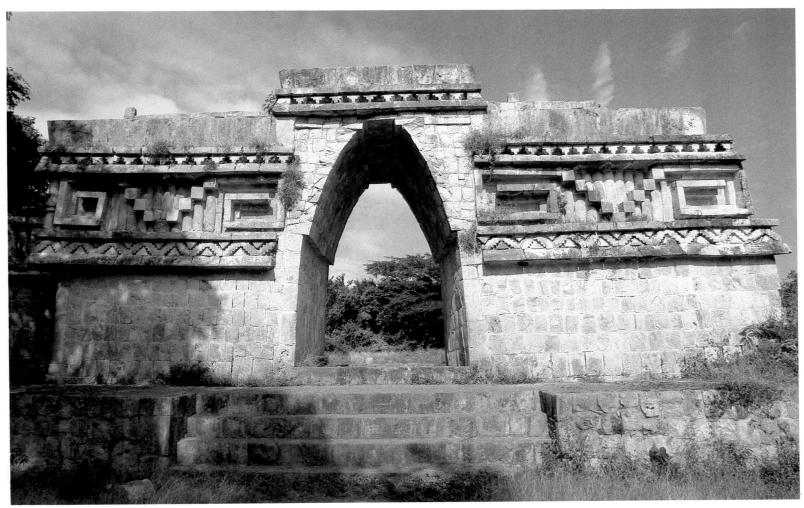

177

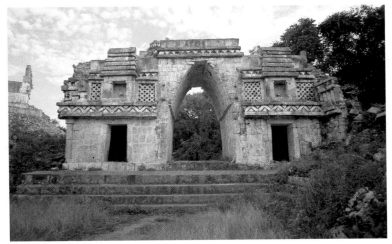

178

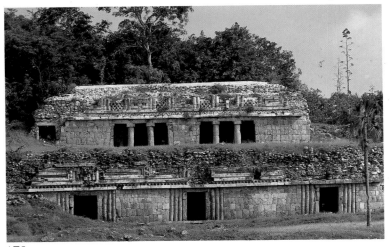

179

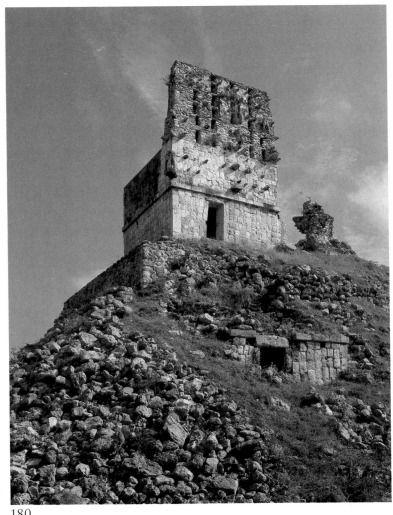

180

a slight adjustment of the figures as suggested by the Mexican authority Juan Martínez. According to Thompson, the close of the Maya cycle referred to by Landa corresponds to the figures 11.16.0.0.0 in the Long Count, the equivalent, in our calendar, of November 14, 1539. On the other hand, Herbert J. Spinden held that the same date in the Gregorian calendar occurred 256 years further back in the Maya calendar. The implications of this were to make the whole of Maya history older by the same number of years, and to create a historical vacuum of over two and a half centuries between the last Maya chronicles and the arrival of the Spanish.

The dispute continued until attempts to date archaeological remains by the radiocarbon method began. At first they seemed to corroborate Spinden's theory. But today expert opinion favours the chronology of Goodman, Martínez, and Thompson (called GMT), which has been supported overwhelmingly by the latest evidence. This system puts the Maya 'year zero' at the mythical date of 3113 BC. The days in the Long Count are, then, calculated from that point.

The antiquity of Maya chronology, which starts well before any trace of civilization in the New World and goes back almost 2000 years before the earliest Olmec constructions, is surprising. The 'zero' date, written 13.0.0.0.0, did not in fact represent the beginning of time, but the end of the preceding cycle of 13 baktuns. Remembering that each baktun lasts 144,000 days, or almost 400 years, we arrive at a figure of 5128 years for the whole cycle, whereupon counting begins again at zero. The Maya system of cycles could repeat itself indefinitely in a universe without beginning or end.

The benefits of carbon-14

Let us briefly review the principles of scientific dating by means of radiocarbon. Any living organism assimilates carbon from the atmosphere. A small part of this (carbon-14, so named because of its atomic weight) is radioactive, and accumulates in the tissues until death occurs. Then the carbon-14 slowly disappears at a constant rate. The proportion of carbon-14 found in living organisms is the same as that found in the atmosphere, and the proportion in a dead organism can be determined by measuring the level of radioactivity still remaining. These amounts will show the age of the organism since death, if the rate is known. Carbon-14 has a rate of 5568 years, the 'half-life' in which half of a given quantity disintegrates.

Thus archaeologists have at their disposal a veritable atomic clock that can supply the age of organic material. But its accuracy demands careful analysis by scientists. And there is always a margin of error—up to a century or two on either side of the date obtained, for Mesoamerican relics—which makes radiocarbon dating only a rough indication of an object's age. Moreover, the operation must be repeated several times to obtain reliable average results. This requires an adequate supply of the organic matter in question, whether wood (preserved from relatively recent periods) or charcoal and bones (from more ancient times). The experiment uses a process of vaporization and destroys each sample, so a new sample is needed for each measurement.

It can easily be understood why the establishment of Maya chronology was fraught with problems. Although the interval between two dates in the Long Count has been exactly determinable for many years now, there was a difference of no less than a quarter of a millennium between the two proposed systems of correlating the Maya and Christian calendars. Until recently, the imprecision of radiocarbon dating did not allow the correct alternative to be chosen. The world of the Yucatec Maya was the last piece of the chronological puzzle to be slotted into place. Indeed some authors, ignoring current research, still follow the obsolete classification into 'Old' and 'New' Empires, which, among other things, ascribed much too late a date to the entire Puuc heritage.

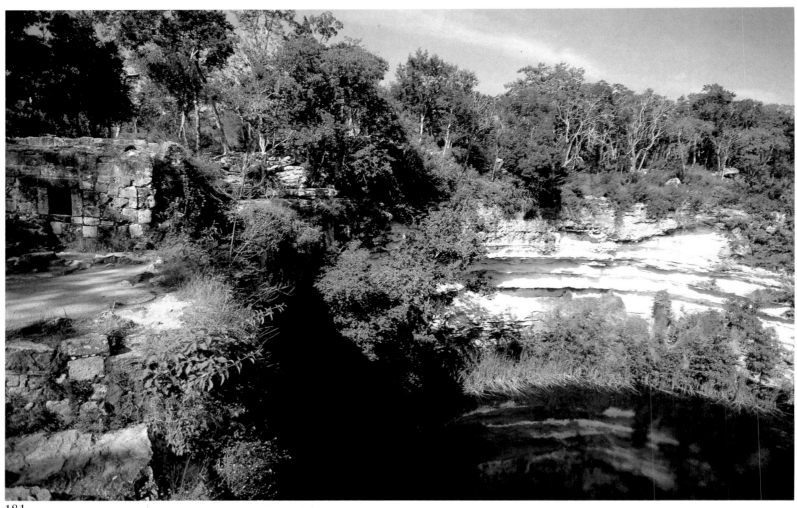

181

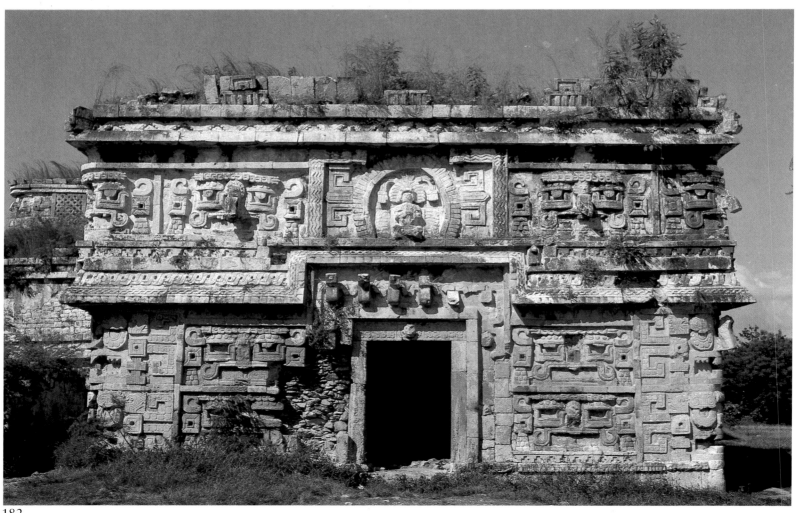

182

VI. The Toltec-Maya renaissance

Earlier I mentioned the extraordinary journey made by the survivors of Teotihuacán, the 'City of the Gods' built on the Mexican highlands, once it had been invaded and destroyed in the fifth century by barbarians forcing their way down from the north. The sedentary Teotihuacanos could not resist these hordes of nomads pouring in from the desert, so they fled. The result was a bottleneck of peoples gradually pushing into the isthmus of Tehuantepec. Refugees, carrying with them the heritage of Mexico's greatest culture, penetrated the southern part of Maya territory. In the highlands at Kaminaljuyú, near modern Guatemala City—a countryside that reminded them of the land they had just lost—they built a new miniature version of the vast 'City of the Gods'.

So after travelling some 1000 kilometres to the south-east, the Mexican refugees settled in an area whose Maya culture had no deep roots. But more enterprising groups pushed on into the heart of the Petén, and caused a considerable upheaval at Tikal, where the construction of large buildings and the erection of stelae ceased temporarily. By the time activity on the site resumed, with fresh vigour, in the middle of the sixth century, the Teotihuacán style had left its mark on several features of Tikal architecture.

The turmoil of events from the middle of the fifth to the middle of the sixth century AD was not a unique phenomenon in the pre-Columbian world. Five centuries later, a relentless wave of barbarians unfurled across the highlands, heading for the Toltec capital of Tula, to the north of Teotihuacán which was then in ruins. A first group of the Chichimecs devastated Tula in the second half of the tenth century, and withdrew. Part of the Toltec population decided to abandon their coveted capital, and it was wiped out in 1168, again by the Chichimecs.

The pressure exerted by the barbarians on the sedentary populations of the highlands was in many ways like that of the Germanic hordes on the Roman Empire. As long as the city-dwellers remained tightly organized, the nomads did not venture to attack. But when the civilized culture was weakened by internal strife, the barbarians took their chance to plunder the farmers' abundant food supplies, and to ransack temples and palaces for treasure. In the Old World, an extended drought was enough to set the nomads of central Asia on the march, causing the demise of more than one ancient empire. Similarly, in pre-Columbian America, periodic food shortages hit the barbarians living in the steppes of northern Mexico and the south of the present United States, to upset the precarious balance between the 'haves' and the 'have-nots'. Chaos ensued: even the highest civilizations were swept away by newcomers,

181 Sacred Cenote at Chichén Itzá: due to the collapse of the limestone crust, a stretch of water 60 m wide is now visible 20 m below the karst plateau of Yucatán. On the left are ruins of the small Toltec-Maya temple from which victims of ceremonial human sacrifice were flung. The bottom of the well has been probed, resulting in the discovery of rich votive offerings and the bones of victims.

182 Façade of a wing of the Nunnery at Chichén Itzá: the Chenes style evident here is still purely Maya. Chac masks, repeated at the corners on both the façade and the frieze, form a luxuriant decorative leitmotif. The doorway, surmounted by a sculpture in a kind of frame, is lined with a row of Chac noses symbolizing the fangs of the god's open mouth.

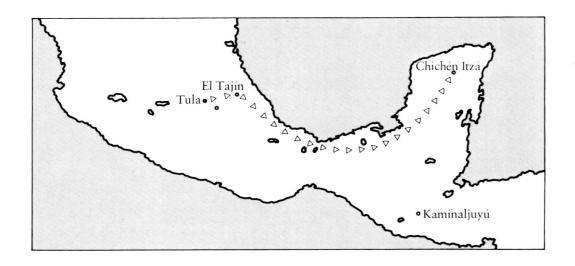

who ruled in their place and became civilized in the process. This is how the Aztec empire arose, reaching its apogee just before the Spanish Conquest.

The Toltec migration

Let us return to the first attack on Tula. Under the leadership of their king Topiltzin—who also took the title of Quetzalcoatl, the great Mexican 'Feathered Serpent' god (the feathers were those of the quetzal bird)—part of the Toltec population set off on their exodus. The reasons for their departure were embellished by later accounts, which claimed that a rebellious faction of believers in the war-god Tezcatlipoca had clashed with supporters of Quetzalcoatl and condemned them to expatriate themselves. But the fact must have been that Topiltzin's troops suffered some military defeat, and were forced into exile with their wives and children. These events took place before 987 AD, and would have repercussions as far away as the north of Yucatán, 1200 kilometres from the Toltecs' point of departure.

The adventures of these emigrants is recounted in pre-Columbian Maya chronicles such as the Books of Chilam Balam, which were transcribed from Maya into Spanish letters. But the documents tell what occurred over five centuries earlier. They contain not only errors due to confusion, but deliberate falsifications with political intent, as a result of the situation created by the conquistadors. Moreover, the history in the annals is entwined with prophetic visions concerning certain events of the Spanish Conquest, which, it was alleged, the Maya priests had predicted.

Whatever the truth, on leaving Tula the Toltecs moved towards the Gulf of Mexico and entered the Totonac city of El Tajín. There they stayed for a time, influencing some aspects of art. Then they set off again, along the coast of Tabasco and Campeche, and finally ended their journey at the Maya centre of Chichén Itzá, which they decided to make their capital. Like the Teotihuacanos long before, the Toltecs constructed, in their new homeland, a replica of the city they had lost. Chichén Itzá became a kind of super-Tula, combining features of Toltec civilization with Maya architectural techniques.

Plan of Chichén Itzá (Yucatán)

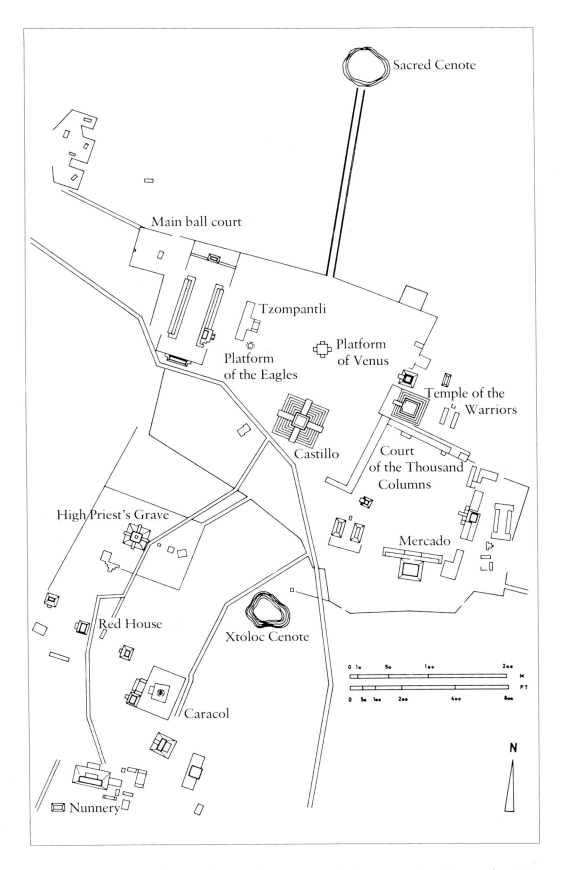

Sacred Cenote

Main ball court

Tzompantli

Platform of Venus

Platform of the Eagles

Temple of the Warriors

Castillo

Court of the Thousand Columns

High Priest's Grave

Mercado

Red House

Xtoloc Cenote

Caracol

Nunnery

N

The Toltecs spoke Nahua, a language of the same family as the Náhuatl of the Aztecs who succeeded them. Their society was organized along military lines, and governed by the warrior orders of the Jaguar, the Coyote, and the Eagle. They left a great number of original architectural works at Tula, the most worthy of mention being the tall 'Atlantean' columns and the columns representing Quetzalcoatl, the Feathered Serpent, which became Kukulcan in the Maya world. This, broadly speaking, was the cultural heritage that the emigrants brought to Chichén Itzá in about 987 AD.

Chichén Itzá before the Toltecs

In the sixteenth century, Bishop Landa visited Chichén Itzá—which is not far from the colonial city of Mérida, itself founded upon the ruins of a Maya site called Tihoo—and described what he saw in his manuscript of 1566. The next person on the scene, after Catherwood and Stephens in 1841, was the explorer Augustus Le Plongeon who, in the course of frantic excavations with dynamite, damaged the building known as the Nunnery (as at Uxmal, the names of structures are fictitious). Subsequently, Maudslay drew up a plan of the site, and the local American consul Edward Thompson (not to be confused with the great British Mayanist, Sir Eric Thompson) explored the Sacred Cenote from 1904 to 1907. Scientific investigation of Chichén Itzá began in 1923, and continued until 1943 under the auspices of the Carnegie Institution in Washington, in conjunction with the Institute of Anthropology and History in Mexico City, supervised by Sylvanus Morley. There were further excavations in the Sacred Cenote in 1960 and 1961, with the help of the National Geographic Society, and in 1967 and 1968 by a team under Roman Piña-Chan.

Chichén Itzá already existed before being taken over at the end of the tenth century by Toltec warriors fleeing Tula. Today there remains a substantial portion of the former ceremonial centre, whose architecture is purely Maya. In the southern part of the site are several buildings that combine the Puuc and Chenes styles. The huge Nunnery, for example (which is itself the result of several superimpositions), has a distinctly Puuc superstructure, although with a mansard roof and decoration on the façade rather than on a frieze. The large facing key frets (four to each motif) are similar to those at Uxmal and Labná.

The low wing protruding eastwards from the Nunnery, on the other hand, displays the luxuriance of the unadulterated Chenes style: decoration covering not only the frieze but the façade wall, and, among a series of Chac masks, a door representing the gaping mouth of the god, in a manner reminiscent of Temple III of the Pyramid of the Magician at Uxmal. The small structure next to the Nunnery, known as the Iglesia ('church'), has a roof comb whose motifs echo those on the façade. They include not only Chac masks, but strips of step-and-fret design —yet another instance of combining these two complementary cosmic themes.

The older part of Chichén Itzá also contains the Chichan-Chob, or Red House, which has the most unusual feature of two roof combs, one behind the other. The taller roof comb stands on the building's central partition wall, while the lower one forms a vertical continuation of the front wall as a 'flying façade'. A further structure built in a fine Puuc style like that of Uxmal (with a frieze decorated by crosspieces and colonnettes, vigorously treated mouldings and a cornice) is the Temple of the Three Lintels; this slender building has three doorways on its long façade.

Curiously, the only date written according to the Long Count method that has been found at Chichén Itzá is inscribed on a lintel which was re-used in the Toltec-Maya period. It bears the figures 10.2.10.0.0, equivalent to 879 AD.

183 Rear façade of the Iglesia at Chichén Itzá: this small building, seen at left, is a Maya structure in the Puuc style, with a powerful frieze over a bare wall, surmounted on the other side by a tall roof comb. In the background are the platforms leading up to the cylindrical Caracol, first constructed in the Maya period, and used as an astronomical observatory.

184 Round tower of the Caracol at Chichén Itzá: this structure has an impressive *atadura* moulding and a frieze decorated with Chac masks facing the cardinal points. The upper cornice has not survived. But at the top of the building is a small chamber with narrow radial shafts, reached by a spiral staircase recalling a snail-shell (*caracol* in Spanish).

185 Outer corridor around the tower of the Caracol: the annular corbel-vaulting, partly collapsed, is unique among surviving Maya buildings.

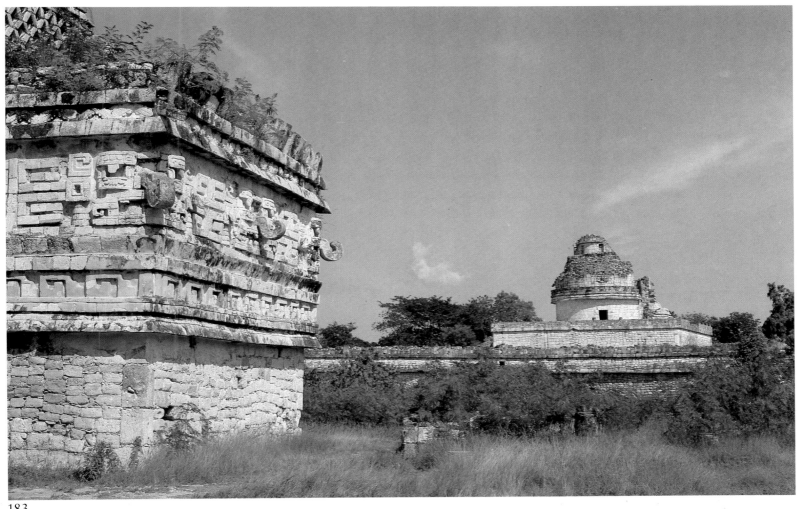

183

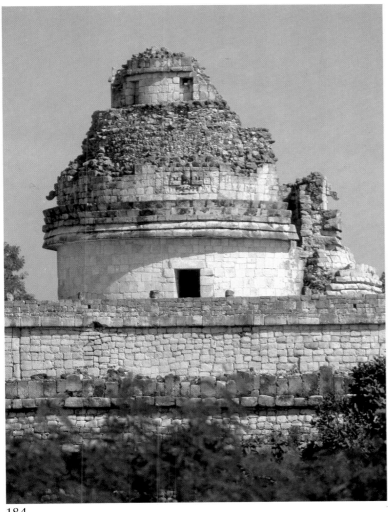

184

185

The Caracol and astronomical observation

Located between the old and new sections of Chichén Itzá, the structure known as the Caracol ('snail' in Spanish) goes back to the Maya period, but underwent substantial alterations after the arrival of the Toltecs. It owes its name to the spiral staircase in the central core of a round tower that was used as an observatory. The complex structure of this tower, consisting of two concentric annular chambers with vaults and four staggered doorways each, is unique in the Maya world.

The upper storey of the Caracol, which is also round, but set back from the ground floor, contains a tiny chamber with radial shafts. Despite the room's poor state of repair (its eastern portion has collapsed), Morley succeeded in determining what the three remaining shafts were used for. They pointed in the direction of the south and the setting of the moon at the spring equinox (March 21), the west and the setting of the sun at the spring and autumn equinoxes (March 21 and September 21), and the setting of the sun at the summer solstice (June 21).

The peculiar outline of the round tower, with its typically Puuc parallel rings of *atadura* moulding, between which Chac masks face the cardinal points, and the numerous changes made to its substructure, show that the building had a special 'scientific' function. It stands on an almost square platform, which has sides 28 metres long and is built on a much larger platform measuring 75 by 57 metres. None of the structure's various units align with each other: the orientation of the tower doorways does not coincide with that of its platform or stairway, which themselves do not coincide with the larger quadrangular platform or its own broad two-ramped stairway. Everywhere, the building shows signs of having undergone successive alterations to meet specific needs.

Our knowledge of Maya astronomy comes partly from inscriptions at Copán, but above all from the Dresden Codex, which dates from the Post-Classic period and could well be a copy of an earlier work. We have seen how the Maya vigesimal and positional notation had accustomed priests, whose task was to set the dates of ritual festivals, to the manipulation of very large numbers and complex calculations. They naturally exploited this mathematical system in their astronomical reckonings.

A few examples will show the enormous sophistication of such calculations. The Maya used a solar year of 365 days, but were aware that the figure was not quite accurate. Modern astronomy has narrowed it down to 365.2422; the Maya used a system of extra days to make up for the discrepancy, bringing their evaluation of the solar year to 365.2420 days. In other words, they were wrong by only two ten-thousands of a day, or 17.28 seconds in a year! This is a nice achievement when one remembers that the Maya had no astronomical telescopes or optical sighting instruments of any kind, let alone a way of measuring hours, minutes, or seconds.

Their results were no less remarkable in calculating lunations (or lunar months). They had two systems. According to one, 4400 days were the equivalent of 149 lunations, giving 29.53020 days per lunation. The figure obtained by modern astronomers is 4400.0574 days, or 29.530587 days per lunation. So the error, made by Maya observers at Copán in 682 AD, amounted to only 33.43 seconds per lunation. The other Maya system appears in the eclipse tables recorded by the Dresden Codex.

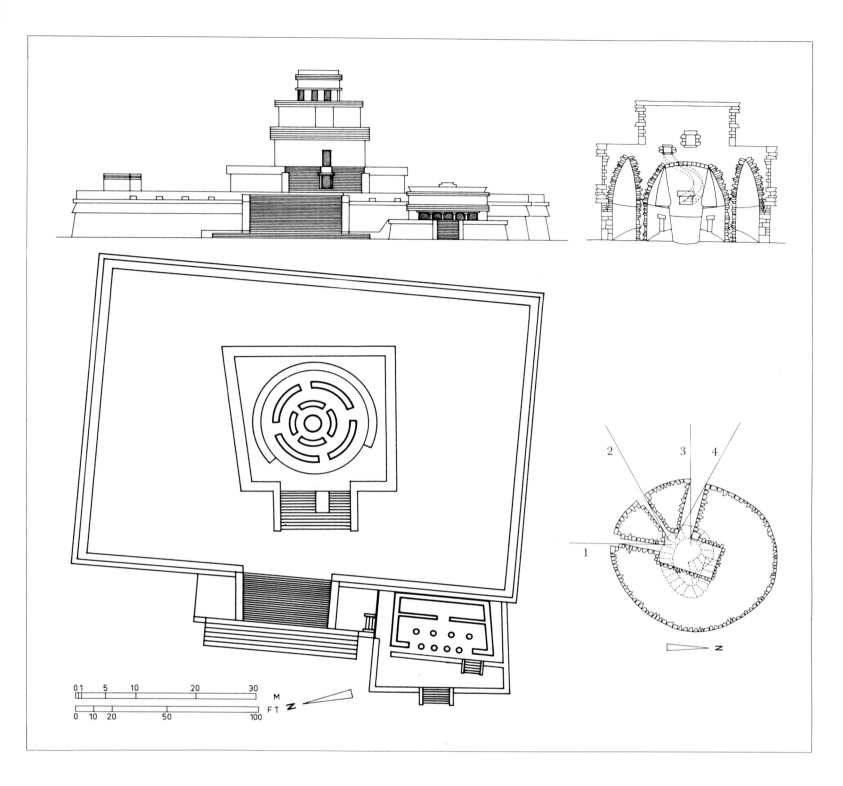

Elevation and plan of the Caracol at Chichén Itzá, with a diagram showing the observatory tower, its upper chamber, and the radial shafts used for astronomical sightings: 1. South 2. Setting of the moon at the spring equinox 3. West and the setting of the sun at the equinoxes 4. Setting of the sun at the summer solstice

These show 405 lunations as corresponding to 46 sacred years of 260 days, or 11,960 days. Modern astronomy finds 405 lunations equivalent to 11,959.888 days. This implies that the Maya were wrong by 23 seconds per lunation, or just 0.112 of a day over 32 years of observation.

One last example will show both the abilities and the limitations of Maya astronomers. They estimated the Venus year (the apparent cycle of the planet Venus) at 584 days, whereas modern calculations put it at 583.92. That difference of 0.08 of a day must have been clear to the Maya. But what interested them in the approximate figure was the fact that 5 Venus years are the equivalent of 8 years of 365 days each. Moreover, 65 Venus years worked out at 104 years—twice the Maya 'century' of 52 years—as well as 146 sacred years of 260 days each. This series of correspondences enabled the Maya to draw up an extremely precise calendar. On the other hand, although their results are astonish-

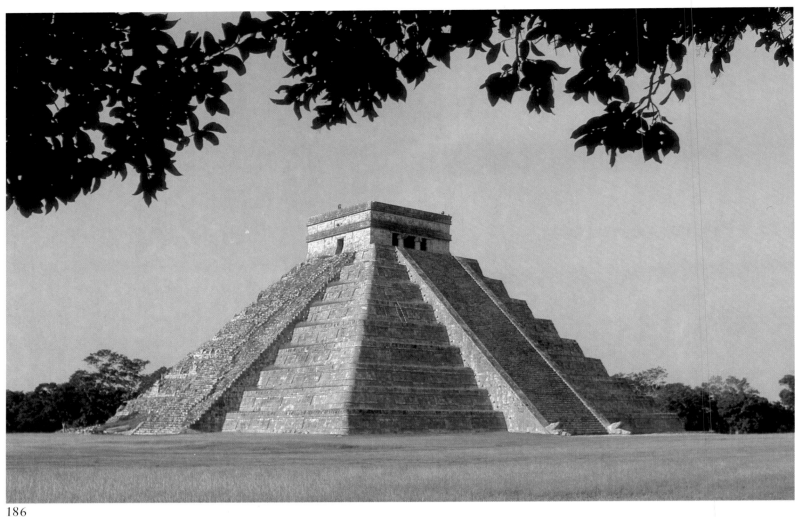

186

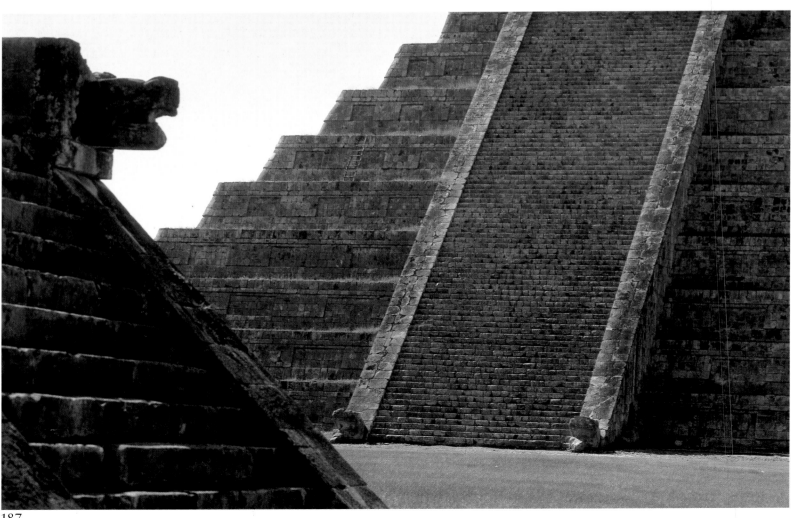

187

Astronomers making sightings with crossed pieces of wood (after the Mexican Bodley codex)

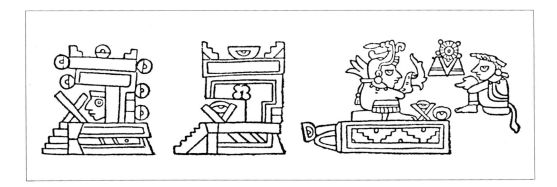

ing from a numerical point of view, they were concerned only with apparent astronomy. The Maya calculated not Venus' actual cycle (its rotation round the sun, which is now thought to be 224 days and 7 hours), but its apparent cycle in relation to the earth, which is of only secondary importance for science.

There remains the puzzling question of how such results were obtained by a people that had no knowledge of metallurgy, the potter's wheel, wheeled vehicles, optical instruments, or machines to measure time. The principal method used by the Maya was sighting by eye. This could be used to determine the cardinal directions, and events like equinoxes and solstices. It was merely necessary to observe the northernmost or southernmost point of the sunrise or sunset on the horizon—which should not have been difficult in such flat country as the Petén or Yucatán.

Yet a second method may be used to complete these basic observations. It involves the combination of a phenomenon like the rising or setting of a celestial body with the altitude of a star on the horizon at a given date. Thus, when the heliacal rising of Venus is seen, simultaneity can be measured down to the last second. Observations of this kind are obtainable by rudimentary sighting devices, such as crossed pieces of wood in an embrasure (shown in some Maya drawings), which can measure angles at a specific moment, as when the sun disappears. But another element must be taken into account—the duration of time. The Maya were prepared to repeat an observation tirelessly in order to get a mathematical average. Their calculation of the Venus year, for instance, was based on data spanning 384 years. So the crudity of their sightings was corrected by a kind of statistics.

These, then, were the techniques that produced the Maya's admirable astronomical system, the most sophisticated in the pre-Columbian world.

A 'super-Tula' in Yucatán

186 Castillo at Chichén Itzá: this Toltec-Maya pyramid was constructed at the end of the eleventh century AD or even in the twelfth. It is square, measuring 55 m on each side, and has nine stages, with four radially symmetric stairways converging on the upper temple, whose top is 30 m above the ground. Restoration work has been completed on the pyramid's north and west sides, but not on its east side. The south side, invisible here, remains as it was when found by archaeologists.

187 Detail of the Castillo: in the foreground is part of the Platform of Venus. A constant feature of this architecture is the placing of sculpted heads of the Feathered Serpent, or Kukulkan, on either side of a stairway.

As we have seen, when the Toltecs settled in Maya territory, they chose the site of Chichén Itzá on which to build a bigger and better version of their lost highland capital, Tula. The immense complex they erected to the north of surviving Maya monuments included a series of large edifices making up the ceremonial centre itself, as well as hundreds of tumuli that have not yet been extricated from the jungle vegetation.

The main buildings of Chichén Itzá have the same overall north-north-east to south-south-west orientation which we observed at Uxmal,

179

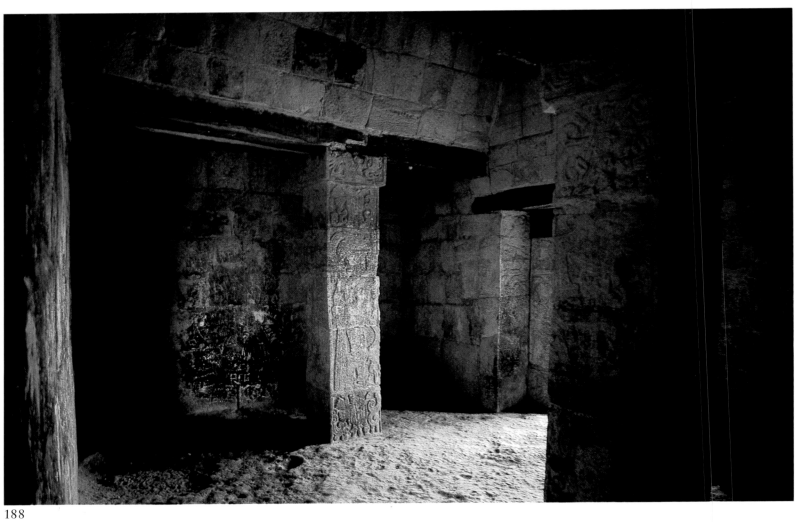

188

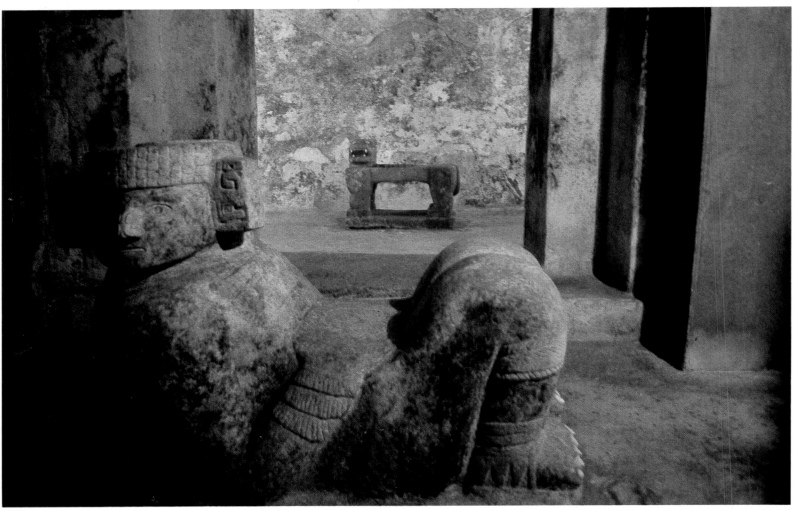

189

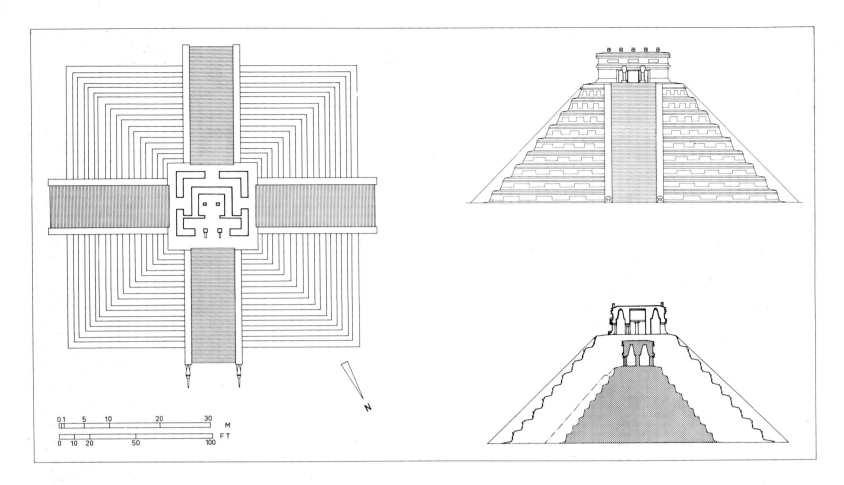

Plan, elevation, and section of the Castillo at Chichén Itzá. The section shows the original Toltec-Maya Castillo discovered underneath the visible part of the edifice

188 Vaulted chamber in the upper temple of the Castillo at Chichén Itzá: the concrete roof supported by sapodilla beams atop two interior square pillars is among the technological innovations of the Toltec-Maya renaissance.

189 The *chacmool* in the Castillo at Chichén Itzá: archaeologists from the Carnegie Institution found this fine stone figure, on which votive offerings were placed, in the temple of the first Castillo, encased by the pyramid that is visible today and also dates from the Toltec-Maya period. At the back of the 'holy of holies' stands an altar known as the Throne of the Red Jaguar, decorated with jade disks imitating the animal's spots; its snarling mouth has bone fangs. The first Castillo was probably built at the end of the tenth, or beginning of the eleventh, century AD.

although here again the angle is not strictly obeyed. So it would be incorrect to speak of planning in the accepted sense of a systematic layout. The architect Horst Hartung has surveyed the site and, as at Uxmal, noted a number of interesting lines of sight. But they do not seem to form any pattern that could be applied to the layout of the principal structures in the Toltec-Maya part of Chichén Itzá.

Of this we can be certain: the choice of the site was guided by the presence of two large *cenotes*. The southern one, the Xtoloc Cenote, was accessible near the Maya part of the centre, and provided the community with water. The other, the Sacred Cenote (or Well of Sacrifice), has sheer walls plunging deep to the water table, and was a holy place used to sacrifice victims by drowning.

The main constructions of the Toltec-Maya ceremonial centre are surrounded by walls which, although not truly defensive, gave a boundary to the sacred area (like a Greek 'temenos'). An immediately striking feature of the buildings within it is that, unlike the great Puuc centres, they do not include any palaces. There are no large groups of structures containing stone-vaulted cells, as in the Nunnery at Uxmal for instance. It is, however, possible that some edifices now in an advanced state of ruin, whose timber roofs were supported by pillars or columns to make a hypostyle hall or covered colonnade, served as living quarters for priests, as at Tula.

The most majestic structure on the Toltec-Maya site of Chichén Itzá is the Castillo, a large square pyramid. It has four radially symmetric stairways converging on an upper temple, the top of which stands 30 metres above the ground. Its base, 55 metres square, occupies more than 3000 square metres. The stairways are identical except for the presence, at the bottom of the north stairway, of two gigantic Feathered Serpent heads set on either side of the steps (the building was also known as the

181

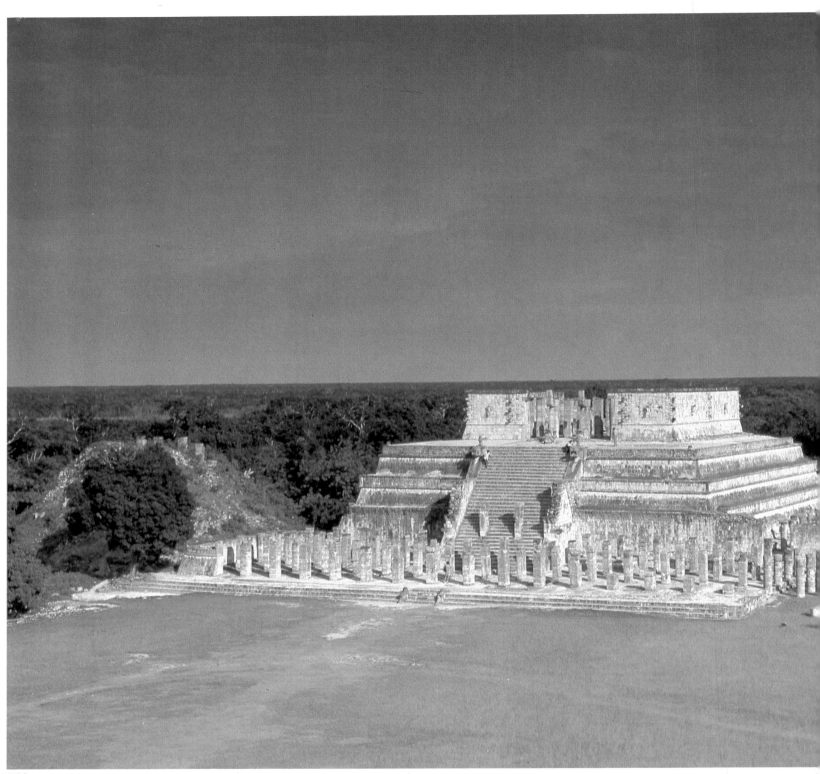

190

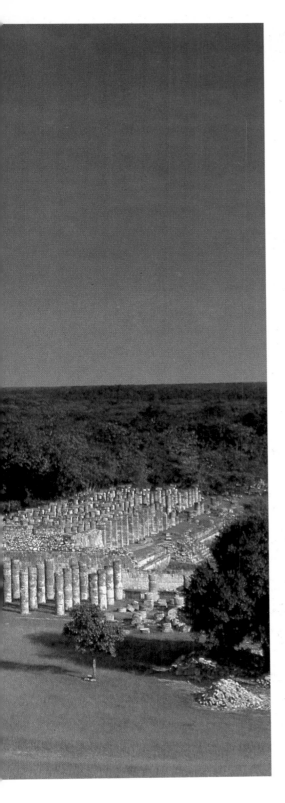

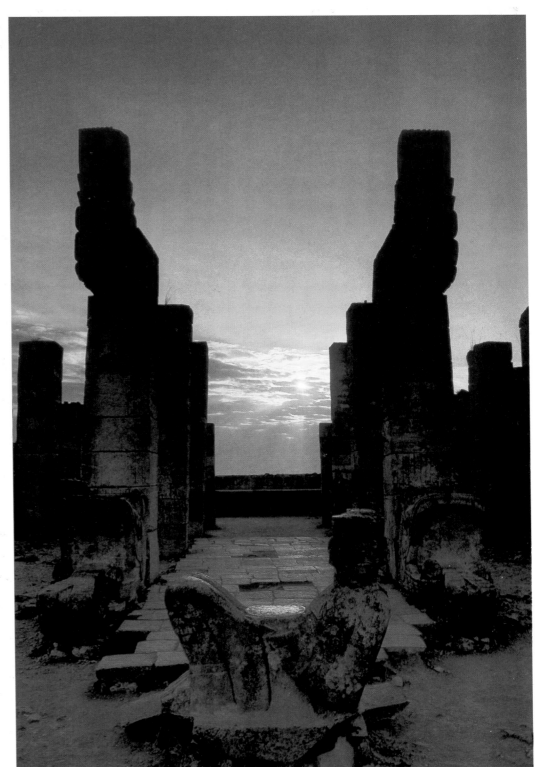

191

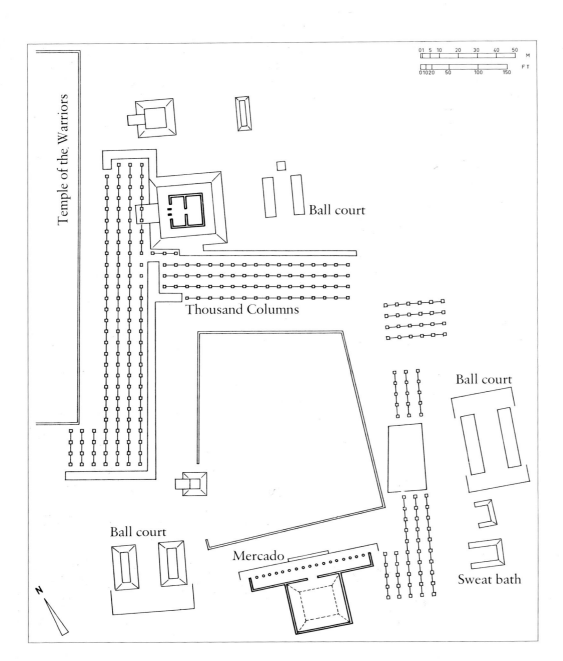

Temple of the Warriors

Ball court

Thousand Columns

Ball court

Ball court

Mercado

Sweat bath

N

190 Temple of the Warriors at Chichén Itzá, seen from the top of the Castillo on its west: this immense Toltec-Maya structure, flanked by the complex of the Thousand Columns, looms against the featureless landscape of Yucatán. The upper temple, once covered with masonry vaulting that has collapsed, stands atop the four stages of the pyramid, which was modelled on the principal temple at Tula.

191 Upper sanctuary of the Temple of the Warriors at Chichén Itzá, viewed at dawn: in the foreground is a large *chacmool*, behind which rise two serpent-columns representing the sacred rattlesnake, the Feathered Serpent of Kukulcan introduced by the Toltec invaders.

192 Façade of the Temple of the Warriors, viewed at dusk: the gaping mouths of the Feathered Serpents seem to be guarding the entrance, while their tails arch back to bear the weight of a lintel which once spanned its three bays. The façades are decorated with Chac masks, showing the high degree of syncretism that had occurred between the religions of the highland peoples and the Yucatec Maya.

193 Detail of the Court of the Thousand Columns, along the side of the Temple of the Warriors at Chichén Itzá: these halls, whose columns consist of superimposed drums topped by a plain abacus, were once vaulted with masonry supported by sapodilla beams; when the wood rotted away, the whole roof collapsed.

Temple of Kukulcan). The total number of steps on the pyramid is 365 (91 on each stairway and one at the entrance to the temple), the number of days in the solar year.

The nine stages of the pyramid display in relief, on their sloping façade walls, a meander motif that may symbolize the sinuous coils of a huge Feathered Serpent. The temple is neither perfectly square nor centred on the upper platform, and stands slightly back from the main entrance. The latter consists of a broad opening divided by two serpent-columns, a typical motif of Toltec architecture. The shafts of the columns form the body of a Feathered Serpent, whose open mouth is situated at ground level—as though guarding the entrance—while a tail covered with the characteristic scales of the rattlesnake curves round at the top, supporting a powerful lintel.

Over the lintel is the arrangement of *atadura* moulding, frieze, and cornice familiar to us from Maya architecture. The interior of the temple also closely combines Toltec and Maya techniques: the stone vaulting is supported by two square piers. This is a novel solution; the only form of Toltec roof at Tula was flat stone-covered timberwork, whereas the Maya had used piers or columns to support a façade opening but never an interior vault. The dark inner sanctuary, which leads to a 'pro-

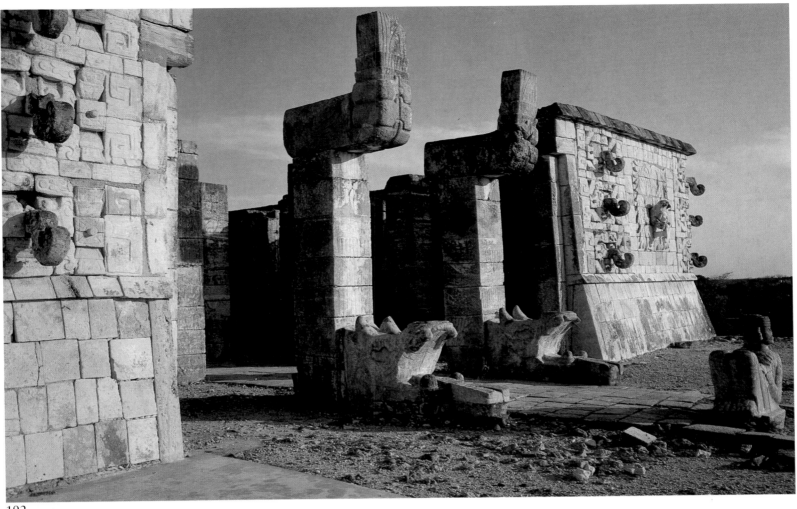

192

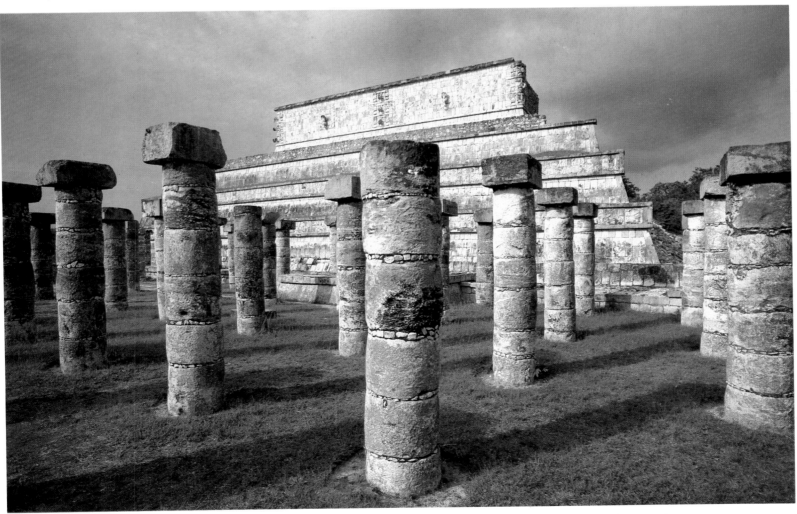

193

naos' and is surrounded by a gallery on its three other sides, stands in the centre of the structure at the top of the Castillo.

Restoration work on this fine symmetric pyramid has given two of its sides their original appearance, while the two others have been left as they were found after removal of the tropical vegetation. Comparison of the two parts of the pyramid in their different states shows what an immense undertaking restoration can be.

As is customary in pre-Columbian archaeology, excavations were carried out in the mass of the pyramid to learn whether it contained an earlier building. They proved successful: beneath the upper temple, archaeologists found another chambered structure, standing on a smaller inner pyramid. The latter is also square and of nine stages, but measures only 33 metres on each side, with a single stairway on its north side. The temple atop this original pyramid, consisting of two chambers arranged breadthwise (as at Tikal), was found in exactly the same state as when it had been left. After one final ceremony performed by priests in the 'Holy of Holies', the edifice was encased by the masonry of the new pyramid and hidden from the world for eight centuries.

The original temple can now be visited. Nothing has changed since its discovery. In the first room, there is a *chacmool*, a strange stone statue of a reclining human figure, leaning back on his elbows, with his knees drawn up. On the belly of this sculpture, Toltec ritual offerings—the hearts or severed heads of sacrificial victims—were placed. Behind the *chacmool*, in the gloom of the 'holy of holies', stands the Throne of the Red Jaguar. This stone sculpture in the round, painted red, represents a snarling jaguar with its head turned towards the entrance of the chamber. It has powerful bone fangs, protruding eyes, and spots on its skin consisting of inlaid jade disks. The temple of this earliest Toltec-Maya pyramid at Chichén Itzá, which may date from the end of the tenth century or the beginning of the eleventh, has a façade decorated with jaguars in procession, a snake-like motif similar to the additions to the Nunnery and ball court at Uxmal, and feathered shields.

The visible part of the Castillo, on the other hand, is probably no older than the end of the eleventh century, or even the beginning of the twelfth. It is the earliest example at Chichén Itzá of a radially symmetric plan, which was later used in the building known as the Ossuary (a miniature replica of the Temple of Kukulcan), as well as in the Platform of the Eagles and the Platform of Venus. This fixture of Toltec design goes back to the central edifice at Tula, and derives from the architecture of Teotihuacán (the Ciudadela and the Moon Pyramid), rather than from the Maya pyramids of Uaxactún and Acanceh or the platforms of Dzibilchaltún and Uxmal.

The Temple of the Warriors and its surroundings

But the apogee of Post-Classic architecture comes with that majestic building, the Temple of the Warriors at Chichén Itzá, north-west of the Temple of Kukulcan. Like the Castillo, it existed in an original version dating from the Toltec-Maya period. This was subsequently overlaid by another structure, which developed and improved upon the initial design. The latter derived from the Temple of the Morning Star at Tula (now also known as Tlahuizcalpantecutli). Yet the sanctuary of the first

194 Mercado at Chichén Itzá: this 'market' building contains a square patio lined by tall columns which supported a timber roof, and resembles a Roman atrium with a central impluvium open to the sky. By the end of the Toltec-Maya period, architecture had undergone some profound changes, and vast covered spaces were built to accommodate meetings of the Toltec warrior orders.

195 Sweat bath, or Temazcalli, at Chichén Itzá: behind this half-ruined columned structure, a tiny door leads into a low, dark, vaulted chamber, where a heating system produced steam.

196 Detail of the Court of the Thousand Columns at Chichén Itzá: this colonnaded hall was the largest covered space built by the Toltec-Maya. In the background are structures awaiting restoration, and columns of the Mercado group appear on the right.

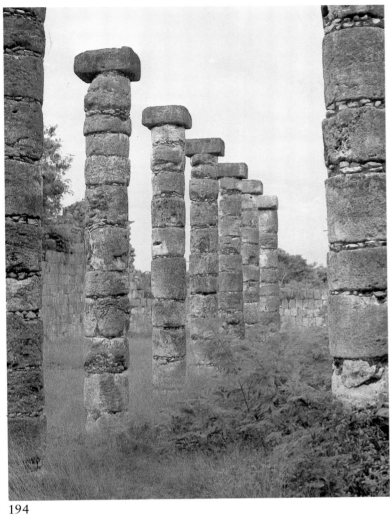

194

195

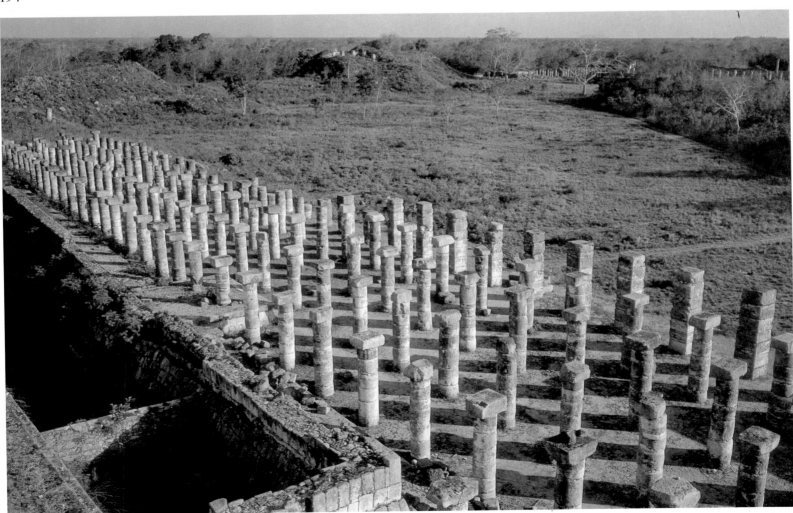

196

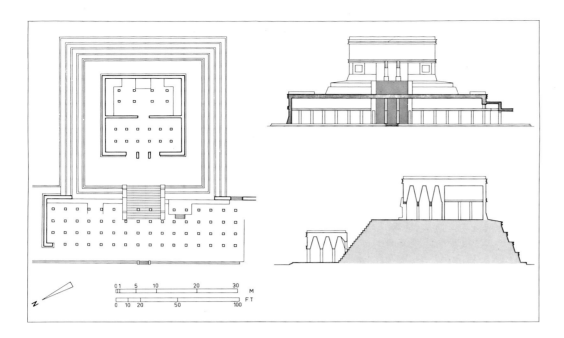

Temple of the Warriors differs from its Toltec model. Atop the pyramid at Tula was a solitary chamber with eight roof supports (four Atlantean columns and four square piers) and two serpent-columns on its façade. The Chichén Itzá version has two rooms, one behind the other ('pronaos' and 'naos'), each with a single row of four columns laid out across it, in front of which stand the serpent-columns representing the sacred rattlesnake.

The other artistically interesting features of the earlier tenth-century substructure are a *chacmool* and some fascinating paintings. These show the canoe-borne Toltecs reconnoitring the Yucatec coast, which is dotted with traditional Maya huts. Rows of columns supporting a roof and forming a colonnaded hall stood in front of the pyramid. This was a feature of Tula design, to be repeated—and improved upon—in the second Temple of the Warriors. The presence of a colonnaded hall answered fresh needs: it could, in particular, be used as a meeting place for warriors belonging to the military orders of the Jaguar, the Coyote, and the Eagle.

The sanctuary encasing the original structure of the Temple of the Warriors also has two chambers set one behind the other. But as each of them is larger than in the first version, they require two rows of supports instead of a single row. Thus each room relies on the same arrangement as the solitary chamber at Tula. The most striking innovation is the combination of supports (which at Tula bore only a flat stone-covered timber roof) and concrete corbel-vaults of the traditional Maya type. While the 'pronaos' room is covered by three transversal vaults resting on two rows of six columns, the 'naos' itself has five longitudinal bays supported by four lines of two columns. This interplay of two perpendicular vault systems buttressing each other, in an almost square temple measuring 20 metres wide and 22.5 metres deep, is remarkably suited to the laws of statics, as well as creating a highly interesting spatial progression.

At the top of the great stairway leading to the entrance of the Temple of the Warriors stands a large *chacmool*. The entrance is flanked by two serpent-columns representing the god Kukulcan. With their gaping mouths at ground level, their square piers, and their tails curved to bear the lintel spanning the three openings of the entrance, these monsters

seem to be guarding the threshold of the temple. The façades of the building stand on an inclined *talud* base, and are decorated with sets of three Chac masks surmounting each other. The centre of each panel contains a serpent's mouth from whose fangs a man's head is emerging —an iconographic trait of Toltec origin, which we have already encountered at Uxmal on the additions to the Nunnery frieze. Two enormous Feathered Serpent heads flank the top of the stairway, looking down over the lateral balustrades. They are topped by small standard-bearers with clasped hands, into which flagpoles were slotted during festivities.

As for the actual pyramid supporting the Temple of the Warriors, it has four stages at Chichén Itzá, while its Toltec model has five. As at Tula, the terraces are made up of an inclined *talud* base, surmounted by a projecting vertical panel with a frame of the Teotihuacán *tablero* design. The panels contain long bas-reliefs, representing figures in the *chacmool* position as well as jaguars and eagles eating hearts. This series of stuccoed friezes was once painted in polychrome colours, as indeed was all Toltec-Maya architecture. Proof is to be found in the great Feathered Serpents before the entrance of the sanctuary, which have retained some of the red paint used to colour their mouths, and on the columns of the original Temple of the Warriors. So the artists of Chichén Itzá saw things on a grand scale, drawing inspiration from Tula and, before that, the vast architectural complexes of Teotihuacán.

But perhaps the greatest advance by Toltec-Maya architects lay in the broad entrance colonnade and the Court of the Thousand Columns, south of the Temple of the Warriors. The Toltec colonnaded hall and the Maya stone vault, in the eleventh and twelfth centuries, combined to produce a spatial revolution. The interiors of Chichén Itzá break away from the 'individualistic' cells of the Maya priests, and mark the advent of a more 'collectivist' society ruled by the orders of the Jaguar, Coyote, and Eagle, whose politico-religious nature called for meeting places that could bring together hundreds of people at a time.

This kind of colonnaded hall had been used at Tula with three rows of pillars to hold a timber roof frame over two bays. At Chichén Itzá there were three bays with stone vaults in the hall before the pyramid of the Temple of the Warriors. The hall was 50 metres wide and 11 metres deep, much larger than any previous Maya room (the main chamber of the Governor's Palace at Uxmal covers 80 square metres). What is more, the hall with square pillars led to the vast Court of the Thousand Columns, whose west wing alone (to the south of the Temple of the Warriors) is 125 metres long and 14 metres deep, with five bays.

Obviously, then, under the impulse of fresh needs, a sudden expansion of internal space occurred during the Toltec-Maya renaissance. Yet these grandiose, prestigious buildings lacked the stability of Classic Maya architecture. The weighty concrete vaults rested not on solid walls, but on slender pillars—or cylindrical columns—spanned by sapodilla beams. The long transversal vaults were thus poorly braced. Moreover, as soon as the wooden structure joining the columns to the masonry roof rotted away, the whole building collapsed like a house of cards. This is why none of the colonnaded halls of Chichén Itzá has survived intact. Only their toothing stones can tell us something of what they originally looked like.

The very large group making up the Court of the Thousand Columns, a series of colonnaded buildings, clearly shows the effect of Toltec

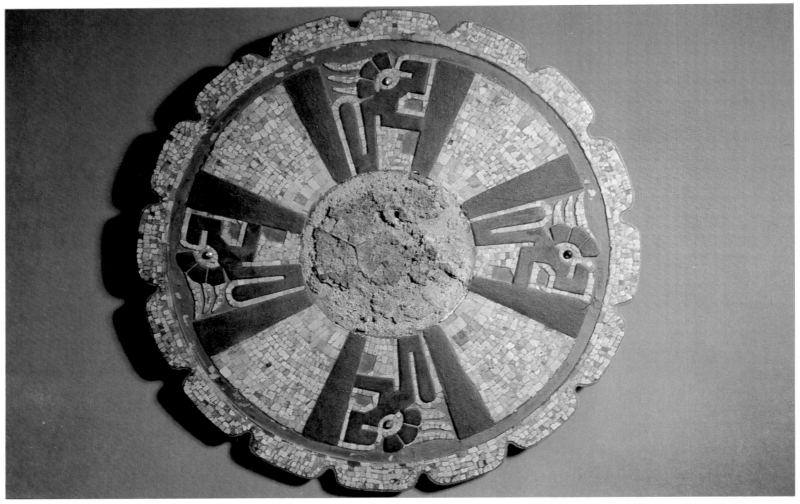

197

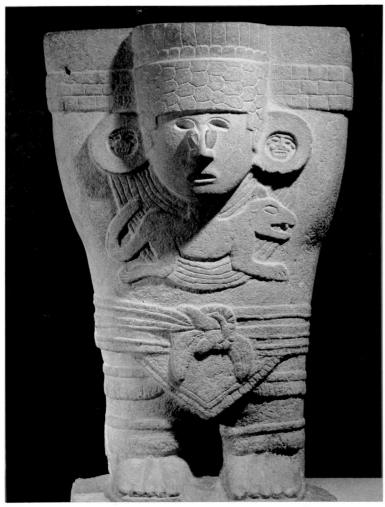

198

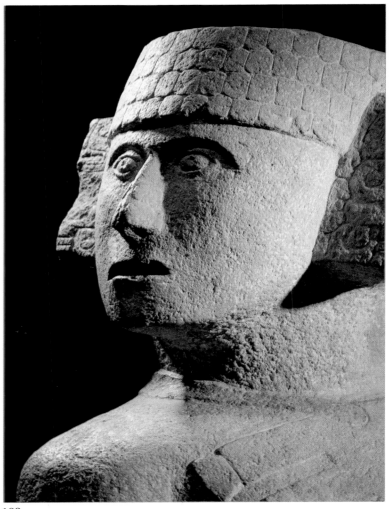

199

influence on Maya architecture. New forms appear for the first time, particularly in the structure known as the Mercado ('market'), which has a long raised portico reached by a broad stairway and consisting of a single line of columns. The portico bears a certain resemblance to a Greek stoa, and a doorway amid its rear wall leads to a square patio surrounded by a tall gallery, rather like a Roman atrium with a central impluvium. The columns of the gallery, more than four metres high including their square abacus, probably supported an inclined timber roof covered with thatch. This new light and elegant way of handling space contrasts strongly with the massiveness of the Maya masonry roofs.

Chichén Itzá also contains, as do the Maya centres of the Classic period, a type of edifice to which I have not yet referred—the sweat bath. A number of small vaulted chambers, with a heating system to produce steam, were used as sweating rooms. The group of the Thousand Columns contains one such sweat bath, located not far from a ball court—one of nine in this Toltec-Maya centre.

The ball game and human sacrifice

We have frequently noted places on Maya sites that were used for the ball game. Archaeologists have restored the largest of Chichén Itzá's nine ball courts, dating from the Toltec-Maya period and measuring 168 by 70 metres. Its layout is traditional: the I-shaped area used for the ritual sport is bounded on each side by walls, 8 metres high, each of which has at the base a small low bench covered with bas-reliefs. A building stands at either end of the court on its median axis (the south building is bigger than the north one).

The most unusual feature of the group is an edifice at the south end of the east wall, which disrupts the delicate symmetry of the whole. Its lower section looks away from the court, while its upper structure overlooks the playing area from the top of the side wall. Known as the Temple of the Tigers (or Jaguars), it consists of a truncated pyramid, at whose base is a three-doored sanctuary topped by a traditional frieze set between an *atadura* moulding and a cornice. The interior of its vaulted chamber is covered with badly worn reliefs. An altar or jaguar-throne stands at the central entrance, sculpted in a ponderous manner that does not compare with the Red Jaguar in the Castillo. The upper temple is more characteristically Toltec-Maya, having an entrance flanked by two great Feathered Serpents, with their snarling mouths at ground level and cylindrical columnar bodies rising to their tails beneath the lintels. Above the lintels is a tall frieze with a richly ornamented mass of motifs such as processional jaguars, Feathered Serpents, and shields. The monumental entrance leads to two vaulted rooms.

This complex was used for the ritual celebrations that accompanied the games between teams of players. Sport was not the sole purpose of such matches, which undoubtedly had a religious role in Maya society. A clear distinction should be made, however, between the version of the ball game played by the Maya during the Classic period in such regions as the Petén or the Motagua and Usumacinta river valleys, and that in the Toltec-Maya world or in the Campeche region (Edzná and Jaina) which underwent Mexican influences at a very early date—as did Yuca-

197 Turquoise mosaic disk from Chichén Itzá: this votive offering, decorated with Feathered Serpent images, was discovered on the back of the Red Jaguar in the first temple of the Castillo. The piece, 24 cm in diameter, was executed on a wooden base that has not survived. Now remarkably reassembled, the disk demonstrates the delicate craftsmanship of the Toltec-Maya in the eleventh century AD (National Museum of Anthropology, Mexico City).

198 Stone 'Atlantean' column from the Temple of the Warriors at Chichén Itzá: this fine sculpture, 88 cm high and showing Toltec influence, was one of several such columns supporting the main altar of the temple (National Museum of Anthropology, Mexico City).

199 Detail of a *chacmool* from Chichén Itzá: the vigorous style of this Toltec-Maya work reflects the spirit of the warriors who ruled over Yucatán from the tenth to the thirteenth century AD (National Museum of Anthropology, Mexico City).

200 Façade of the Temple of the Jaguars overlooking the ball court at Chichén Itzá: robust serpent-columns support a tall frieze decorated with processional jaguars, which give the building its name. The rites performed in this temple were probably connected with the sacred game played in the court.

201 Ball court at Chichén Itzá, seen from the top of the Castillo: only the southern section of the structure is visible here. In the centre is the Temple of the Jaguars with two sanctuaries, one at the bottom facing outwards, the other at top overlooking the court. Behind, the flat Yucatán landscape stretches as far as the eye can see.

200

201

tán during the Puuc period, to judge from certain features of the ball court at Uxmal.

Ball courts in the first group have wide, gently sloping sides as at Copán, with markers projecting from the sides and set into the centre of the floor. Those in the second category are lined by vertical walls with small sloping benches at their base. High on the walls, halfway between the two teams of players, are huge stone rings, held to the masonry by tenons and projecting perpendicularly outward. These are the 'goals' through which the players attempted to send the rubber ball.

There were obviously different rules in each case—and, it would seem, a different type of ball. Vase paintings from the central region of the Petén show a very voluminous and heavy object, whereas in areas under Mexican-Toltec influence a much smaller ball was used (between a tennis ball and a football in size). And while a team had seven players at Chichén Itzá, as can be seen from the fine bas-reliefs that decorate the side benches, 'doubles' (two against two) were apparently the rule among the Maya of the Classic period.

In general, players were not permitted to throw the ball with their hands. The only parts of the body that could be used during what must have been a highly acrobatic game were the forearm, the knees and, above all, the hips. Players wore protective equipment, mainly a wide padded belt strapped around the torso from the hips to the armpits. A knee guard was attached to the right knee which, unlike the left knee, was seemingly allowed to touch the ground. And the right forearm was given a protective covering, as is shown by a bas-relief from the ball court at Chinkultik in Chiapas.

In the case of the players at Chichén Itzá, it would appear that their equipment was somewhat different. Instead of a padded belt, they wore round the waist an object which is called a 'yoke' in the Totonac region (El Tajín). Stone imitations of this have been found, suggesting commemorative representations of a wooden device from which the ball rebounded (some authors term it a 'deflector'). As well as the 'yoke', made of some tough material, their equipment included an 'axe', which has been found in a stone version (known to Mexican archaeologists as

202 Temple of the Jaguars viewed from the Platform of the Eagles, part of which appears in the right foreground, along with some of the Feathered Serpent heads that are a constant feature of Toltec-Maya art at Chichén Itzá.

203 Ball court at Chichén Itzá: shown here is the area, 150 m long, on which the sacred sport was played. Fixed into the side walls, halfway between their ends, are the two stone rings that were used as 'goals'.

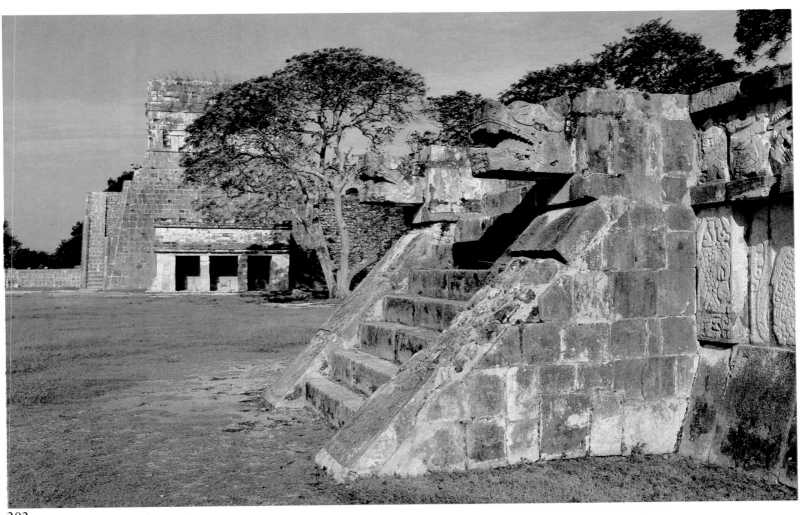

202

203

a 'palma'), and was a kind of bat like those used by players depicted on a fresco at Teotihuacán. Also represented at Chichén Itzá is a sort of 'clog' or 'handle' decorated with a jaguar's head, probably used to provide extra support on the ground. Undecorated examples of this object are found in Olmec monumental statuary at San Lorenzo. It should be remembered that the ritual ball game had Olmec origins.

The scenes depicted on the bas-reliefs of the main ball court at Chichén Itzá leave no doubt as to what became of the captain of the losing team: he was sacrificed to the gods by decapitation. The Toltecs had sanguinary customs. The head, severed by an obsidian blade, was then exhibited on the skull-rack platform, or Tzompantli, next to the ball court. The bas-reliefs which decorate every side of the Tzompantli, portraying row upon row of human skulls skewered on vertical stakes, prove that the invaders from Tula imported this Mexican tradition, which also lingered on in the Aztec city of Tenochtitlán and disgusted the conquistadors.

The cruelty displayed by the Toltecs was not a trait unknown among the Maya, as is proved by the Bonampak paintings, which show captives being tortured. Yet the Maya never committed human sacrifice with the gusto of the highland peoples, who slaughtered on a massive scale—no less than 20,000 people are thought to have had their hearts cut out in a single ceremony at Tenochtitlán. Bloodbaths on that scale were not compatible with Maya religion. It would seem, in any case, that no one was put to death after ball games in the regions of the Petén, the Motagua or the Usumacinta. Human sacrifice by the Classic Maya was chiefly a part of the funeral ceremonies of dignitaries, as we have seen in regard to the crypt at Palenque, confirmed by scenes painted on vases. In addition, self-multilation was performed by thrusting spines or cords through the tongue, ears, or genitals, yielding blood for the gods—a kind of mortification to gain spirituality.

One of the more spectacular methods of sacrifice employed by the Toltec-Maya was death by drowning in the Sacred Cenote, already mentioned. Located 500 metres to the north of the Castillo, the *cenote* measures 60 metres across, and its sheer walls plunge 22 metres below ground level to the expanse of water. The bottom of the well, some 15 metres below the water surface, has been probed by divers since the beginning of the century. Many objects have been dredged from the sediment—human bones, skulls, pottery votive offerings; bits of sculpture from a small building on the edge of the *cenote*, from which victims were flung alive; fragments of alabaster, flint, obsidian, pyrite, seashells; jade, turquoise, and amber plaques; and a series of relics made of copper and gold, which mark the beginnings of pre-Columbian metallurgy in the Maya region around the eleventh or twelfth century.

Scenes of great interest, such as heart sacrifice, are portrayed on a number of marvellous gold disks decorated by the repoussé method. The finest examples were taken out of the country without the knowledge of the Mexican authorities, and are now in the Peabody Museum at Harvard University. There are also copper bells. These are the first specimens of metal objects found by archaeologists in Maya country, but do not mean that metallurgy was an indigenous activity. No mines occur in either the Petén or Yucatán. Presumably the gold came from workshops in Costa Rica and Panama, and the copper from Oaxaca in central Mexico. Such metal was restricted to decorative and cult objects.

204 Lower structure of the Temple of the Jaguars at Chichén Itzá: this part of the Temple, facing outwards, is a sanctuary in the form of a portico on square piers, surmounted by a simple frieze between a traditional moulding and cornice.

205 Vaulted interior of the lower structure of the Temple of the Jaguars: it is covered with finely carved bas-reliefs. On the right is an altar in the shape of a jaguar, like that discovered in the first temple of the Castillo.

206 Detail of the sculpted decoration on the inner walls of the lower structure of the Temple of the Jaguars: it shows a Toltec-Maya warrior, standing in front of some skulls on the far right, wearing an eagle-shaped helmet and carrying a feathered spear and round shield.

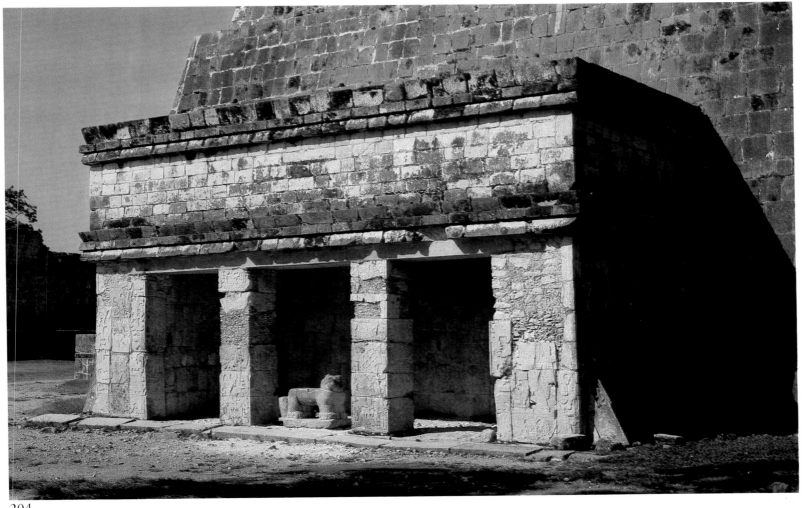

204

205

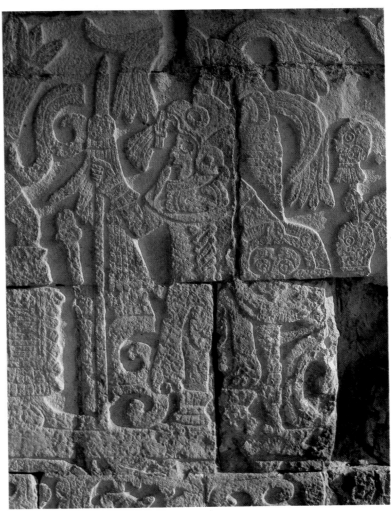

206

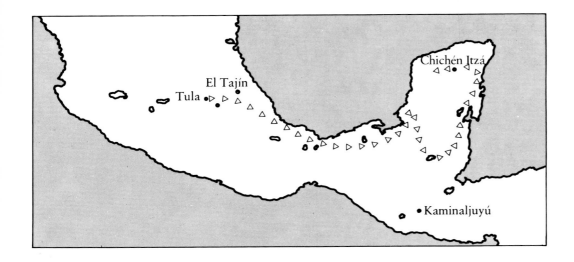

Map of the migration of the Itzá tribe from its highland home to Champoton on the edge of Maya territory, and after 1200 into the Petén as far as Lake Petén Itzá, then entering Quintana Roo and settling in 1263 at Mayapán

The pre-Columbians of Mesoamerica continued to use stone tools and weapons until the arrival of Europeans, who introduced iron.

The Maya universe and the gods

Evidently the lives of the Maya were deeply imbued with religion. Their universe teemed with deities and obeyed a cycle of creations and destructions. Each cycle lasted for 13 baktuns, or about 5128 years. And as the current cycle began, in our calendar, in 3113 BC, it would have come to an end in the year 2015 AD.

How the Maya envisaged their world is not easy to grasp, but it seems that they conceived of the earth as flat and square. Each corner indicated a cardinal direction point, associated with a 'fundamental' colour—red for east, yellow for south, black for west, and white for north—while the centre was green and the zenith probably blue.

Of the countless gods inhabiting the Maya pantheon, I shall mention only the most important. Itzamná was the supreme divinity in heaven; Chac was the rain-god; Yum Kax the god of maize, who governed fertility and, possibly, resurrection; and Ah Puch the death-god. There were also a sun-god, a black war-god, a god of human sacrifice, and gods of celestial bodies such as the north star-god and the Venus-god. Another lofty figure was the wind-god, apparently identified with Kukulcan after the Toltec invasion. As well as the nine deities of the underworld, various calendar deities existed—thirteen for the katuns, nineteen for the 18 'months' of the solar year and the 5 extra unlucky days, and so on.

The last centres of the Maya world

After the Toltecs had given Maya civilization a powerful new artistic impetus by building the 'super-Tula' at Chichén Itzá, whose architecture was such a successful combination of traits from both cultures, the Maya world suffered a steady decline. Toltec domination of Yucatán

207 Skull-rack platform, or Tzompantli, at Chichén Itzá, with the Platform of the Eagles in the background on the right.

208 Bas-reliefs on the Tzompantli: these sculptures, covering every side of the platform, leave little doubt as to the function of this monument, on which the heads of sacrificial victims were exhibited after sacred ball games.

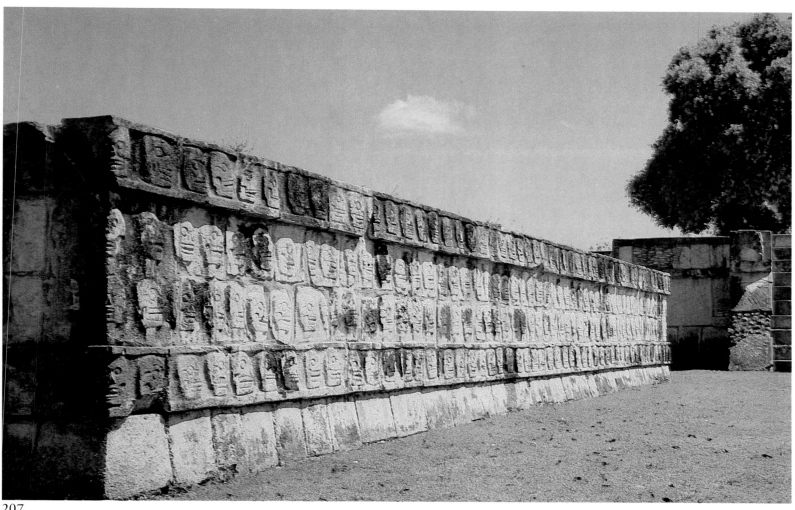

207

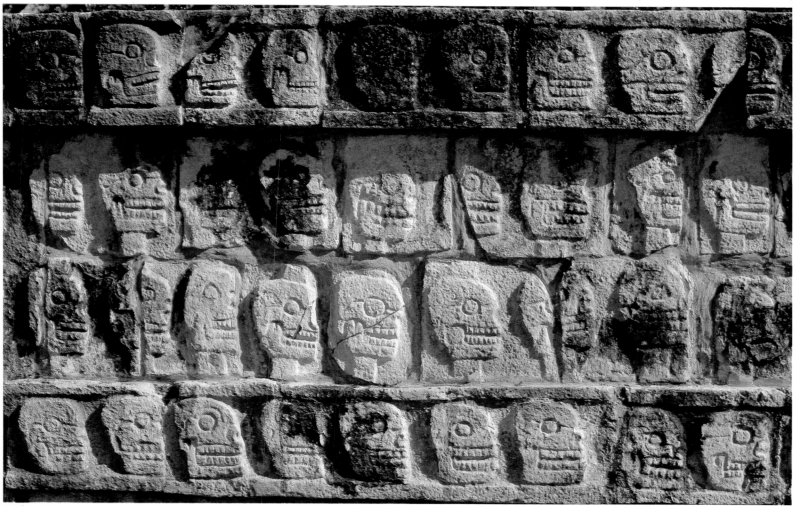

208

ended in 1224. A new tribe, called the Itzá, migrated from Mexico in about 1200, and entered Maya territory in the region of Champoton on the coast of Campeche. From there, they struck south towards the Petén, passed Lake Petén Itzá, turned north into Quintana Roo, and ended up at Chichén Itzá.

It is worth noting that the actual name of this Toltec-Maya capital owes to an unfortunate misunderstanding at the beginning of our century, when the Itzá were thought identical to the Toltec tribe who had invaded Yucatán at the end of the tenth century. After their peregrinations in Maya country, the Itzá eventually settled in 1263 on the site of Mayapán, which became their capital until 1283, when the country was plunged into civil war following a revolt by the Cocom, a tribe related to the Itzá.

One of the most admirable sites of the Maya world is the town of Tulum, on the east coast of Yucatán. Opposite, to the north, lies the island of Cozumel, once venerated by the Maya, who went there to offer up sacrifices to lxchel, the rainbow-deity and wife of Itzamná, the god of heaven. Placed on a cliff overlooking the Caribbean coral reefs, the site is 380 metres long, 170 metres wide, and surrounded on three sides by a wall from 4 to 6 metres high. Its fourth side, dotted with palm trees, runs along the cliff edge above the white sands of the seashore, and required no fortifications.

The size of the settlement, whose dwellings must have stretched far along the coast outside the walls of the ceremonial centre itself, is attested by the first conquistadors. They sailed in front of the site, but decided not to risk a landing. A chronicler accompanying Juan de Grijalva's expedition in 1518 compared Tulum to Seville. Excavations have revealed the remains of some fifty edifices at Tulum, some in a relatively good state of preservation and containing paintings, but rather small and of poor architectural quality. The temples of Tulum, however, occupy a unique place in Maya art because of their location overlooking the sea.

The Castillo, or great pyramid, has a main stairway leading up to a sanctuary, and is flanked by two wings with small temples in front. The building is composed of a series of superimpositions. The design of the sanctuary derives partly from the Toltec-Maya structures of Chichén Itzá and their serpent-columns. But in this case the stonework of the columns is crude, massive, and unsophisticated. Buildings at Tulum display degenerate versions of previous stylistic features such as *atadura* mouldings and projecting cornices. There has been a slackening of form: the doorways of the Temple of the Diving God, for example, are trapezoidal, while several façades on the site show a marked—and intentional—negative batter (leaning outwards), which emphasizes the top as opposed to the base.

The wall paintings in the Temple of the Frescoes are similar in style to Mixtec pictorial manuscripts, and demonstrate again how powerful an influence was exerted by Mexico on the Maya world of the time. One of them portrays the goddess Ixchel bearing small effigies of Chac, a clear allusion to the connection between rain and rainbows. The corners of the same building are embellished with large stucco masks of the rain-god, treated in a representational manner unlike that of works dating from the Classic period at Uxmal or Kabáh. Traces of paint which still remain on these friezes demonstrate that this stuccoed architecture was polychrome.

The visible relics of Tulum were built during the final centuries of Maya culture. But the site must have been occupied in the Classic period, as is proved by the discovery of a stele there dating from 564 AD. Its coastal position soon made it an important point of departure for Maya traders conducting business with neighbouring peoples.

Turning to the extreme south of the Maya world, we find, among the later sites, a number of centres built in present-day Guatemala. Of these I shall mention Iximché, Mixco Viejo, and Zaculeu. The site of Iximché, excavated and restored by the Swiss archaeologist Georges Guillemin from 1959 to 1965, was the 'capital' of a Maya tribe called the Cakchiquel. Located at an altitude of 2260 metres in the highlands, less than 100 kilometres west of Guatemala City, and surrounded by a magnificent landscape of pine forests, Iximché is a fortified centre perched on a rocky spur, whose natural defences were reinforced. It was founded as late as 1470, and destroyed only 54 years later, in 1524, by the Spaniard Pedro de Alvarado.

The interesting feature of Iximché, although it was inhabited by the Maya for only half a century, is that it provides us with the key to the characteristically pre-Columbian custom of superimposition. Several layers of painted stucco can be detected on its ruined pyramids, palaces, and ball courts. This suggests that, with each new reign, the centre was completely resurfaced and repainted. Each building was given at least one layer of stucco, if it was not transformed by superimposition. Such protohistoric monuments are also significant because certain events connected with them were recounted to chroniclers just after the Spanish Conquest by the last surviving custodians of Indian traditions.

Mixco Viejo, like Iximché, is a quite large Post-Classic fortified town. It was excavated by a French team under the leadership of Henri Lehmann between 1954 and 1967. The fortress, which goes back to the thirteenth century and lies some 50 kilometres north-west of Guatemala City, was the capital of the Pokomam, a warlike Maya people resembling the Quiché to the north and the Cakchiquel to the south. Again like Iximché and Tulum, Mixco Viejo shows marked Mixtec influences, as does the great site of Zaculeu, near Huehuetenango in the north-west of the country.

Excavated and (excessively) restored by the United Fruit Company, the Maya centre of Zaculeu has its origins in the Classic period, but most of its visible structures are Post-Classic. Everywhere, Maya art slowly gave way to modes of expression imported from Mexico, whose various civilizations were expanding fast. The chief Maya centres, on the other hand, had all gone into decadence and even, in some cases, been abandoned by their inhabitants.

Plan of the walled town of Tulum, and plan and elevation of the Temple of the Frescoes

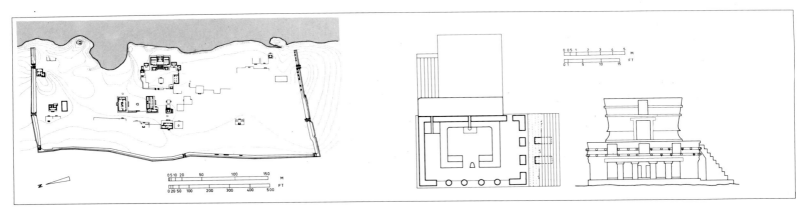

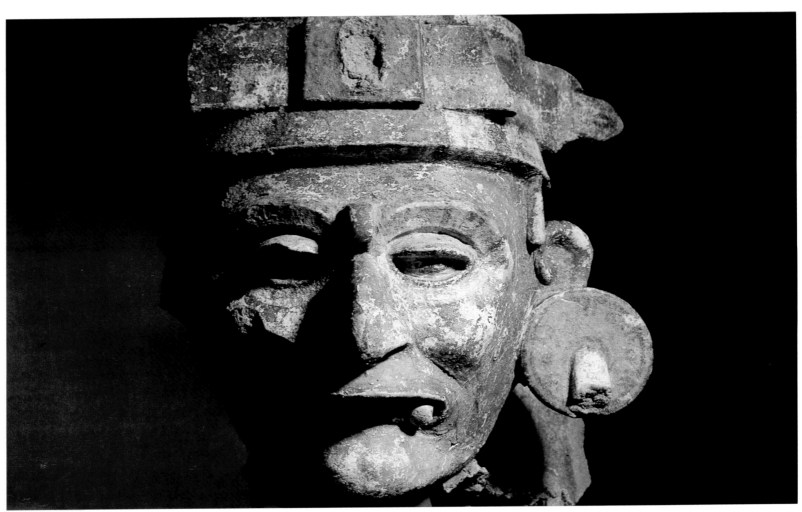

209

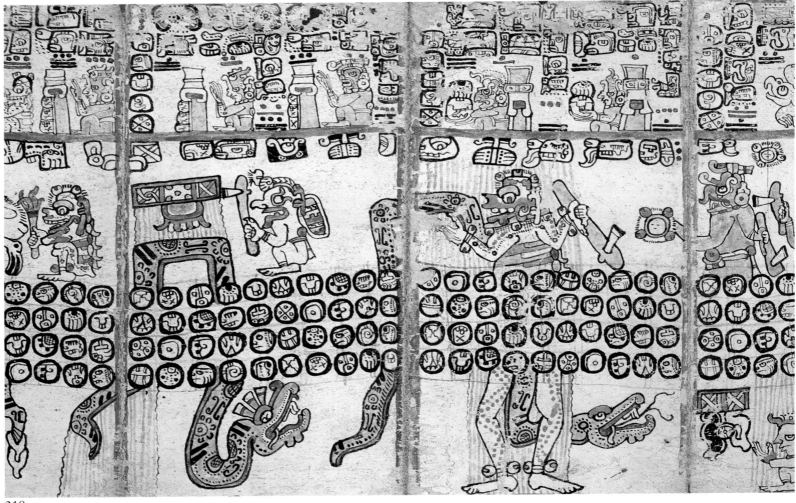

210

Conclusion

Can it really be argued that the Maya world came to a mysterious end? It lasted, in its most vigorous and expressive form, from the third to the tenth century AD, spanning about seven hundred years. One is reminded of the 'mortality' of civilizations: the Maya, as we have seen, arose and evolved, reached an apogee of classicism, then stagnated before degenerating under the ever stronger influence of foreigners. Is this not the natural fate of all societies, and part of the cyclical order of existence?

The very endurance of Maya civilization is surely as surprising as its demise. Of how many cultures could it be said that they flourished and were productive for so long? In the case of Greece, such a period of time stretched from Homer to the Christian era; and in Rome, from the establishment of the republic to the barbarian invasions. An equivalent interval in the Islamic world went from Mohammed to the surrender of Granada, and in medieval Europe from Charlemagne to the discovery of America.

The Maya are indeed still, in some ways, an enigma. Their country became considerably depopulated. But a main reason is that wave after wave of intruders swept across the area when the Maya were already on the decline, looting their towns and killing the inhabitants. There was also, perhaps, increasing pressure from the jungle, which could be held in check only by unremitting discipline and activity. And this overripe society was further weakened by inter-tribal dissension and civil wars.

A theory that the Maya suddenly decided to emigrate is discounted nowadays. By the time the conquistadors landed in Yucatán, the Maya had outlived their glorious heyday. Yet their traditions continued to be proudly preserved by priests, who knew how to read ancient texts, calculate dates according to the old calendar system, and perform Maya rites (which by then had undergone Mexican influences). These descendants were able to pass on to Bishop Landa, and to the handful of Spaniards curious enough to ask questions, the remnants of a cultural heritage that was already more than 1000 years old—much as Egyptian priests told an enthralled Herodotus of the moribund civilization of the Pharaohs.

In order to understand why Maya civilization died out, there is no need to imagine a deadly epidemic, massive exodus, terrible famine, cosmic cataclysm, or murderous rebellion. Only a little of such accidents, combined with a foreign invasion, sufficed to bring the shaky edifice of late Maya society to the ground. The barbarians from the north were tougher, fiercer, and better equipped for warfare than the old Maya tribes, who had exhausted their energies creating works of art, erecting ceremonial centres, and rebuilding pyramids for centuries.

209 Polychrome pottery from Mayapán: this fine piece, 21 cm high and dating from the Toltec-Maya period, shows the god Chac in one of his latest forms, with visible canine teeth, after the Mexican invasion of Yucatán (Mérida Museum).

210 Detail of the Madrid Codex, one of the few surviving codices: dated in the Post-Classic period about 1100 AD, and expressed in the Yucatec language, it shows Mexican influences. Such manuscripts, made of ficus-bark fibre covered with a layer of plaster, were folded like concertinas. They treated such subjects as religion and astronomy. This specimen is thought to have come from Tayasal in Yucatán (Museum of America, Madrid).

But a further explanation for the end of the Maya is due to the recent NASA discovery of a network of canals in the Petén lowlands. These canals—the result of enormous efforts by the Maya to drain their water-logged soil and make it cultivable, while benefitting from the natural fertilizers provided by seasonal floods—required constant maintenance. It goes without saying that a process of decline, followed by the gradual abandonment of this extraordinary agricultural system, because of civil disturbances and invasions that upset the collective discipline essential to its proper working, was bound to impoverish Maya life.

For once the soil was drained, instead of being permanently swampy, the tropical forest could grow there. Within a few centuries, the country had been overrun by vegetation. In a culture that had lost cohesiveness, food production collapsed and the population level plummeted. The Maya 'maize factory' seized up and turned into a pestilential jungle. So it was apparently man who, by causing changes in the environment, caused the rampant growth of the tropical forest which now covers the lowlands once occupied by the Maya—and which strangled their 'cities' and ceremonial centres.

The Maya experienced a painful dissolution, after a period of glory which, between the sixth and tenth centuries, reached such a peak that subsequent generations, until the Spanish Conquest five centuries later, looked back on it as a kind of Golden Age. This process of life and death in a civilization should excite no wonder. Other pre-Columbian peoples replaced the Maya in turn: the expanding Mixtecs, then the imperialist and bloodthirsty Aztecs who imposed their rule over most of the civilized areas of North America. The Aztecs were stopped only by an unprecedentedly violent confrontation with the guns, iron armour, and horses of a few European adventurers and fortune-hunters, even stronger in will than the last of the pre-Columbians at their height. But such is the lot of cultures which climb to a pinnacle of genius and slide into oblivion.

The mysterious disappearance of the Olmecs must be approached from another angle, as their final creations were those of a civilization in its prime. Although lasting over 1000 years, it always showed, even at the end, amazing vitality—from the invention of writing, a calendar, and numerals to the production of some powerful artistic works such as statuary and jades. How can these facts be squared with sudden extinction? There is a certain persuasiveness in the audacious theory of Jacques Soustelle, who proposes to put back the starting point of Olmec time-reckoning by a whole baktun, equivalent to 144,000 days or 394.5 years. This would make Stele C at Tres Zapotes date from 425 BC instead of 31 BC. Such a date seems to agree better with the Olmec cultural context. It would be easier to understand the close relationship between the death of the Olmec world and the birth of Maya culture—a relationship that resembles a direct transfer of knowledge and experience from the Olmecs to the Maya, undoubtedly advantageous for the latter.

Analogous was the connection between ancient Greece and Rome (with the important difference that neither population vanished): as soon as the Greek cities lost vigour, their leadership passed to the Romans. Just as it would be wrong to regard the Romans as 'descendants' of the Greeks, so the Maya should not be confused with the Olmecs. One civilization was the natural heir to another, in neighbouring and not necessarily overlapping territories.

211 Castillo at Tulum, in Quintana Roo: this building, high on a cliff over the Caribbean, occupies one of the most spectacular sites in the Maya world.

212 West side of the Castillo at Tulum: a great stairway leads up to a temple that imitates the structures with serpent-columns at Chichén Itzá. The building dates from the twelfth or even the thirteenth century AD.

213 Temple of the Frescoes at Tulum, with the Castillo in the background: a gallery of four massive stone columns supports the temple, whose walls lean outwards like those of many other buildings on the site.

214 Stucco mask at a corner of the Temple of the Frescoes at Tulum: this is the god Chac in his late form with projecting canines, no longer distinguished by the long nose that was typical of the rain-god during the Classic Maya period. Such stucco masks were polychrome and must have lent a special brilliance to this architecture in its tropical setting.

215 Detail of a painting from the Temple of the Frescoes at Tulum: the style of this art is modelled on that of Mixtec manuscripts, and shows the importance of Mexican influence in Yucatán during the final centuries before the Spanish Conquest.

216 Along a coastline dotted with temples and ceremonial centres, Tulum was still a large Maya trading town even at the beginning of the sixteenth century AD, when the first conquistadors compared it to Seville.

217 Structure 1 at Zaculeu, in the Guatemalan highlands: between the thirteenth and sixteenth centuries AD, Zaculeu was an important centre where a Mixtec-influenced Maya culture succeeded in surviving. This edifice, highly restored, is a stepped pyramid entirely covered with stucco, which must originally have been polychrome.

218 Iximché, in the Guatemalan highlands: this site was the capital of the Cakchiquel tribe for only 54 years. The fortress, with its temples, terraces, palaces, and ball court, was razed in 1524 by the conquistador Pedro de Alvarado.

At all events, the close bond between the Olmecs and the Maya has been amply corroborated. Any analysis of the legacy bequeathed by these two peoples, whose artistic production dominates the New World's native cultural heritage, shows the consistency of their view of the universe, as well as the diversity of forms it could take in either province. An equation of La Venta with San Lorenzo is no more plausible than one of Tikal with Copán, or of Palenque with Uxmal. And from the viewpoint of plastic expression, there are as many differences between each region of Maya art as there are between whole nations in the rest of the pre-Columbian world, such as the Zapotecs and Teotihuacanos, the Totonacs and the Mixtecs, or the Toltecs and the Aztecs.

Despite the unity of its common background, the astonishing multiplicity of Maya art suggests that it was produced by a civilization which had more in common with the diversity, independence, and individualism of Greek cities than with the monolithic centralization of the Roman Empire. Indeed, among the most interesting aspects of Maya art is its spirit of freedom in seeking varied forms of expression. Aesthetically speaking, it is hard to see what a Yaxchilán bas-relief shared with a Puuc geometric frieze, or what parallel may be drawn between the stelae at Copán or Quiriguá and the Jaina figurines.

If nothing in the pre-Columbian world compares with the powerful architectural inspiration of Uxmal, if the summits of the art of painting were reached by the Bonampak murals, and if the stucco heads of Palenque achieve universality, it is because, over a period of seven centuries, the Maya attained a superb balance between discipline and freedom, between constraint and inspiration. This was the quality which enabled them to assimilate the contribution of their invaders and to produce, like a swan-song, the grandiose sombre renaissance of Chichén Itzá.

The Maya left a message that can still resound sympathetically in the hearts of twentieth-century observers. To hide the appreciation aroused in us by Maya art, its sheer originality, the splendour of its manifestations, and the refinement of its concepts, would be futile. Few experiences are more moving than the discovery of a different yet intelligible, familiar yet outlandish, order of things. For are we not trying to discern a new facet of humanity when we see signs of beauty in the countenances of the Maya of old, and when we find, in their devotion to time and numbers, a sublime defiance of the laws of ultimate destruction?

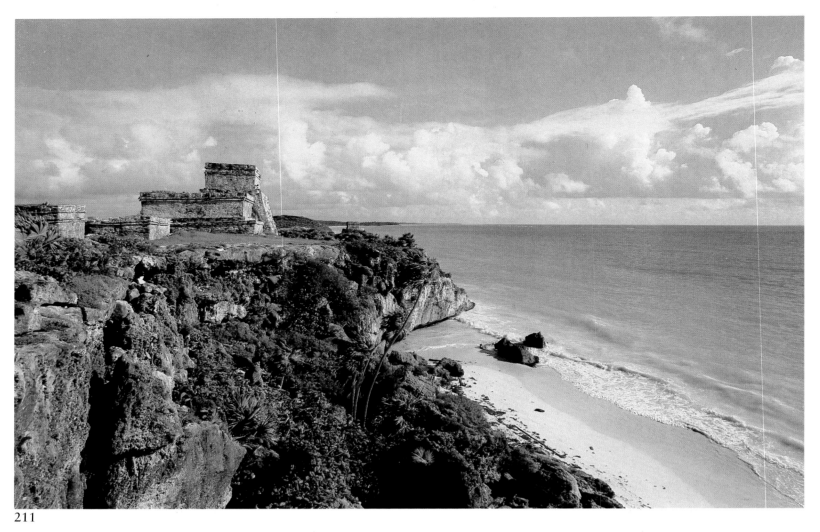

211

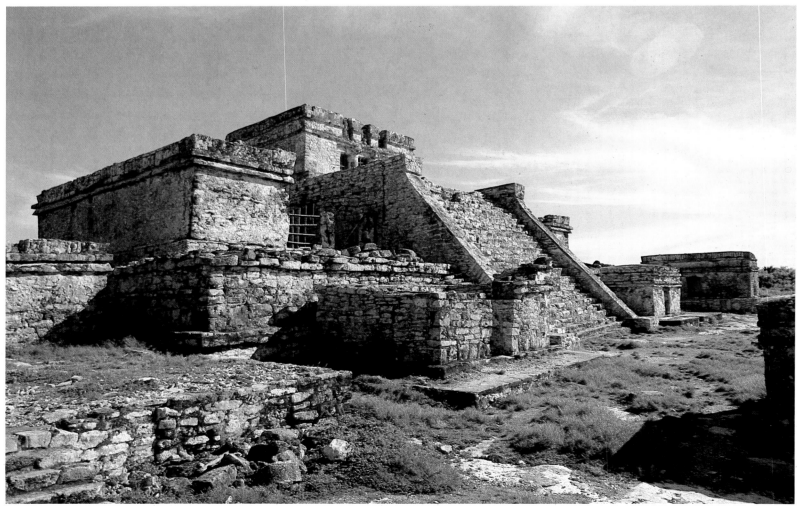

212

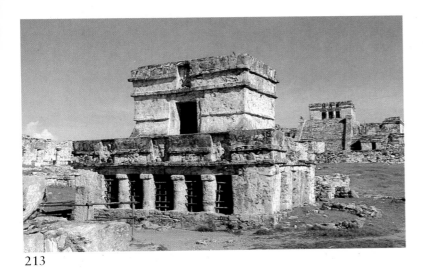

213

214

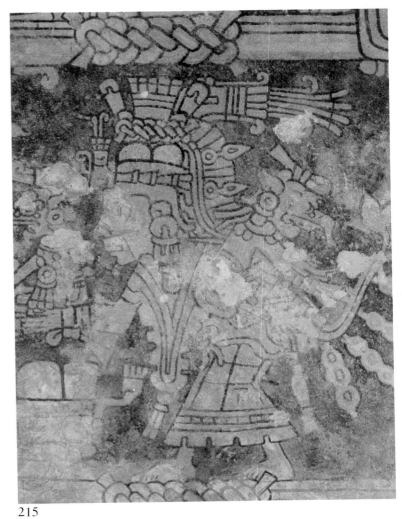

215

216

Select bibliography

Alcina, José, *L'Art précolombien*, Editions Lucien Mazenod, Paris, 1978.

Anton, Ferdinand, *Art of the Maya*, Thames and Hudson, London, 1970.

Benson, Elizabeth P., editor, *Dumbarton Oaks Conference on the Olmec*, Dumbarton Oaks Research Library and Collection (Trustees for Harvard University), Washington, D.C., 1968.

Benson, Elizabeth P., 'An Olmec figure at Dumbarton Oaks', in *Studies in Pre-columbian art and archaeology 8*, Dumbarton Oaks, Washington, D.C., 1971.

Benson, Elizabeth P., editor, *The Olmec and their Neighbors*, Dumbarton Oaks, Washington, D.C., 1981.

Berlin, Heinrich, *Signos y significados en las inscripciones mayas*, Instituto Nacional del Patrimonio Cultural de Guatemala, Guatemala City, 1958.

Bernal, Ignacio, *Mexique précolombien*, La Bibliothèque des Arts, Paris, 1968.

Bernal, Ignacio, Roman Piña-Chan, and Fernando Camara-Barbachano, *Tesoros del Museo Nacional de Antropología de Mexico*, Ediciones Daimon, Mexico, 1977.

Caso, Alfonso, '¿Existió un imperio olmeca?', in *Memorias del Colegio Nacional*, Vol. V, No. 3 (1964), Mexico, 1965.

Coe, Michael D., *Map of San Lorenzo, an Olmec site in Veracruz, Mexico*, Department of Anthropology, Yale University, New Haven, 1968.

Coe, Michael D., 'San Lorenzo and the Olmec civilization', in *Dumbarton Oaks Conference on the Olmec*, Washington, D.C., 1968.

Coe, Michael D., *The Maya*, Penguin Books, Harmondsworth, 1971.

Drucker, Philip, Robert F. Heizer, and Robert J. Squier, *Excavations at La Venta, Tabasco, 1955*, Smithsonian Institution Bureau of American Ethnology, Bulletin 170, Washington, D.C., 1959.

Foncerrada de Molina, Marta, *Fechas de radiocárbono en el area maya*, Estudios de Cultura Maya, Mexico, 1964.

Fuente, Beatriz de la, *Las cabezas colosales olmecas*, Fondo de Cultura Economica, Mexico, 1975.

Grove, David C., 'The Olmec paintings of Oxotitlán Cave, Guerrero, Mexico', in *Studies in Pre-columbian art and archaeology 6*, Dumbarton Oaks, Washington, D.C., 1970.

Hartung, Horst, *Die Zeremonialzentren der Maya*, Akademische Druck und Verlagsanstalt, Graz (Austria), 1971.

Heizer, Robert F., 'New observations on La Venta', in *Dumbarton Oaks Conference on the Olmec*, Washington, D.C., 1968.

Hellmuth, Nicholas M., *Pre-columbian ballgame, archaeology and architecture*, Foundation for Latin American Anthropological Research, Progress Reports, Vol. I, Guatemala City, 1975.

Hunter, C. Bruce, *A guide to ancient Maya ruins*, University of Oklahoma Press, Norman, 1974.

Joralemon, Peter David, 'A study of Olmec iconography', in *Studies in Pre-columbian art and archaeology 7*, Dumbarton Oaks, Washington, D.C., 1971.

Kubler, George, *Pintura mural precolombiana*, Estudios de Cultura Maya, Mexico, 1967.

Marquina, Ignacio, *Arquitectura prehispanica*, Instituto Nacional de Antropología e Historia, Mexico, 1951.

Medellín Zenil, Alfonso, 'Monolitos olmecas y otros en el Museo de la Universidad de Veracruz', in *Corpus Antiquitatum Americanensium, Mexico*, Vol. V, Instituto Nacional de Antropología e Historia, Mexico, 1971.

Morley, Sylvanus G., *La civilización maya*, Fondo de Cultura Economica, Mexico, 1961.

NASA News, 'NASA radar experiment discovers Mayan canals', Release No. 80–76, Washington, D.C., 28 May 1980.

Nicholson, H.B., editor, *Origins of Religious Art and Iconography in Preclassic Mesoamerica*, University of California Press, Los Angeles, 1976.

Ochoa, Lorenzo, *Notas preliminares sobre el proyecto: arqueología de las tierras bajas noroccidentales del area maya*, Estudios de Cultura Maya, Mexico, 1976–1977.

Piña-Chan, Roman, *Informe preliminar de la reciente exploración del cenote sagrado de Chichén Itzá*, Instituto Nacional de Antropología e Historia,. Mexico, 1970.

Proskouriakoff, Tatiana, *Historical data in the inscriptions of Yaxchilán*, Estudios de Cultura Maya, Mexico, 1963–1964.

Proskouriakoff, Tatiana, 'Olmec and Maya art: problems of their stylistic relation', in *Dumbarton Oaks Conference on the Olmec*, Washington, D.C., 1968.

Robertson, Merle G., editor, *Mesa Redonda de Palenque*, Robert Louis Stevenson School, Pebble Beach, California, 1974–1980.

Ruz Lhuillier, Alberto, 'El juego de pelota de Uxmal', in *Miscellanea Paul Rivet, octogenatio dicata* (I), Universidad Nacional Autonoma, Mexico, 1958.

Ruz Lhuillier, Alberto, editor, *Estudios de Cultura Maya*, Vols. I–IX, Universidad Nacional Autonoma, Mexico, 1961–1977.

Ruz Lhuillier, Alberto, *La civilización de los antiguos mayas*, Instituto Nacional de Antropología e Historia, Mexico, 1963.

Ruz Lhuillier, Alberto, *Costumbres funerarias de los antiguos mayas*, Seminario de Cultura Maya, Mexico, 1968.

217

218

Ruz Lhuillier, Alberto, *El Templo de las Inscripciones, Palenque*, Instituto Nacional de Antropología e Historia, Mexico, 1973.

Ruz Lhuillier, Alberto, *Más datos historicos en las inscripciones de Palenque*, Estudios de Cultura Maya, Mexico, 1973.

Schele, Linda, *Notebook for the Maya Hieroglyphic Writing Workshop at Texas*, Institute of Latin American Studies, University of Texas at Austin, Texas, 1980.

Soustelle, Jacques, *Les Olmèques, la plus ancienne civilisation du Mexique*, Editions Arthaud, Paris, 1979.

Stierlin, Henri, *Maya*, Collection Architecture Universelle, Office du Livre, Fribourg, 1964.

Stierlin, Henri, *Mexique ancien*, Collection Architecture Universelle, Office du Livre, Fribourg, 1967.

Stirling, Matthew W., *Stone monuments of southern Mexico*, Smithsonian Institution Bureau of American Ethnology, Bulletin 138, Washington,D.C., 1943.

Studies in Pre-columbian art and archaeology, Dumbarton Oaks (Trustees for Harvard University), Washington, D.C., 1970–1971.

Thompson, J. Eric S., *The rise and fall of Maya civilization*, Norman, London, 1956.

Thompson, J. Eric S., *Algunas consideraciones respecto al desciframiento de los jeroglíficos mayas*, Estudios de Cultura Maya, Mexico, 1963.

Wicke, Charles R., *Olmec, an early art style of Precolumbian Mexico*, University of Arizona Press, Tucson, 1971.

List of plates

List of figures, maps and plans

Index

Acknowledgements

The author/photographer is indebted to the following institutions and individuals for facilitating the completion of this book:

The National Council of Tourism in Mexico, and in particular Sr. Alfonso Garcia Beltrán, Director of Information, and Sr. Javier Rivas Garcia, Assistant Director, in Mexico City.

Aeromexico S.A., and its General Directorship in Mexico City, as well as M. Roland Boninsegni, Director for Switzerland.

The National Institute of Anthropology and History in Mexico City, and in particular Sr. Lic. Javier Oropesa y Segura.

The National Museum of Anthropology and History in Mexico City, and Sr. Arturo Romano Pacheco, Interim Director.

The Museum of Jalapa, Veracruz, and Sr. Alfonso Medellín Zenil, Director of the Institute of Anthropology in the University of Veracruz.

The Museums of Tabasco, La Venta at Villahermosa, and Palenque in Chiapas.

The National Museum of Anthropology and History in Guatemala City, and Sr. Lic. Francisco Polo Sifontes, Director.

The Popol-Vuh Museum, Francisco Marroquin University, in Guatemala City, and Dr. Luis Muñoz, Director, as well as Sr. Alfredo Gomez, Conservator.

The Museum of Copán, Honduras.

The Museum of Ethnography in Basle, and Mme Dr. A. Foote-Baldinger.

The Museum of Ethnography in Geneva, and M. André Jeanneret, Director.

The Swiss Society of Americanists, Geneva, and M. René Furst, President.

The author is also most grateful to Linda Schele and Gillett Griffin for reading the text and providing valuable information. Linda Schele also kindly contributed to the section on Maya hieroglyphic writing.

Photographic credits

Of the 218 colour photographs illustrating this book, those not belonging to the author are compliments of:

Maximilien Bruggmann, Yverdon: nos. 47, 48, 49, 51, 52, 56, 217.
Roland Burkhard, Geneva: no. 50

Yvan Butler, Geneva: no. 209.
Peter Horner, Basle: no. 54.
Michel Mohr, Geneva: nos. 131, 132, 133, 134.
Oronoz, Madrid: no. 210.
Rodolfo Reyes Juarez, INGUAT, Guatemala City: nos. 53, 55.

The aerial radar map of Maya canals on page 50 was kindly provided by the NASA Press Service in Washington, D.C. The illustration of the Palenque crypt on page 90 is due to the courtesy of the National Institute of Anthropology and History in Mexico City.

This book was printed in July 1981 by Arts Graphiques Héliographia S.A., Lausanne

Photolithographs:
Cooperativa lavoratori grafici, Verona
Binding: Mayer & Soutter S.A., Renens

Editorial: Jon van Leuven
Layout: Henri Stierlin
Production: Oscar Ribes

77
1711